Luxury Resorts & Spas
OF INDIA

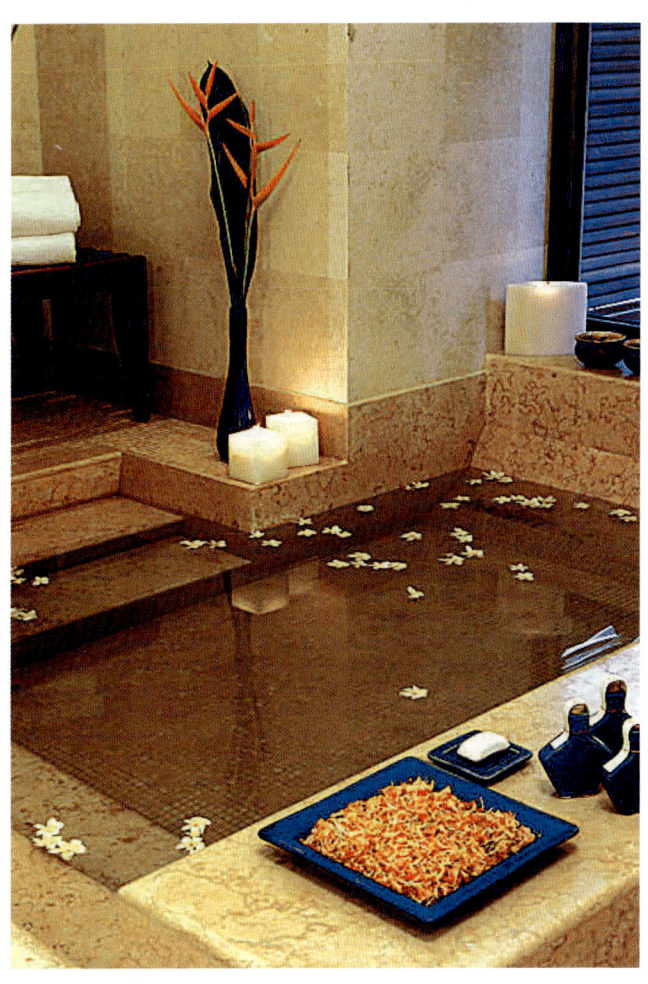

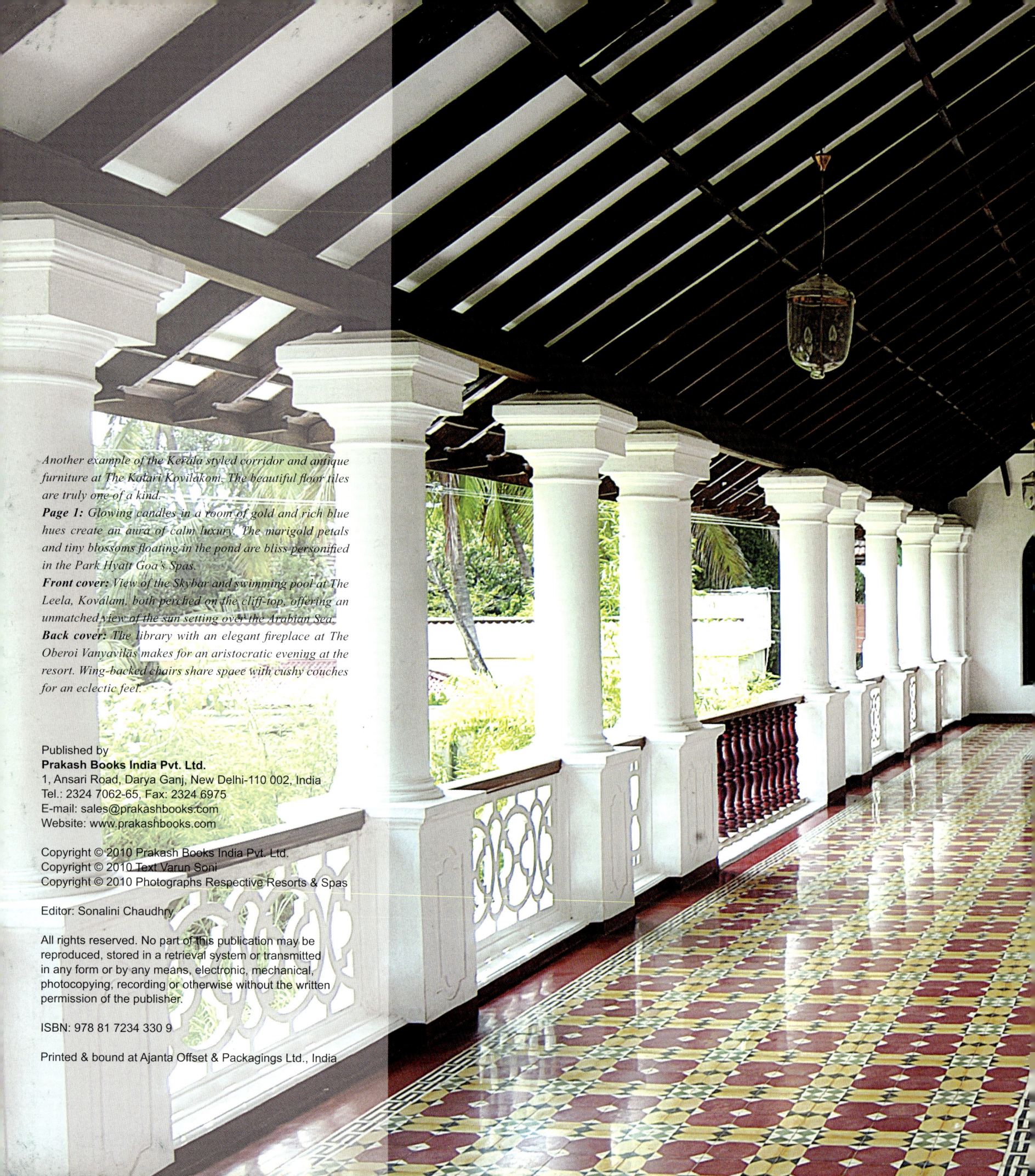

Another example of the Kerala styled corridor and antique furniture at The Kalari Kovilakom. The beautiful floor tiles are truly one of a kind.
Page 1: *Glowing candles in a room of gold and rich blue hues create an aura of calm luxury. The marigold petals and tiny blossoms floating in the pond are bliss personified in the Park Hyatt Goa's Spas.*
Front cover: *View of the Skybar and swimming pool at The Leela, Kovalam, both perched on the cliff-top, offering an unmatched view of the sun setting over the Arabian Sea.*
Back cover: *The library with an elegant fireplace at The Oberoi Vanyavilas makes for an aristocratic evening at the resort. Wing-backed chairs share space with cushy couches for an eclectic feel.*

Published by
PRAKASH BOOKS INDIA PVT. LTD.
1, Ansari Road, Darya Ganj, New Delhi-110 002, India
Tel.: 2324 7062-65, Fax: 2324 6975
E-mail: sales@prakashbooks.com
Website: www.prakashbooks.com

Copyright © 2010 Prakash Books India Pvt. Ltd.
Copyright © 2010 Text Varun Soni
Copyright © 2010 Photographs Respective Resorts & Spas

Editor: Sonalini Chaudhry

All rights reserved. No part of this publication may be reproduced, stored in a retrieval system or transmitted in any form or by any means, electronic, mechanical, photocopying, recording or otherwise without the written permission of the publisher.

ISBN: 978 81 7234 330 9

Printed & bound at Ajanta Offset & Packagings Ltd., India

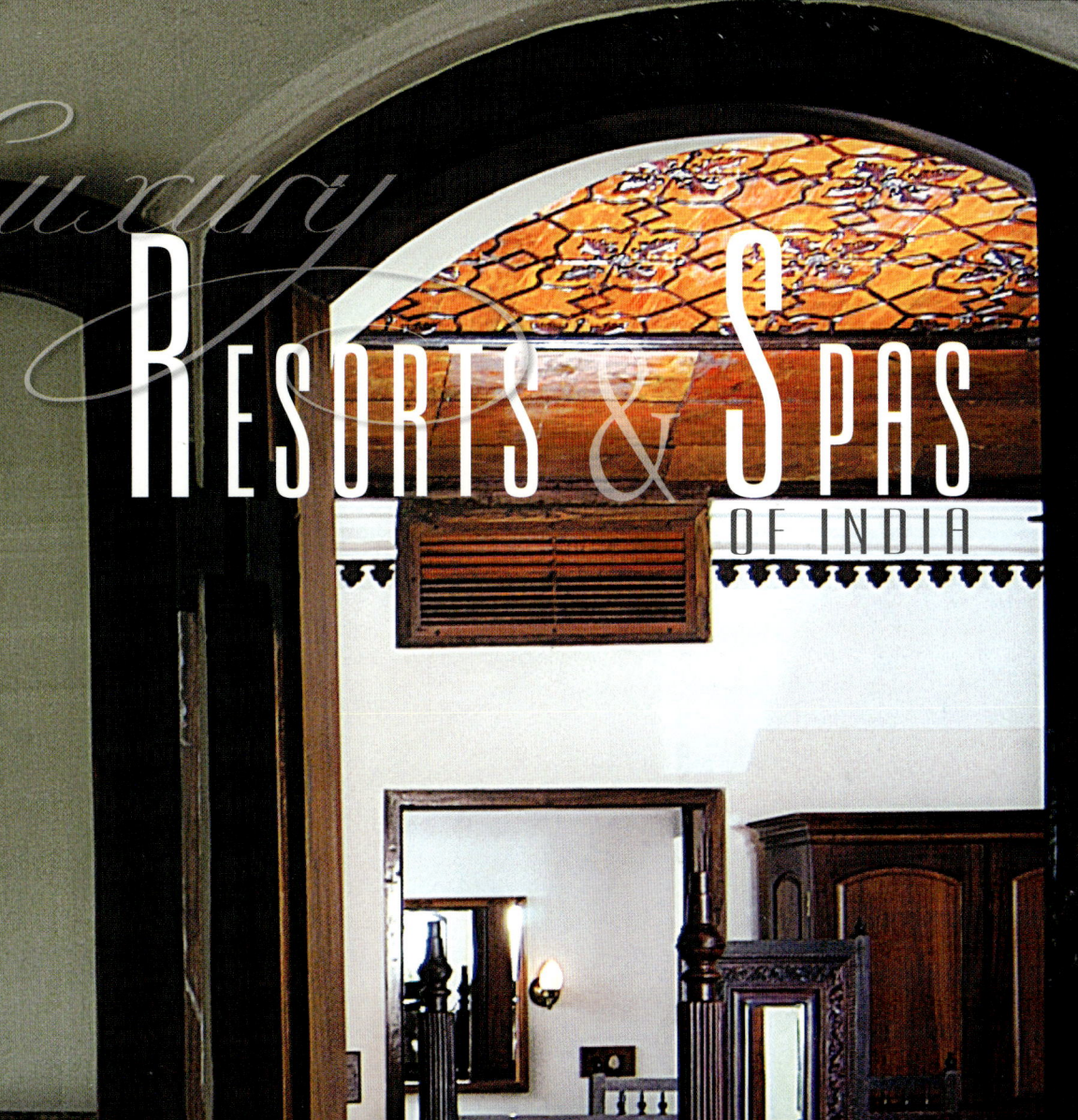

Luxury Resorts & Spas
OF INDIA

VARUN SONI

PRAKASH BOOKS

I would like to dedicate this book in the loving memory of my grandparents, Mrs. Shakuntala Devi and Diwan Hari Charan Dass Soni. This book would not have been possible without the support of my wife Dr. Vandna Soni, my son Rushil, my parents Mrs. Kamini and Dr. P.L. Soni, and my brother Vipul, his wife Sarika and their son Manit.

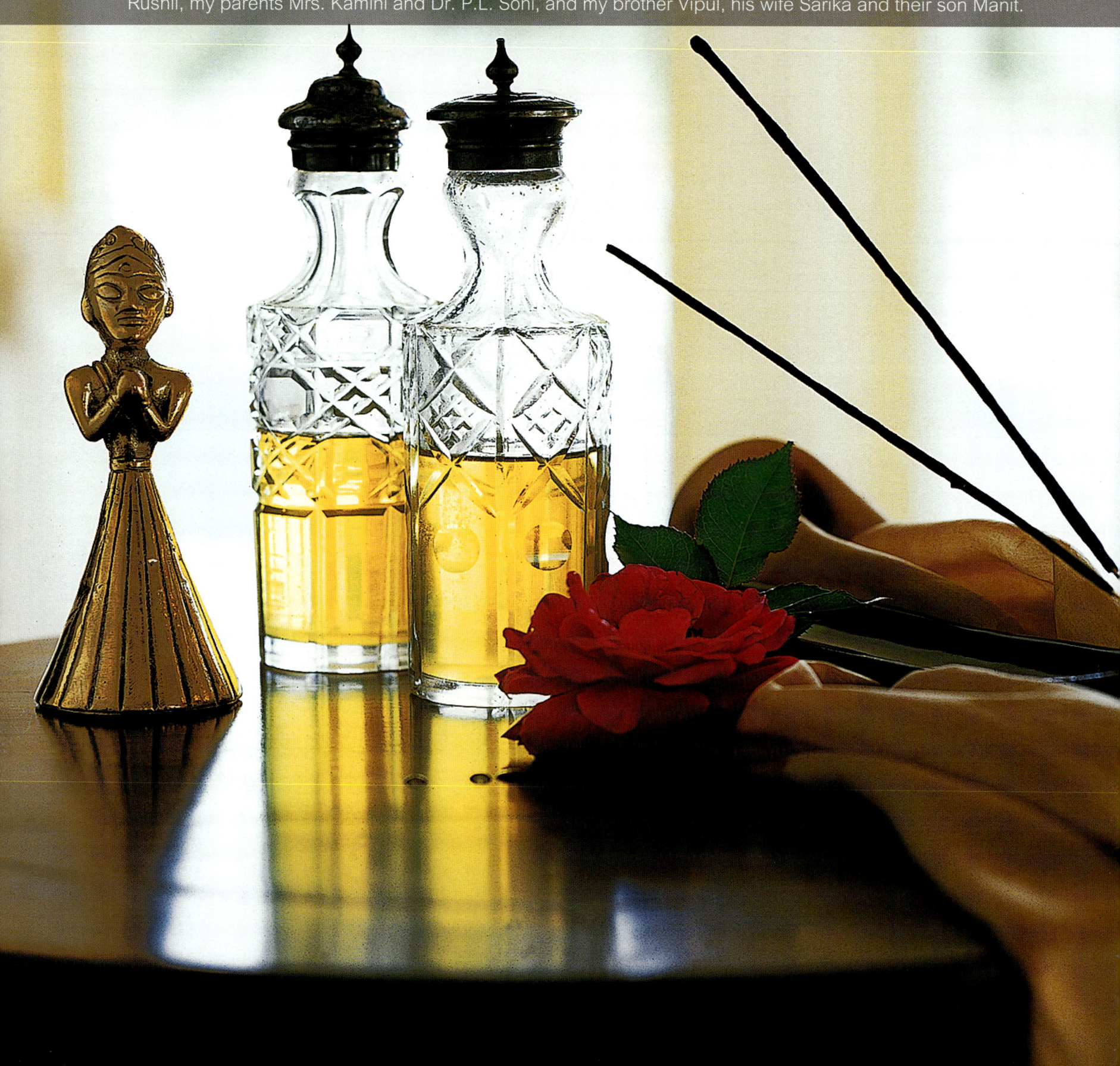

Contents

Park Hyatt Goa Resort and Spa • 8

The Zuri White Sands, Goa Resort & Casino • 20

The Leela Kempinski Goa • 30

The Taj Exotica, Goa • 42

Fisherman's Cove, Tamil Nadu • 54

The Leela Kempinski Kovalam Beach • 64

The Taj Green Cove Resort, Kovalam • 78

The Poovar Island Resort, Kerala • 86

The Kumarakom Lake Resort, Kerala • 96

The Kalari Kovilakom, Kerala • 106

Shreyas, Bangalore • 116

Angsana Oasis Spa & Resort, Bangalore • 128

The Vedic Village, Kolkata • 138

The Oberoi Vanyavilās, Ranthambhore • 150

The Oberoi Udaivilās, Udaipur • 160

The Oberoi Rajvilās, Jaipur • 172

Manuallaya, Manali • 180

Ananda in the Himalayas, Tehri Garhwal • 188

Wildflower Hall, Shimla in the Himalayas
– An Oberoi Resort • 200

The Kikar Lodge Nature Retreat and Spa, Ropar • 210

The Westin Sohna-Gurgaon Resort and Spa • 218

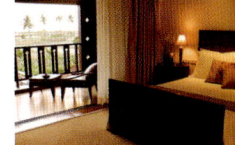

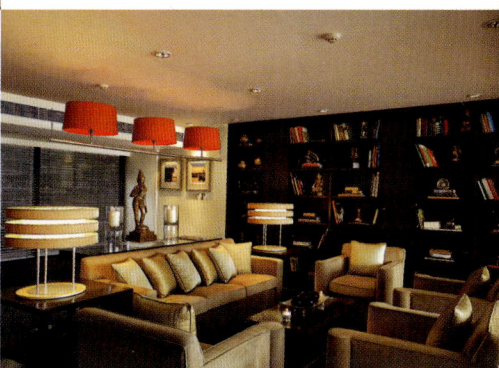
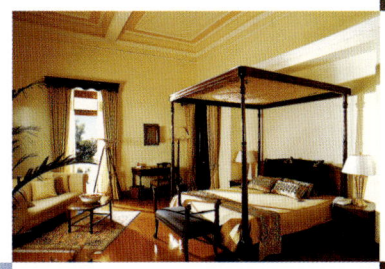
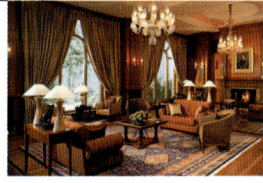
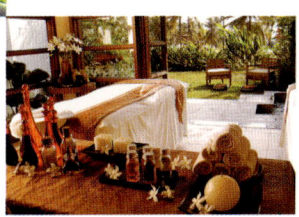

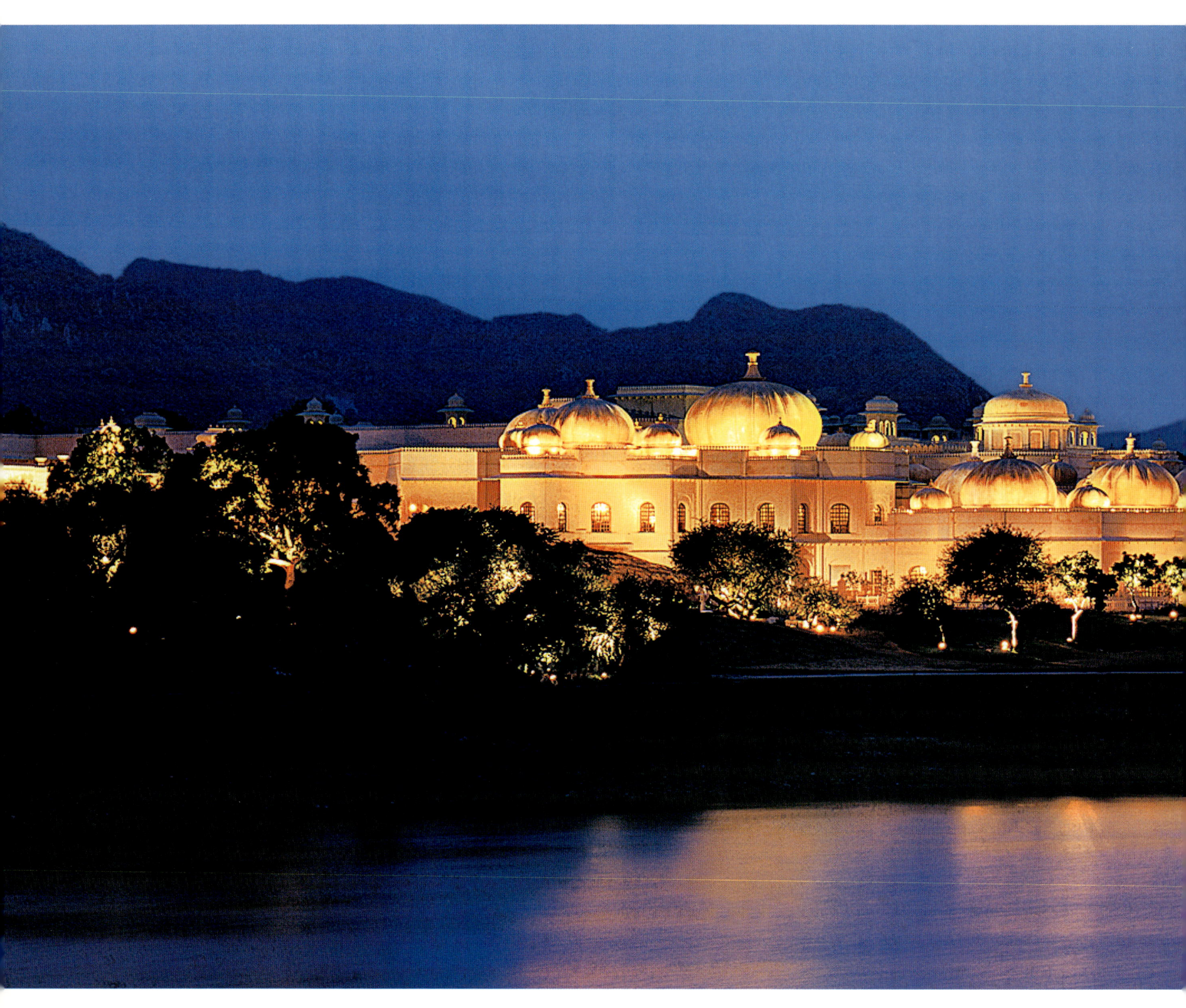

The Oberoi Udaivilās, illuminated at night casts a golden glow over the placid waters of the Lake Pichola. **Page 4:** *Charming glass bottles of aroma oils, a brass figurine incense sticks and a rose blossom on a walnut polished table recreate pampering fit for royalty at the spa in Oberoi Udaivilās.*

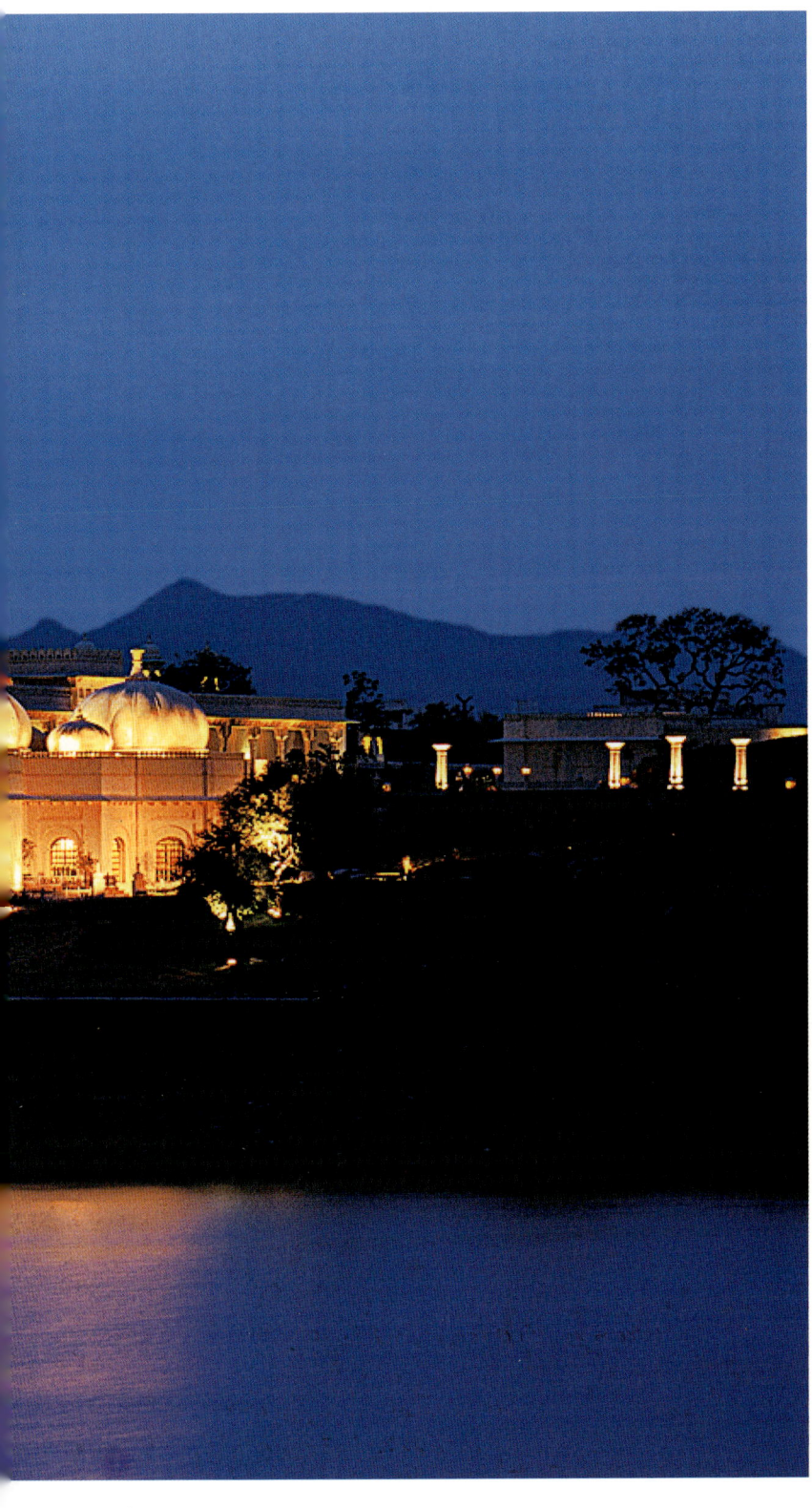

My fetish for travel has taken me to many holidays across India; every experience enriching and enchanting in its own way. Beauty in language, beauty in art, beauty in landscape – beauty in all its forms is what I search for perhaps. Maybe, this is the impetus behind my travels.

Opportunity has just to knock on my door, and off I am with family in tow, flying out to distant locales, to rejuvenate in the magical retreats that welcome enticingly.

I remember that time, which as I think back now, probably planted the seed of this book in my mind. It was my first ever Spa vacation, spas having become the latest fad just then. It was the Ananda, in Tehri Garhwal. For me, it truly was my slice of Heaven, as I sat with my feet in a pebble pool, the refreshing water taking my cares away. The aroma oil, the perfect massage; the whole experience brought me to peace with the real and the ethereal.

As the stress was gently eased out from my body, my eyes were opened to a whole new realm of beauty. I took great delight in all that I saw, and apart from the natural beauty of the environs, it was the absolutely wonderful interiors that caught my imagination. And this was just the beginning of my love affair with the immense splendour and beauty of the luxury resorts and spas of India. The entire length and breadth of my fascinating country revealed to me such perfect gems that offered the best spa treatments from the world over and interiors that were a feast for the senses.

Here, in this book, I have brought together the best Luxury Resorts and Spas of India. The Oberoi Udaivilās and Rajvilās were a study in royalty. For those who want to bring some opulent grandeur into their homes, these would be great resources. The Vanyavilās, Kikar resorts, Vedic Village all bring out the primal element. The Goan resorts are bliss personified, especially the Portuguese Village of the Park Hyatt, Goa. Its Sereno Spa offers the most divine treatments too. Kalari Kovilakom's Ayurveda and its concept of locking out the outside world helps one absorb the beauty within. The old-world charm and grace is something one will carry back home.

I have put together this book for all those who want to know about the best Spas of India, detailing the treatments and facilities they have to offer. Also those looking for a truly, sumptuously relaxing holiday – the book details the specialty of each resort, its location and what to expect there.

And especially those who are doing the interiors of their spaces – homes, offices, even exotic bathrooms! This book brings together the exceptionally beautiful works of many well-known designers and architects who have created the masterpieces that these resorts are.

I hope the reader, decorator and vacationer, will enjoy this book and these resorts as much as I did.

VARUN SONI

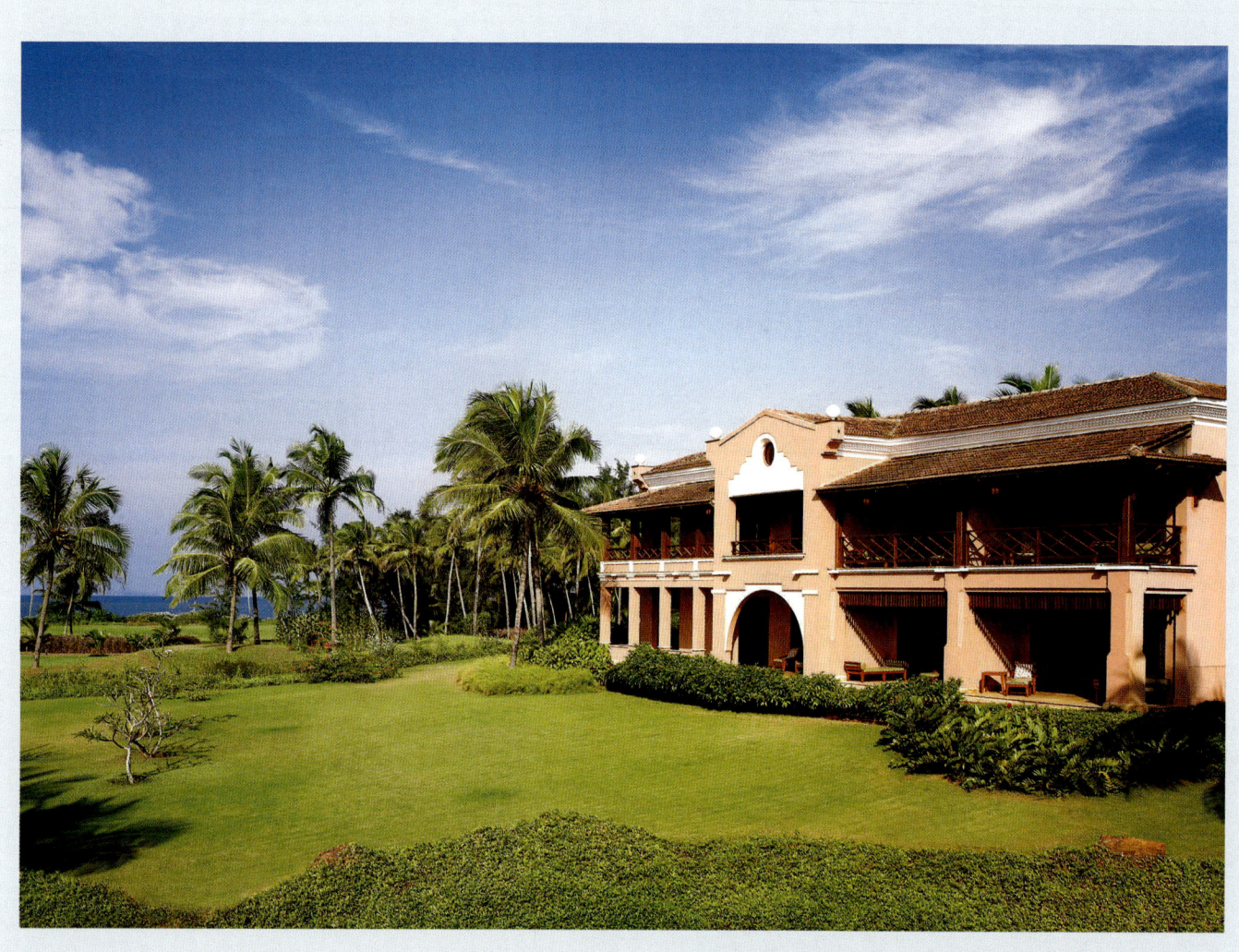

Park Hyatt Goa Resort and Spa

blending Ayurveda with modernity

The Park Hyatt Goa Resort and Spa successfully fuses ancient Ayurvedic treatments with modern-day spa systems to bring about a positive change in physical health, emotional balance and spiritual enlightenment...

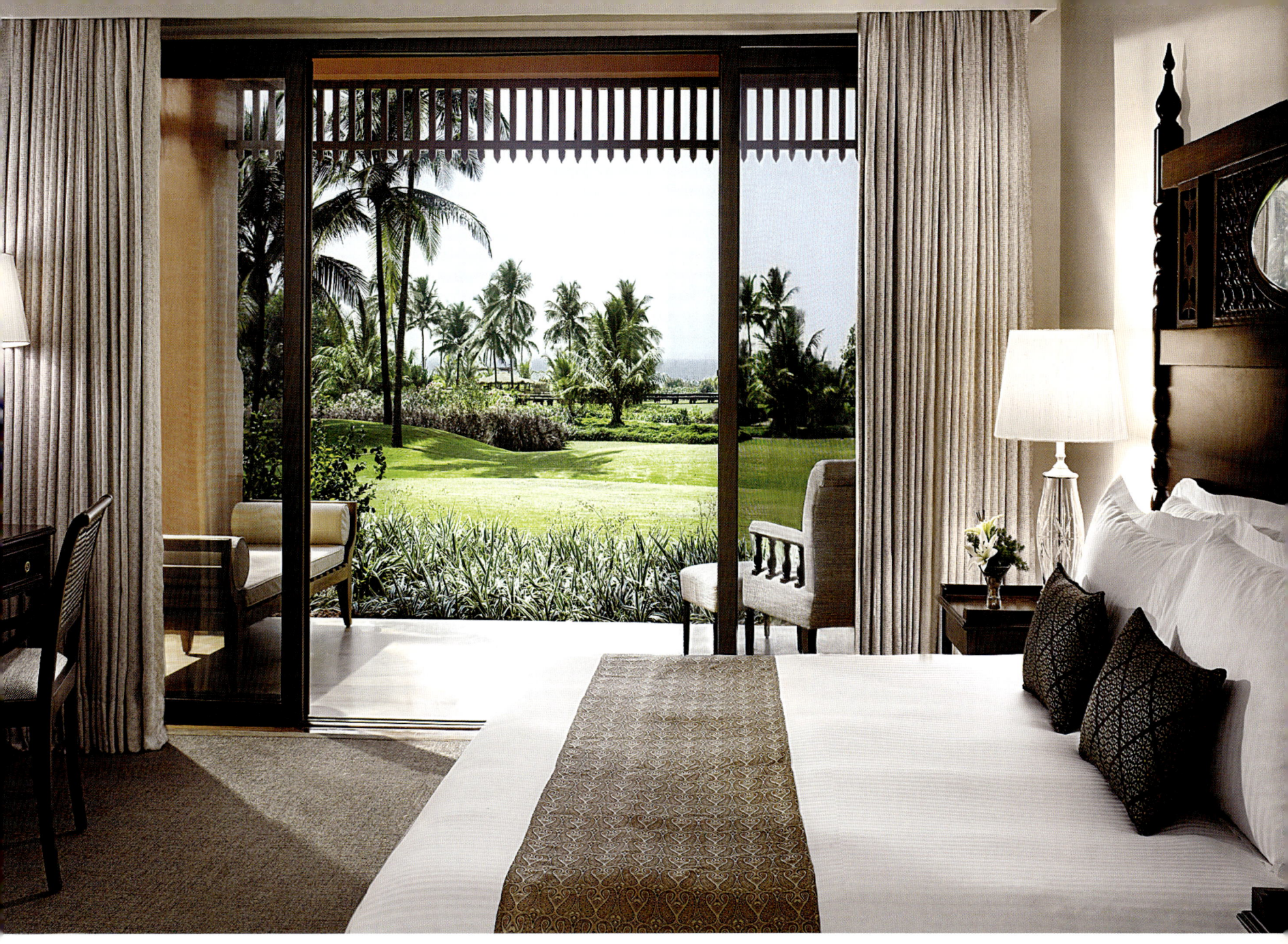

ocated in the most idyllic part of South Goa and a 15-minute drive from Goa's Dabolim Airport, the resort overlooks the breathtaking blue waters of the Arabian Sea. Spread over 46 acres, this resort and spa has been conceptualized as an Indo-Portuguese village, resembling a lively picturesque township, full of fragrant plant-filled courtyards and gardens, linked by Venice style canals, bridges and cobbled streets.

Designed by famed resort architect, Simeon Halstead from Spain, and landscape designer, Peter Imrik of California, the Park

The unique feature of the resort is its Indo-Portuguese style villas – Pousadas comprising 250 guest rooms. The interiors of these rooms are comfortable and chic, and overlook a tropical garden. **Page 8:** *Indo-Portuguese style Pousadas overlooking the Arossim beach.*

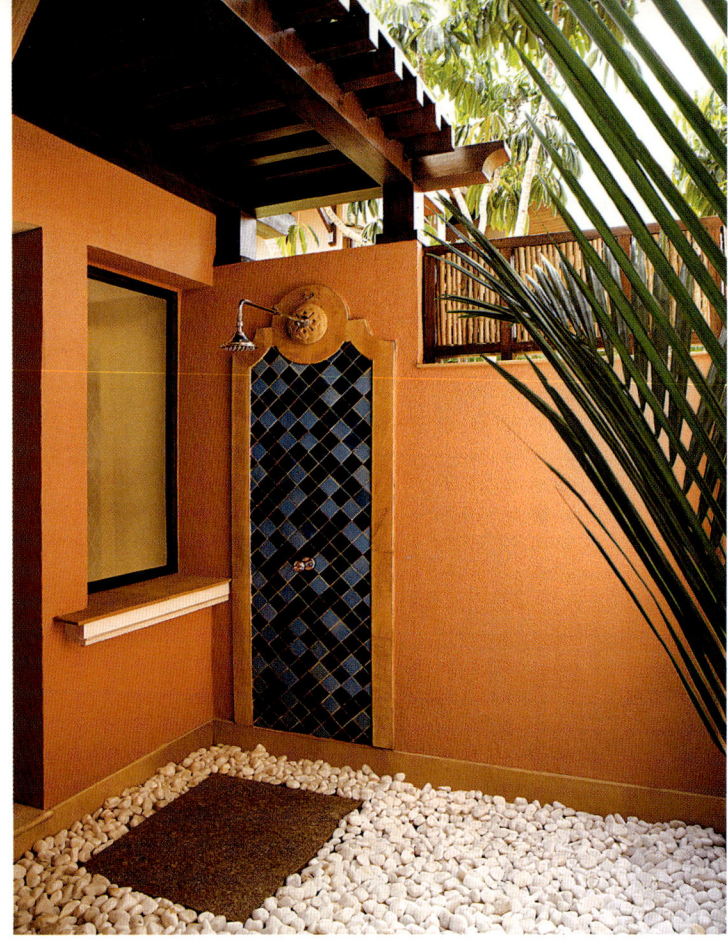

Hyatt Goa Resort and Spa recreates the relaxed atmosphere of a small Goan village and overlooks the pristine Arossim Beach and the clear waters of the Arabian Sea.

Voted as the 'Number One Spa in the World' and the 'Best Spa in Asia and the Indian Sub-continent' by Conde Nast Traveller Reader's Spa Awards in 2006, apart from its design, The Park Hyatt Goa Resort and Spa is also known for its Sereno Spa therapy approach that follows the ancient sciences of Ayurveda and Yoga.

The resort is anchored by two main plazas – the village and the lobby plaza, each characteristically different from the other. The frontage of the hotel is a huge patio, which leads into an intimate lobby area, resembling the scale and character of a grand old Goan house. Located along its corridors is the lobby bar that resembles a living room of a Goan mansion, inspired and named after the state's celebrated cartoonist, Mario Miranda.

The unique features of the resort are its Indo-Portuguese style villas – Pousadas – comprising 250 guest rooms. These Pousadas are divided into five courtyards, each sporting a distinctive theme, architecture and landscape. The Pousadas are set apart from each other by lagoons, tropical gardens and bridges, and interconnected with cobbled village streets.

Set around a cobbled courtyard, the village plaza reflects a bustling Goan marketplace with an interactive dining, shopping and cultural experience. The Village Square comprises a bakery and a host of Indian and international specialty restaurants situated in the heart of the bustling retail area of the Village Square.

The lobby plaza is quieter and more formal in comparison – it doubles as a grand outdoor pre-function area for the adjacent ballrooms, allegorically the Town Hall of the resort. Other features of the resort include a dedicated children's area and India's largest swimming pool measuring 20,000 sq ft.

The dining options at the resort include five restaurants, all serving you a different cuisine. The Casa Sarita is a signature fine dining Goan restaurant that serves authentic culinary delights created in a traditionally designed Goan house. Here you can savour delectable Goan specialties including Bacalao, traditional Prawn Curry, Pomfret Recheado, Lamb Xacutti and Pork Vindaloo.

*Top: The shower area in the guest room exhibits a Mediterranean feel and opens out to nature. **Bottom**: The guest rooms afford an enchanting view of the blue waters of the Arabian Sea beyond.*

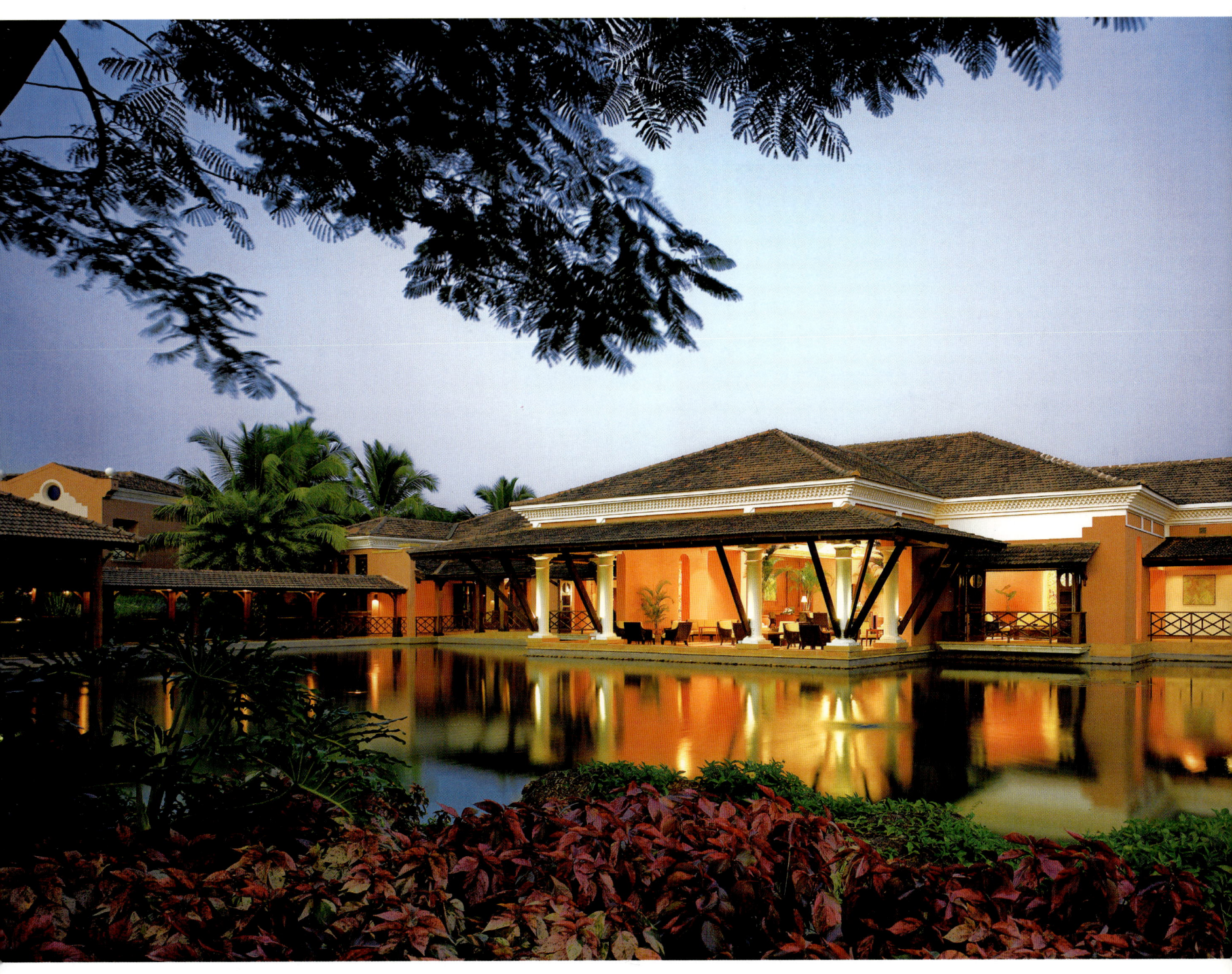

*The exquisite lobby overlooks serene waters and rich green foliage. **Page 14:** The Village Sqaure has an eclectic design theme. The coloured tiles on the floors, the cane chairs with iron frames lend a relaxed feel to the open-air dining area. **Page 15:** The beachside grill and seafood restaurant – The Palms – is a feast for the senses. It is all natural with its wooden deck feel and soft candle lighting adding a touch of romance.*

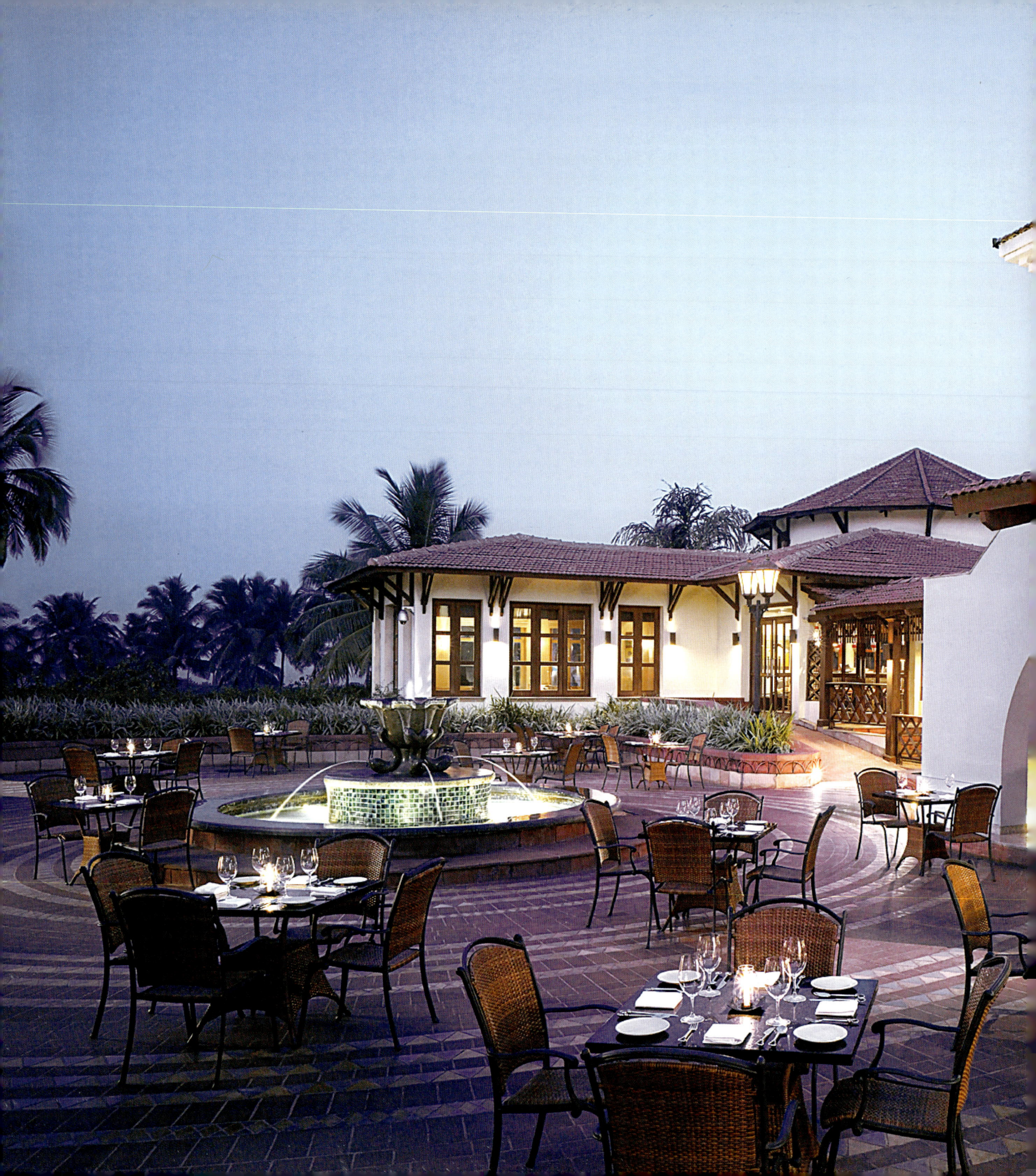

The Masala is a North Indian specialty kitchen that is distinguished by its sophisticated use of spice and herbs, offering the best of North and South Indian cuisine. The Italian Trattoria called Da Luigi is located at the Village Square and offers a wide selection of authentic pizzas, fresh pastas, as well as an array of delights for lunch and dinner.

The Village Cafe is the all-day dining place that offers a lavish spread of gourmet dishes. Last, but not the least is the beachside grill and seafood restaurant called The Palms.

Nestled among the natural sand formations, this open-air restaurant offers a dramatic and ideal dining ambience. You can savour the delectable cuisine that includes fresh seafood delicacies, charcoal-grilled and spit-roasted meats, hand-picked wines and delicious salads.

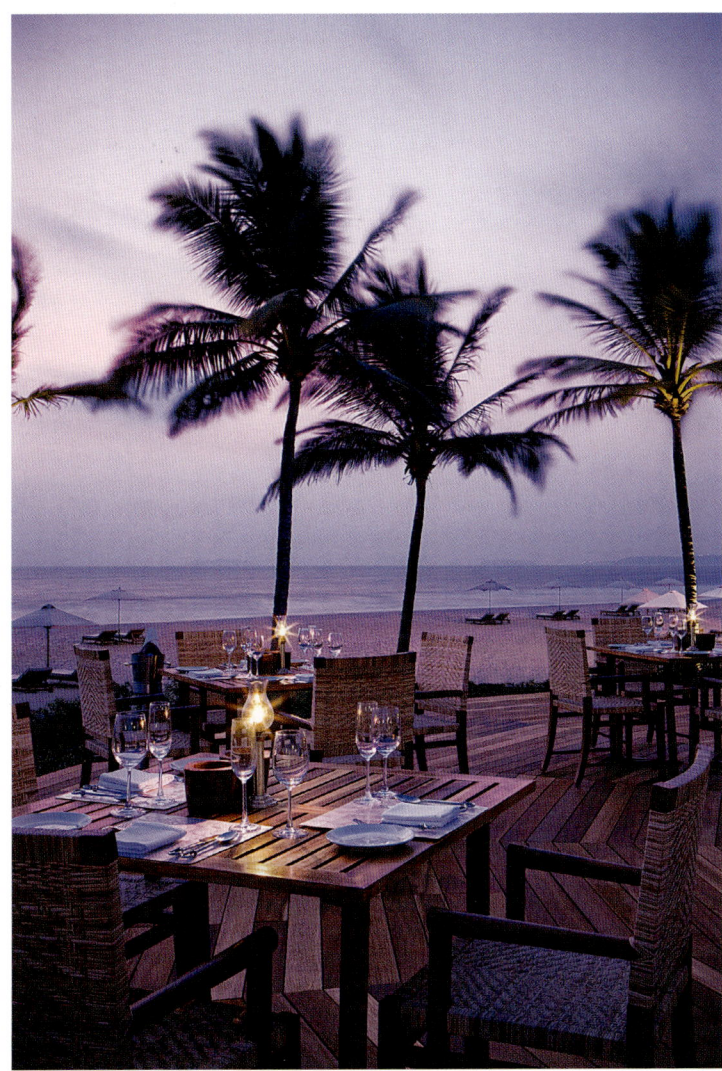

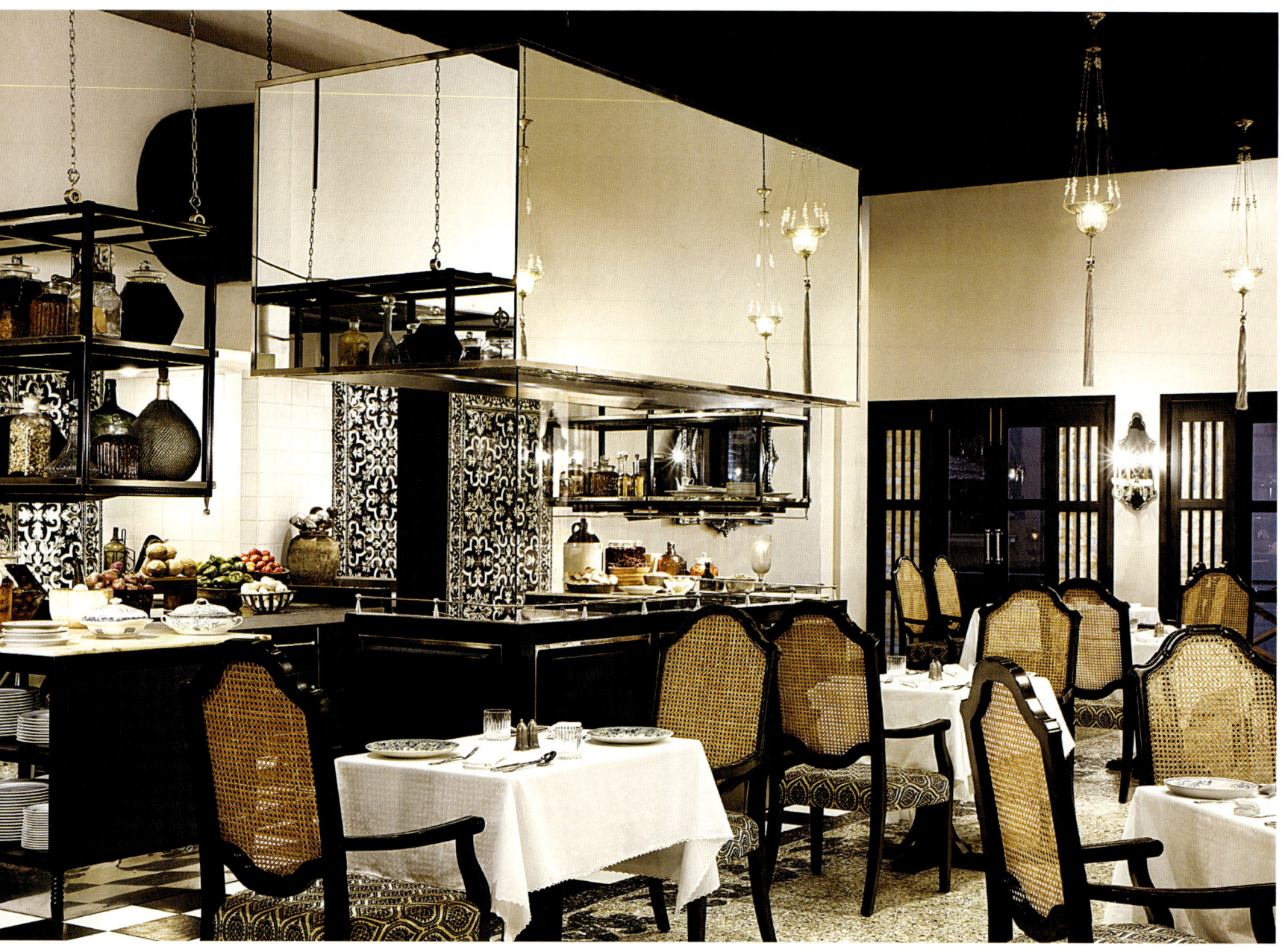

The resort has two lounge bars namely Praia de Luz, which is located at the end of the Village Square, and the Poolside Bar which is located at the center of the resort.

Situated at the north end of the property and spread over 36,000 sq ft is the Sereno Spa, a wellness sanctuary designed to provide a holistic experience inspired by Ayurvedic and Yogic traditions. The integrated wellness programme at the spa combines lifestyle assistance with advice on natural self-care techniques, organic nutrition concepts and fitness options.

The spa features single and double treatment suites, outdoor therapy spaces, separate male and female sauna and steam rooms, gymnasium, aerobic and Yoga studio. To top it all, the nine indoor

The Casa Sarita showcases an open kitchen plan. Glass and ceramic jars of all shapes and sizes are an eye-catching decor element. Delicate glass lamps suspended from the ceiling cast a glow on the traditional Portuguese-Goan furniture and tiles.

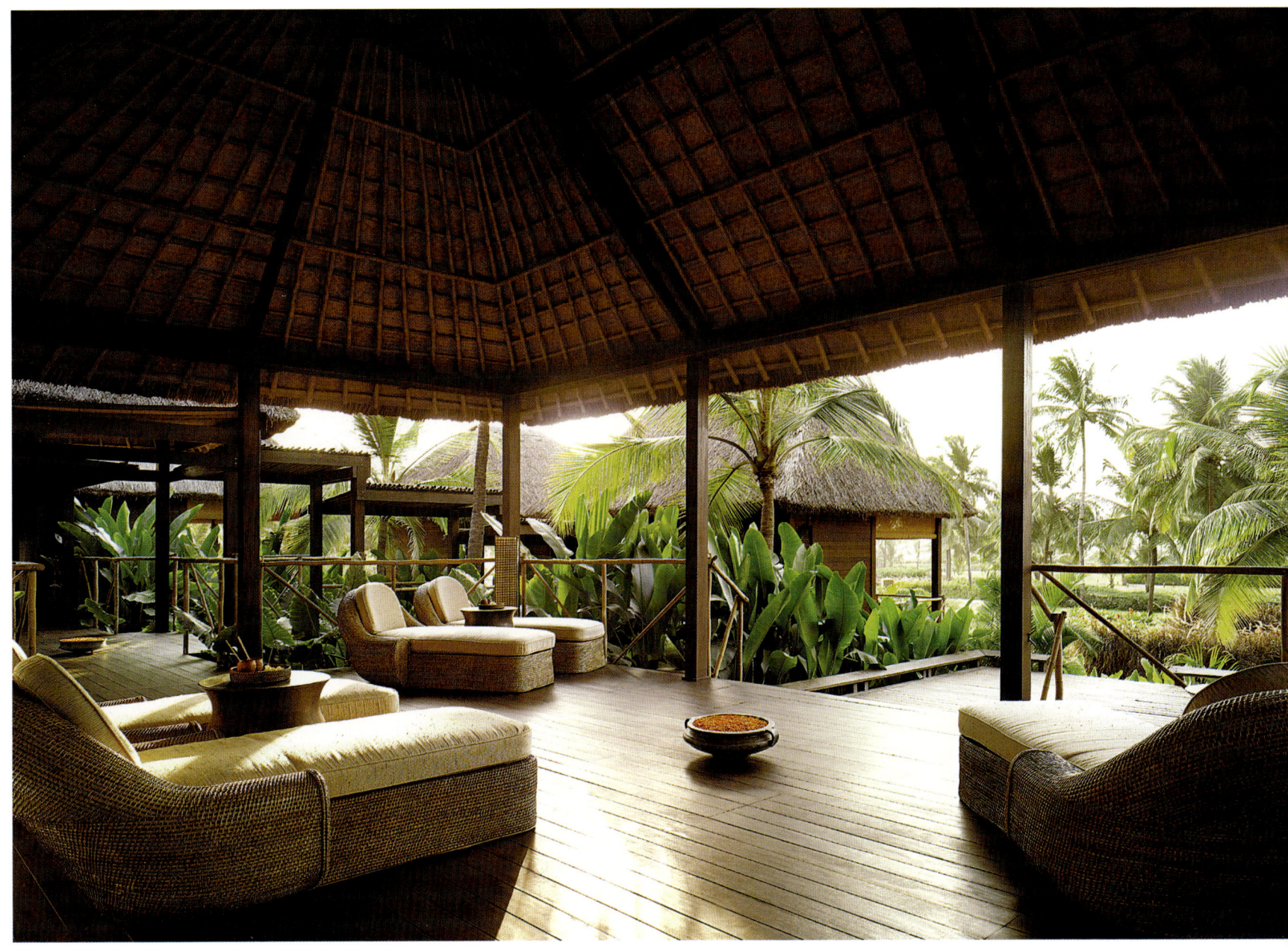

treatment suites have been arranged around lush gardens, where therapists help you relax with the help of age-old Ayurvedic therapies.

The Park Hyatt Goa Resort and Spa has a comprehensive menu of Ayurvedic treatments – from Shirodharas to Marma Abhyangas and detoxifying Panchkarma. Yoga Asanas and Pranayam under the guidance of Yoga gurus also form an integral part of the wellness programme.

Some of the spa treatments offered at the resort include the Vata Abhyanga in which firm rhythmic strokes are used to nourish and soothe the mind, while the *Dosha*-specific aroma-infused herbal oils balance body, mind and character. This traditional massage helps to induce sleep and nourishes the cells.

The Spa Lounge overlooks the greens. Interiors are designed with natural elements, wooden flooring, thatched roofs and unique cane recliners.

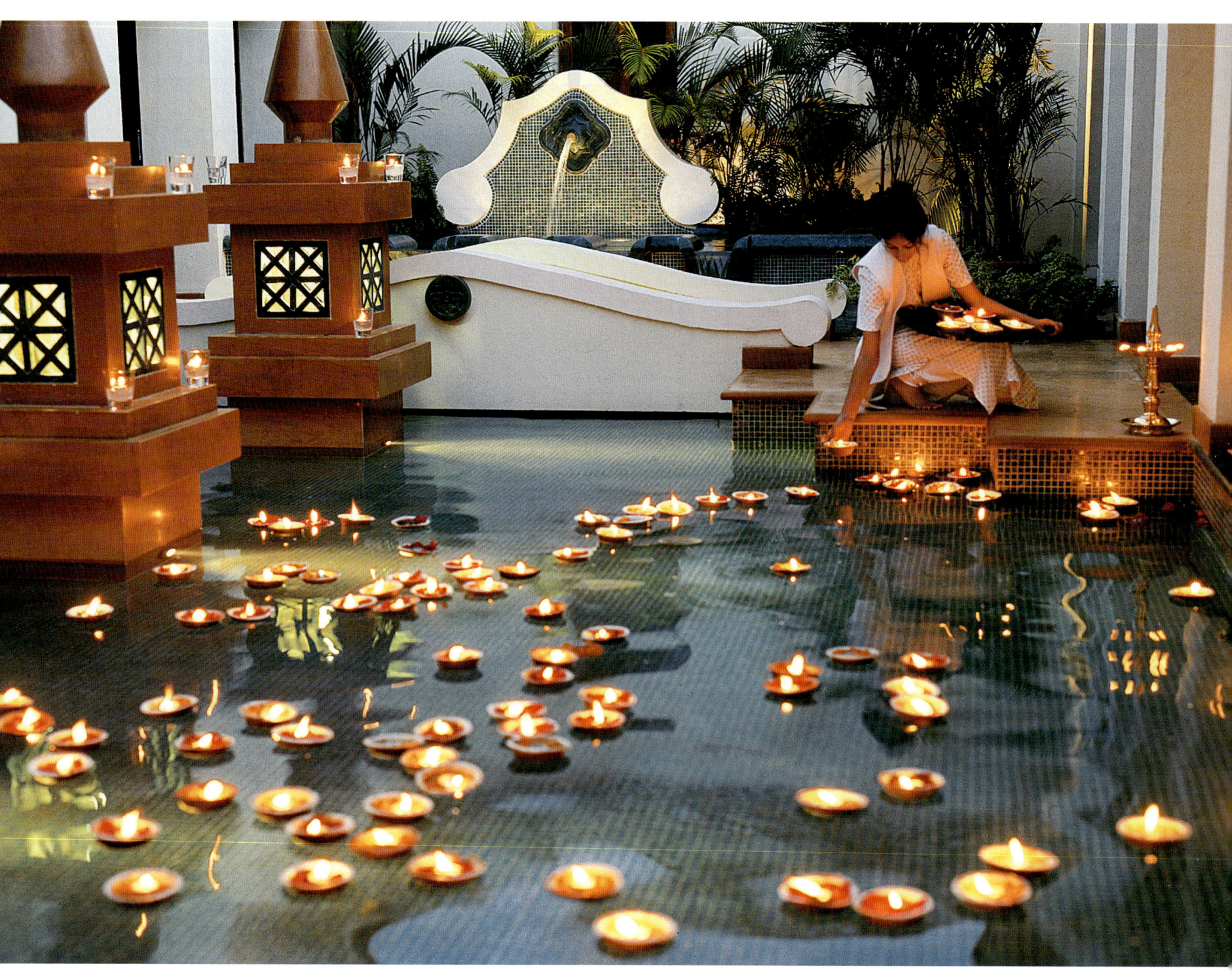

The water fountain and pond at The Sereno Spa echoes Portuguese elements in design. The lighted diyas are a traditional Indian touch.

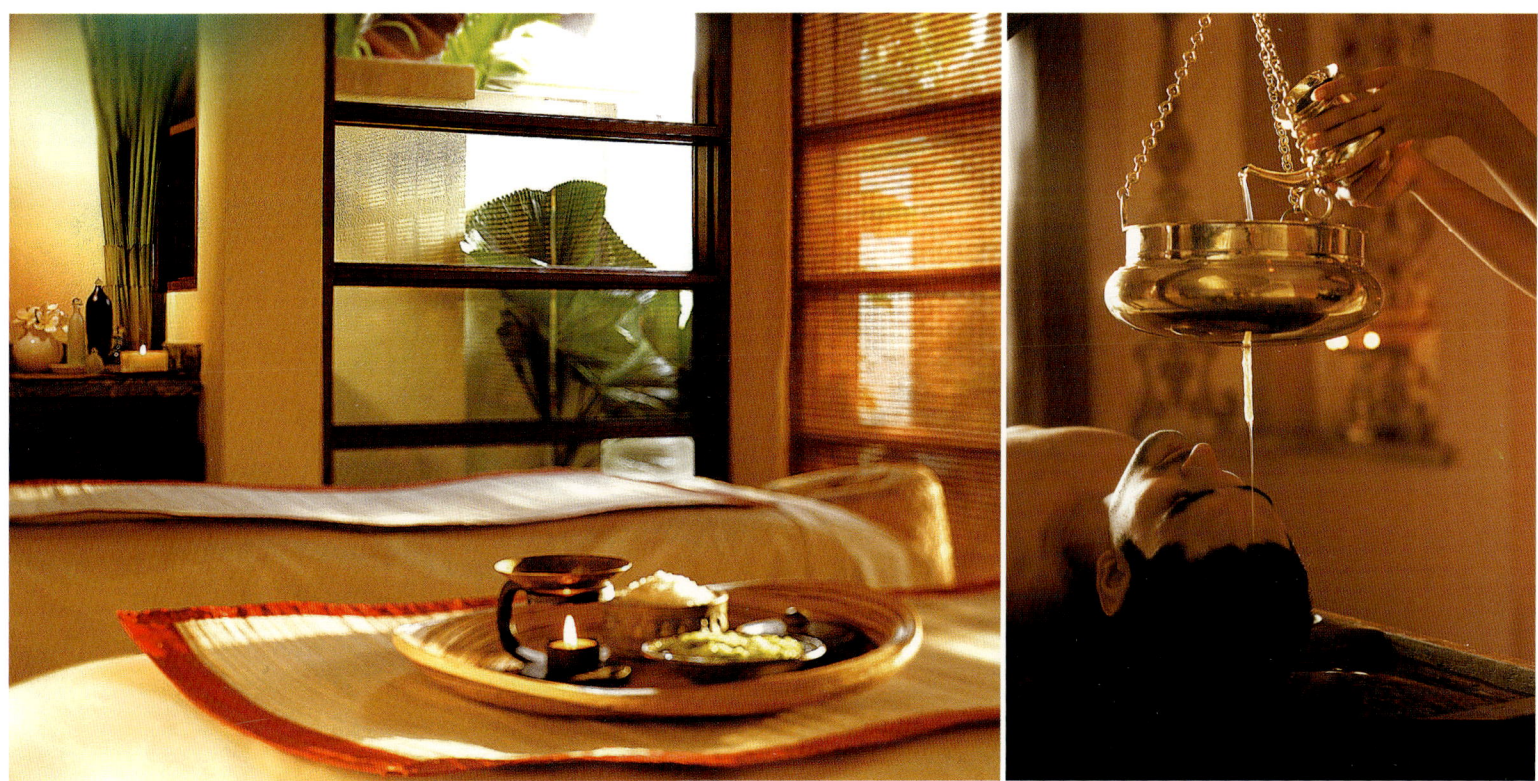

The Synchronised Abhyanga is a traditional form of massage performed by two therapists with synchronised and rhythmic movements. It invigorates and warms the body and mind using brisk, long strokes. The Pitta Abhyanga helps recovery from fatigue and improves circulation.

While the Marma Abhyanga is designed to stimulate the natural cleansing processes in the body and improve the mind-body balance, the Udwarthanam is a special therapeutic form of dry herbal powder massage, where firm pressure is applied with a constant flow of upward strokes.

The Kalpa Moksha energises and revitalises with its unique back and scalp therapy. The Netra Raksha is designed to prevent early damage to the eyes, cleansing and promoting good vision. The Bhuja Raksha, on the other hand, helps to release excess tension from the upper back, neck, shoulders and hands to counter posture-related problems.

After a soothing massage, you can saunter along the miles of white sandy beaches near the resort that are perfect for sunbathing and water sports. The resort offers a host of activities including jet skiing, parasailing, and dolphin cruises.

However, if you want to go beyond the obvious, you can explore some attractions near the resort like the Basilica of Bom Jesus (a World Heritage monument built in 1695), the Braganza House considered to be the grandest of Goa's colonial mansions, the Calizz Museum, the Doodhsagar Waterfalls believed to be amongst the highest falls in the world, go shopping at the Anjuana Flea Market, visit the Shri Mangeshi Temple or take a tour of the Spice Plantations situated in the Ponda region.

Truly an escape into an eco-sensitive and relaxing property set amidst the picturesque landscape of Goa!

*Left: The Sereno Spa is designed on straight lines, no clutter with fresh flowers adding a soft touch. Seen here is the Spa's couple suite. **Right**: Traditional Shirodhara treatment.*

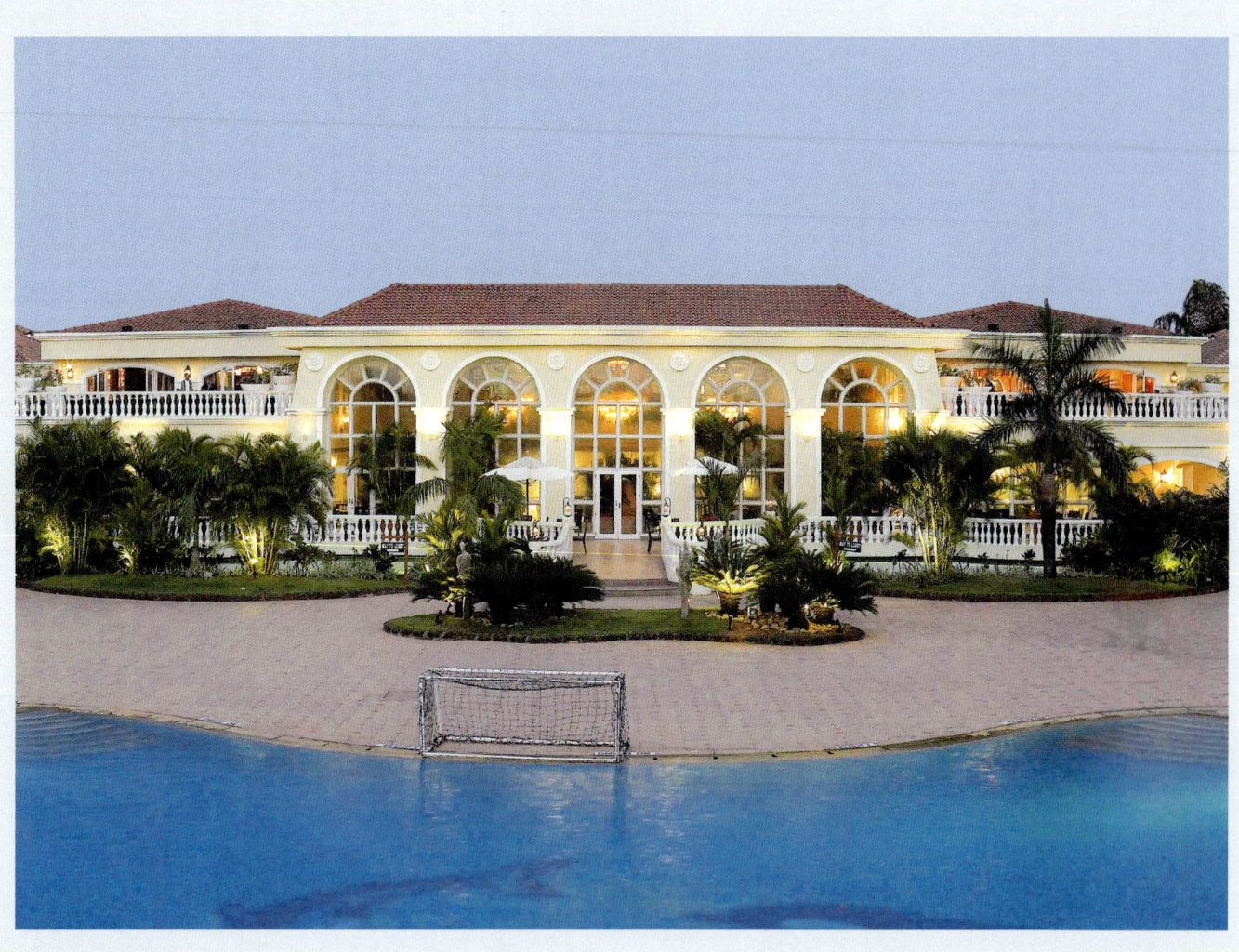

The Zuri White Sands, Goa Resort & Casino

bliss on the world's longest beach

The Zuri White Sands, Goa Resort & Casino blends the joyous, fun loving spirit of the state with international hospitality standards...

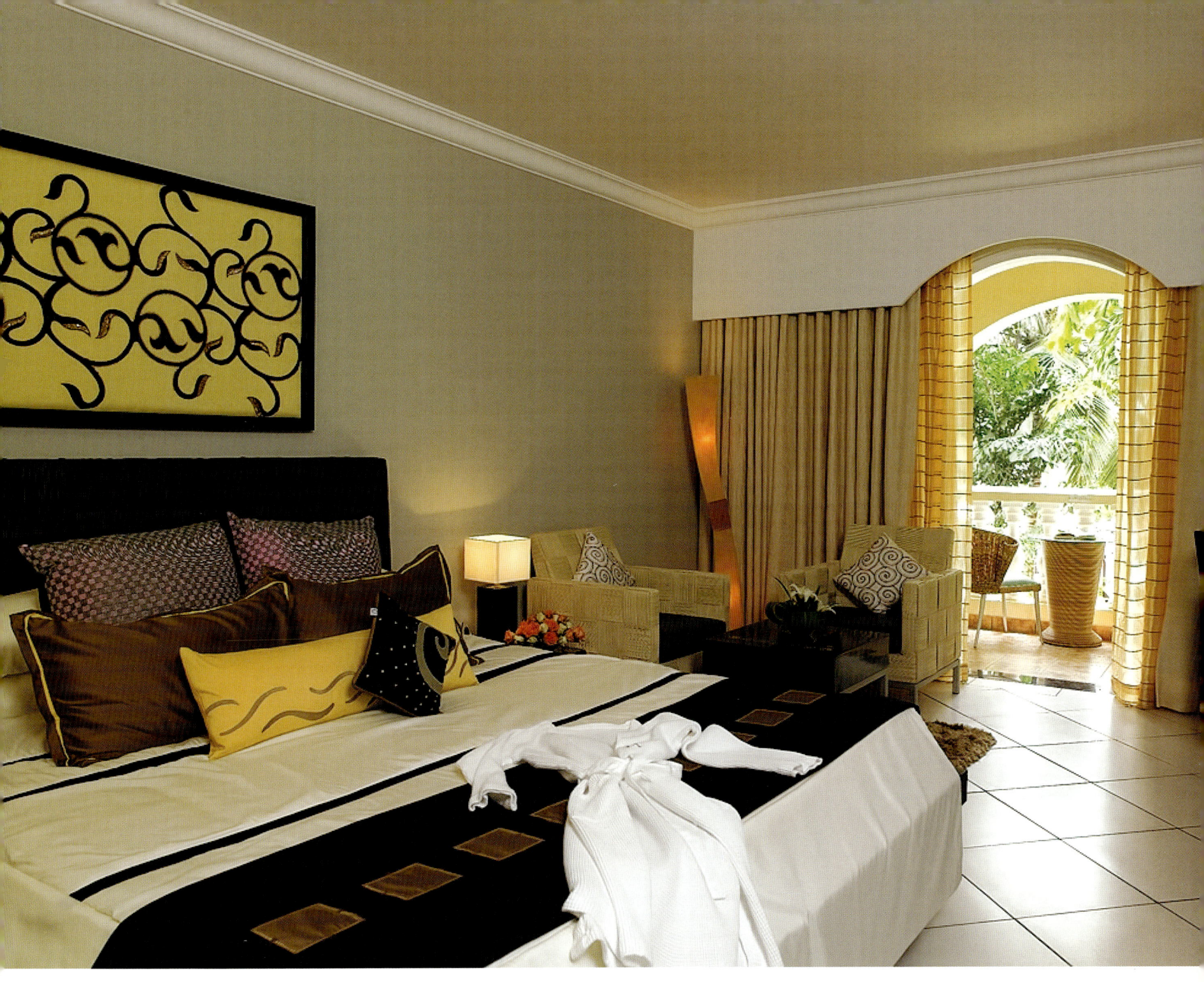

The Zuri White Sands, Goa Resort & Casino is a fine example of the joie de vivre of the state. It stands on one of the world's longest beaches – South Goa's Varca beach. A plush resort with fascinating interiors and great ambience, it stands near major business centres and sightseeing attractions. The Zuri White Sands, Goa Resort & Casino surely appeals to both business and leisure travelers alike.

Contemporary interiors combine light textures and calming colour schemes. Page 20: The Zuri White Sands, Goa Resort & Casino offers a serene refuge of comfort and hospitality, where Goan culture, Indian tradition and modernity are blended into exacting international standards.

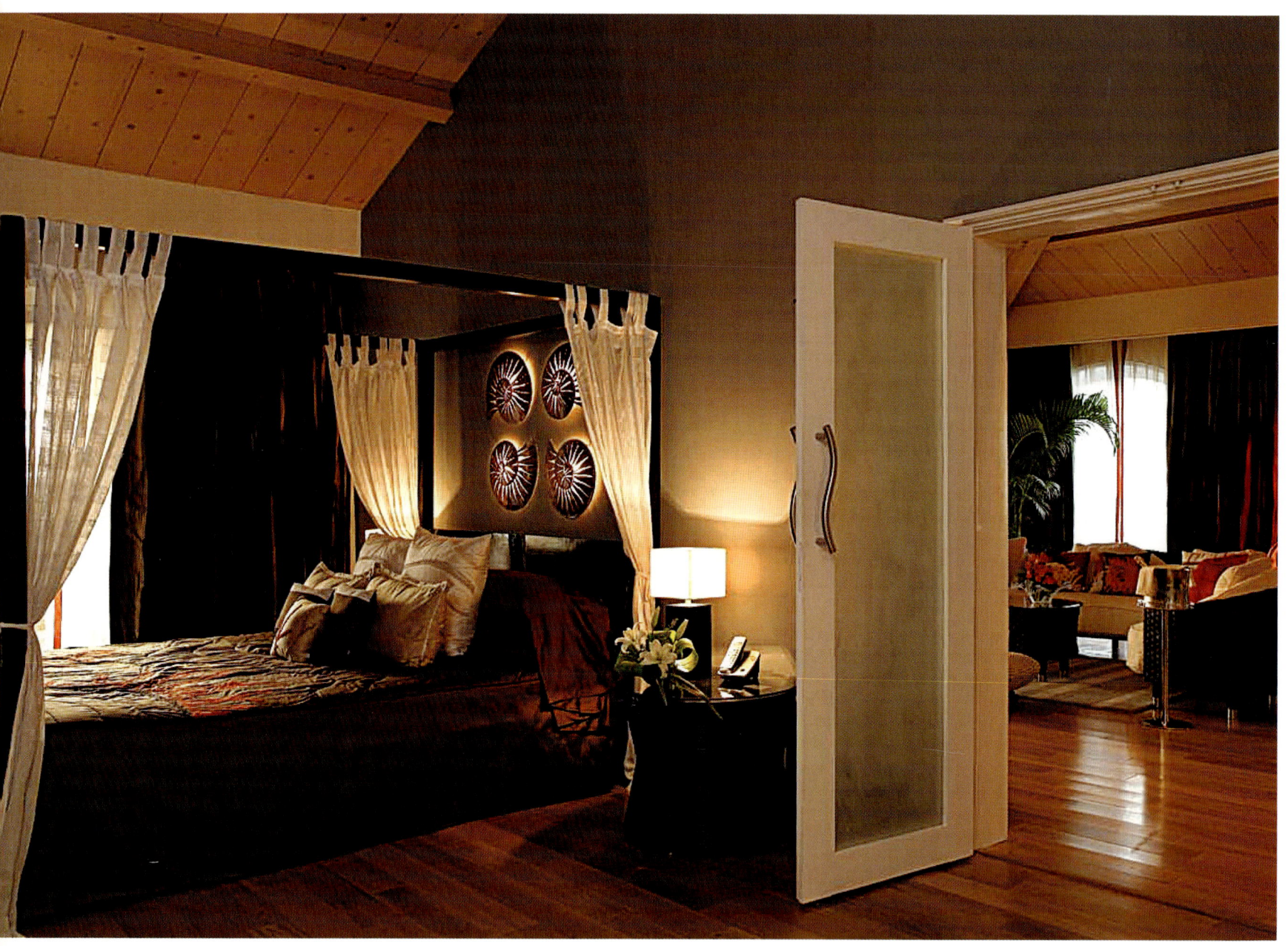

Centrally located, just 30 minutes from the international airport, the resort is just steps away from parasailing, banana boat rides, windsurfing, waterskiing and many other activities. It offers a serene refuge of comfort and hospitality, where Goan culture, Indian tradition and modernity are blended to exacting international standards.

The spacious, attractively decorated rooms and suites at The Zuri White Sands, Goa Resort & Casino feature welcome amenities such as individual safes, coffee/tea makers, minibars and 25-inch flat screen televisions. There are 154 well-appointed rooms including four luxurious suites. While the deluxe suites feature everything that is synonymous with luxury and comfort, one of the unique features of the resort is its free-form swimming pool, approximately 4 meters from each of the resort's ground floor room

Rich earth tones combined with wooden flooring are a luxurious treat. The sea finds echo in the shell-shaped lamps above the bed.

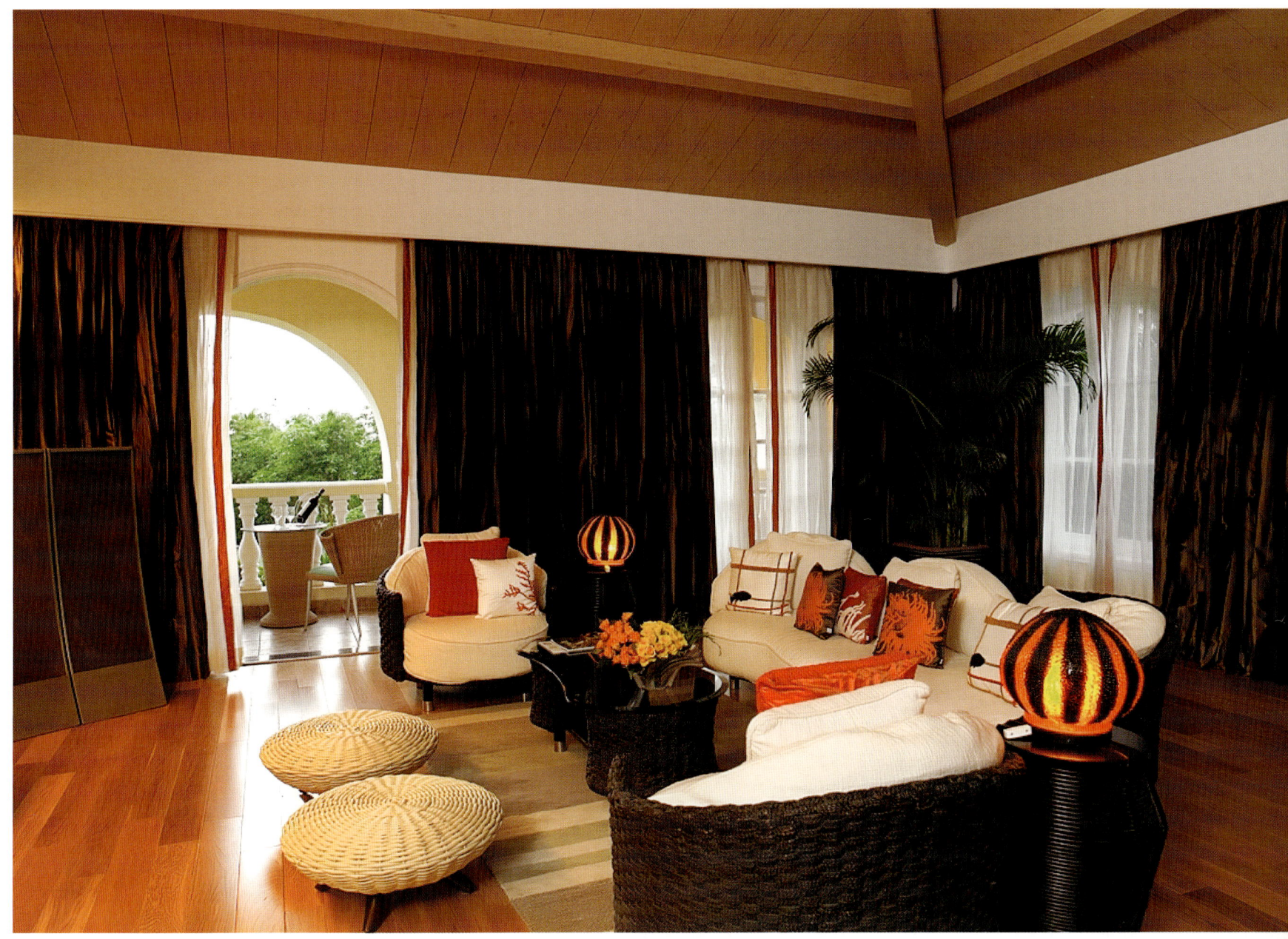

terraces. You can even be adventurous and enjoy living in tents on the beach with all luxurious amenities.

When it's time to relax, guests at The Zuri White Sands, Goa Resort & Casino can enjoy a massage at the Maya Spa – a luxury Ayurveda spa from a team whose family has been following the Ayurveda tradition for the last 1,800 years. To keep yourself in shape, there is a gymnasium as well as three Jacuzzis, two saunas and two steam rooms.

Its central location makes the resort ideal for corporates to hold a variety of meetings and events for as many as up to 450 people. The resort also features well-appointed function spaces ranging from an executive boardroom to an elegant ballroom.

State-of-the-art conferencing facilities include the latest audio-visual equipments, a fully-equipped business centre

The sloping roof adds to the charm of this sitting area decorated with contemporary wicker furniture and prints.

with comprehensive secretarial support and communication equipment.

As far as food outlets go, The Zuri White Sands, Goa Resort & Casino serves delicious regional specialties cooked to perfection at Flavors, which offers both indoor and outdoor seating. Guests will also find Goan seafood specialties served in a beachfront setting at Dhow and Rambooze as well as casual 24-hour dining at Waterfalls Café.

Flavors offers North-West Frontier cuisine, cooked to perfection while you watch. Situated at the lobby level, Flavors offers a fine dining experience at a lovely terrace overlooking the swimming pool. The Waterfalls Café has a delectable buffet spread for breakfast, lunch and dinner.

N.U.T.S – "Never Underestimate The Spirits", the acronym says it all. Its air-conditioned lobby bar and terrace lounge live up to its name and style. Exotic cocktails or that whisky straight up send your spirits soaring. Of note is also the Blue Lagoon, the resort's pool bar.

After a light meal, you can always go in for some treatment at the Maya Spa. Some of the treatments on offer include a whole body massage with specific medicated herbal oils for stress relief, nervous stimulation, toning up of muscles, obesity, diabetes, skin diseases, rejuvenation and immunization.

You can also go in for an oil bath that is very useful for rheumatic diseases, arthritis, paralysis, sexual weakness, neurological disorders, blood pressure, nervous weakness, diabetes, blood pressure, fits, convulsions, and helps to arrest the aging process.

As far as recreation is concerned, children and adults alike can flock to the Gravity Pool, where the recreational facilities include bowling alleys, video games and pool tables. A cyber café, an outdoor Jacuzzi, children's pool, mini-theatre, archery, croquet, badminton, air hockey and bicycles are other facilities available. Water sports like parasailing, banana boat rides, jet-skiing, wind surfing, water skiing and excursions are available through the hotel's public beach.

If you are in a mood to venture out of the resort, you can visit a host of churches that date back to hundreds of years and are in the vicinity of the hotel. Other activities include going shopping in the flea market or just driving around the Goan countryside with its lush greenery and picturesque locales.

Truly, a blend of the joyous, fun loving spirit of Goa with the acclaimed international standards of The Zuri White Sands.

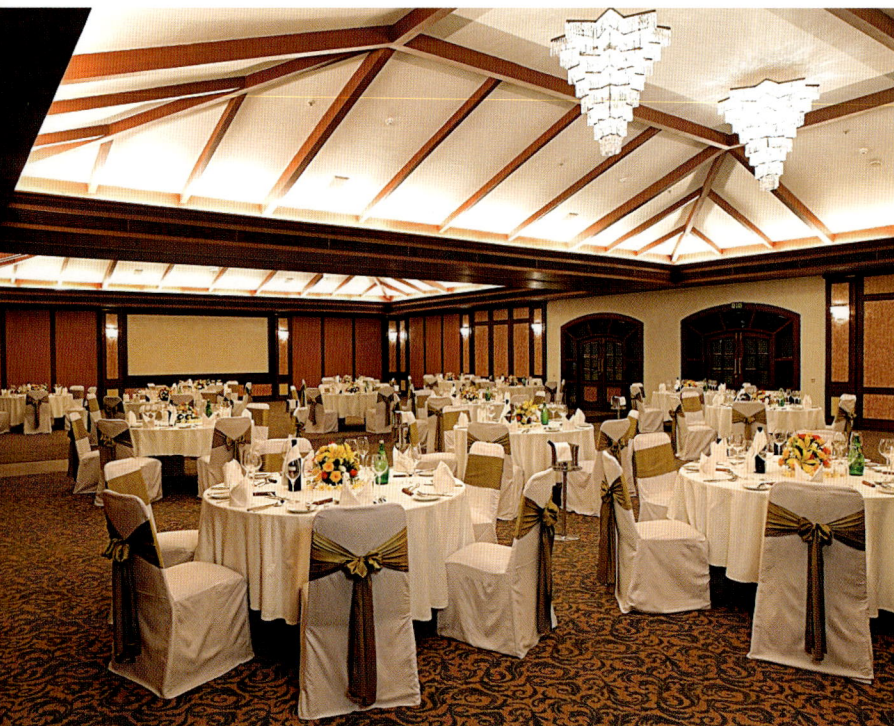

Top: The fuss-free and elegant boardroom is given a nature-inspired touch with the leaf painting on the wall and floral arrangements placed strategically.
Bottom: A view of the banquet at the resort.

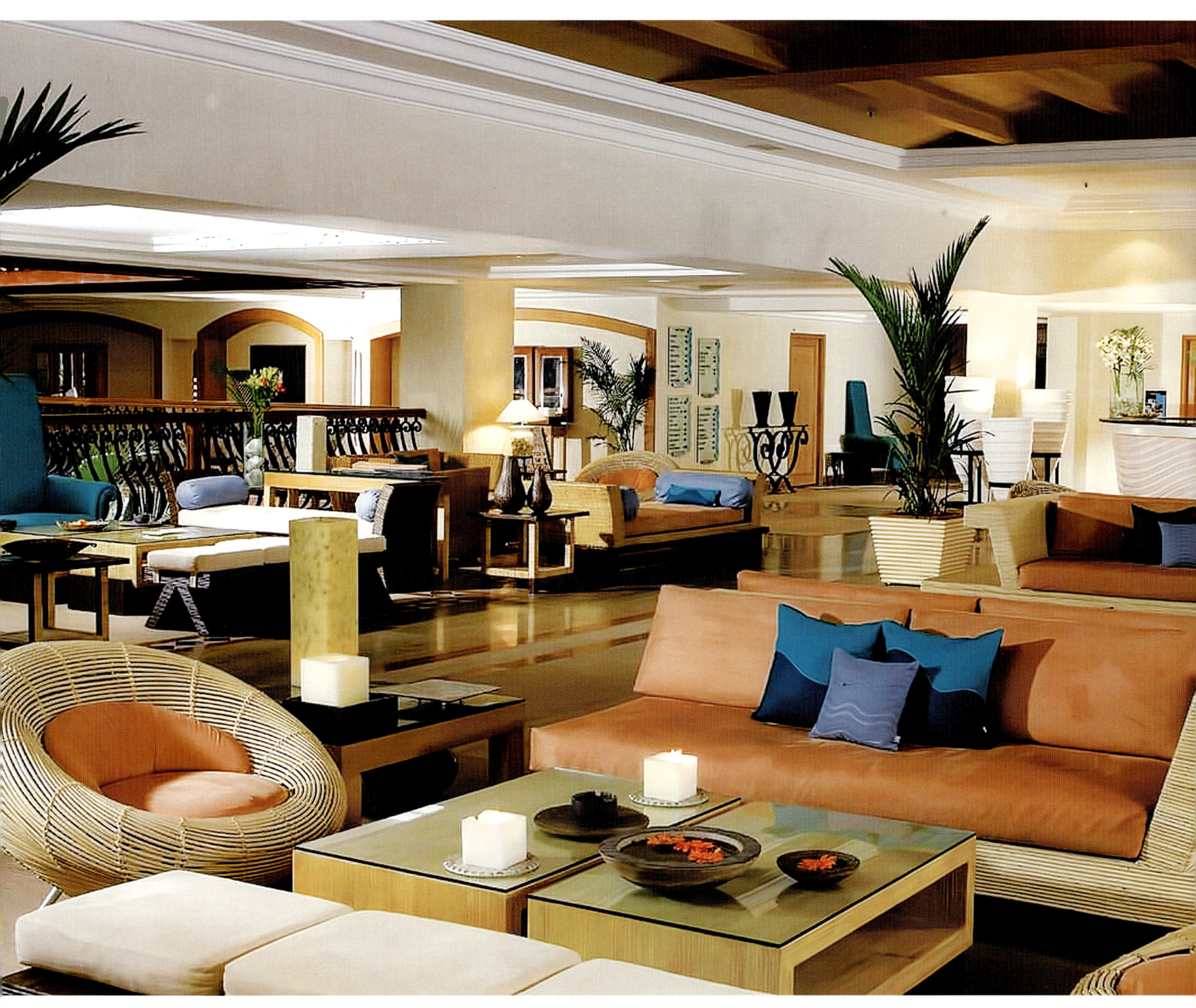

A light colour palette and sleek furniture imparts an ethereal feel to the lobby. The colours of the sea are reflected in the blues used in the decor.
Page 28-29: An elegantly appointed dining area done up in accents of blue.

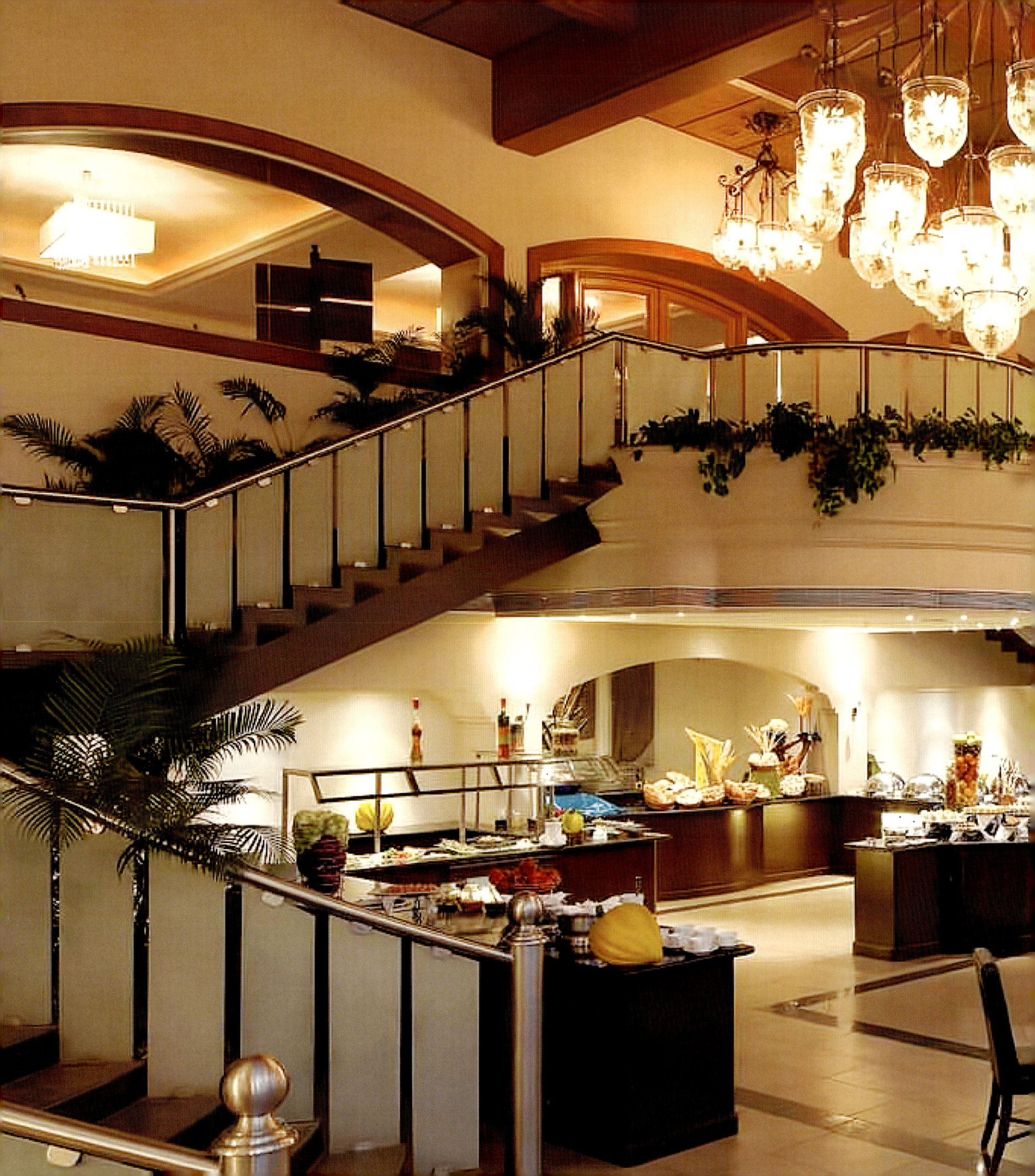

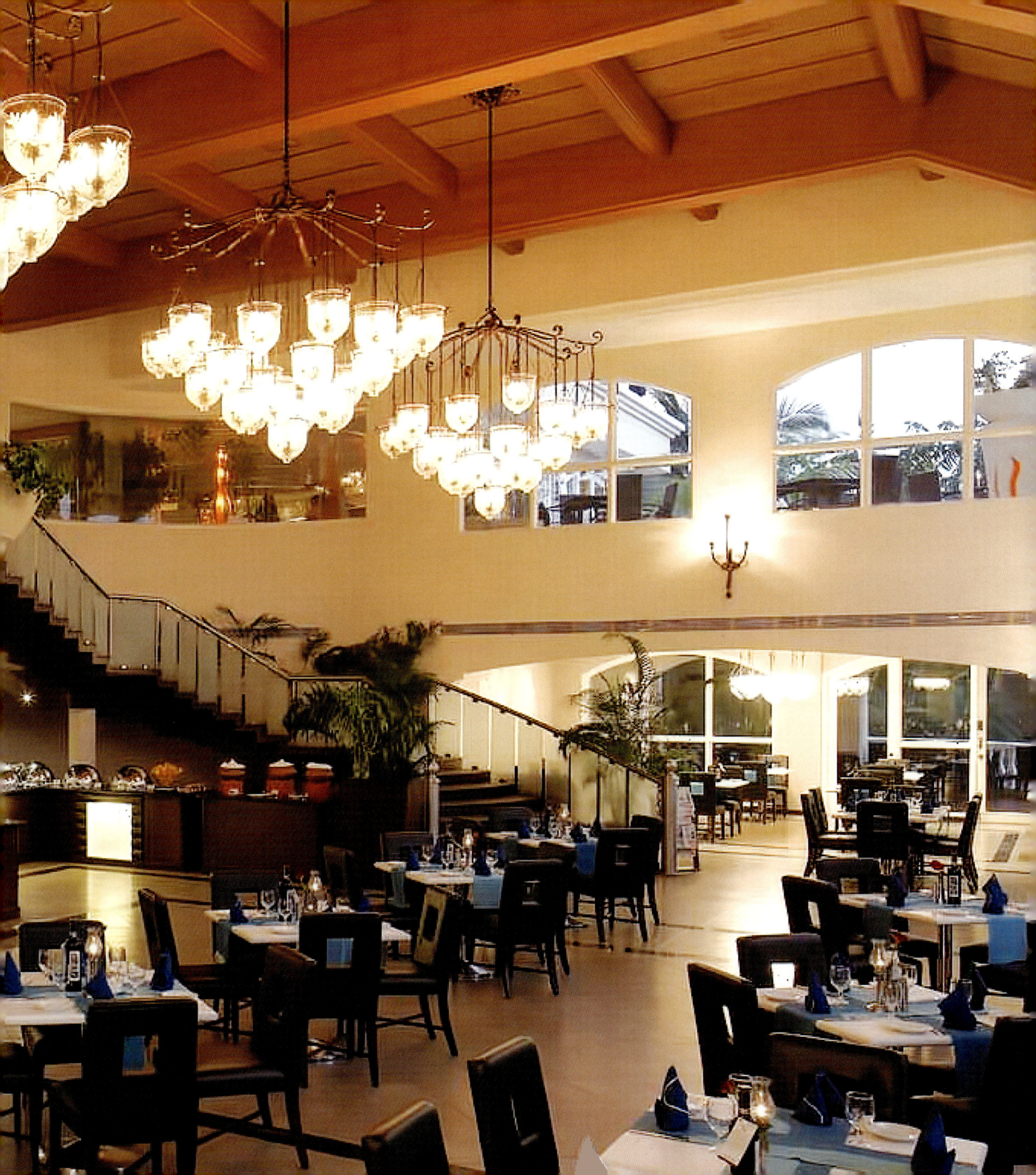

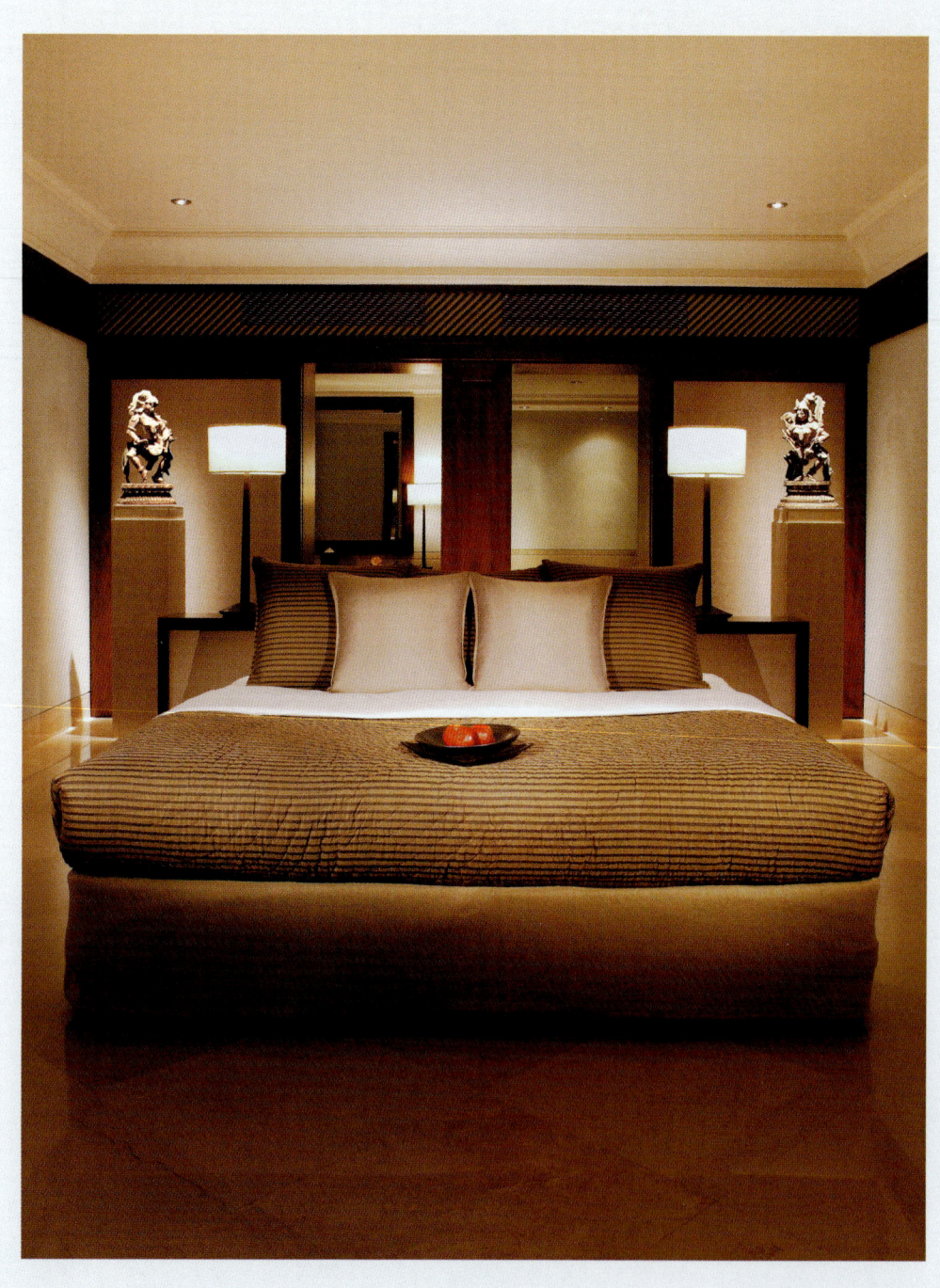

The Leela Kempinski Goa

South India meets Portugal

The Leela Kempinski Goa is a contemporary celebration of the temple and palace architecture of the Vijayanagara Empire and Goa's Portuguese heritage, complemented with Ayurvedic spa treatments to complete the relaxed atmosphere...

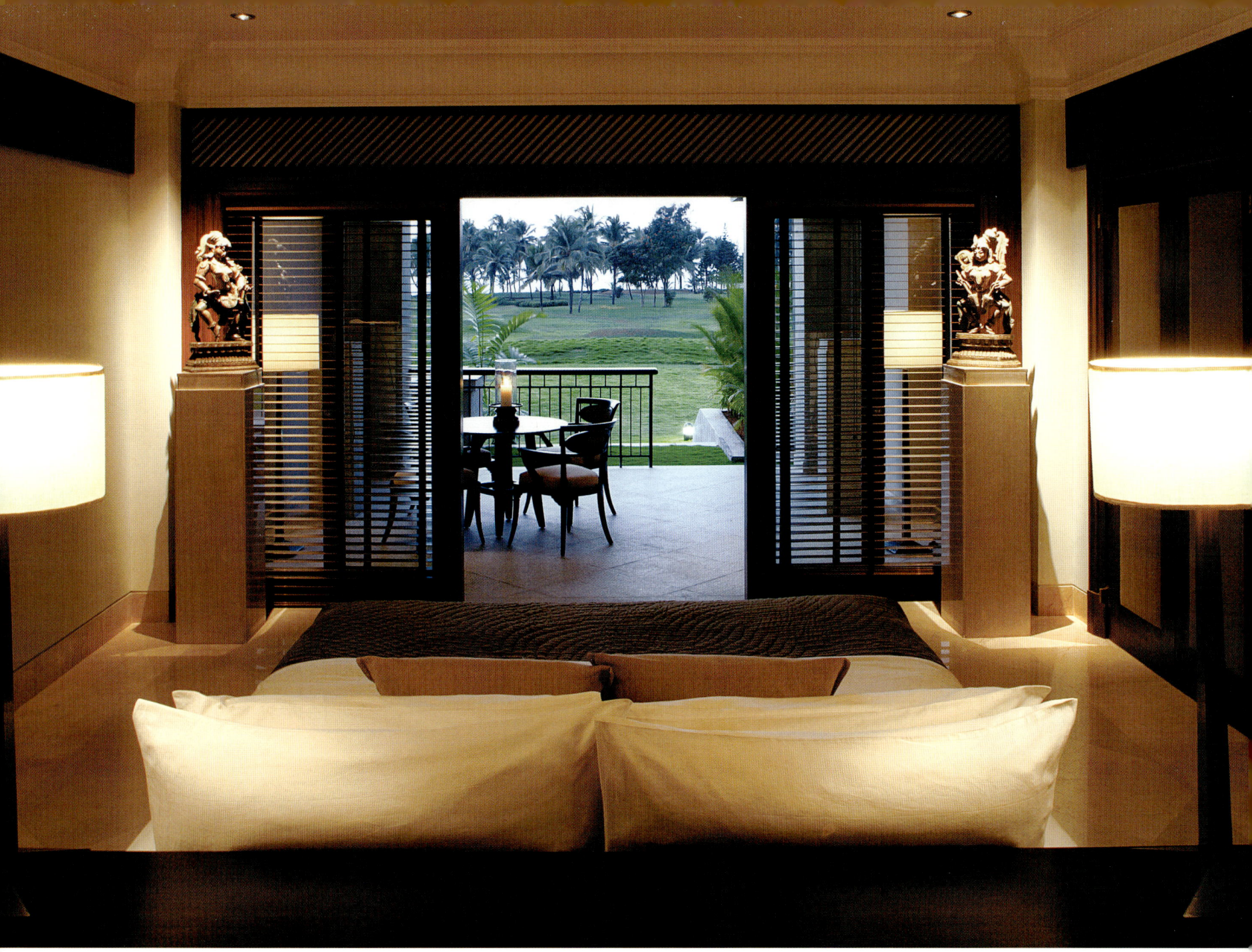

What do you get when you blend South India's temple traditions with Portuguese heritage? The answer is: a luxurious beach resort called The Leela Kempinski Goa. Covering over 75 endless acres in idyllic South Goa, the property boasts of a 12 hole, par 3 golf course for the aficionados. And if you prefer to unwind by not doing anything at all, you have the Mobor beach pretty much to yourself. The bustling fishing village along the Sal River to the south, offers a fascinating insight into how the lucky locals of Goa live.

You can look out onto the greens while relaxing in your plush and luxurious room. Page 30: The 186 room resort pampers guests with a choice of luxurious villas, suites and rooms characterized by plush furnishings and serene ocean views.

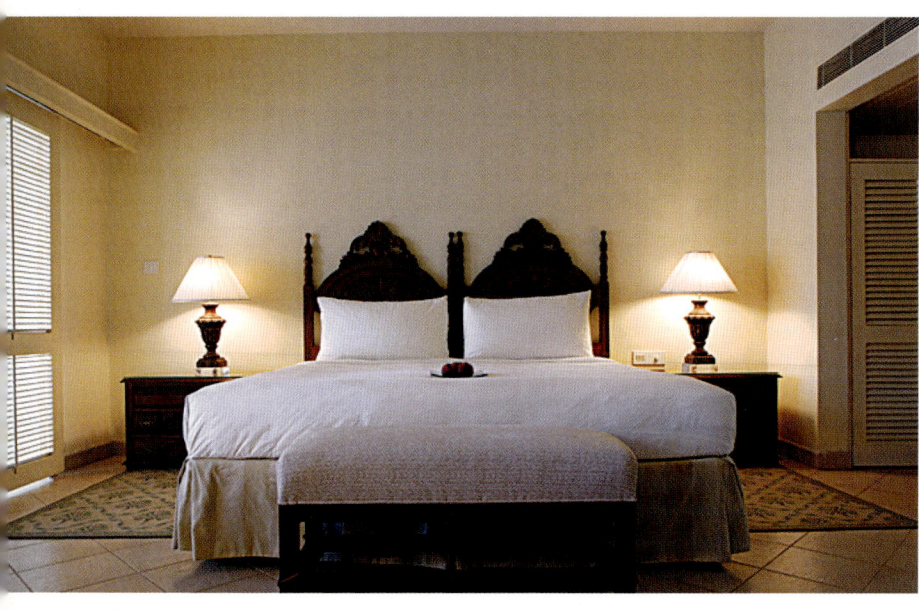

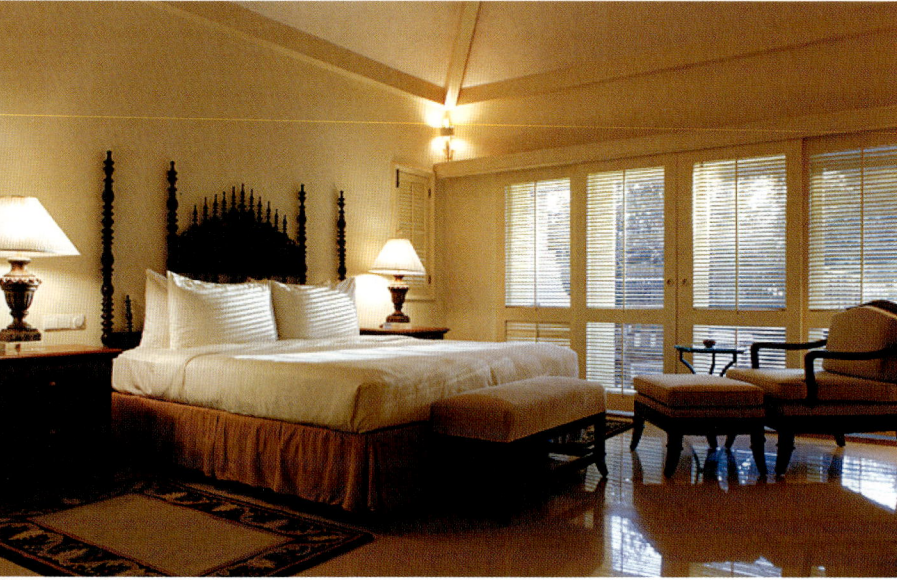

The resort is situated 47 kms from the airport. The drive to the resort passes through the scenic beauty spots of Goa with the shoreline always in view.

Being a luxury resort means that The Leela Kempinski Goa offers you a choice of 186 rooms, suites and villas, as well as a host of dining options and leisure activities. Add to this a state-of-the-art business centre and you have the perfect destination for a company conference too.

The design of the resort is a contemporary celebration of the temple and palace architecture of the Vijayanagara Empire and Goa's Portuguese heritage. But, by far the biggest USP of the resort is the fact that it is hugely popular with Bollywood stars and even heads of state like the former President of the United States, Bill Clinton. Its close proximity to the financial capital of Mumbai ensures that it always gets a steady stream of guests.

The resort is cradled between the Arabian Sea on one side and the River Sal on the other. The 186 room resort pampers guests with a choice of luxurious villas, suites and rooms characterized by plush furnishings and serene ocean views. Of the 98 suites in varying sizes, the Club Suites, the Royal Villas and the Presidential Suites provide the guests with their own private plunge pools.

The resort is widely known throughout the state for its wide variety of eating options. Of note is the beachside seafood grill restaurant, 'Susegado', that has on offer a variety of local fresh seafood. While the 'Pool Bar' serves up a selection of cool cocktails, the 'Riverside' is an intimate Italian eatery with a Mediterranean twist, both indoor and on an alfresco deck with views of the River Sal. 'The Café', offering Western and Asian cuisine, overlooks the swimming pool, while 'Aqua' plays host to a wide selection of fine wines, cognacs, malt whiskies and cigars.

The Indian connection can be traced to the 'Jamawar', while 'Yali' lounge overlooking the gardens offers a variety of cocktails and refreshments. True to its name, the décor of the Indian restaurant includes the Leela's fabulous collection of original, antique Jamawar shawls. Last, but not the least, is 'Las Vegas' that has mechanical casino games including roulette, six lane derby and slot machines.

However, the talk point of the resort is The Club at The Leela Kempinski Goa, which brings a new style and exclusivity to an area already renowned for its sophistication. Set in a tastefully designed enclave adjacent to the main resort property, The Club

Top and Bottom: The design of the 15 one-bedroom and six plunge pool suites called Club Suites, has been developed with painstaking attention to detail to ensure the highest guest comfort. Each suite provides a spacious living room and bedroom, with the design making way for an open and well-planned environment.

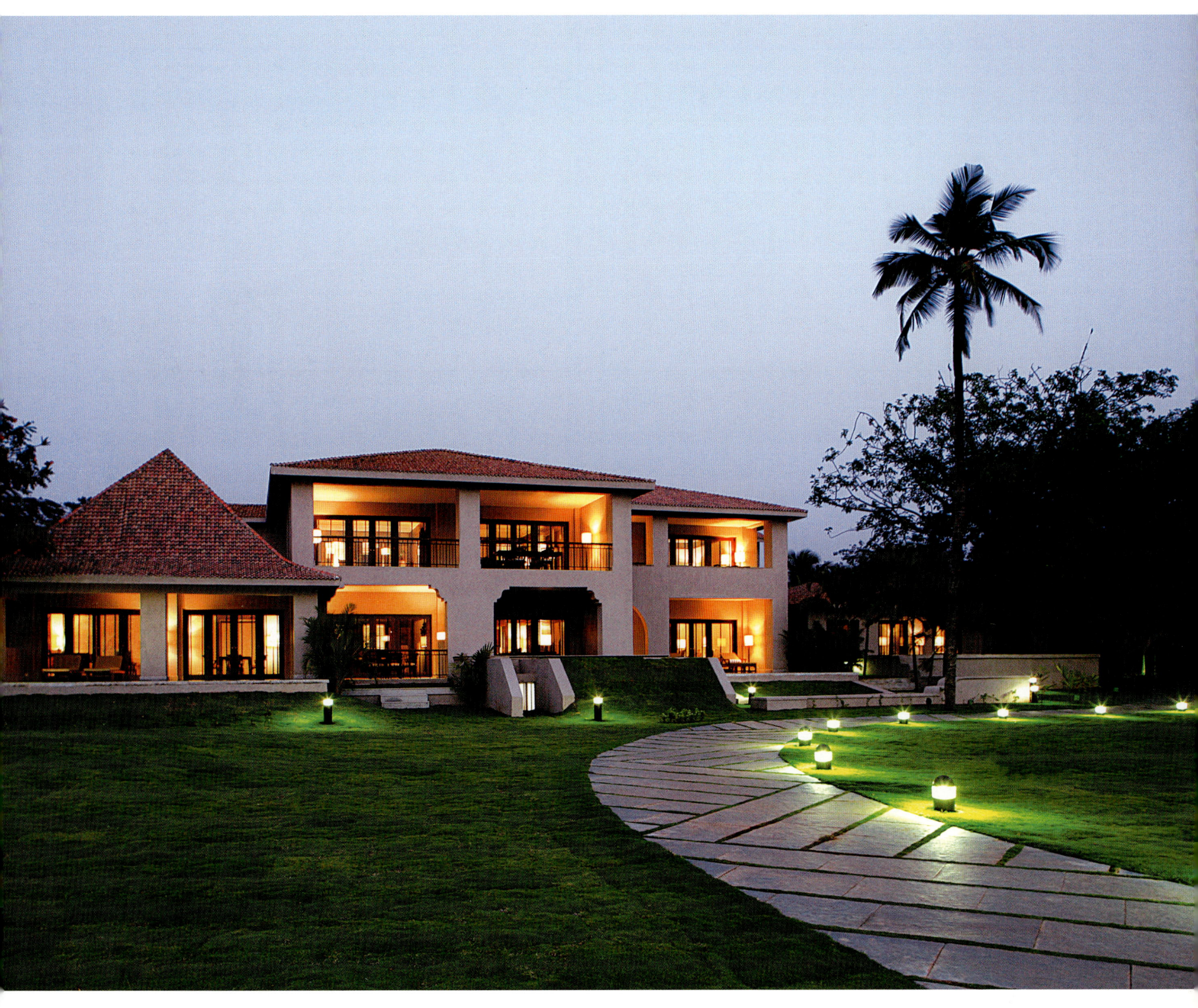

Of the 98 suites in varying sizes, the Club Suites, the Royal Villas and the Presidential Suites, provide the guests with their own private green areas.
Page 34-35: *The design of the resort is a contemporary celebration of the temple and palace architecture of the Vijayanagara Empire and Goa's Portuguese heritage.*

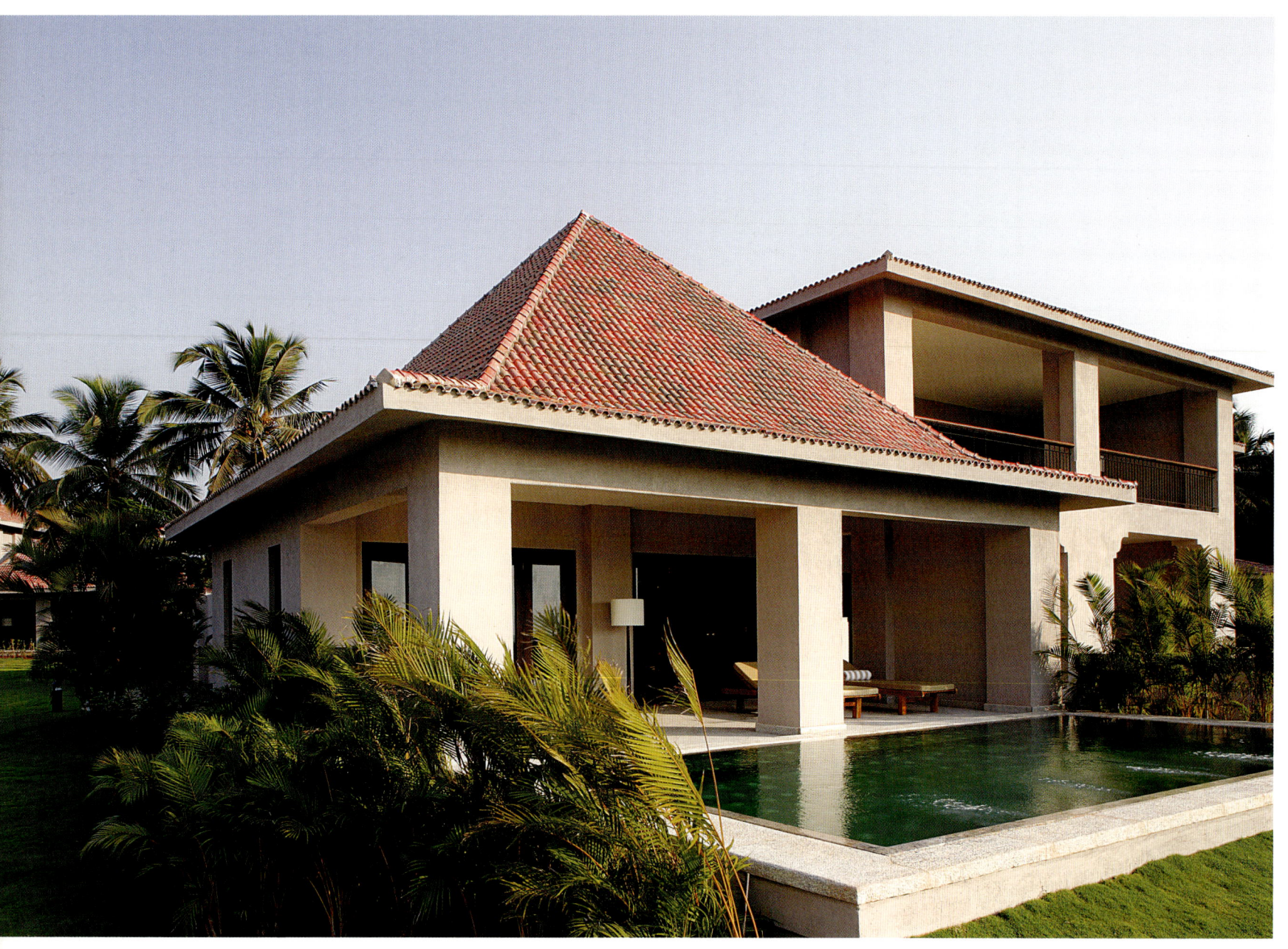

offers breakfast, light lunches and evening cocktails. The 25 metre swimming pool and a separate beach area make it truly exclusive.

The design of the 15 one-bedroom and six plunge pool suites called Club Suites has been developed with painstaking attention to detail to ensure the highest guest comfort. Each suite provides a spacious living room and bedroom, with the design making way for an open and well-planned environment.

Furniture and fittings in the Club rooms have been exclusively designed by noted interior designer, Jaya Ibrahim. Individual touches include the provision of an Espresso machine and a Bose CD player, LCD and flat screen television, cable programming, and

The private plunge pool with the Royal Villas gives you a chance to swim your worries away.

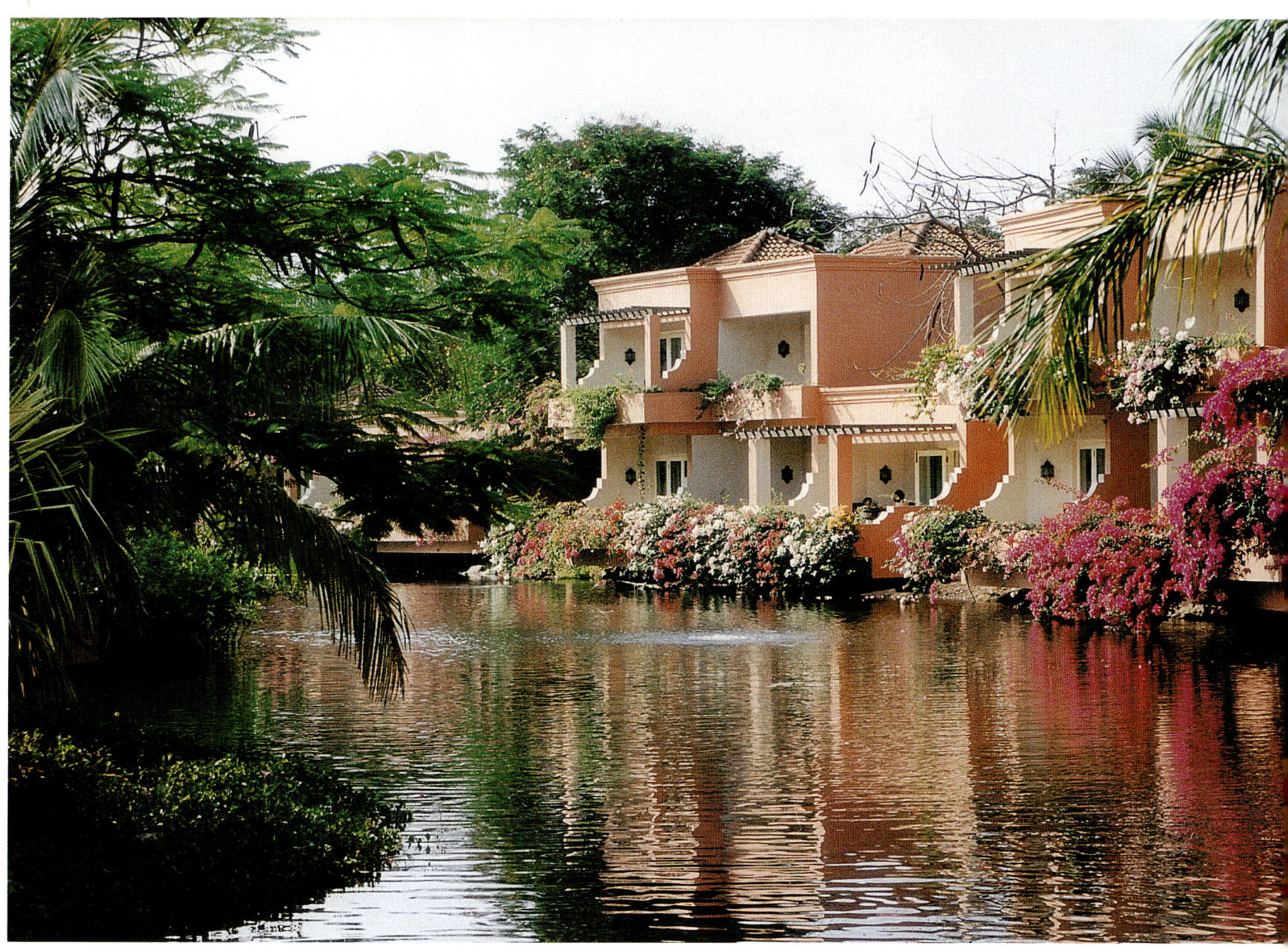

DVD player in each suite provides visual entertainment. Another touch of pampering is the inclusion of a full mini-bar, and Club beverages and breakfast in your suite.

Of note at the resort is its internationally acclaimed spa that is renowned for its extensive selection of professional Ayurvedic therapies and services. An in-house Ayurveda doctor and an expert team of therapists ensure that guests have a genuine, rejuvenating experience. The *Shirodhara* and Warm Stone Massages are signature therapies of the Spa and are highly recommended for the ultimate stress-relief and relaxation.

The word 'Shirodhara' breaks down into two parts: 'shiro' meaning head, and 'dhara' meaning flow. Together they form a

The resort is cradled between the Arabian Sea on one side and the River Sal on the other.

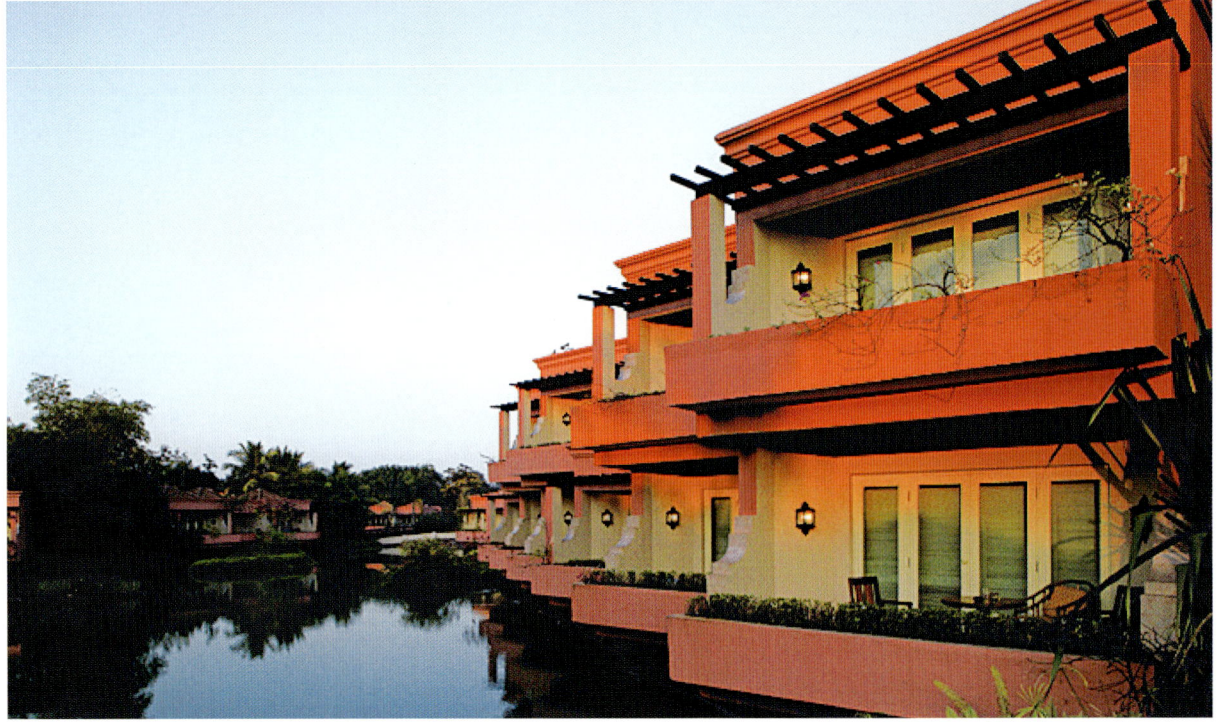

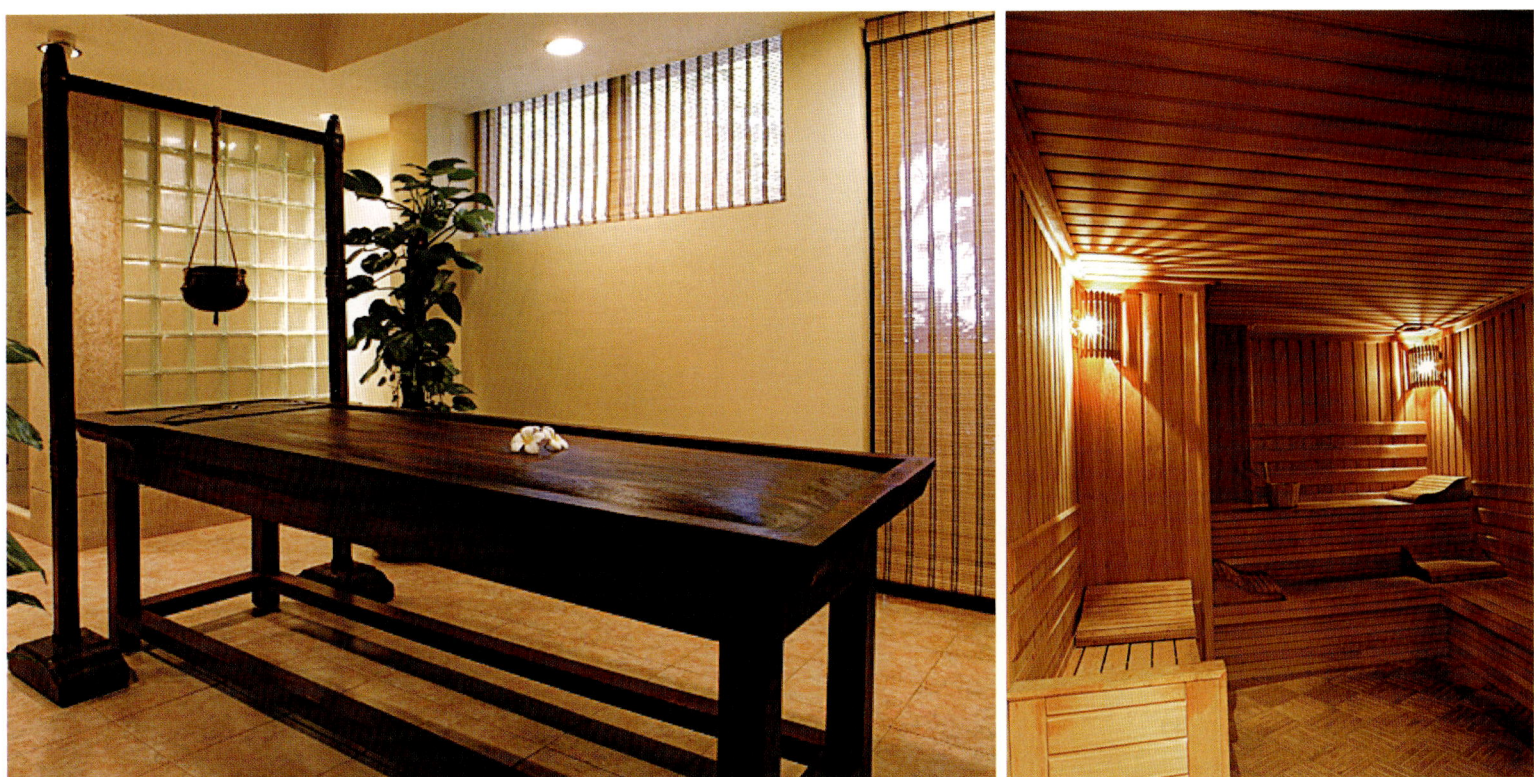

concept that aims to bring physical and emotional balance by rejuvenating the spirit and preserving health. This is achieved through a relaxing technique in which warmed oil is poured over the forehead, followed by head and shoulder massage and a warming body wrap to seal in moisture.

The Warm Stone Massage, on the other hand, has been around for a very long time – with evidence of stones being used for healing purposes, dating back before written history. This exotic treatment involves the placement of heated polished lava rocks on pressure points and chakra points, and the application of heated stones with oil on the skin. Aromatic oils encourage deep relaxation and calm the soul. This therapy is very effective in creating harmony and a positive energy flow, thus promoting a sense of balanced energy and peace.

Reflecting Goa's unique mix of Eastern and Western traditions, the Spa also offers massages and treatments from around the world, as well as Yoga, steam rooms, saunas and a fully equipped gym.

Subsequent to a massage treatment for leisure, the resort includes a tennis club with three floodlit courts, a 300 metre stretch of white sandy beach and a variety of watersports. Wherever you look, you are bound to encounter water bodies, whether it is the swimming pool, the lagoon that winds across the resort, or the breathtaking views of the Arabian Sea.

If you are in the mood to sightsee, you can always venture outside the resort to explore the beauty of North and South Goa. Goa has some of the best churches and Portuguese mansions that you simply must visit. Of special interest is the Basilica of Bom Jesus, a World Heritage Monument that has housed the sacred mortal remains of St. Francis Xavier since 1695.

And like the state, the resort too enables you to experience two cultures.

Of note at the resort is its internationally acclaimed spa that is renowned for its extensive selection of professional Ayurvedic therapies and services. On the left is a typical massage room and on the right is the sauna room. **Opposite page, Top and Bottom:** *At The Leela Kempinski Goa, wherever you look, you are bound to encounter water bodies, whether it is the swimming pool, the lagoon that winds through the resort, the breathtaking views of the Arabian Sea or the placid waters of the River Sal.*

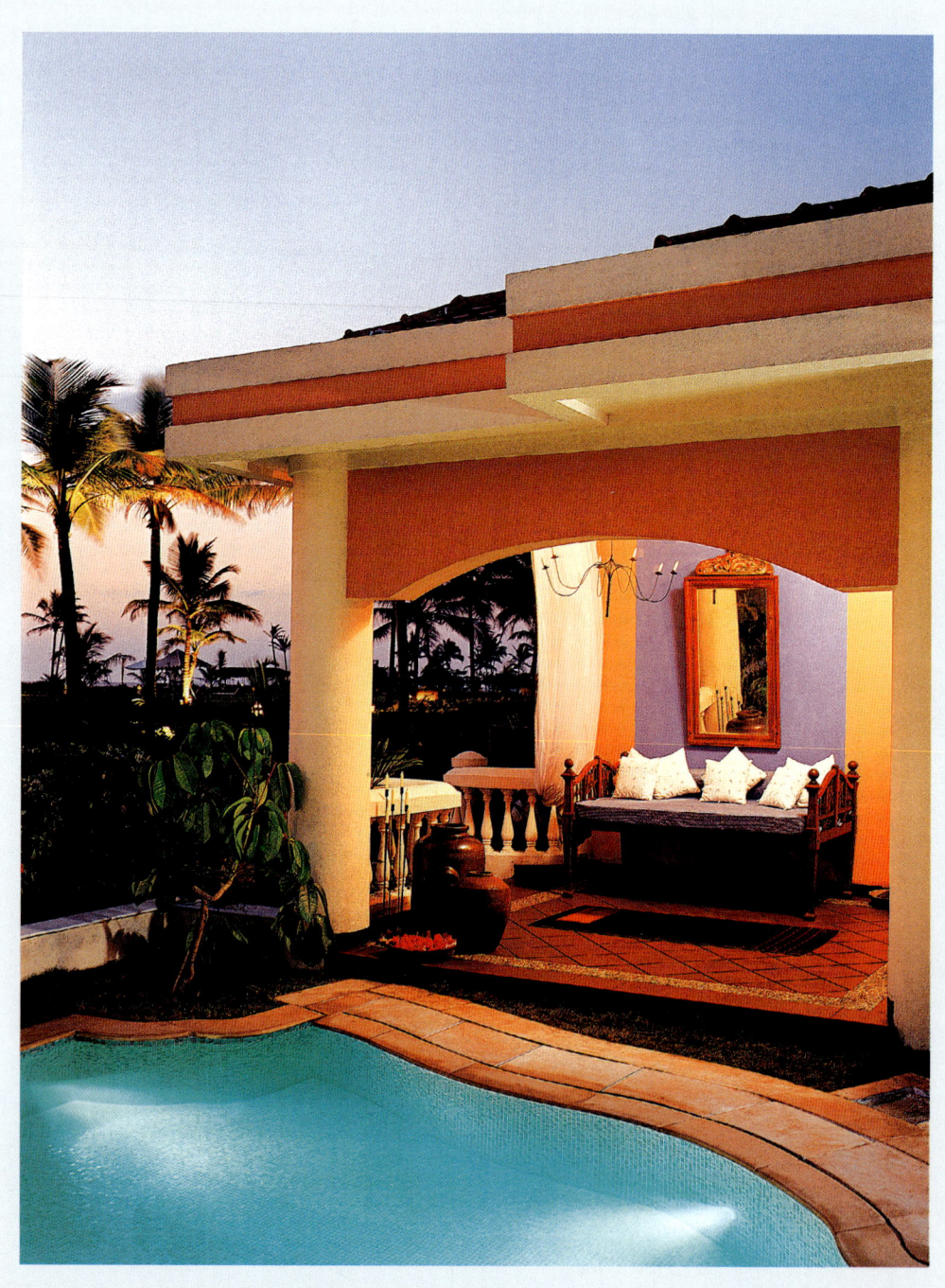

The Taj Exotica, Goa

the sea beckons

The slow rhythmic massage techniques of The Taj Exotica's Jiva Spa at Goa are the perfect solution towards calming the mind and body...

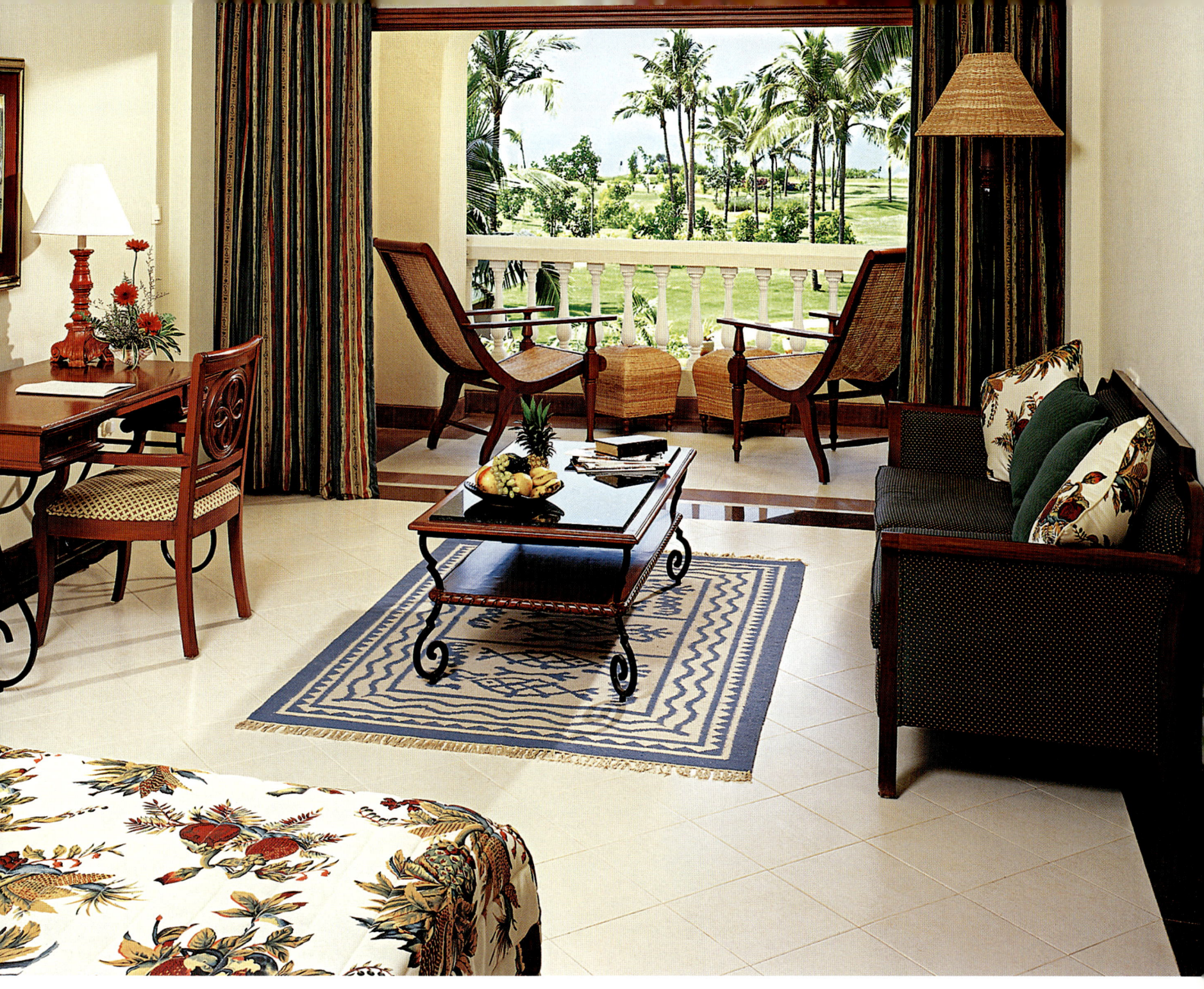

*L*ocated on the southwest coast of Goa, overlooking the Arabian Sea, this Mediterranean-style luxury resort is one of the best properties in the state and has a way of slowing down time to a tranquil tempo. Set amidst fifty-six acres of lush gardens, The Taj Exotica is a showcase with tropical-inspired design touches, grand architecture, a sun-drenched atrium, wide shady corridors, and flower lined patios.

The Garden View Villas are comfortably appointed, imparting soothing views of the green areas beyond. Page 42: At The Taj Exotica, the Sunset Pool Villa rooms have been designed in an elegant blend of Goan and Portuguese style, set amidst palm trees and lush greenery.

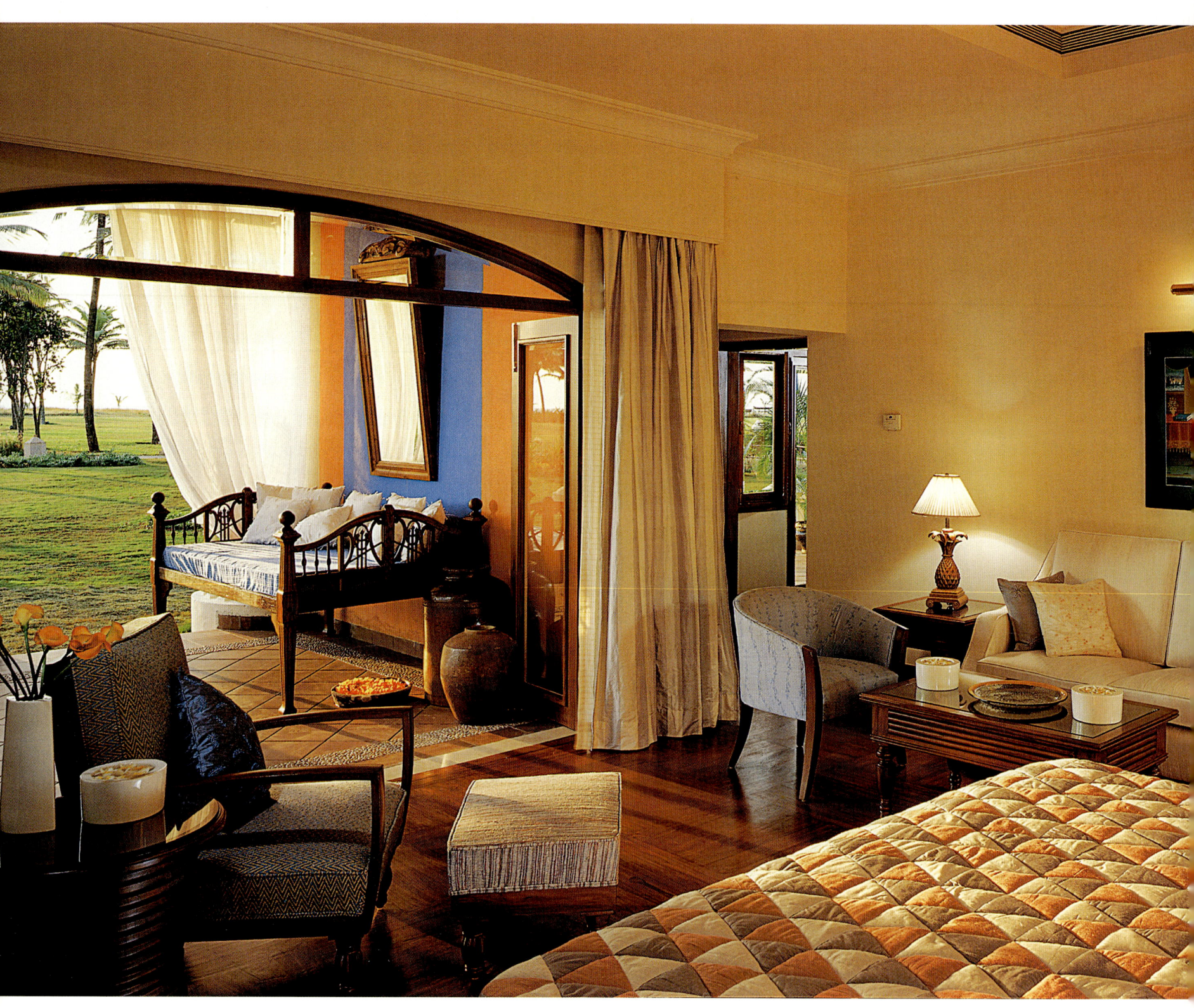

Interiors stand out at the resort with their elegant blend of Goan and Portuguese style. The deluxe rooms are light, airy and spacious, offering a panoramic view of the sea and the garden.

The resort is located along a 700 meter stretch of the Benaulim beach and is a breathtaking 45 minutes drive from the airport.

The resort is divided into the main hotel building with spacious deluxe and luxury rooms, and two and four bedroom villas. It is a majestic architectural structure that is complemented by the Jiva Spa, reminiscent of traditional Kerala temple architectural design. The spa offers an exclusive, discrete Ayurveda sanctuary located in the midst of widespread, evergreen gardens. Treatments at the private beachside spa pavilions further transpose and lift you up.

Apart from the basic modern amenities and facilities that all five-star properties offer, The Taj Exotica also has a 4,600 square feet ballroom, one of the largest pillar-less banquet halls in Goa. There are exclusively-fitted private dining rooms with truly breathtaking interiors. A specially-designed part of the beach, called the Palm Grove is reserved for midsized to large groups and is another example of great design.

Spacious and sophisticated, all guestrooms at The Taj Exotica embody the Indian tradition of luxurious design and comfort. Interiors stand out with their elegant blend of Goan and Portuguese style. The deluxe rooms are light, airy and spacious, offering a panoramic view of the sea, from private balconies.

While The Garden View Villas are comfortably appointed, imparting soothing views of the garden, the Deluxe Sea View Villas offer a panorama of the Arabian Sea. Of note are the Sunset Pool Villa rooms that have been designed by an elegant blend of Goan and Portuguese style, set amidst palm trees and lush greenery. You can look forward to a large veranda as well as the thrill of your own private plunge pool.

The Luxury Suites are opulent and spacious, while the Presidential Suites exude both grandeur and elegance. Each villa has a large living and dining room, a master bedroom, a guestroom, a fully equipped and stocked pantry, a very large private garden, which overlooks the golf course and the sea, as well as its own private plunge pool with a massage pavilion tucked away in lush tropical foliage.

As far as dining facilities go, The Taj Exotica has it all. Probably the only resort in Goa to have seven restaurants, the resort offers casual, all-day, formal and fine dining options.

For instance, at Adega Camoens, you can unwind in the plush romantic setting of a handsomely-panelled lounge bar. At Allegria,

you succumb to the charms of old-world architecture and the incredibly fresh flavours of Goan cuisine.

Eugenia lets you explore the cuisines of the world, including authentic Indian fare, exotic specialities from South-East Asia and classic Continental dishes served with contemporary flair. The Li Bai enables you to sample the succulent flavours of the Orient with Sichuan, Canton, and Hunan specialties.

Lobster Shack is a thatched beachfront restaurant offering a delectable selection of seafood and an impressive array of new world wines. At Miguel Arcanjo, you can relax in an old-world atmosphere and feast on delicious Italian, Moroccan, Spanish, and Provencal fare.

Before you start saying wow, hold your breath, for there's more to come. The Pool Side Sandwich Counter and Fresh Fruit Bar is a dazzling blue pool, setting the perfect ambience for a quick bite at this inviting counter.

From relaxing Ayurveda massages to meditative archery or a fast-paced game of tennis, you can look forward to a wide variety of recreation and fun. Architecturally reminiscent of the temples

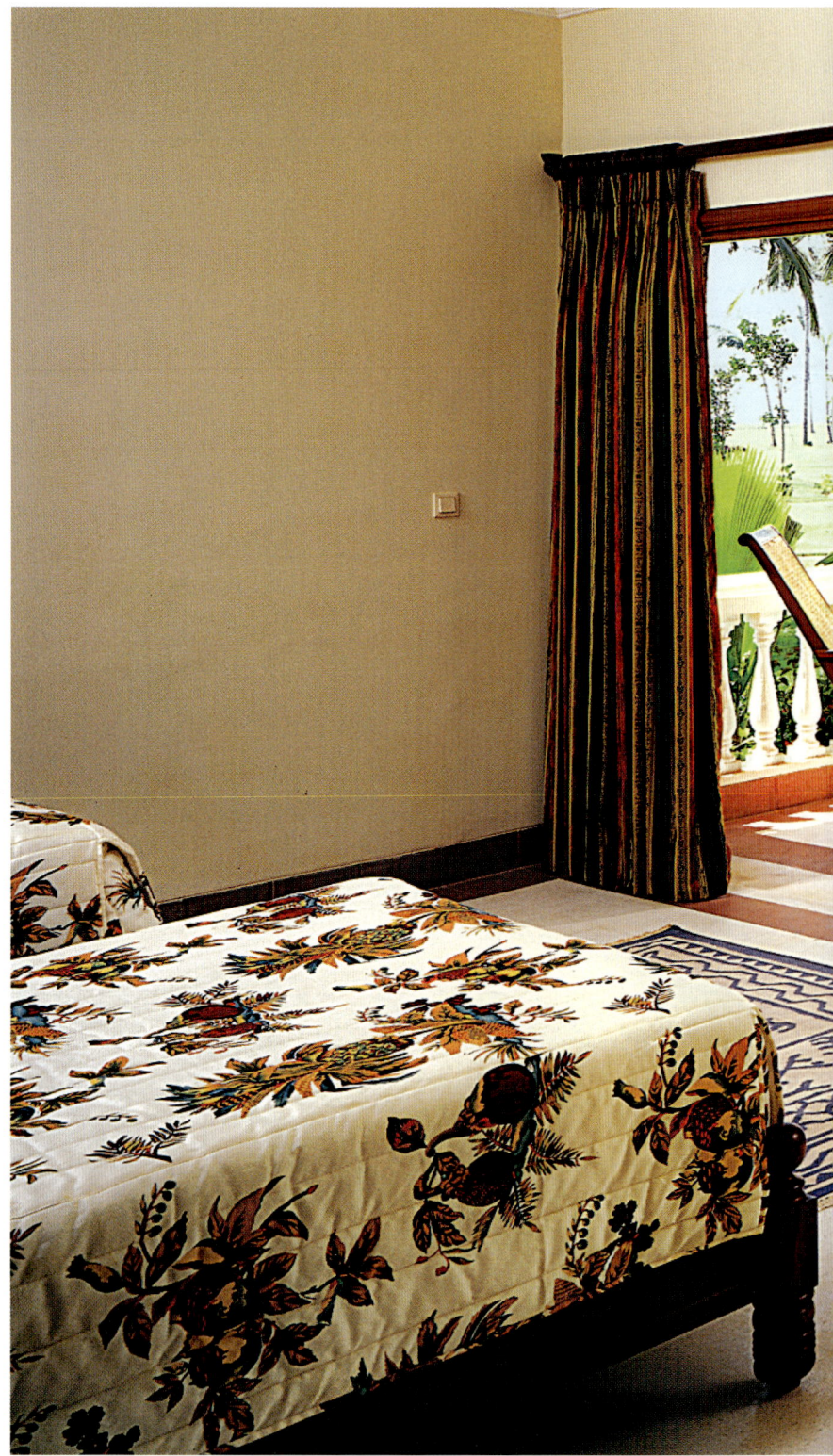

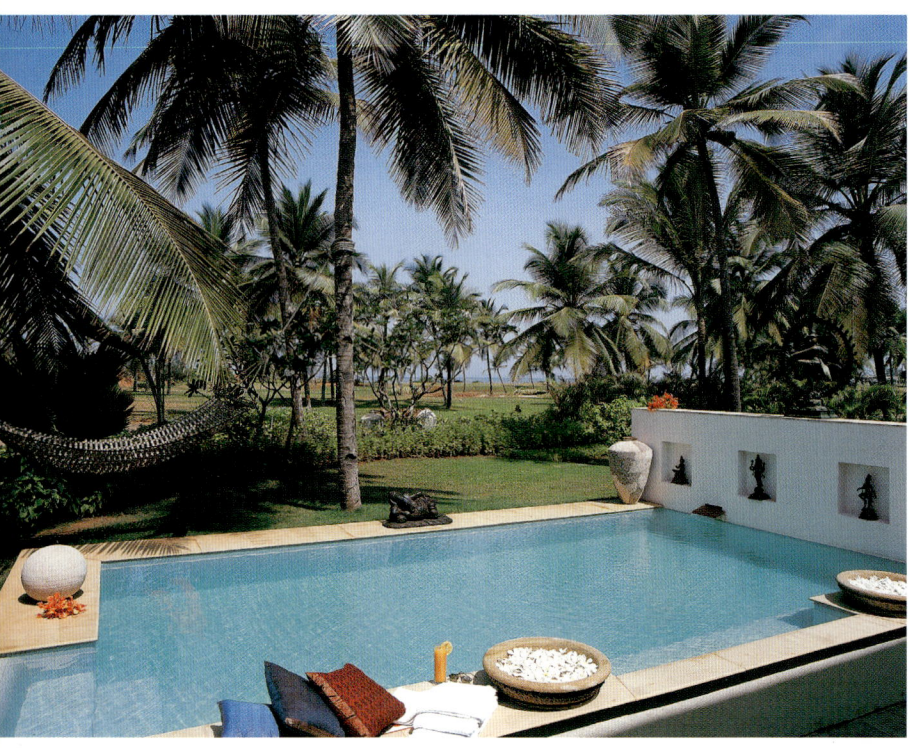

The relaxing bathing pool at the Jiva Spa in the resort offers a truly restful experience.

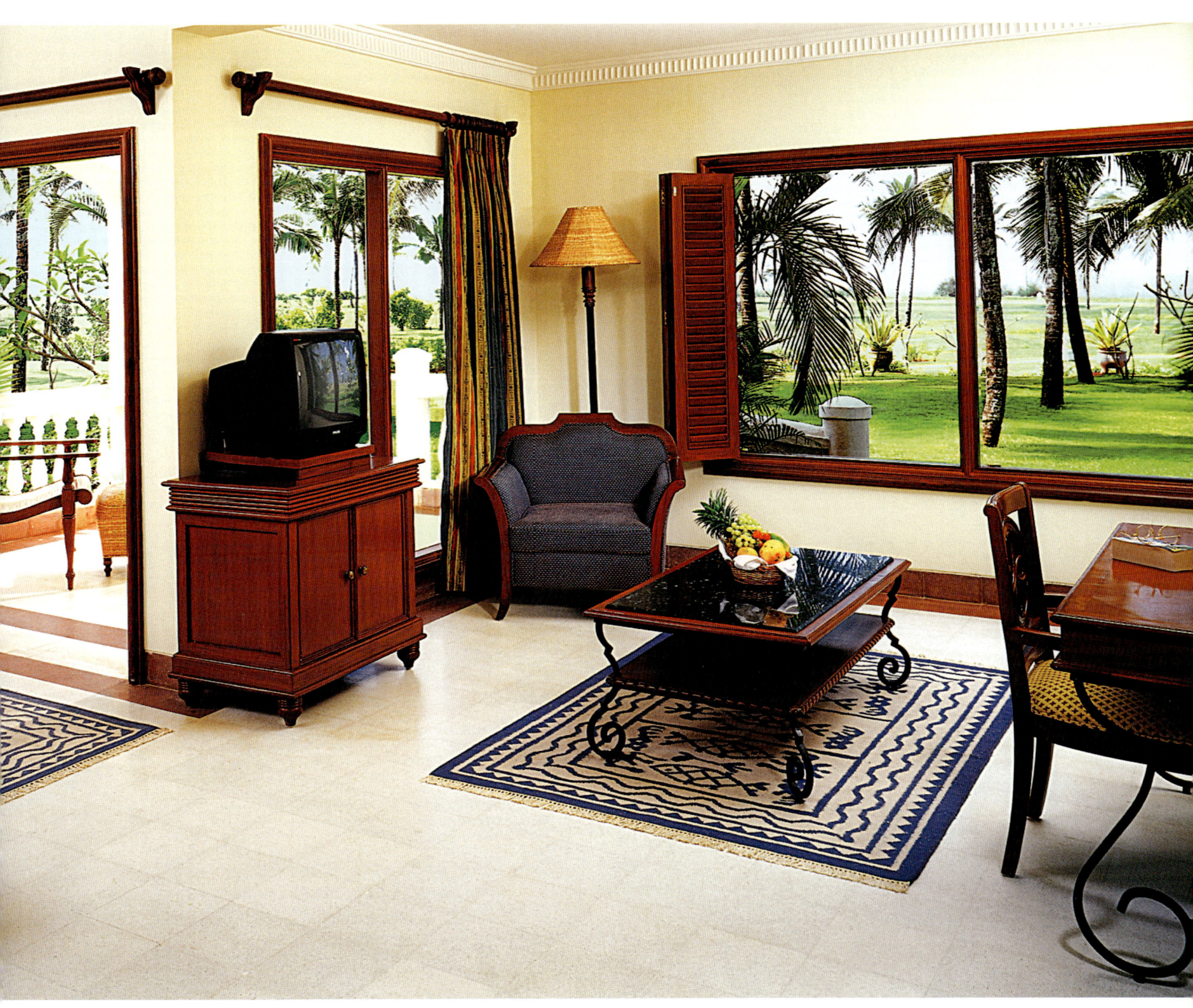

Another view of the plush guest rooms offering a view of the large expanse of greens beyond.

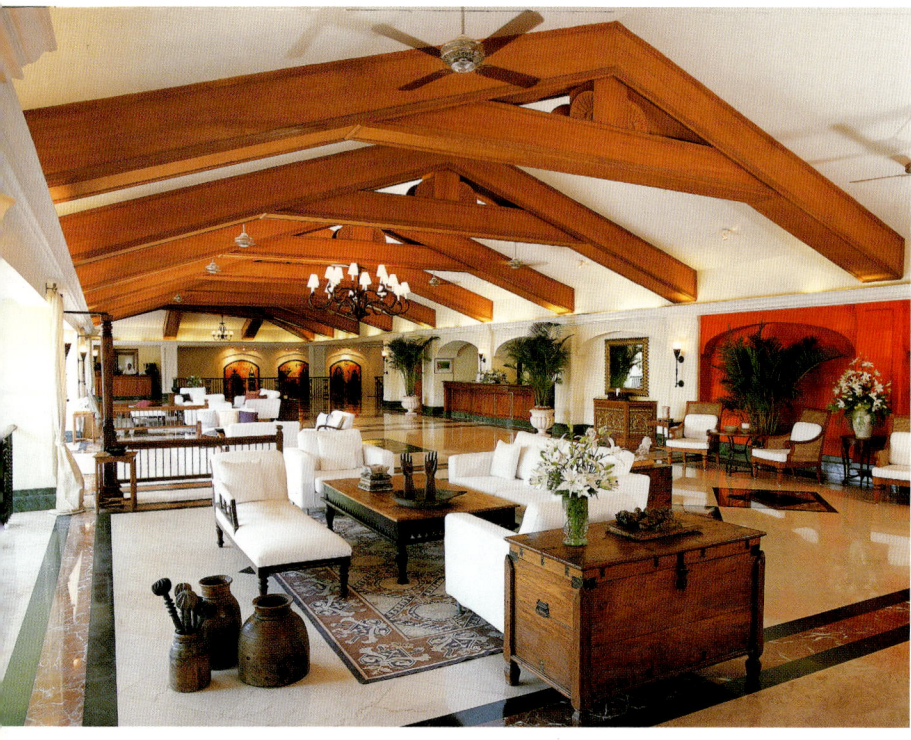

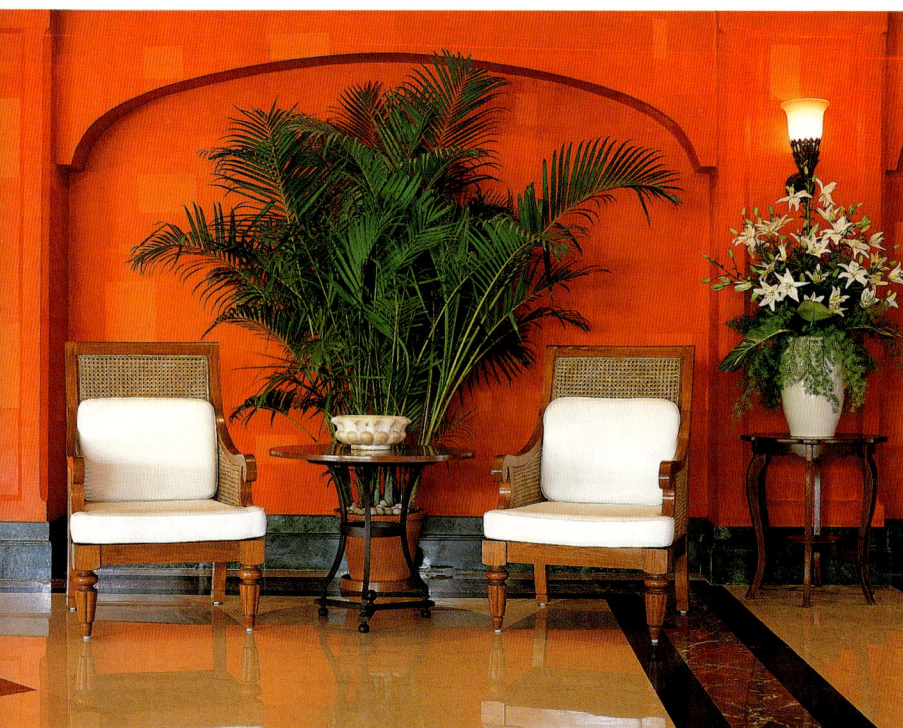

of Kerala, the Jiva Spa is truly a holistic healing experience. The spa offers oil lamps, incense, and natural surroundings as well as spacious treatment rooms with private gardens and a relaxing bathing pool.

The most unique treatments that the Jiva Spa offers at The Taj Exotica, are the aroma and bio-marine therapies. The massages use a harmonious blend of essential oils including Rose, Geranium, Clove, Lavender, Rosemary Officinalis, English Peppermint and West Indian Bay Leaf. The primary objective is to soothe and ease muscular tensions.

One of the treatments that falls under this category is Bio-Energy. This is a massage that uses a vibrant blend of essential oils, including English Peppermint, Rosemary, Eucalyptus Globulus, and Lavender. It helps in revitalizing mind and body.

The Body and Soul massage uses a soothing blend of essential oils, including Frankincense, Myrrh, Lavender, Rose, Geranium, Ylang Ylang, Sandalwood, Patchouli, and Eucalyptus Citrodora. It is ideal for relaxation.

Awakening uses a harmonious blend of essential oils, including Rose, Geranium, Clove, Lavender, Rosemary Officinalis, English Peppermint, and West Indian Bay Leaf. It soothes and eases muscular tension.

And finally, there is Bio-Detox that uses a tangy blend of essential oils, including Eucalyptus Citrodora, Lemon, Grapefruit, Cypress, Niaouli, and Juniper Berries, to combat the effects of pollutants, toxins, water retention, and sluggish circulation.

If you want to spend leisure time inside the resort, you can try your hand at archery, badminton, beach volleyball, cricket and other beach games. You can also indulge in clay pigeon shooting, take dance classes or try your hand at either kite flying or golf.

Children have a special area earmarked for them that includes activities like board games, life-size puzzles, a kids swimming pool with water slides and toy floats, a children's library, a computer station, kids movies, workshops for arts and crafts, pottery, nature trails, star gazing and cooking demos.

A day trip outside the resort can enable you to explore the Colva beach that is 3 kms away. Then the Madgaon City, pay a visit to the famous Mangeshi and the Shantadurga temples as well as the St. Francis Church or revel in the splendour of the Dudhsagar waterfalls.

A truly exotic holiday to remember for a lifetime.

Top: A distant view of the lobby flaunting a log-panelled roof, earthenware and rustic woodwork. Bottom: A close-up view of a seating arrangement in the lobby set against a bright, colourful wall.

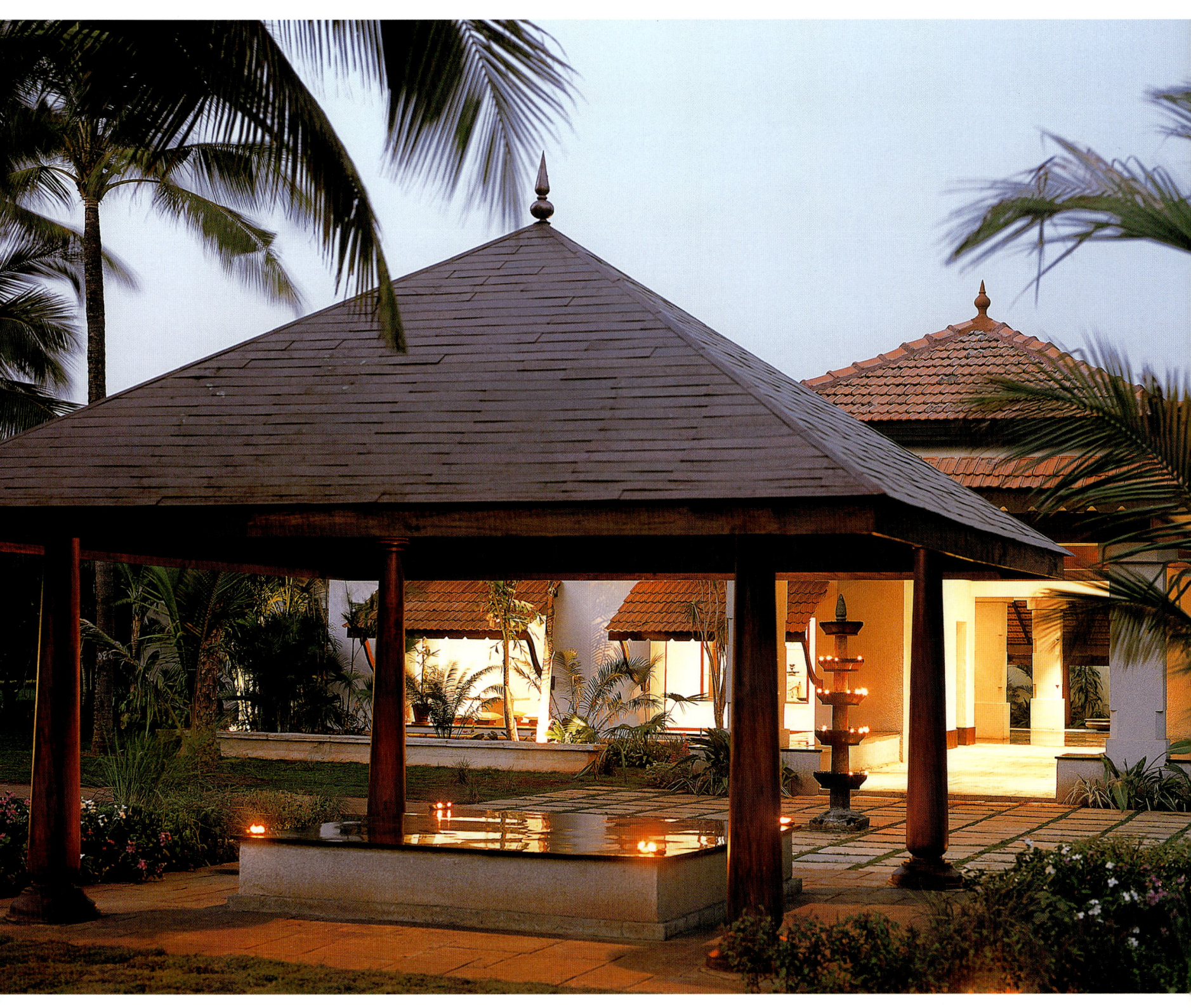

From relaxing Ayurveda massages to meditative archery or a fast-paced game of tennis, you can look forward to a wide variety of recreation and fun at the Jiva Spa. Architecturally reminiscent of the temples of Kerala, the spa offers a truly holistic healing experience.

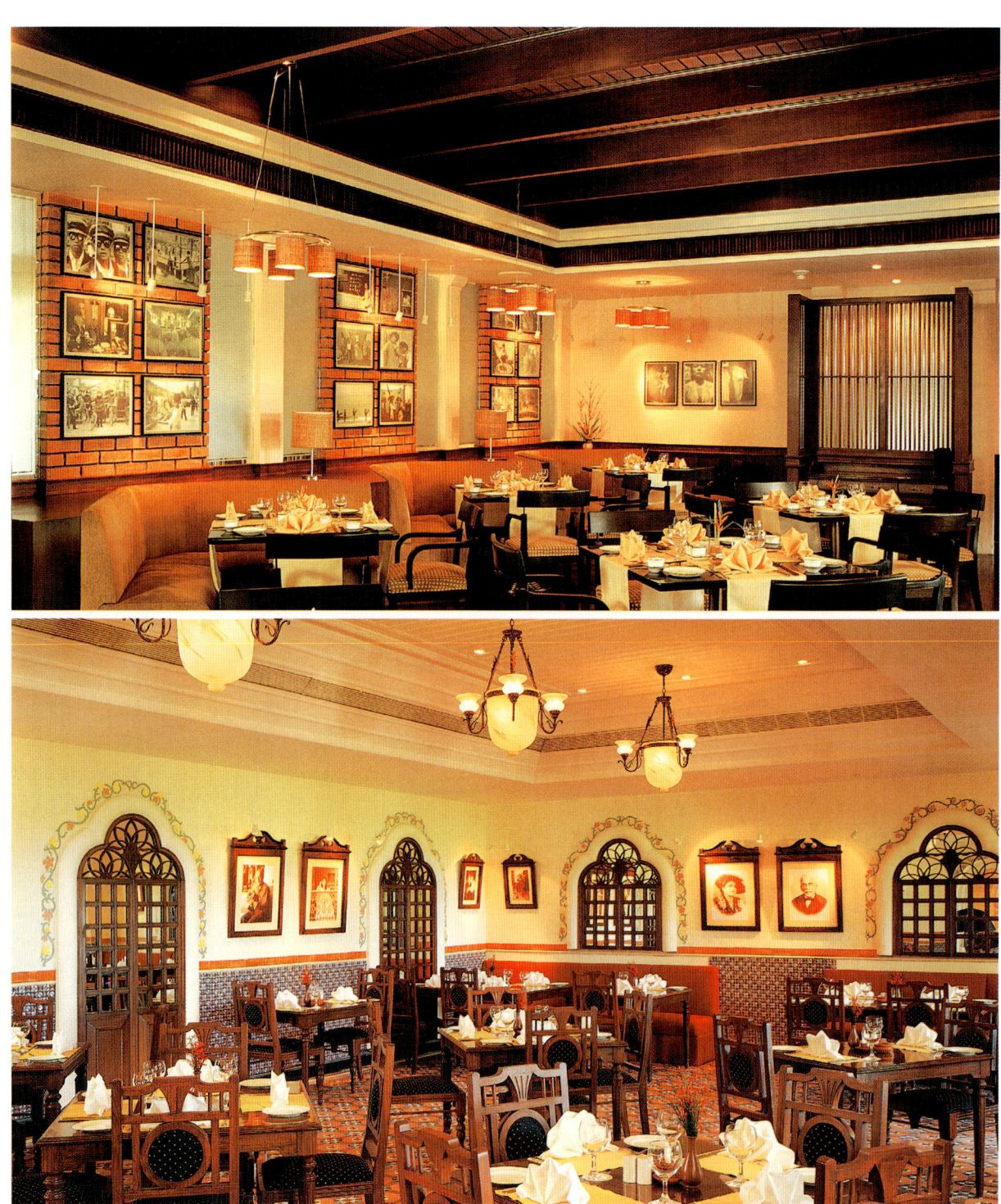

Top: At Miguel Arcanjo, you can relax in an old-world atmosphere and feast on delicious Italian, Moroccan, Spanish, and Provencal fare. Bottom: At Allegria, you succumb to the charms of old-world architecture and the incredibly fresh flavours of Goan cuisine. Opposite page: Eugenia lets you explore the cuisines of the world, including authentic Indian fare, exotic specialties from South-East Asia and classic Continental dishes served with contemporary flair.

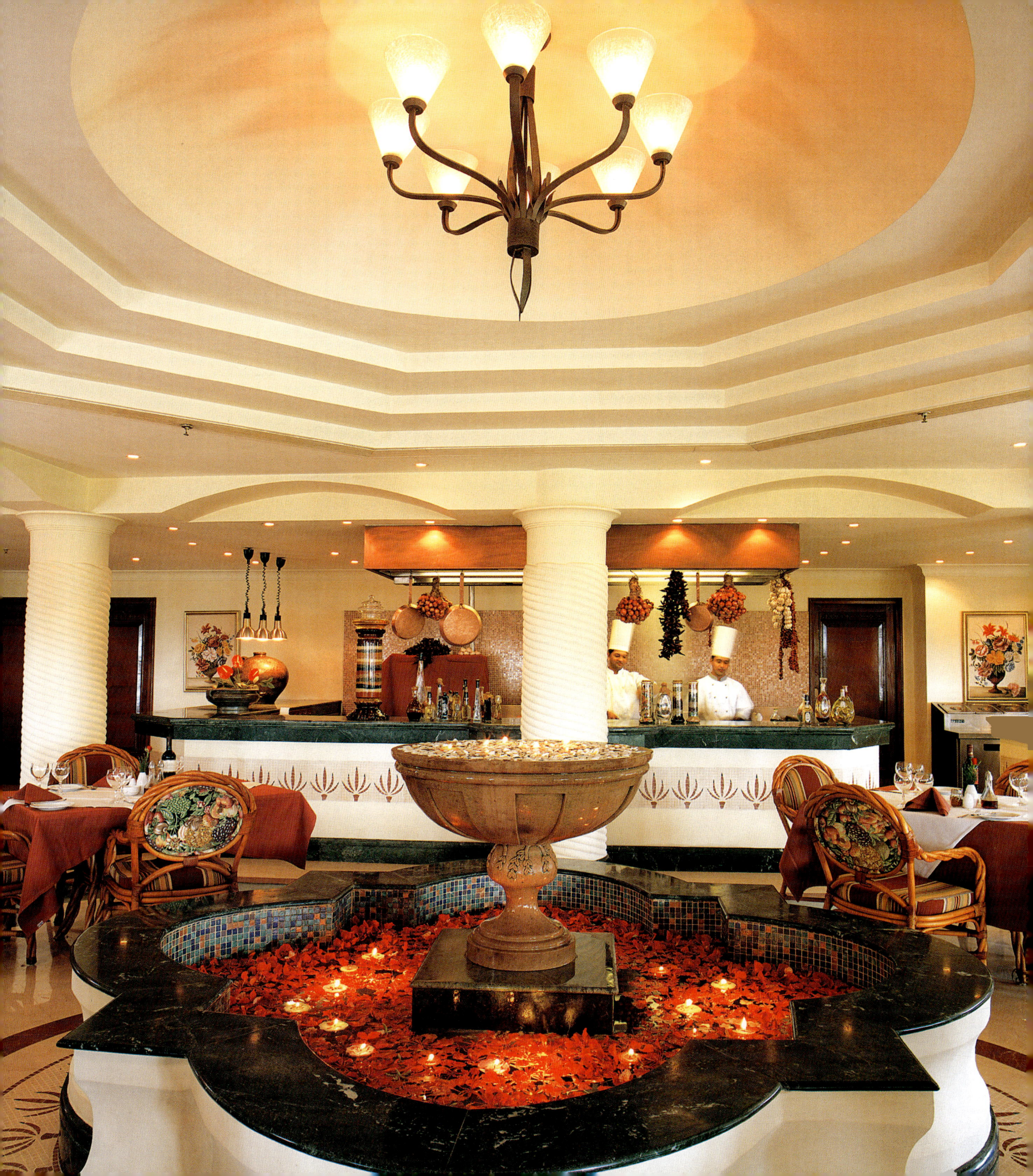

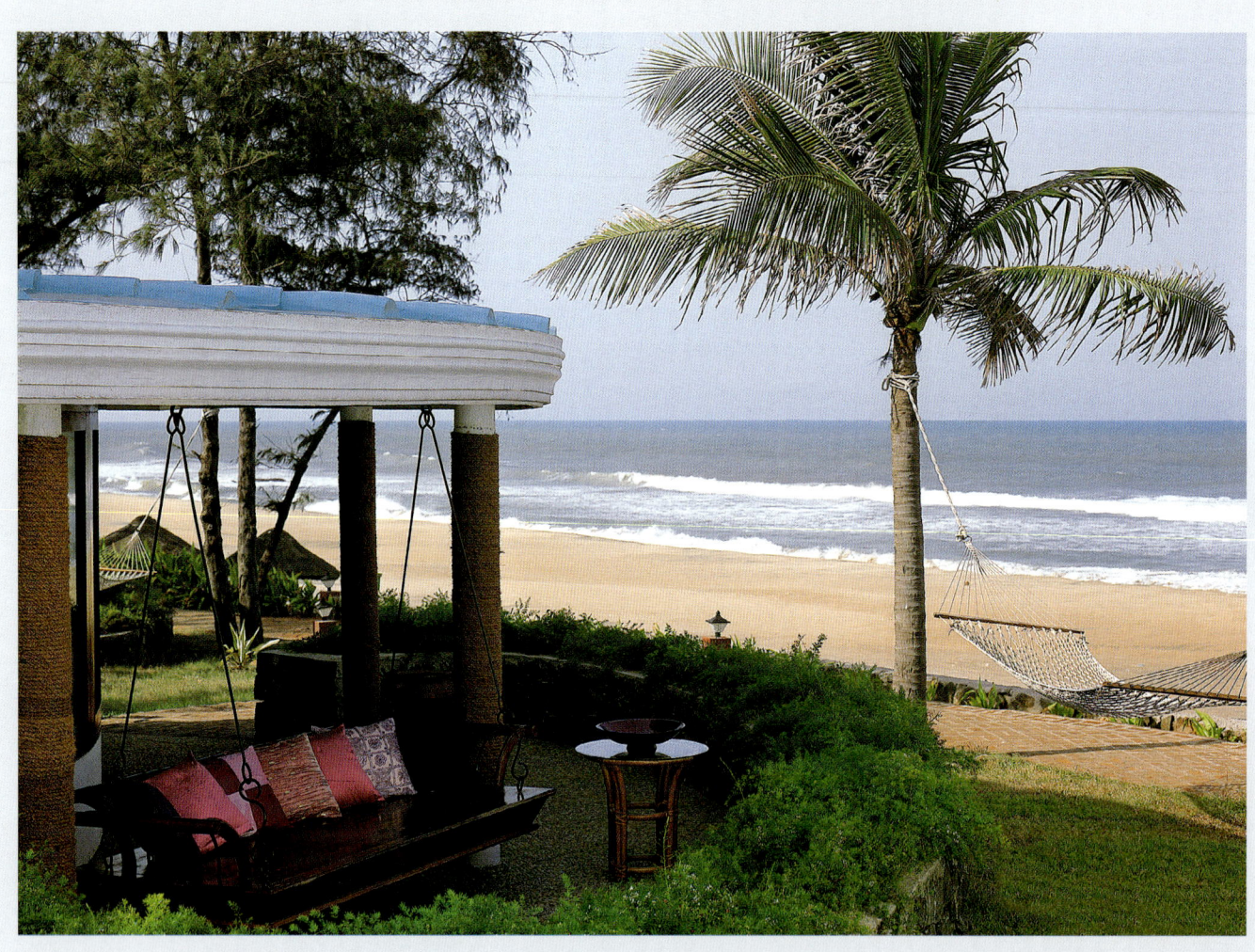

Fisherman's Cove, Tamil Nadu

a cove(ted) experience

Arguably the best resort in South India, Fisherman's Cove adds zest to its splendour by offering the guests an authentic Indian spa experience...

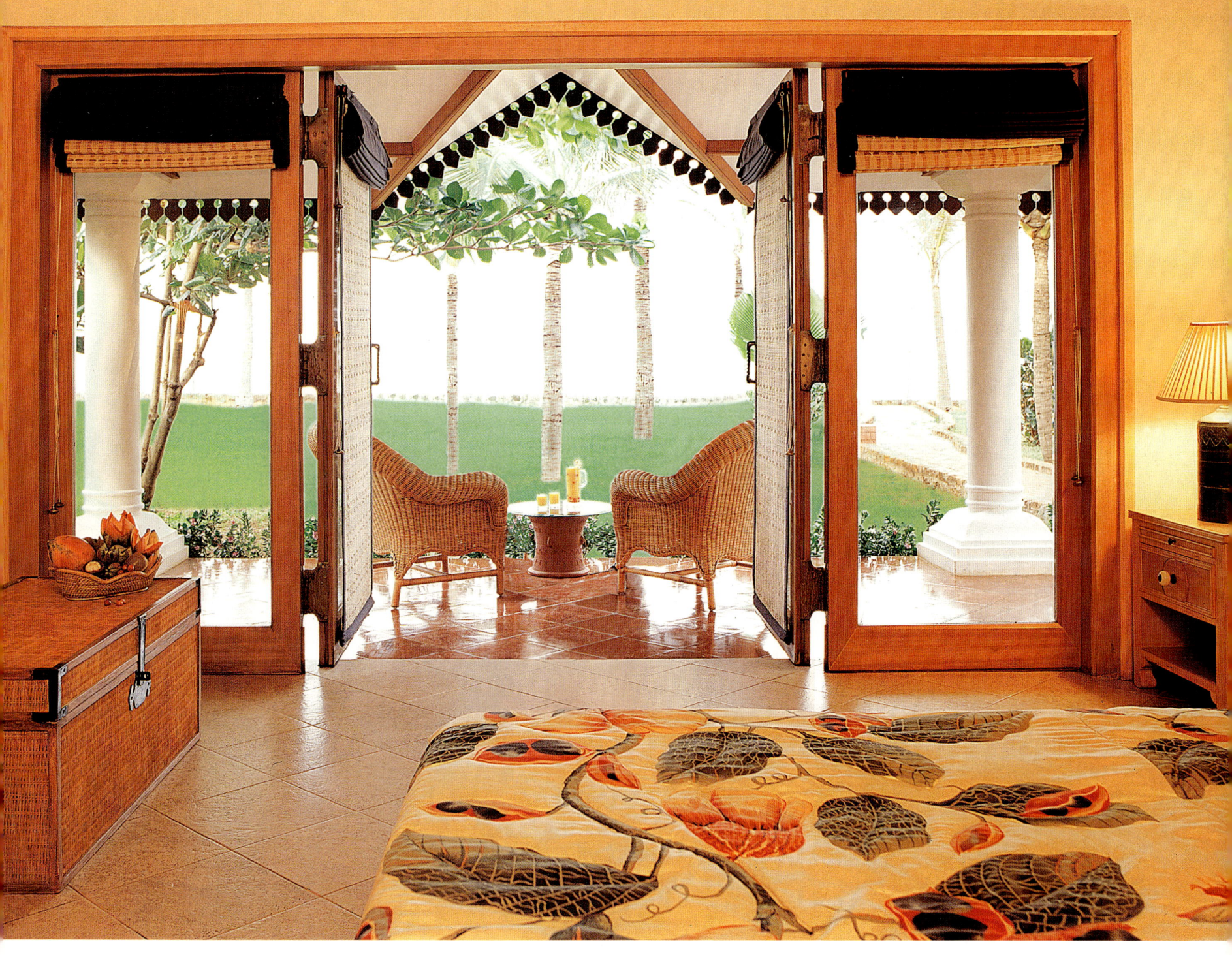

It is a scenic seaside resort built on the ramparts of an 18th century Dutch fort. A short drive from Chennai, Fisherman's Cove is located south of the East Coast Road (ECR) en route to the famed tourist spot of Mahabalipuram. The airport is 32 kms away and the drive from the capital of Tamil Nadu takes you along the Bay of Bengal for a good 50 minutes.

The spacious, rustic garden cottages offer private sit-outs amid lush greenery as well as the exhilarating experience of open-air garden showers. Light wood and cane furniture creates the feeling of weightlessness. Page 54: Beautiful garden setting with a plush, cushioned seating is the ideal place to watch the sun rise and set on the blue water.

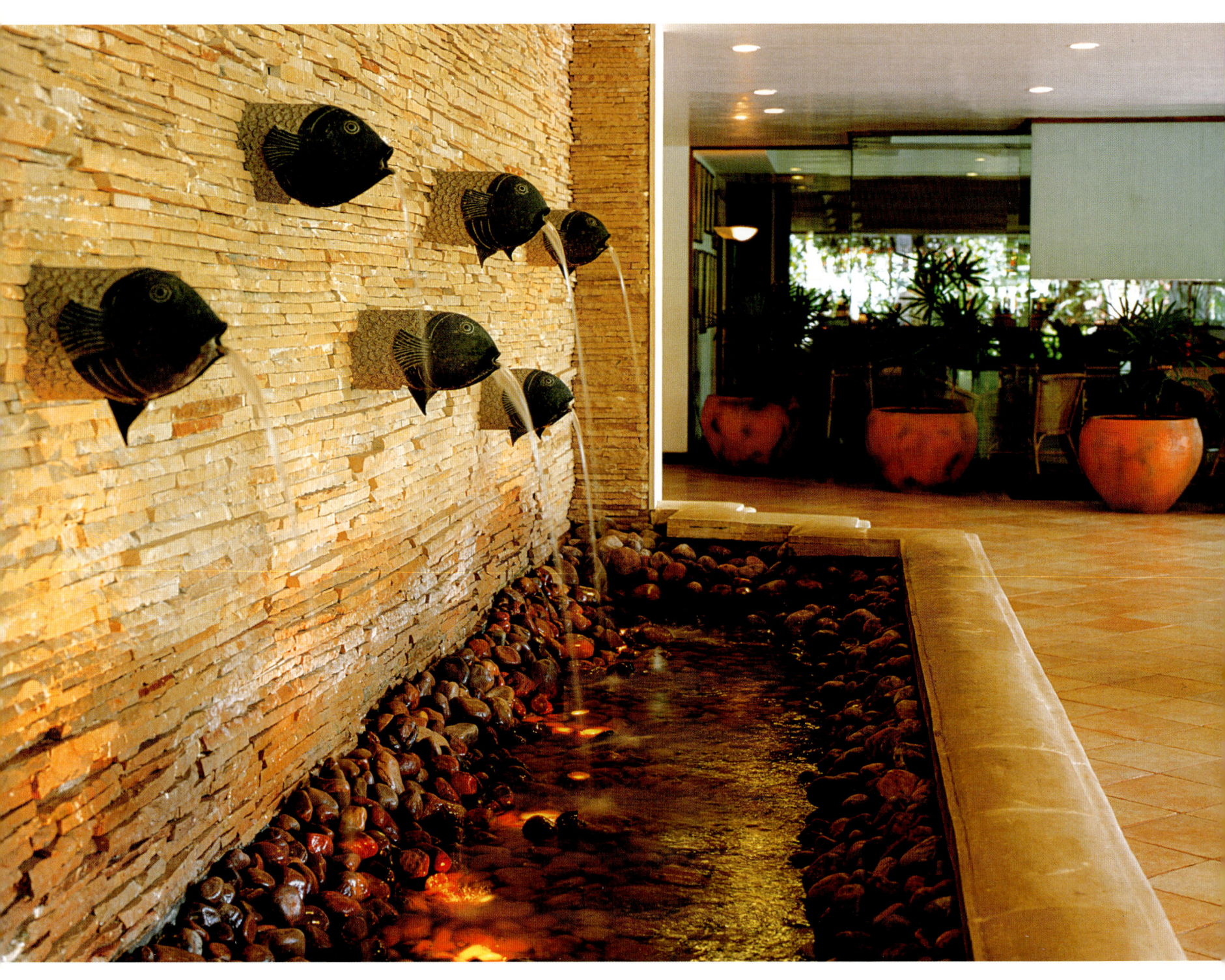

An interesting element in the lobby, the fish waterfall, is the precursor to interior delights yet to come.

With its spectacular view of the deep blue yonder, this Taj resort is a heavenly place to unwind. It has eighty-eight luxury cottages and comfortably appointed rooms. Bask in the warm glow of its friendly service and spacious rooms with views of the white sand beach, lapped by the waters of the Bay of Bengal. To ensure that the guests enjoy a sun-drenched holiday on the pristine sands, the cottages are set on the palm-fringed beach.

Fisherman's Cove's pride, the famed Jiva Spa, welcomes guests to an authentic Indian spa experience. Designed in a minimalist style with touches that reflect the elements of nature, the Jiva Spa is equipped with single treatment rooms, double treatment suites, meditation and Yoga pavilion with a separate Ayurveda enclave with thatched roofs, a swimming pool, a fully-equipped gym and a beauty salon amongst others.

Guests can discover peace and tranquility in the resort's airy luxury villas, sea-facing cottages, and standard rooms. The spacious, rustic garden cottages offer private sit-outs amid lush greenery as well as the exhilarating experience of open-air garden showers.

If you want to relax and soak the sea in, opt for the sea view cottages or the luxury villas that offer an uninterrupted view of the sea.

As far as the dining experience at the resort goes, from casual, all-day eateries to formal, fine dining, guests can look forward to a wide selection of delectable dishes and refreshing drinks. The Taj resort offers a distinctive dining experience, one that explores the nuances of the finest Indian and international cuisines, serving traditional and contemporary favourites.

Some of the eating options at the Fisherman's Cove include the Bay-view Point (which offers fresh seafood located off the Coromandel Coast with its main draw being the soothing views of the sea); the Pool Side Sunken Bar (where guests can satisfy cravings for gorgeous views as well as refreshing cocktails), The Seagull (a multi-cuisine restaurant and coffee shop providing a menu full of local delicacies from the coastline region as well as Mediterranean fare); The Anchor Bar (its exotic, tropical-inspired décor makes this the perfect bar to enjoy lush, fruity cocktails and fine wines) and Upper Deck (from risotto to antipasto and pizza

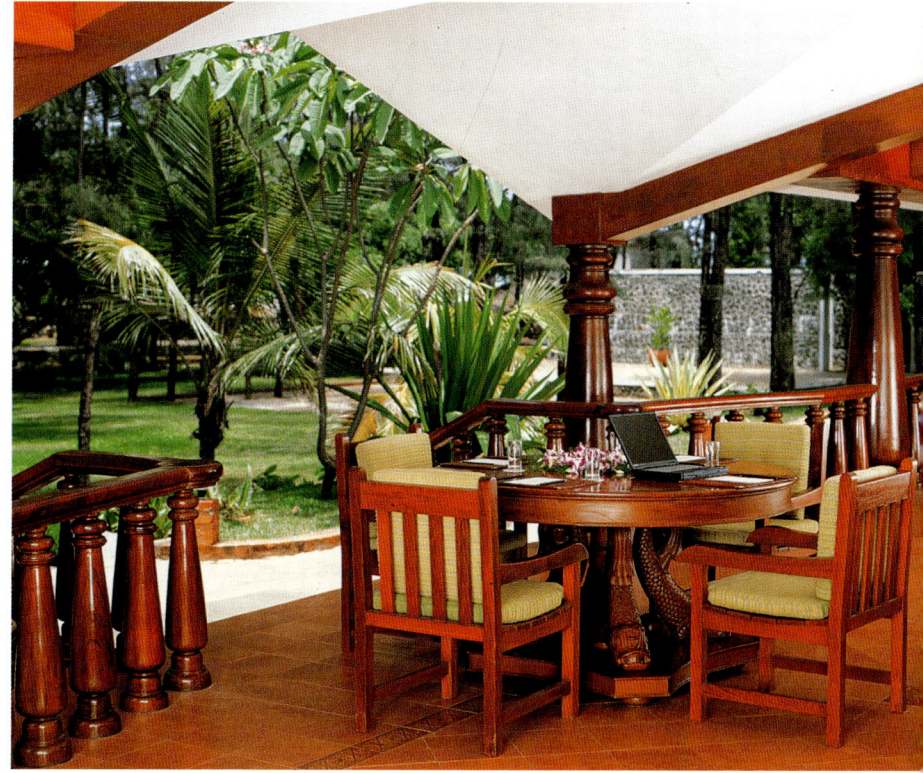

Top: The well-stocked pool bar lets you enjoy your drink without coming out of the water! Bottom: This eating area uses the gardens as the backdrop to a perfect meal.

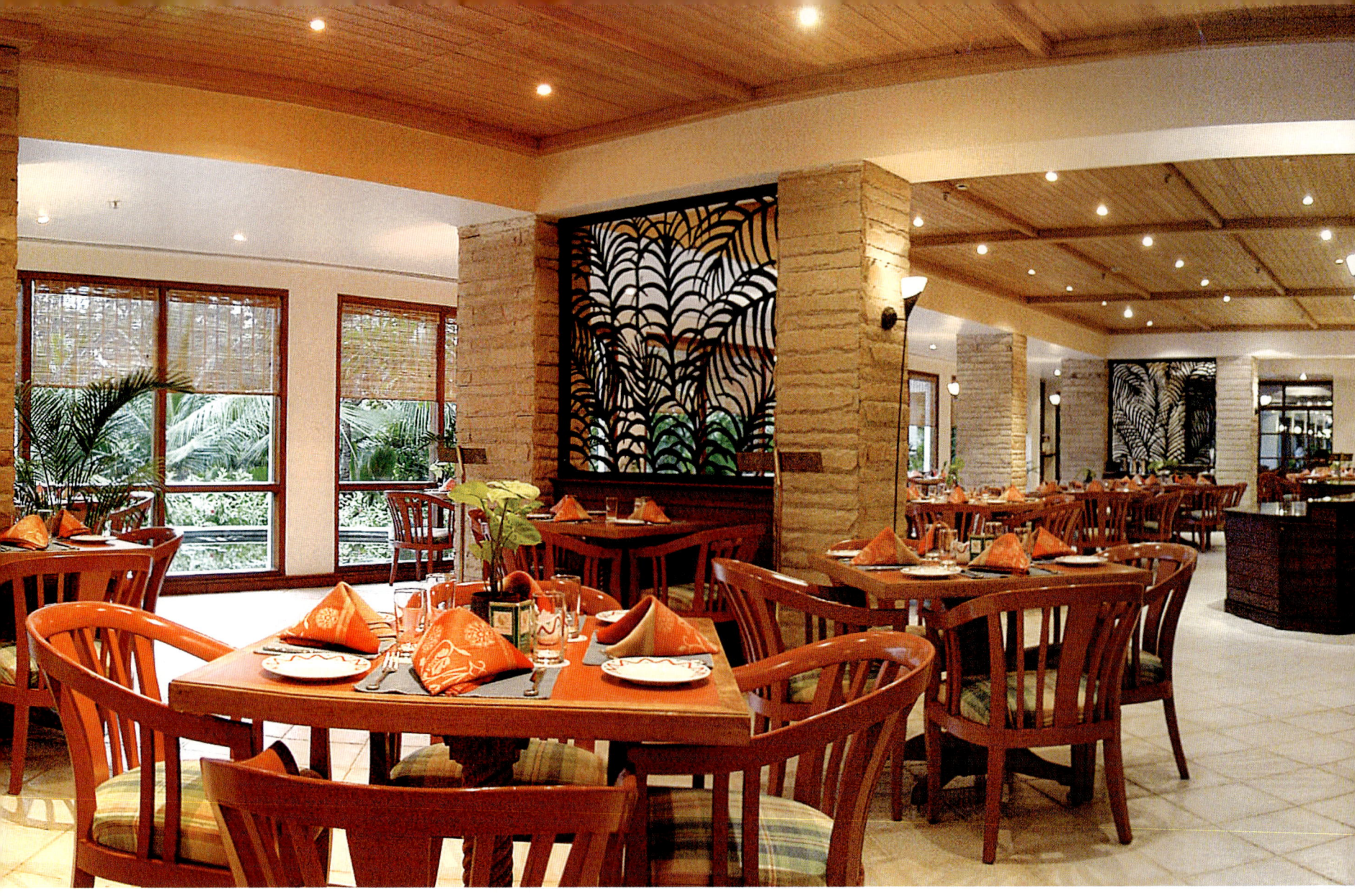

to pasta, this open-air restaurant offers candle-lit, alfresco dining, and a number of tempting Mediterranean dishes).

If you want to go in for a massage, the signature Jiva Spa experience brings in rejuvenation and engaging experiences from the splendour of regal India. Blending ancient Indian wisdom with contemporary therapies, the Jiva Spa unveils the best in Indian rejuvenation therapies ranging from Indian aromatherapy massages, time-honored Indian treatments, body scrubs and wraps. Contributing their skill to the wellness experience are trained practitioners of Ayurveda, meditation, Yoga as well as Indian and other signature body therapies. The whole ambience of the Jiva Spa is tranquility enhanced by soothing music, gentle lighting, plants and a rustic yet contemporary, well-planned décor.

Inspired by the ancient Indian science of the planning of space, the Jiva Spa at Fisherman's Cove unfolds a refreshing idiom of spa design that emanates a harmonious balance of energy and elements in their restful tropical overtones, organic design and contemporary finishes. Some of the signature Taj

The green touch of nature livens up The Seagull. Palm fronds and ferns are the design elements here, with the stone pillars and wooden ceiling adding to the natural feel.

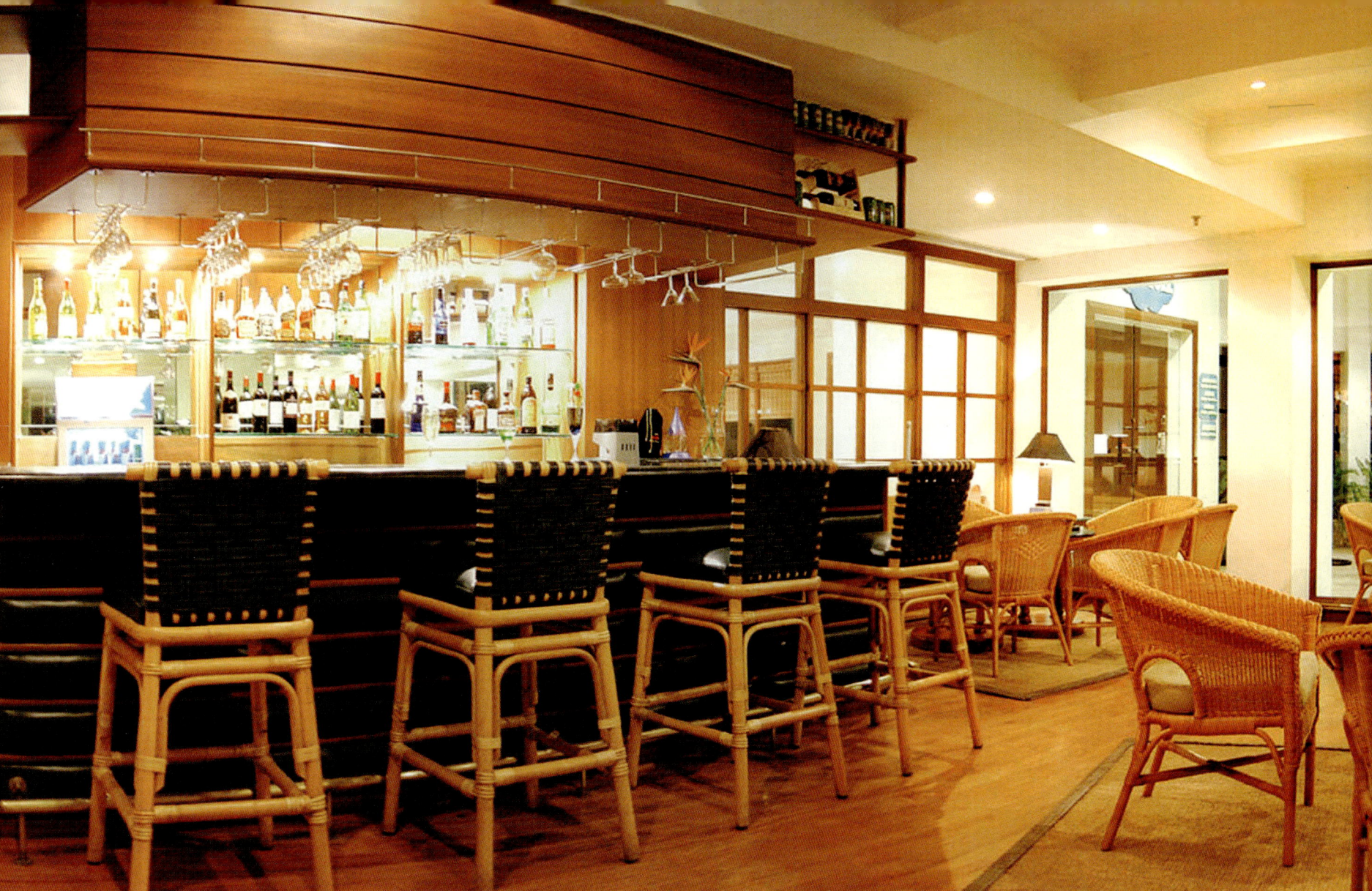

treatments on offer are:

JIVANIYA (Invigorate): An energizing treatment to relieve muscular tension and improve blood circulation. This treatment includes an exfoliating herbal scrub, a heat-stimulating wrap of exotic spices and herbs from the hills of India, followed by a massage.

SHUDHIKARA (Detoxify): A treatment consisting of a lymphatic drainage massage, a wholesome cleansing scrub and a plantain leaf wrap, leaving you with a feeling of lightness.

SAMA (Balance): This holistic treatment has been developed to balance the subtle energy of the body and create a heightened sense of well-being. You will experience the power of healing, the stabilizing properties of the essential oils, the grounding effects of a guided meditation and the nurturing qualities of the gentle and balancing massage.

PEHLWAN MALISH (Warrior Massage): For centuries, Indian wrestlers have been given powerful massages. Experience the not-so-sweet pungency of mustard oil which is extremely good

The exotic, tropical-inspired decor makes the Anchor Bar a perfect place to enjoy lush, fruity cocktails and fine wines. Cane furniture is the accent.

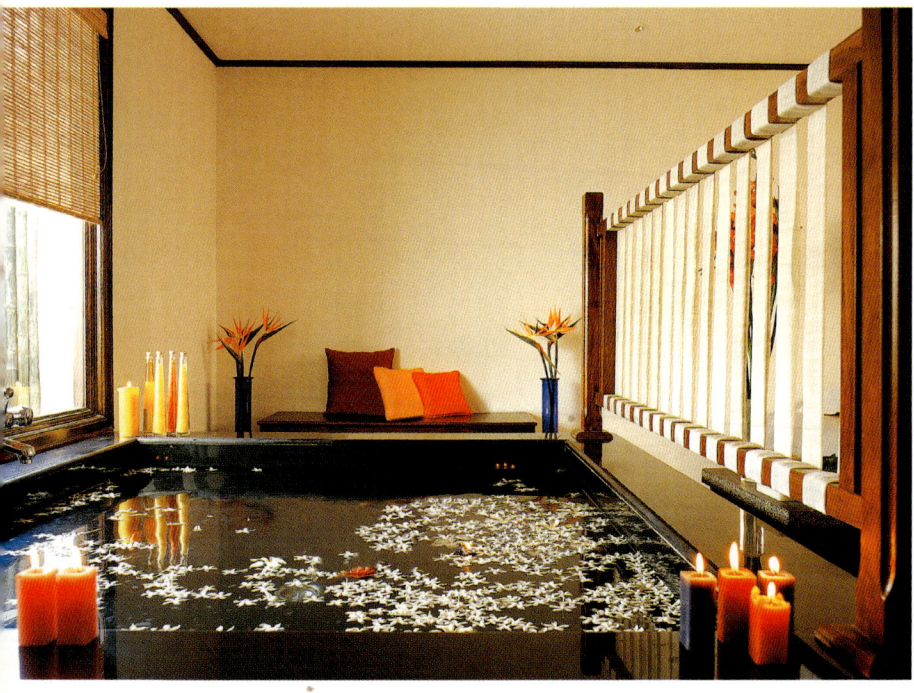

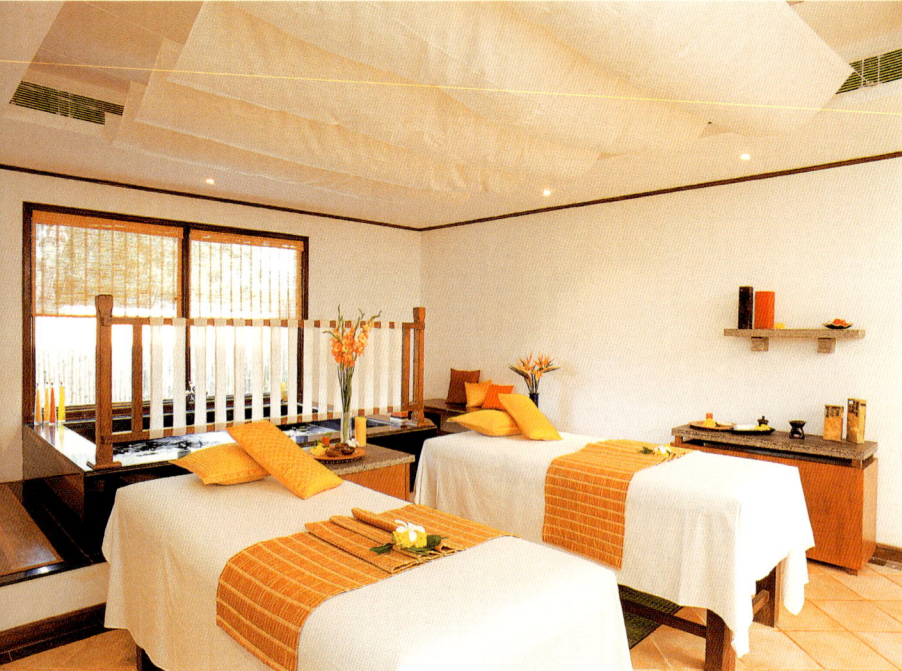

for the skin and helps to provide relief to aching, sore and tense muscles. Alternatively, you can opt for the resort's signature aromatherapy oil.

SAMMARDANA (Indian Deep Tissue Massage): Experience a customized technique of muscle massage by specially trained therapists to enhance the mobility of joints and induce a deep sense of relief.

PADA MARDANA (Indian Foot Massage): An age-old favourite, this ancient art of massage commences with a traditional Indian foot cleansing ritual followed by a pressure point foot massage creating a deep sense of comfort and relaxation.

PRISHTA MARDANA (Back Treatment): Ideal for sore back muscles, this treatment has been created to eliminate tension and bring relief through a back and shoulder massage. The treatment includes deep cleansing, exfoliation, steam and the application of a herbal mask which is ideal for sore back muscles.

CHAMPI (Traditional Indian Head Massage): This massage releases muscular tension from the head, neck and shoulder region creating a sense of ease and joy. Head massage is said to promote hair growth, maintain hair's shine and improve the clarity of mind.

For recreation, there is sunbathing, beach volleyball, tennis, cricket, fishing trips, go karting, snake catching trips and horse riding.

Excursion outside the resort includes a day trip to the Cholamandalam Artists Village, The Crocodile Farm, Dakshinachitra – a cultural village, the Shore temples of Mahabalipuram, Mamallapuram or the Marina Beach in the heart of the city.

A perfect place to get pampered in true colonial style.

The whole ambience of the Jiva Spa at the resort is tranquility enhanced by soothing music, gentle lighting, plants and a rustic yet contemporary, well-planned decor, be it the Jacuzzi (top) or the massage rooms (bottom).

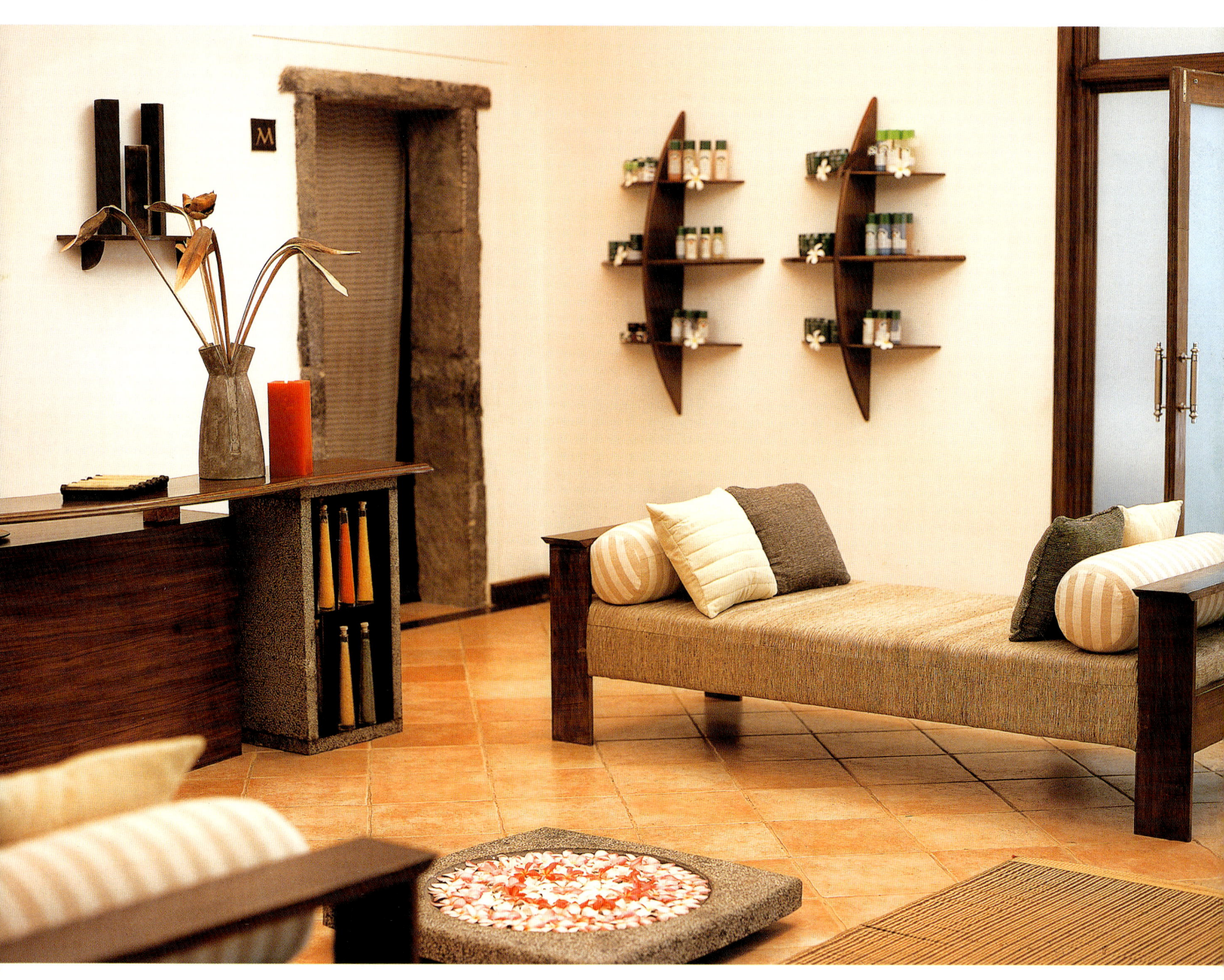

Inspired by the ancient Indian science of the planning of space, the Jiva Spa at Fisherman's Cove unfolds a refreshing idiom of spa design that emanates a harmonious balance of energy and elements in their restful tropical overtones, organic design and contemporary finishes.

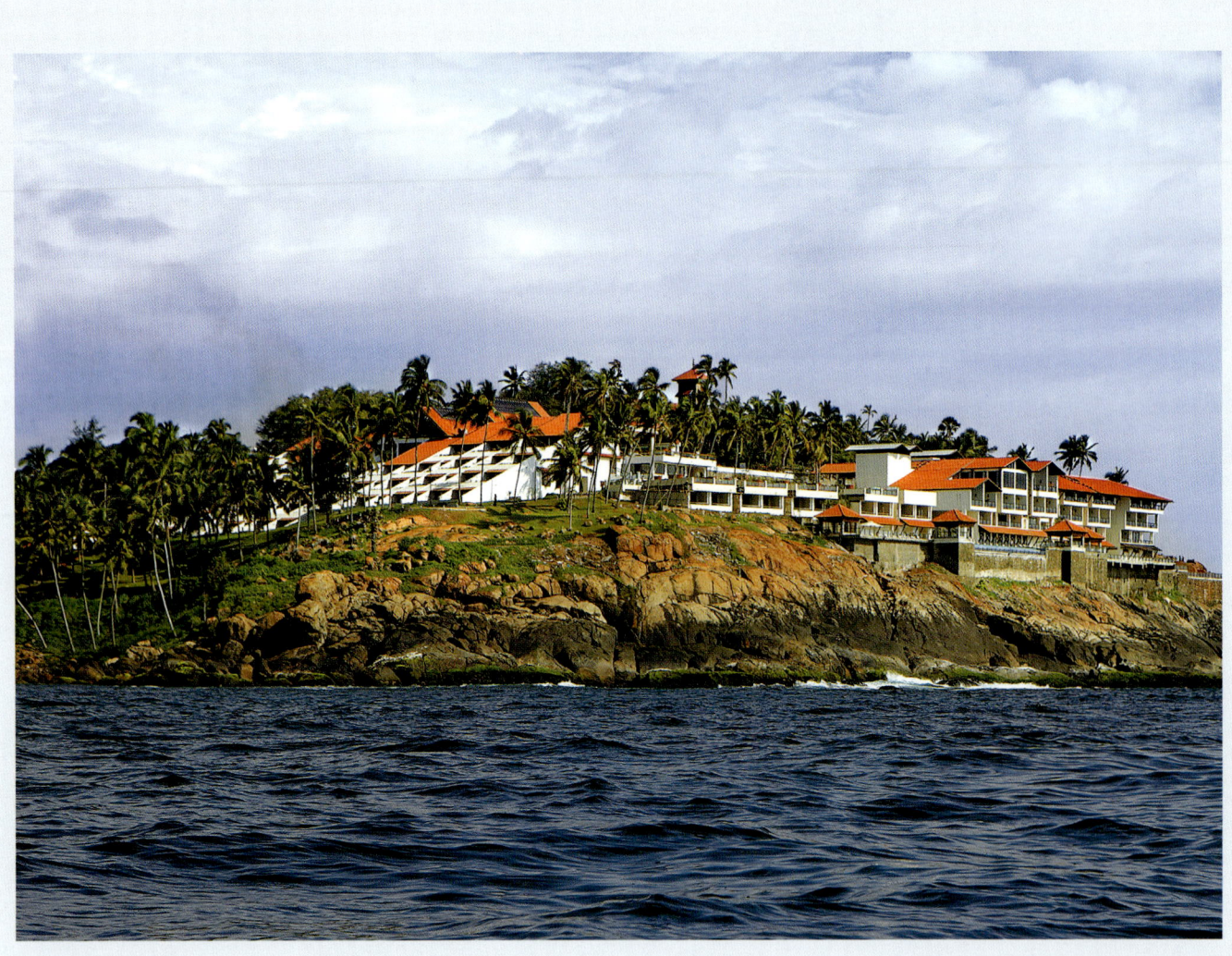

The Leela Kempinski Kovalam Beach

luxury exemplified

Contemporarily designed and furnished, The Leela Kempinski Kovalam Beach gives you the feel of being on a luxury cruise liner...

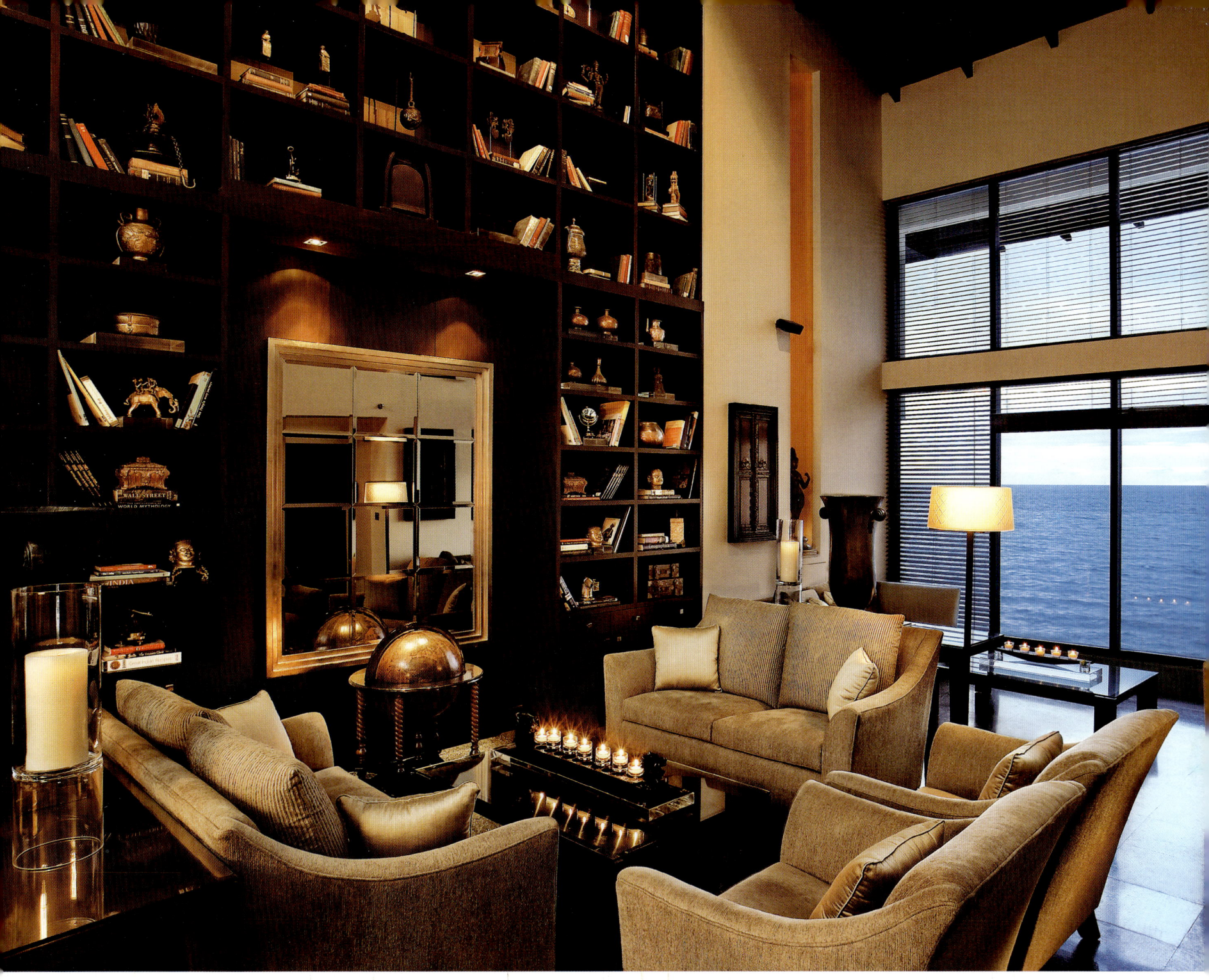

The fascinating Kovalam was brought to the public eye by the Maharaja of Travancore in the 1930s. It was then that the European guests of the then Travancore kingdom discovered the potential of the Kovalam beach as a tourist destination. However, the beach shot into limelight in the early seventies with the arrival of masses of hippies. That started the transformation of a sleepy fishing village of Kerala into one of the most important tourist destinations in the world – the Kovalam beach.

The Library creates a warm and comfortable ambience with ceiling-high bookshelves in solid dark wood and study couches. **Page 64:** *Perched on a rock-face, The Leela Kempinski Kovalam Beach offers the most panoramic views of the famed Kovalam shoreline.*

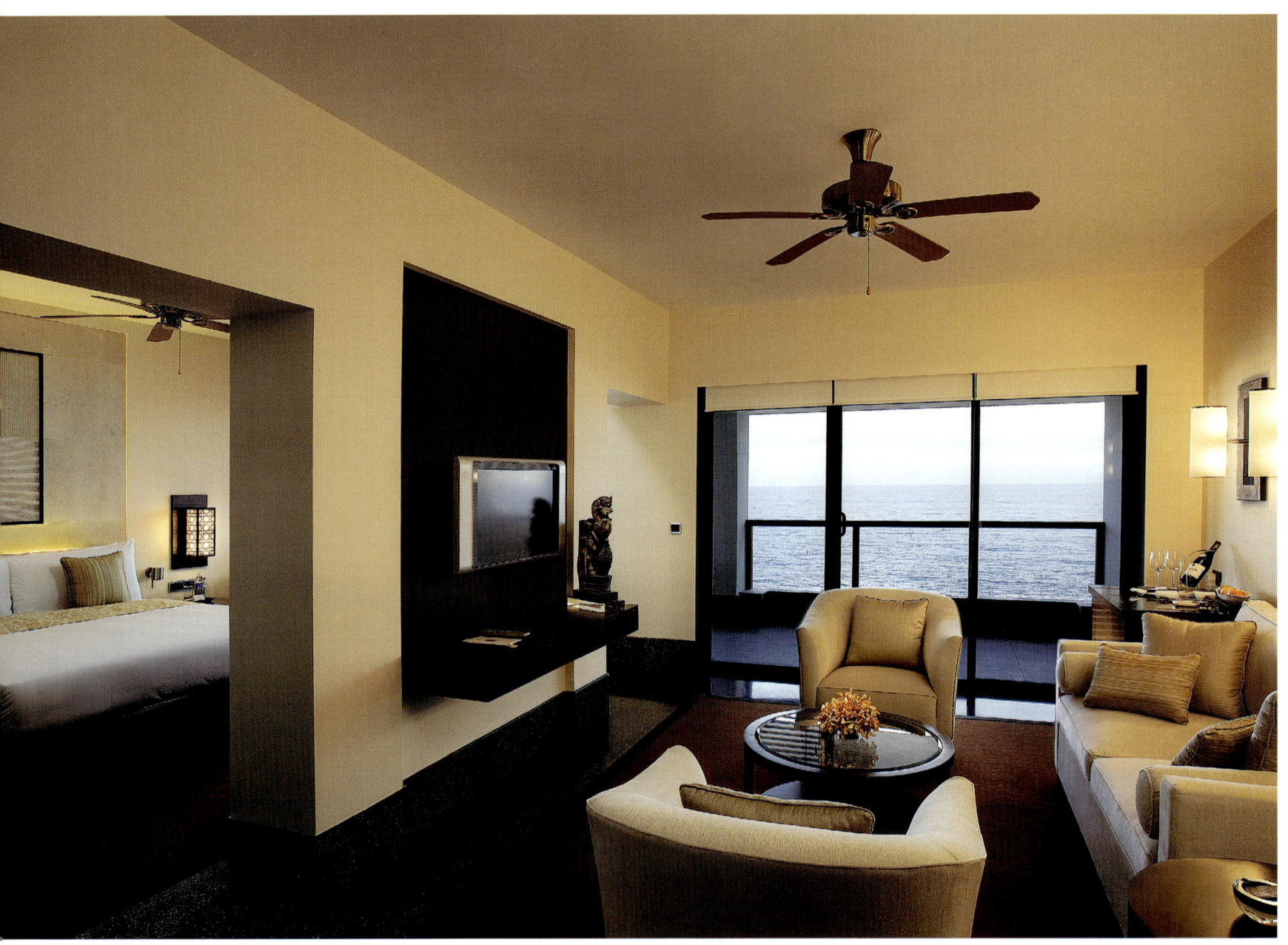

Apart from its natural beauty, the beach area also has another claim to fame – that of being home to Kerala's largest beachside resort cradled between two sweeping beaches. Perched on a rock-face, this deluxe resort offers the most panoramic views of the famed Kovalam shoreline.

Called The Leela Kempinski Kovalam Beach, the property has 182 rooms and suites dotted over many verdant acres. In keeping with the stark, yet stunning setting at the resort, it has arranged its rooms in three unique wings. Each room in every wing comes with stunning sea views and sunsets. Sporting a linear and minimalistic design, the resort exudes an old-world charm at the same time.

Each room in every wing at the resort comes with stunning sea views and sunsets. Furnishings are spacious yet elegant, creating space for the sea breeze to wash over you.

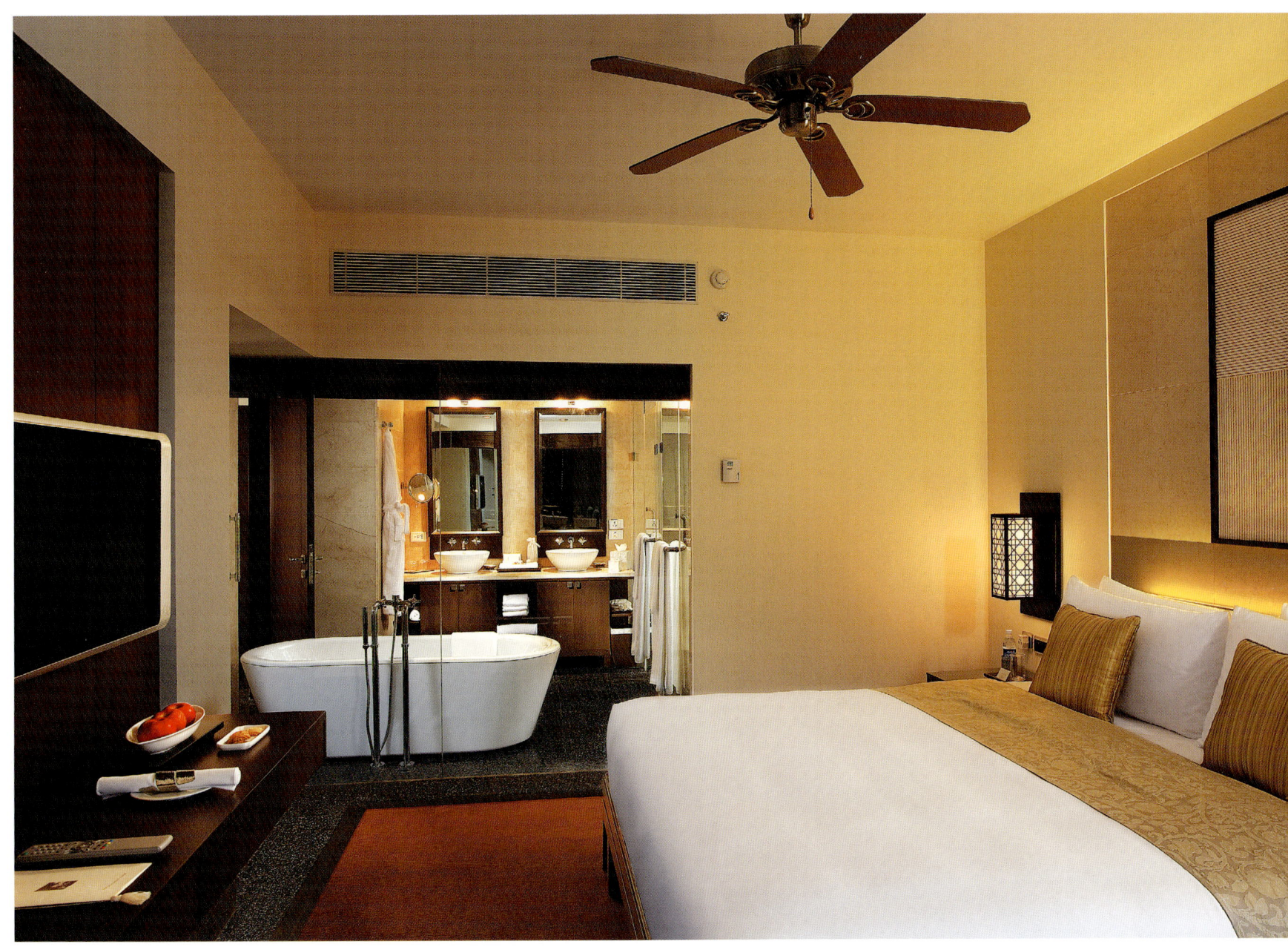

The Beach View Rooms are located on the main block atop the cliff. All rooms have a private sundeck overlooking the beach and the sea. The rooms have a contemporary décor with modern amenities like mini-bar, safe, etc, but all with a touch of traditional Kerala in the art and artifacts.

Ideal for the romantic in you, the Beach View Rooms are detached from the main building and certainly have more privacy with the advantage of the same view of the sea and beach. An open air bathroom and sunken bathtub with rain head showers are the ultimate in luxury.

Sporting a linear and minimalist design, the rooms with their attached bathrooms at the resort exude a chic charm.

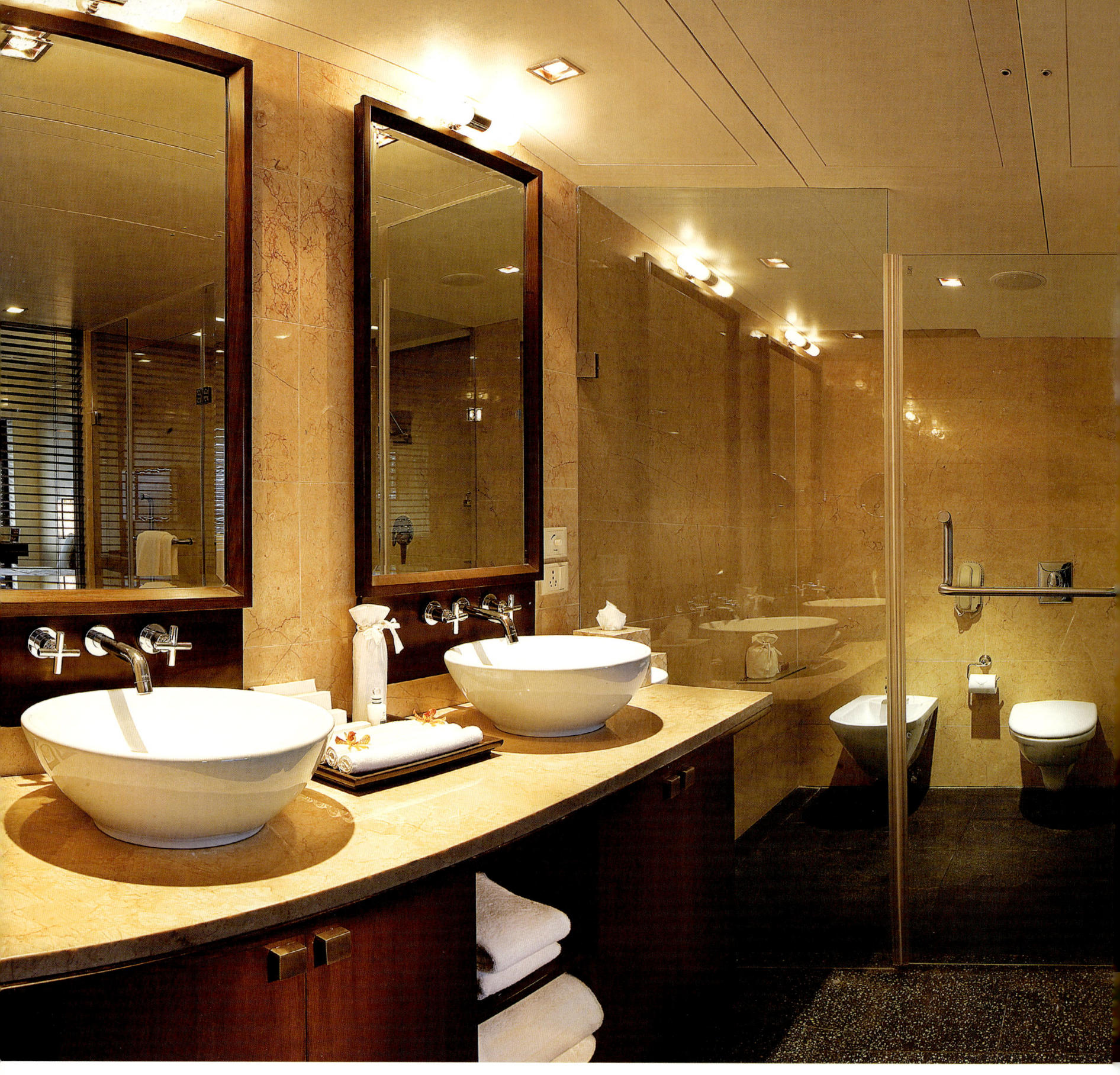

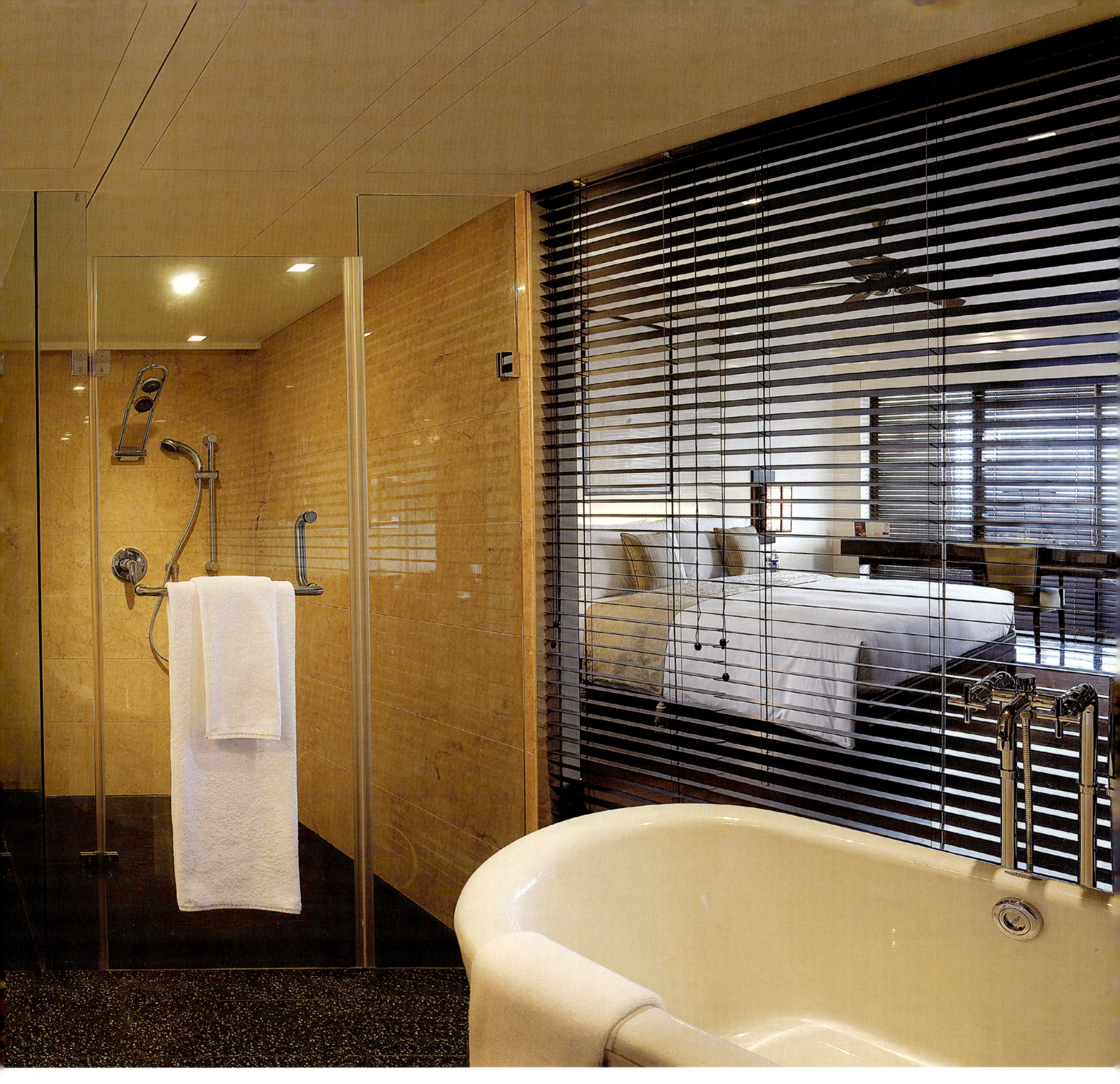

The bathrooms are truly a story in luxury and include all amenities for comfort. The design sensibility is very sleek and clean, not given to fussy ornamentation.

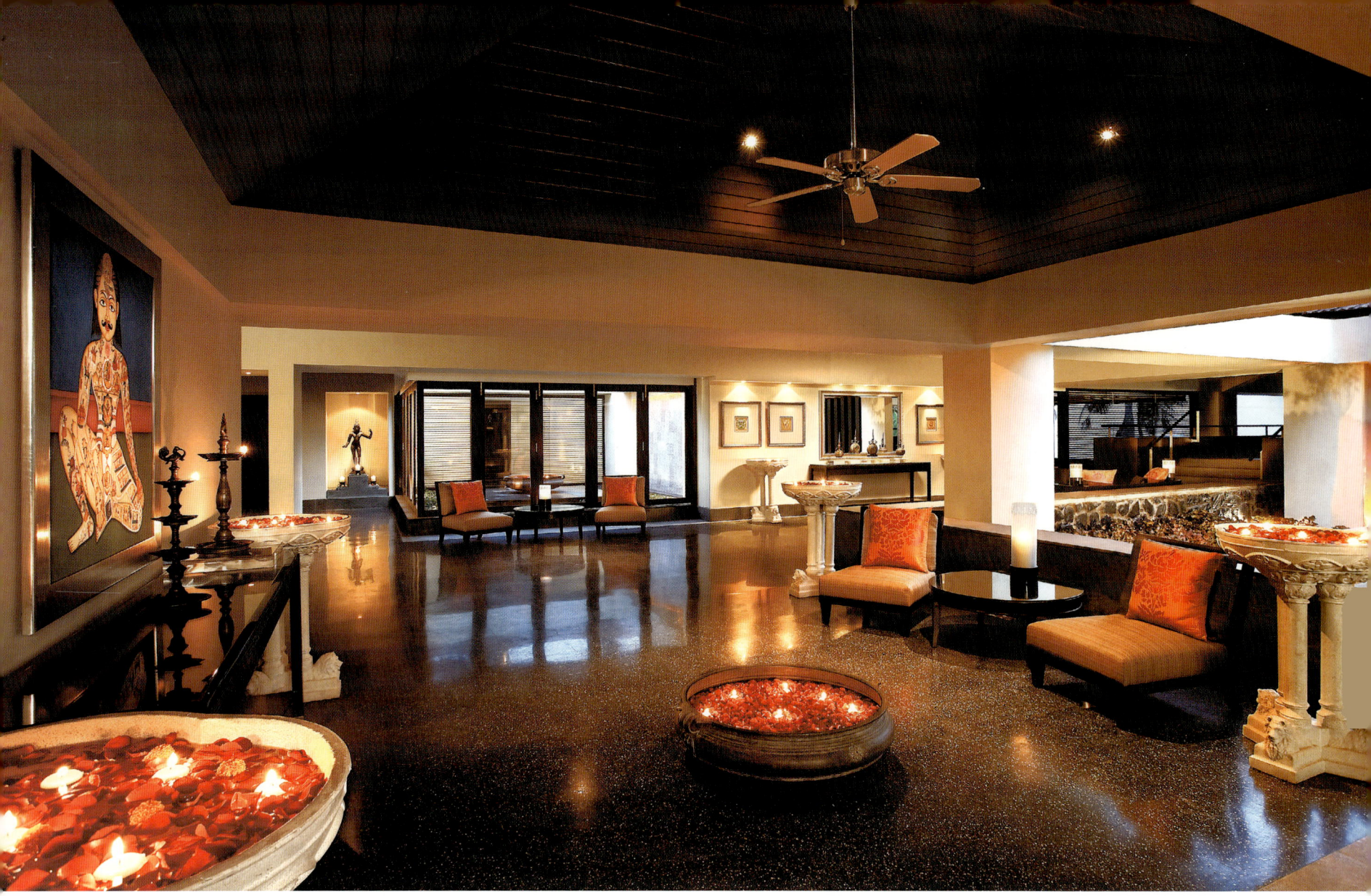

If privacy is what you are looking for, the Sea View Pavilion rooms are meant for you. Located at the beach level, away from the main building, the Pavilion Rooms are individual units of two each, surrounded by coconut groves and are a minute's walk from the beach. With their own secluded pool and green lawns, these rooms are ideal for a holiday by the beach with the novel you never got to read.

Of note is an entirely exclusive wing only for The Club residents. It's hard to decide which is the best part of the Club experience: the room or the exclusivity of the Club wing with the ocean rim infinity pool, or The Café serving delicacies to suit your taste and dishes you would have never dreamed of, like spiced ice creams. Sunsets could never have been better than in the exclusive lounges of The Living Room and The Library.

Built on the edge of the cliff-top, all The Club Rooms have an astounding view of the Arabian Sea. Standing on the balcony of the room, one could gaze for hours at the expanse of the ocean in front, with the rhythmic sound of the waves crashing below, coupled with the balmy breeze from the ocean.

Built to showcase the vision of a hotel within a hotel, The Club at the resort is actually the epitome of a luxury hotel within a luxury hotel. The resort offers you a wide variety of wining and dining, each one of which maximises its natural beauty.

There is The Terrace, a multi-cuisine buffet restaurant that's

Contemporarily designed and furnished, The Leela Kempinski Kovalam Beach at the same time exudes an old-world charm with traditional urlis, brass lamps and artwork.

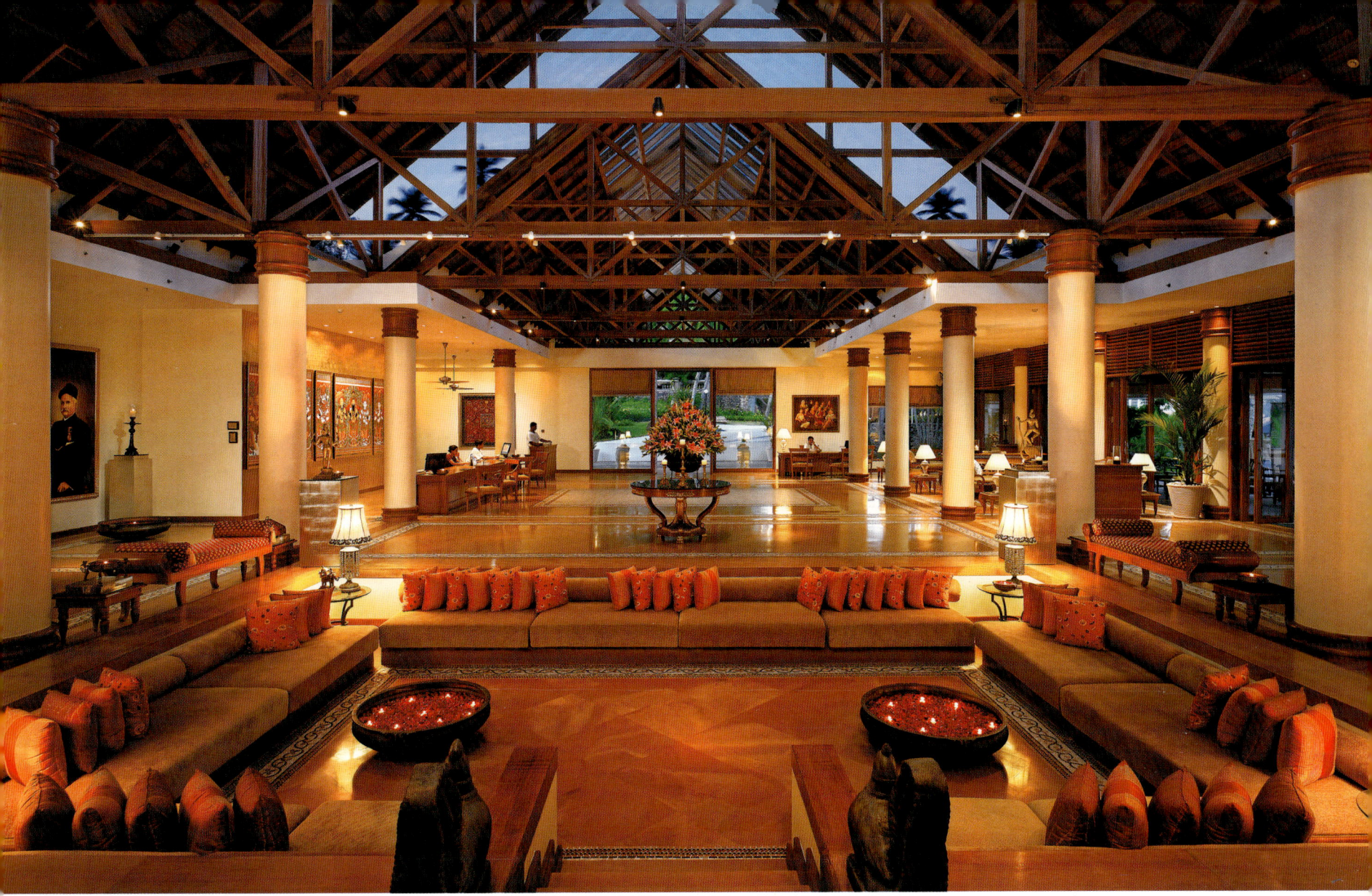

open 24 hours. This restaurant offers an awe-inspiring view of the Arabian Sea and a pleasing array of cuisines too. The Skybar, perched on the cliff-top, offers an unmatched view of the sun setting over the Arabian Sea. It is an eclectic open-to-sky lounge bar with a modern and trendy design. It offers a wide range of alcoholic and non-alcoholic beverages, specialized cocktail bar and live tapas kitchen serving international fusion snacks.

The Bar has been created to invoke memories of yore and has a beach view deck where you can choose from an impressive and extensive collection of drinks, while you watch palm fronds framing the restless sea.

For residents of The Club, there is The Café that specializes in Oriental, Continental and Indian delights along with authentic Kerala cuisine. The Living Room at The Club is a lively lounge that stocks an extensive collection of both international cigars and snacks. Last but not the least is The Library, which is a residential library lounge for guests of The Club. It invites you to just walk-in and take in the atmosphere, one drink at a time.

Along with spoiling you with a host of impeccable dining and entertainment options, The Leela Kempinski Kovalam Beach also has Divya, an authentic Ayurveda Wellness Spa. You could also choose to unwind in its splendid infinity pools that merge into the Westerly horizon.

Ayurveda is the ancient Indian science of life and at Divya, the Leela Kovalam's spa, it is practised to perfection in eight treatment rooms sprawled over 8,000 sq ft. Each room marries

The lobby at the resort exhibits traditional Kerala interiors.

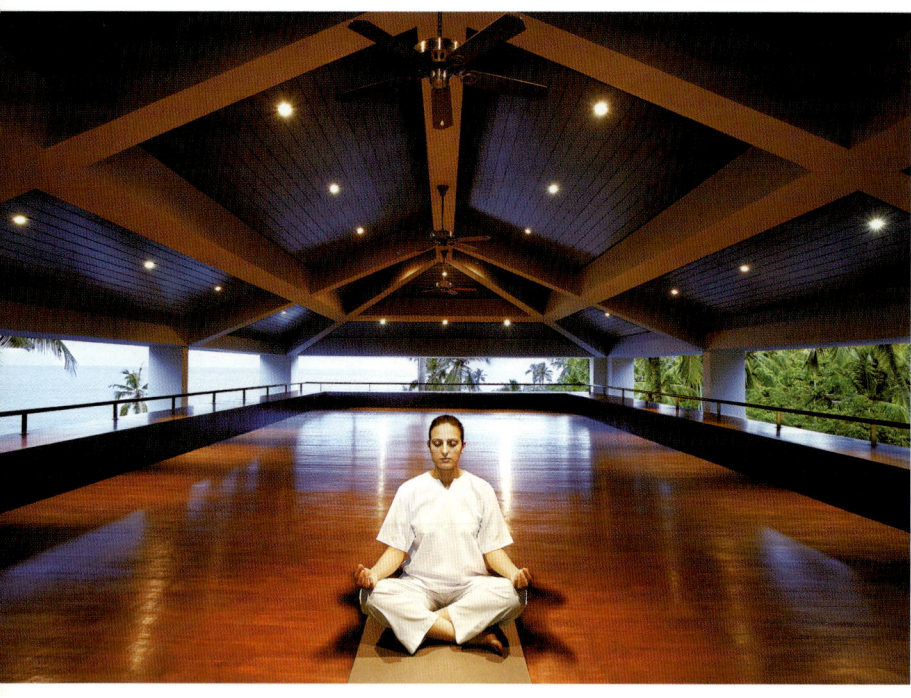

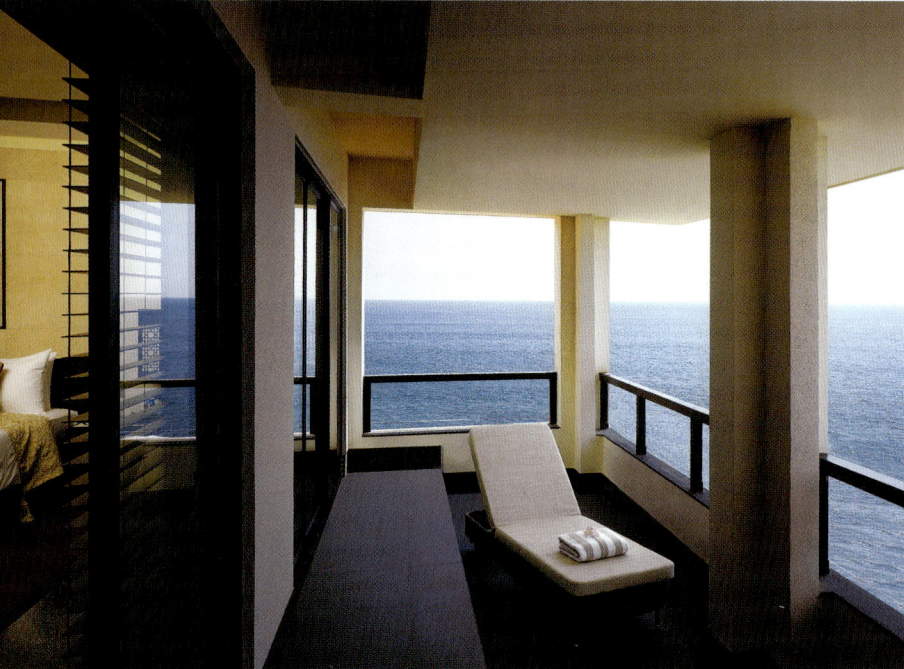

state-of-the-art amenities with centuries-old wisdom and learning to give you treatments for a host of ailments, both of the mind and body.

Divya, which means divine light, is an intimate spa, decorated in a contemporary Indian style to reflect its surroundings. Relaxation and wellness are the top priorities in this luxurious hideaway. Whether you are looking to complement your holiday with a rejuvenating treatment or wanting to align body and mind with a longer therapy, the spa has something for everyone.

The Ayurvedic programmes offered at Divya range from one to 28 days. Guests spending a short time at The Leela Kempinski Kovalam Beach can indulge in the Ayurvedic De-stress Programme, the Ayurvedic Detox and De-stress Programme and the Ayurvedic Refreshment Programme.

The spa also boasts of three signature treatments based on the ancient Kalari massages of Kerala and include the Vishram (relaxation massage), the Sukhakara (energising massage) and Sammardana (Indian deep tissue massage).

A Kalari massage is that in which the masseur applies varying degrees of force and weight with his legs, while holding on to suspended ropes for support known as Utsadana. When the masseur works just with his hands, it is known as Samvahana. When two masseurs work together at the same time, it is called Suparithala Kriya.

A Kalari massage includes techniques of balancing the *chakras* or energy centers and Saptha Dhatu (seven tissues in the human body – plasma, blood, muscle, fat, bone, bone marrow and semen), stimulation of Nadisuthra points (Ayurvedic acupressure), working with Marma or vital points, and the awakening of Prana.

Running alongside the spa treatment packages, you can complement their therapies with Yoga and meditation.

For recreation, you can stay at the resort and enjoy water sports like beach volleyball, diving and water scooters or go for excursions outside Kovalam. The sea port of Vizhinjam is about 3 kms away and famous for its special varieties of fish, old Hindu temples, big churches and a mosque.

Definitely, a resort that spoils you luxuriously!

Top: Yoga and meditation room at the Divya, an authentic Ayurveda Wellness Spa at the Leela resort. All in wood and open to nature, forming a seamless whole.
Bottom: All beach view rooms at the resort have a private sundeck overlooking the beach and the sea. Straight lines keep your focus on the sea.

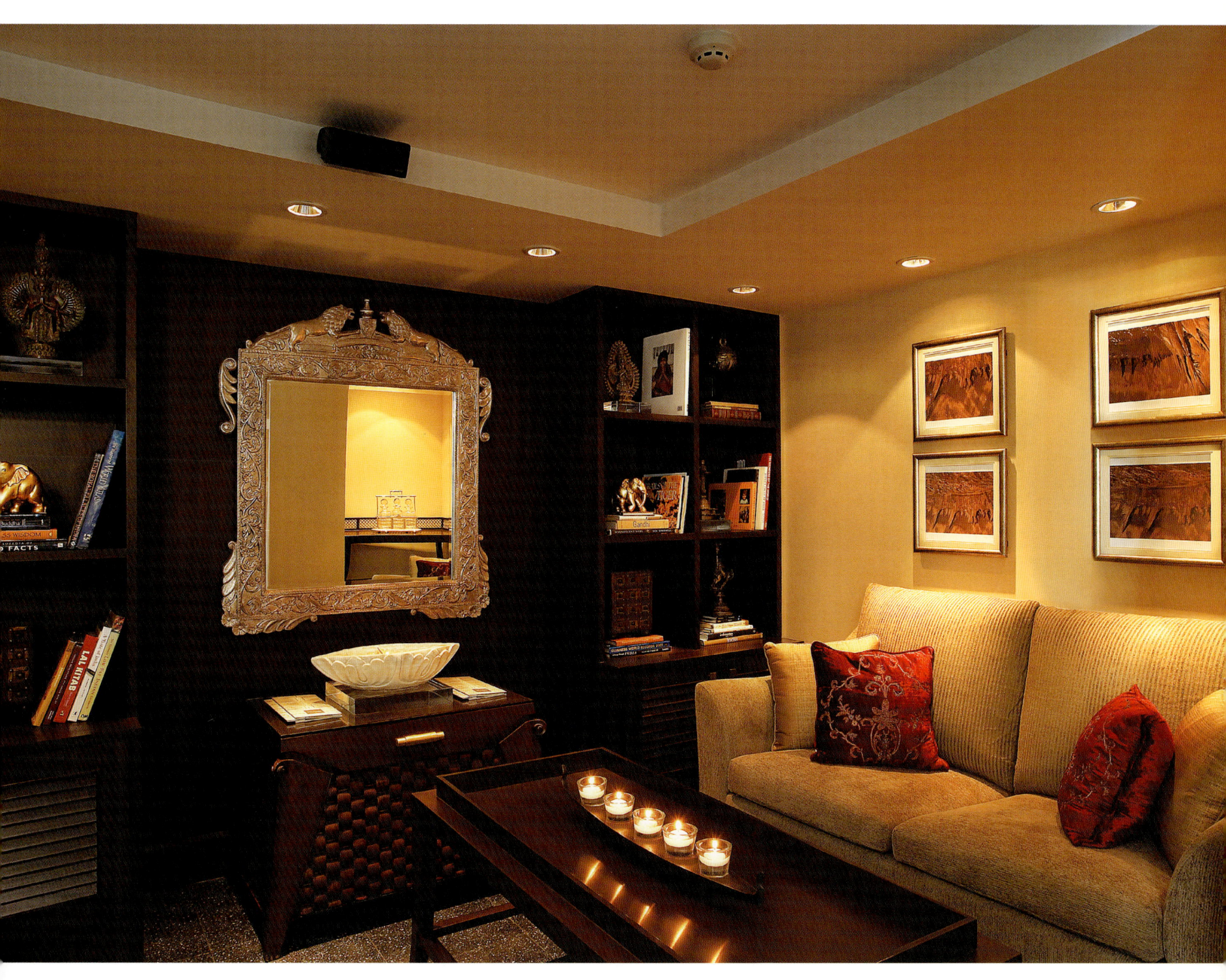

Most of the lounge areas in the resort sport a look that is a mix of traditional and modern, opulent and simple. **Page 76-77**: *Views of the Skybar and infinity pool, both perched on the cliff-top, offering an unmatched view of the sun setting over the Arabian Sea.*

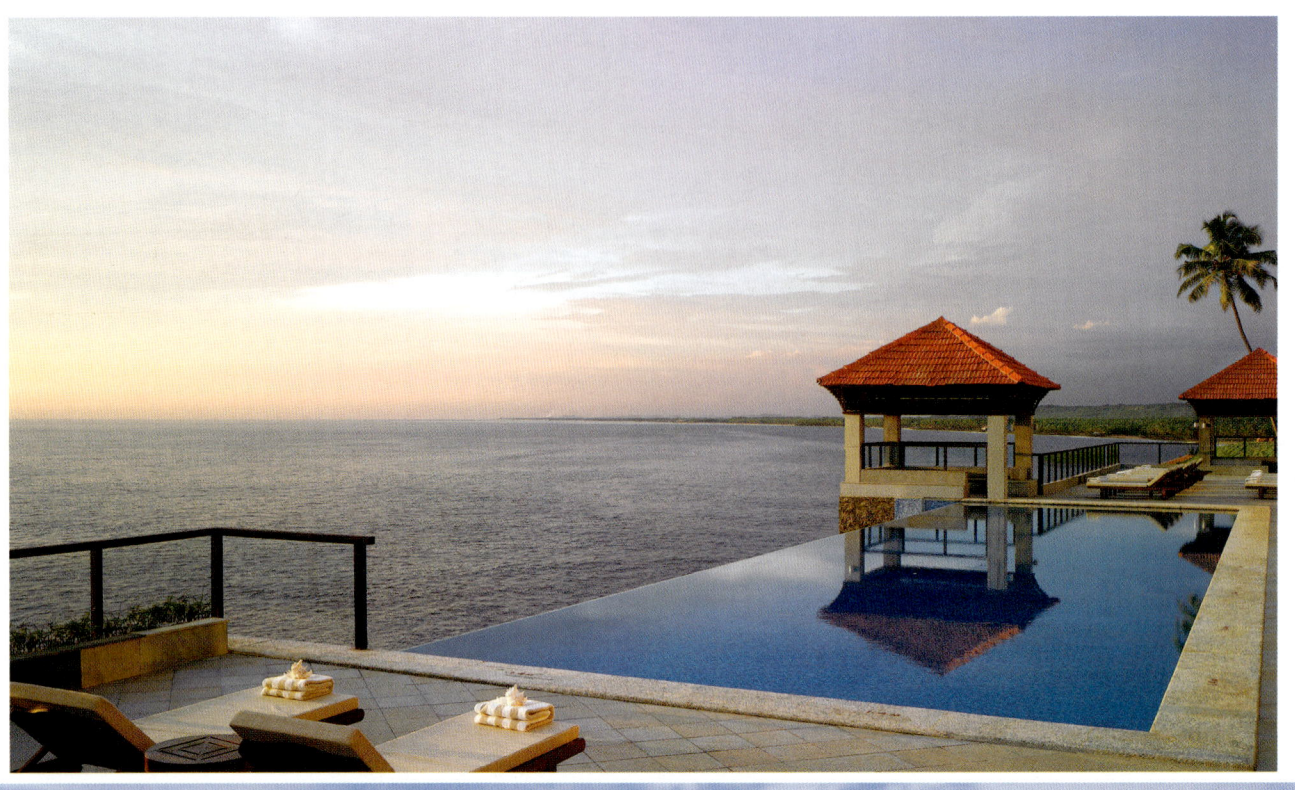

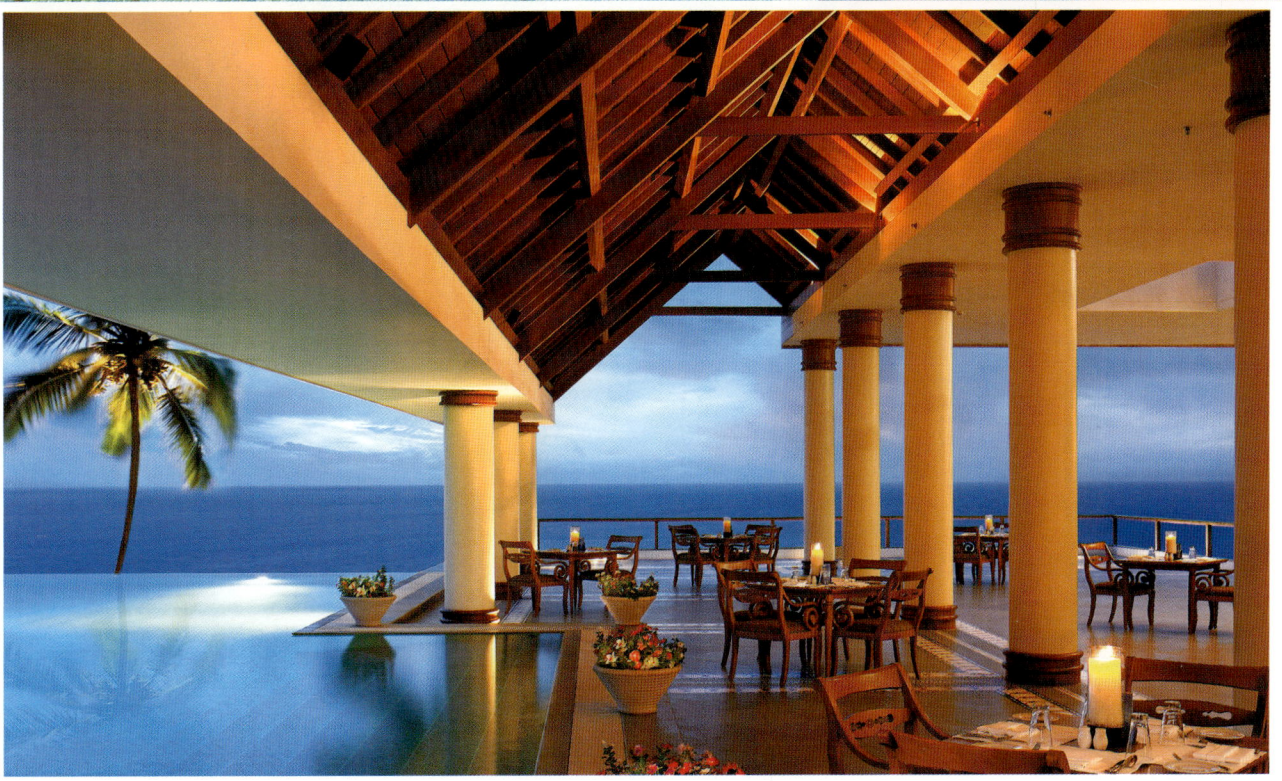

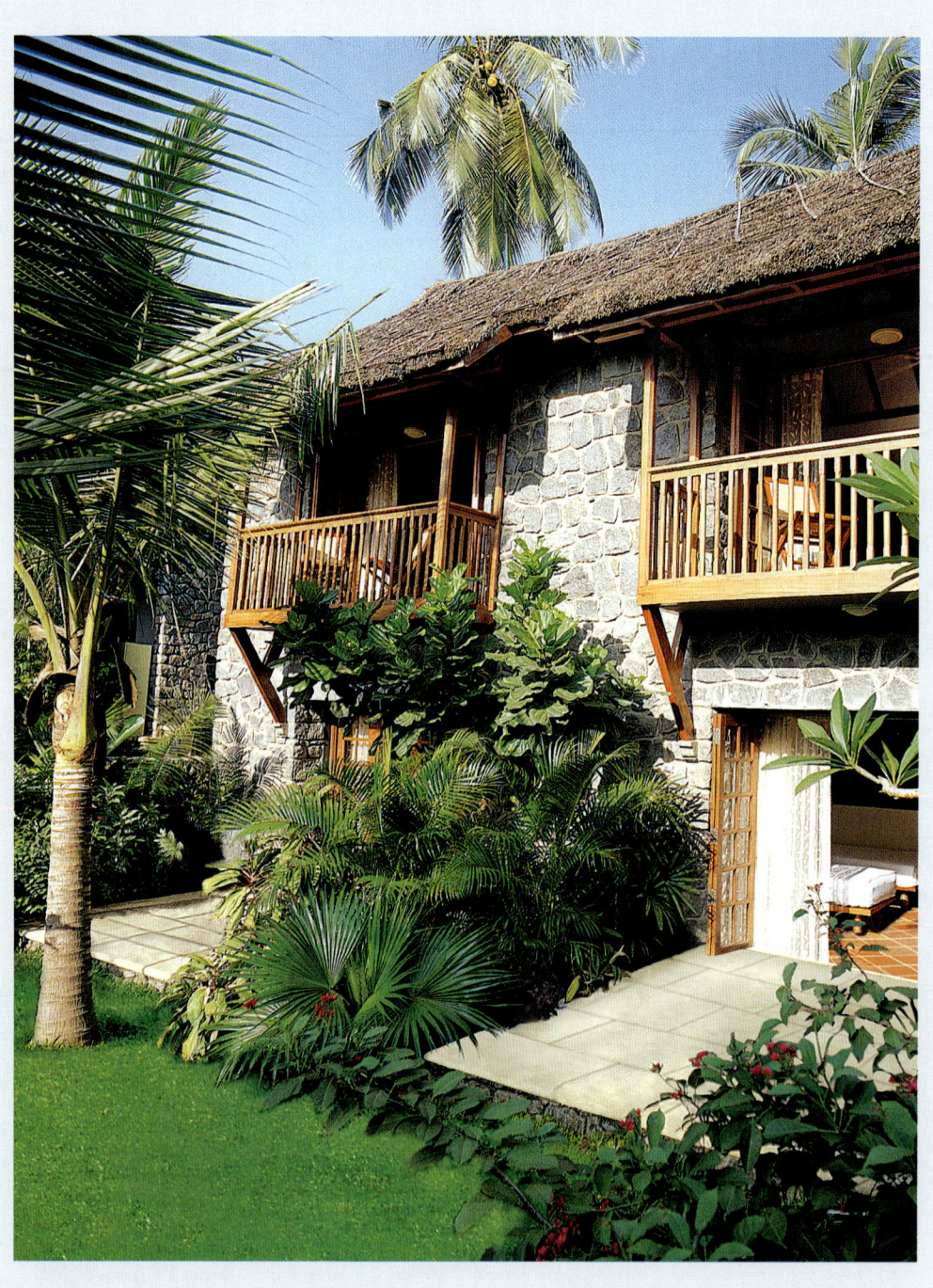

The Taj Green Cove Resort, Kovalam

a heady combination

The Taj Green Cove Resort and Spa at Kovalam is just what the doctor ordered for wearisome souls looking for that perfect moment of bliss and serenity...

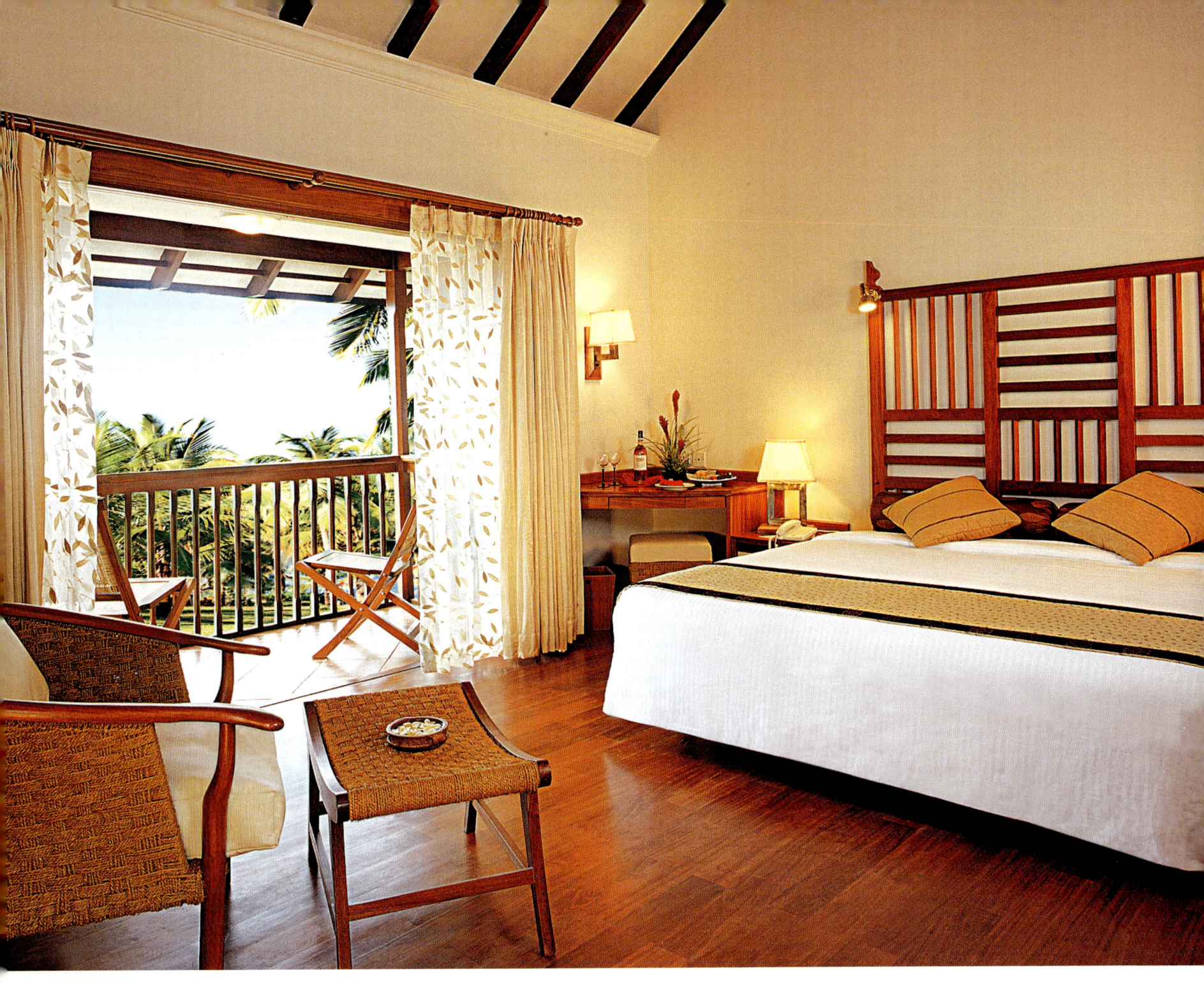

It is a unique combination of a beach resort, a backwater escape, a hill retreat and a spa. The Taj Green Cove Resort at Kovalam is an invitation to guests to savour the true essence of the scenic coastal state of Kerala.

A refreshing mix of style and spacious elegance, the guest rooms and suites at the resort offer peace and tranquility as well as the comforts of modern day living.
Page 78: With its exotic tropical beauty and relaxing hospitality, The Taj Green Cove Resort is the perfect place to rejuvenate your mind, body and soul.

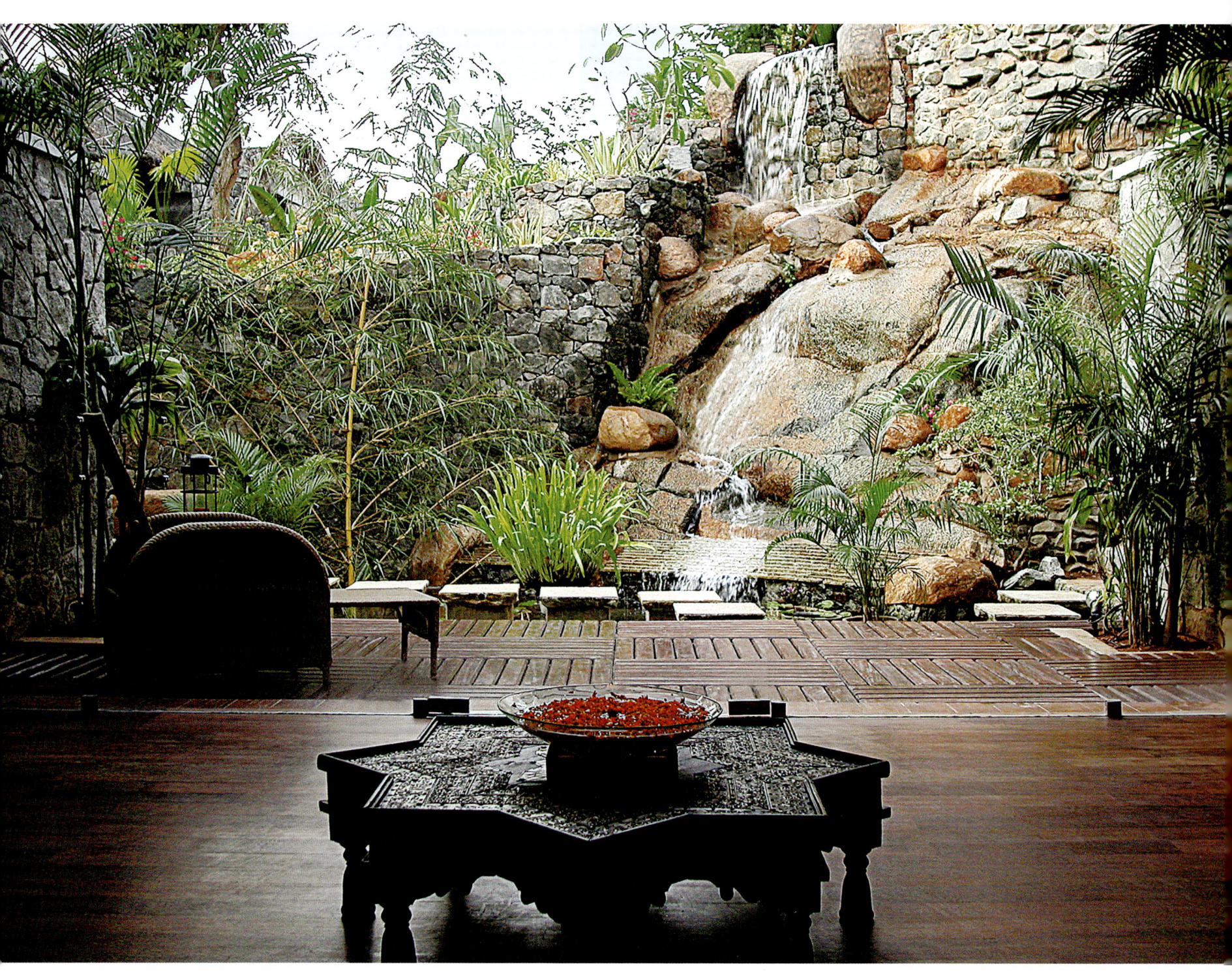

Unwind and take in the view at the relaxation lounge at the resort, overlooking a private waterfall garden courtyard.

Situated 16 kms south of Thiruvananthapuram, the resort offers breathtaking backwaters, lush landscapes, coconut palms and pristine beaches. It is located just 12 kms from the Thiruvananthapuram airport and 14 kms from the station. You can also approach it from Kochi, from where it is a picturesque five hour drive.

Located on one of India's most popular beaches, Kovalam, the property is spread across 10 acres of land, offering a spectacular view of unspoiled beaches. With its exotic tropical beauty and relaxing hospitality, this getaway is the perfect place to rejuvenate your mind, body, and soul.

With detailing in pristine white and earthy wood finishes that tender a soothing, calm ambience, the Jiva Spa at the resort is a treat for the senses. Unwind and take in the view at the relaxation lounge as it overlooks a private waterfall garden courtyard. You can even enjoy Yoga in the Yoga lounge or on the golden sands of the beach. The communal wet area encompasses a steam room, a hot and cold Jacuzzi open to the sky, with a panoramic view of the ocean.

Blending ancient Indian wisdom with contemporary therapies, the Jiva Spa unveils the best in Indian rejuvenation therapies ranging from Indian aromatherapy massages, time-honored Indian treatments, body scrubs and wraps, Yoga and meditation.

The living quarters at the resort include cottages and suites. A refreshing mix of style and spacious elegance, the guest rooms and suites offer peace and tranquility as well as the comforts of modern day living. The cottages are made from granite stone with elephant grass thatched rooftops and a private balcony. Large French windows offer a panoramic view of the sea.

Light, airy, and modern, each granite stone cottage at the resort offers natural details including wooden or tiled floors, high rafters, and Bisazza bathroom mosaics as well as modern amenities like a walk-in wardrobe, etc.

For those wanting to pamper themselves, there are suites with a sitting room as well as French windows opening to panoramic views of the sea with private balconies or garden sit-outs and an irresistible thrill – a private pool and sun deck.

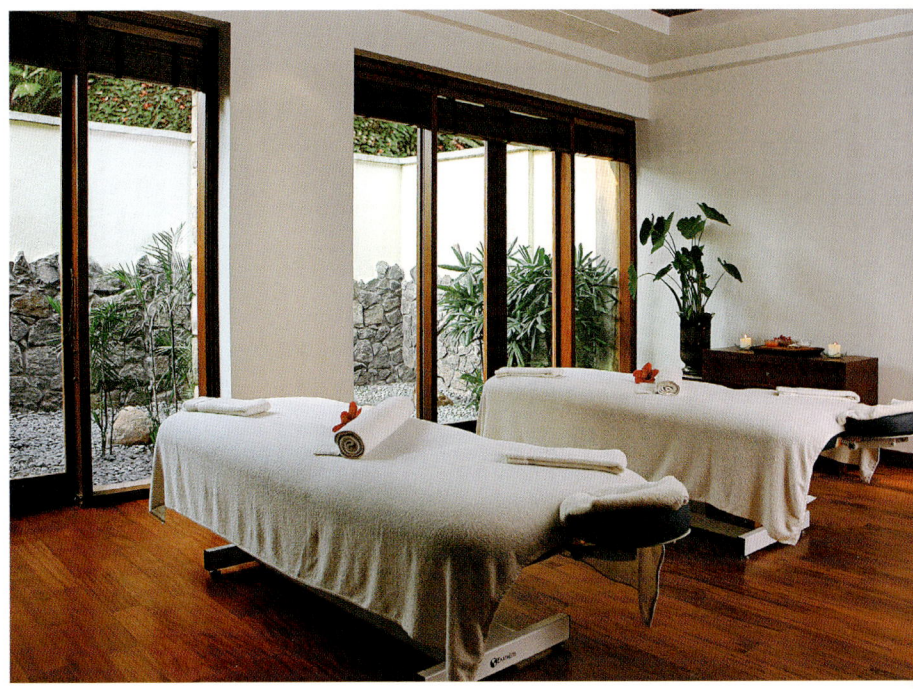

Top: At the chic and plush bar, Neera, you can indulge yourself in amazing cocktails to unwind. Bottom: The couple massage room at the Jiva Spa offers tranquil interiors.

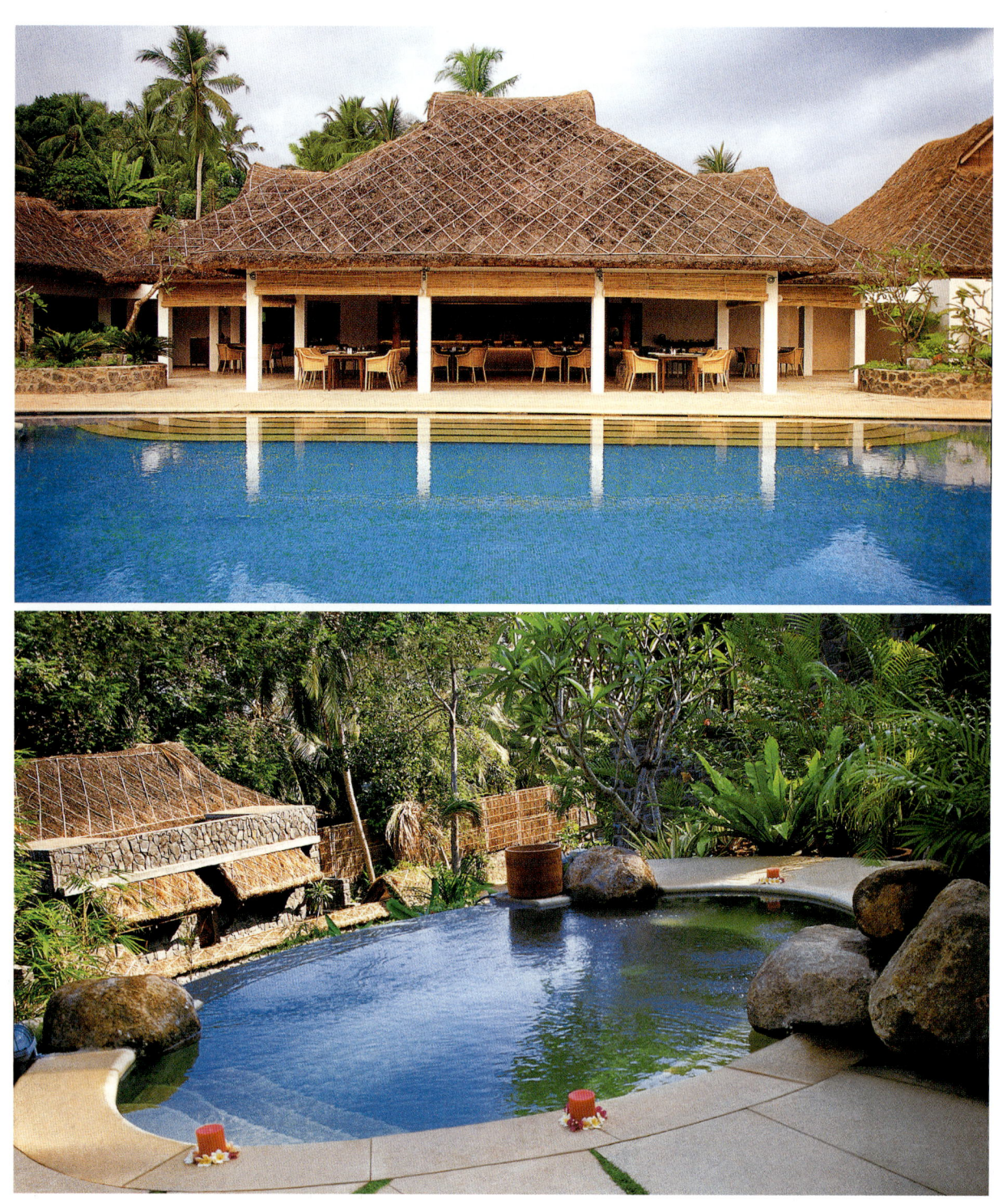

Different views of the swimming pool and other water bodies at the resort, imparting a calming feel to the guests.

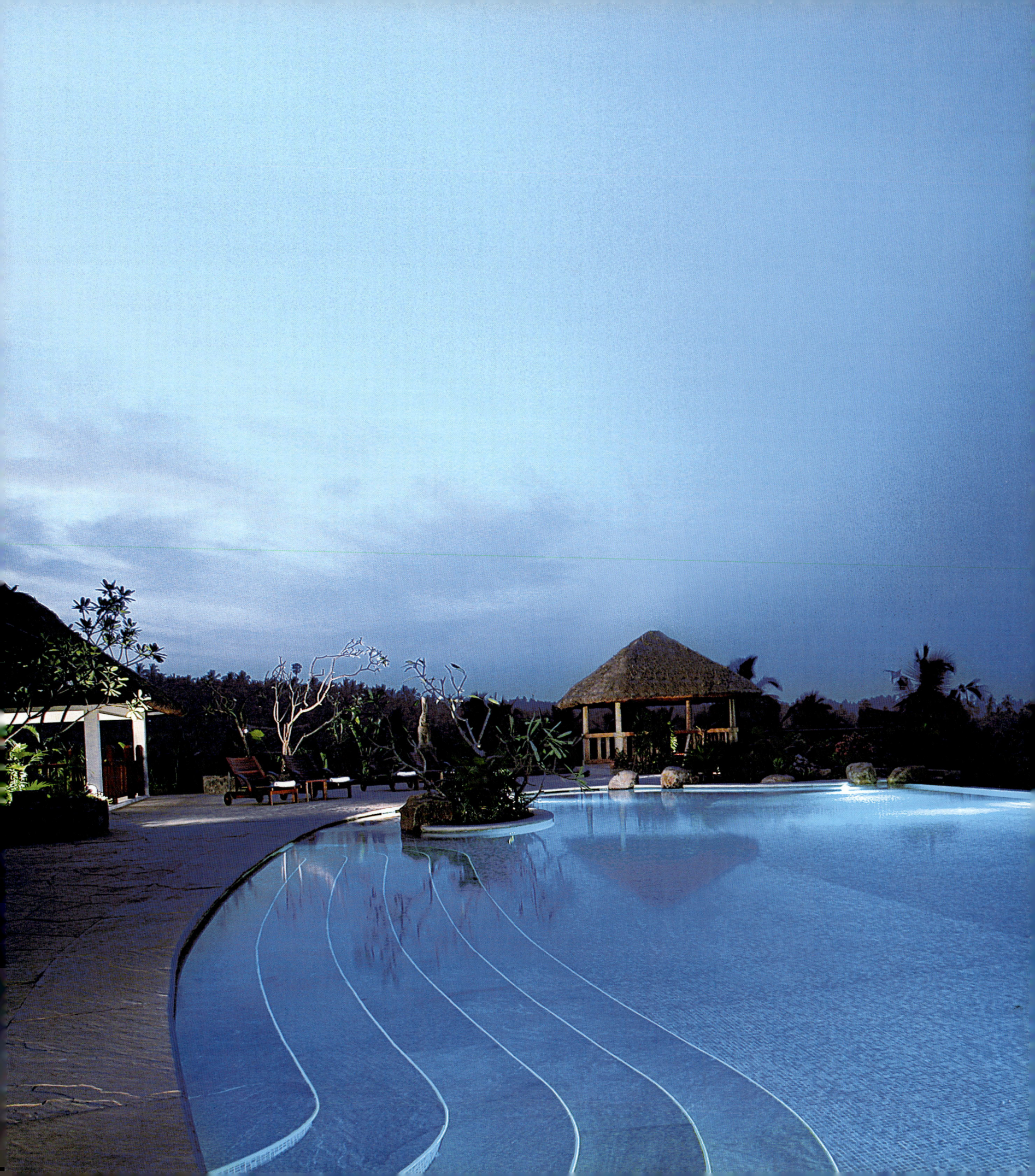

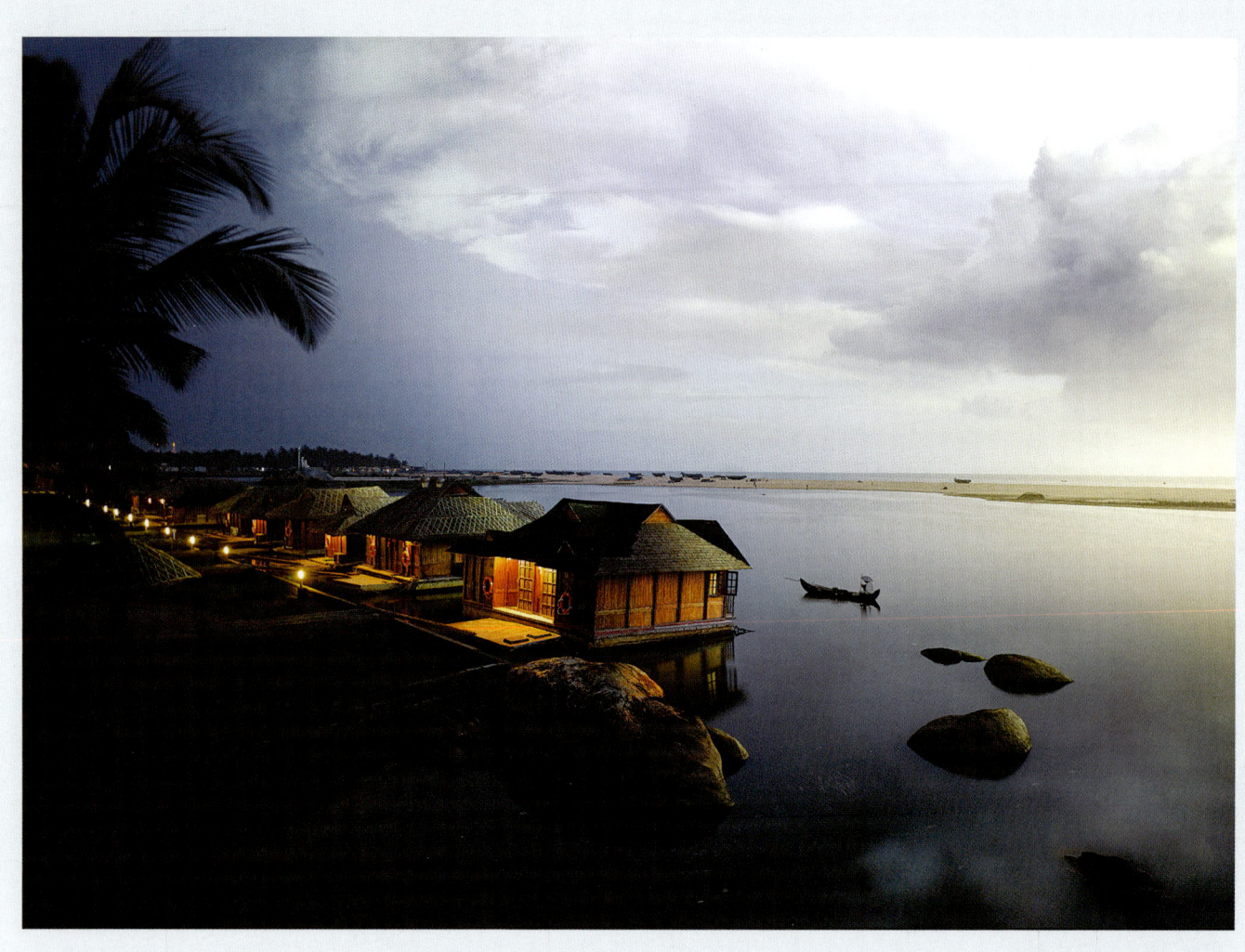

The Poovar Island Resort, Kerala

picture perfect

The Poovar Island Resort is a rare find of Kerala, unspoilt and miraculously unexplored...

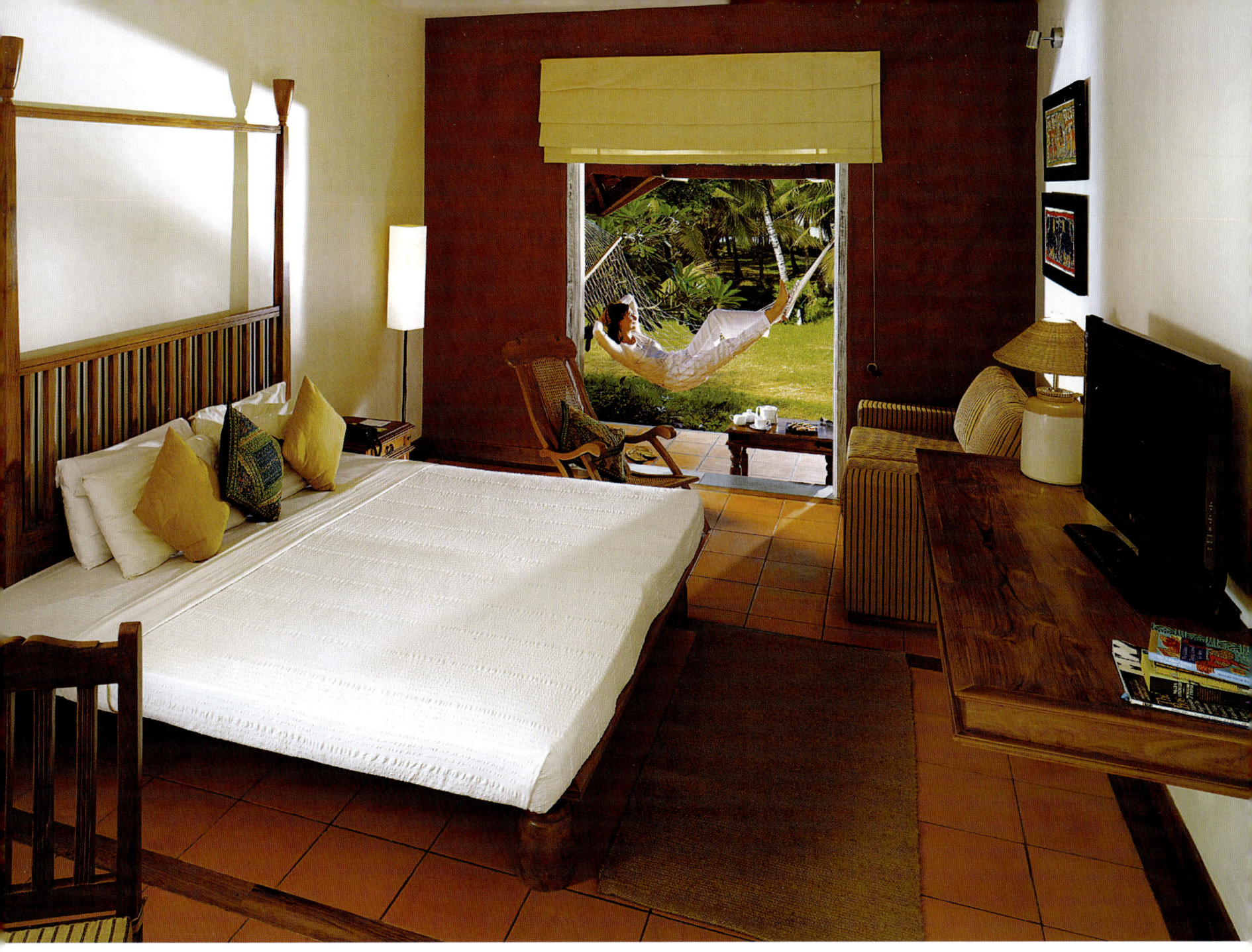

On the south-western coast of India, sandwiched between the Arabian Sea and the majestic mountains of the Western Ghats, lies a narrow strip of beautiful land. A bountiful land famed for its awe-inspiring natural beauty, called Kerala, 'God's Own Country'.

Apart from the backwaters and the lagoons, an unexplored part of the state – an island of almost indescribable beauty awaits

Earthy terracotta hues in this Land Cottage bedroom open out to green vistas beyond. **Page 86:** *The Resort's floating cottages are the ideal way to enjoy the beauty of Kerala.*

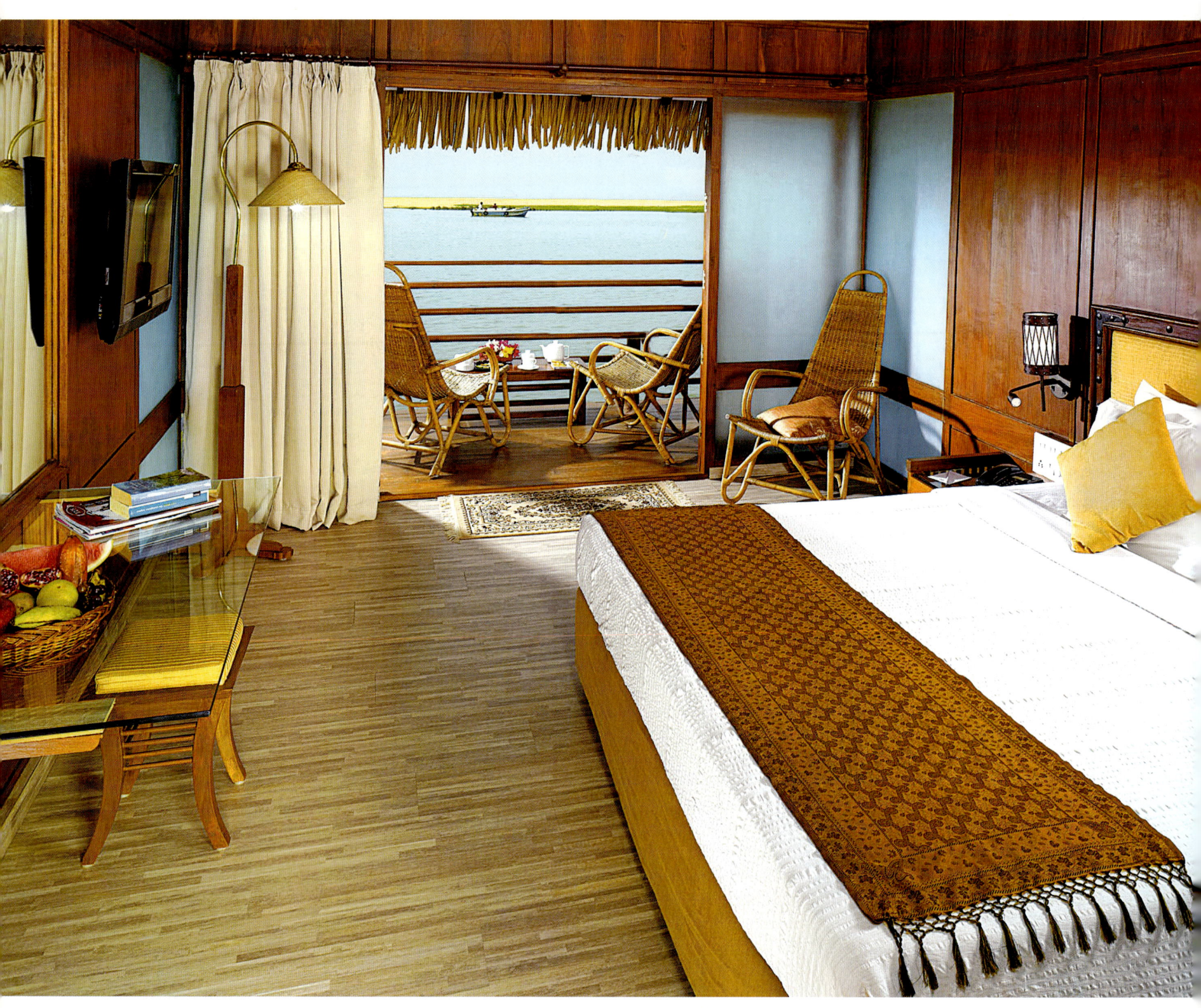

The most unique aspect of the resort is the 16 floating cottages that will make every visitor wonder with delight. The bedrooms with wood floors and walls, and a large private deck offer glorious views of the estuary and beach. The interiors colour scheme remains warm and earthy.

you, just 30 minutes from Thiruvananthapuram, the capital city of Kerala. It is a place where nature is at her enchanting best – picture-perfect. Swaying coconut palms, endless golden sands, deep-blue sea, emerald green backwaters, red-orange sunsets and verdant green vegetation – nature has used all the colours of her palette to create this dreamscape around the Poovar Island Resort.

Enveloped by the most serene backwaters and a dream golden beach, this island resort is truly a window into paradise. The resort offers you total privacy on this naturally secluded land.

The Poovar Island Resort features a variety of unique habitats. A total of 78 cottages including Floating Cottages, Land Cottages, Premium Land Cottages & Ayurveda Land Cottages set in spacious 22 acres; they are built in typical Kerala architecture, spread across the island fringed with coconut groves and offer you a traditional ambience combined with state-of-the-art facilities. With vast and cosy interiors styled with typical Kerala furniture, the ground floor rooms even have a large private veranda facing the coconut groves.

The most unique aspect of the resort is the sixteen floating cottages that will make every visitor wonder with delight. These well-appointed cottages are living rooms with all the amenities coupled with its real floating pleasure. The bedrooms with one entire wall in glass and a large private deck, offer glorious views of the estuary and beach. You can even view people moving on country boats up, close and personal. Needless to say, the floating cottages are furnished in style with warm wood finishes, ethnic colour tones, and yet modern and soothing to maximise your enjoyment.

The resort has two specially designed eco-friendly floating cottages which provide you with health benefits. This unique habitat is built of environment-friendly materials like wood from the coconut palms and 'Ramaccham' (famed for its medicinal properties) and roof made of thatched coconut leaf.

At The Poovar Island Resort, the culinary treats conjured up by master chefs evoke passion. Every meal is a feast fit for the gods. The multi-cuisine restaurant 'Tiffins' offers a delectable choice of Continental, Asian, Indian and Kerala cuisine to choose from. For a quiet romantic dinner, there is 'The Fish Market', the specialty seafood floating restaurant famous for its delectable cuisine. The restaurant has been built on wood and tied to the shore with the help of thick ropes and wooden planks. It is open for dinners only

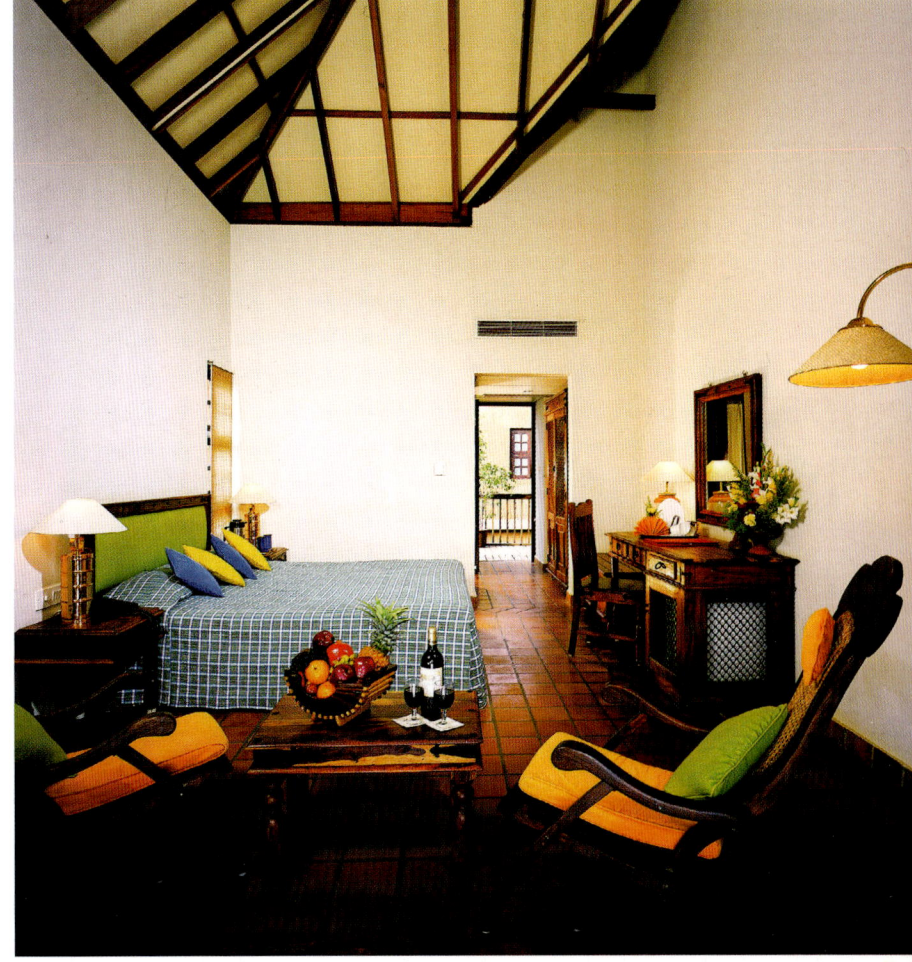

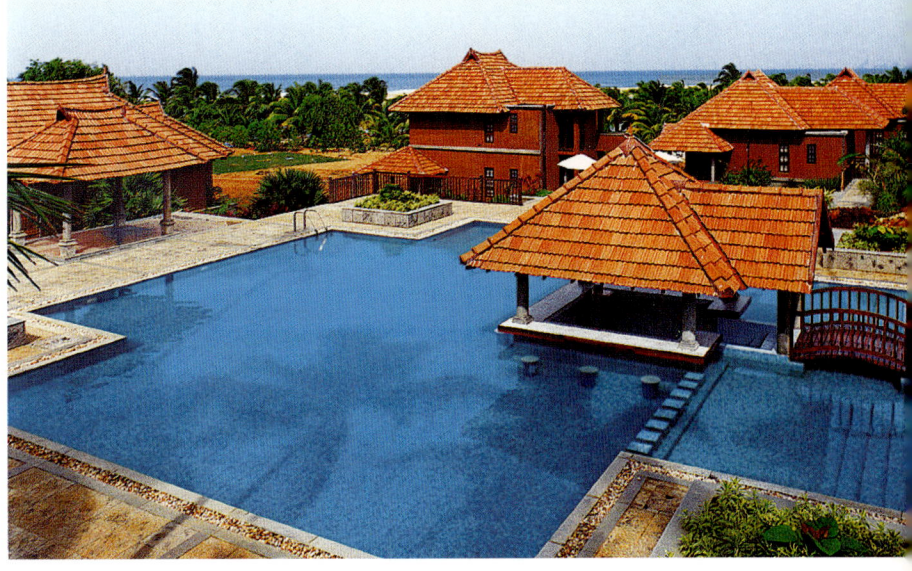

*Top: Another view of the well-appointed and plush guest rooms at The Poovar Island Resort. The slanting ceiling is the focal point of the room. **Bottom**: The resort also has a special sunken pool bar (see in the centre) at the swimming pool. You can enjoy your favourite drink, beverage or fruit juice with your swim.*

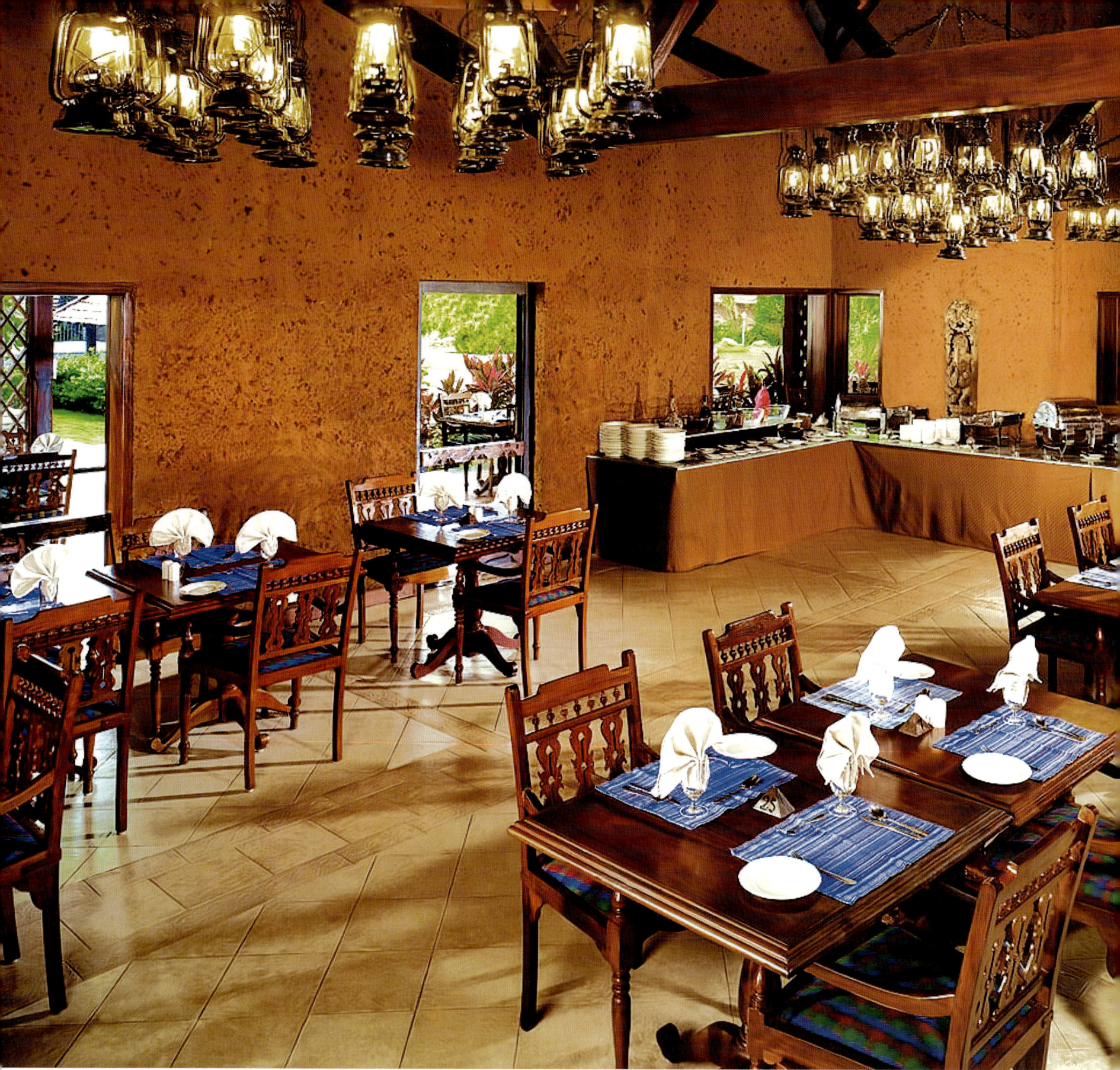

Warm hues, bright colour linen, and lantern lights make this an enchanting dining setting.

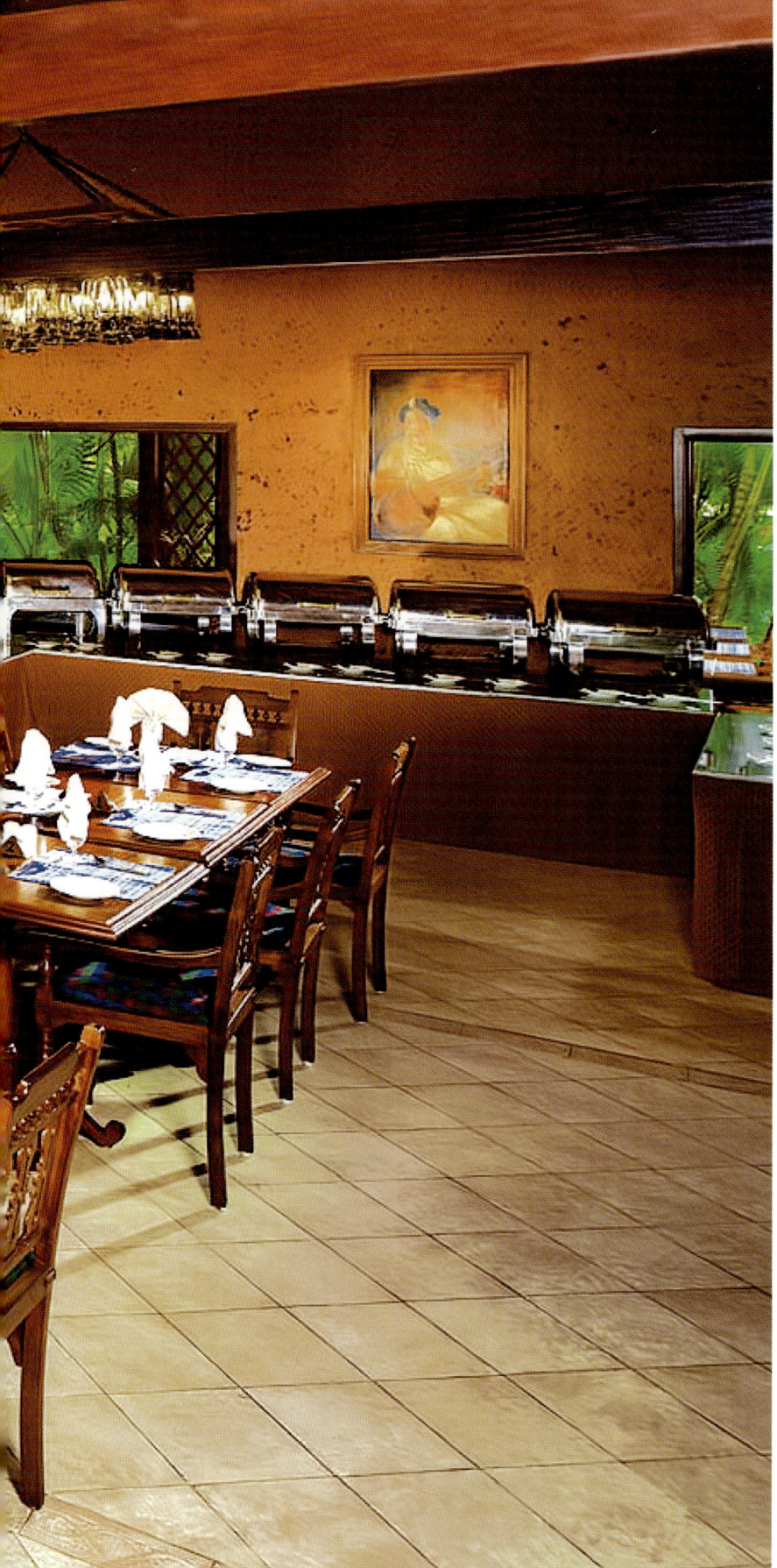

and serves a wide variety of sea-food specialties in traditional Kerala-style preparation or in the Continental style.

The resort also has a special sunken pool bar at the swimming pool. You can enjoy your favourite drink, beverage or fruit juice with your swim. The Kids Pool, alongside the main swimming pool is a sure dive for water fun. The extensive green landscape, dotted with palm trees, offers avenues for private enjoyments outside the cottages.

The resort also gives you the perfect ambience to enjoy, understand and absorb the ancient remedies of Ayurveda. An exclusive Ayurveda treatment and rejuvenation centre, 'Ayurveda Village' is one of the few places where this 6,000 year old ancient healthcare system is still practiced in its purest form. A thoughtfully crafted package of therapies designed to relax, refresh and rejuvenate you.

Of note is the Rasayana Chikitsa (Rejuvenation Therapy). The underlying theory behind this treatment is to reverse the degenerative processes happening in the body. This is achieved by bringing about a balance of the body, mind and soul through rejuvenating the functional systems of the body.

The Panchakarma Sodhana Chikitsa (Body Purification Programme) helps in purifying the whole body to attain the *dosha* equilibrium as well as in helping reinforcing the body's immunity system. Kayakalpa Chikitsa (Body Immunization Therapy) is an optimum combination of the purification and rejuvenation programme.

Mana Swastha Chikitsa (Stress Management Therapy) helps you to manage and reduce the effects of stress, depression and melancholy. It also has specialized programmes to treat various psychosomatic disorders. Medodhara Chikitsa (Weight Loss Programme) consists of a restructuring of diet, and a combination of massages and oral medications.

Ayurveda is probably the only science that has an answer to the problem of degenerative joints. At Poovar, there is a special programme to help reduce and retard the effects of this disease, especially for the spine and neck region.

When inside the resort, the best pastime is water sports. The resort has facilities like indoor games, cookery classes and outdoor barbeque. However, if you have time to spare, then you can go for a day-long sightseeing trip to Thiruvananthapuram. Visits to local villages, fishing places, boating on country boats or motor boats around the Poovar River and sunset cruises will leave an indelible memory of your sojourn.

The Poovar Island Resort gives you an opportunity to explore and revel in nature's unexplored bounties.

Small water bodies full of plants offer a feeling of solace in the Ayurveda treatment room in the Ayurveda Village at the resort.

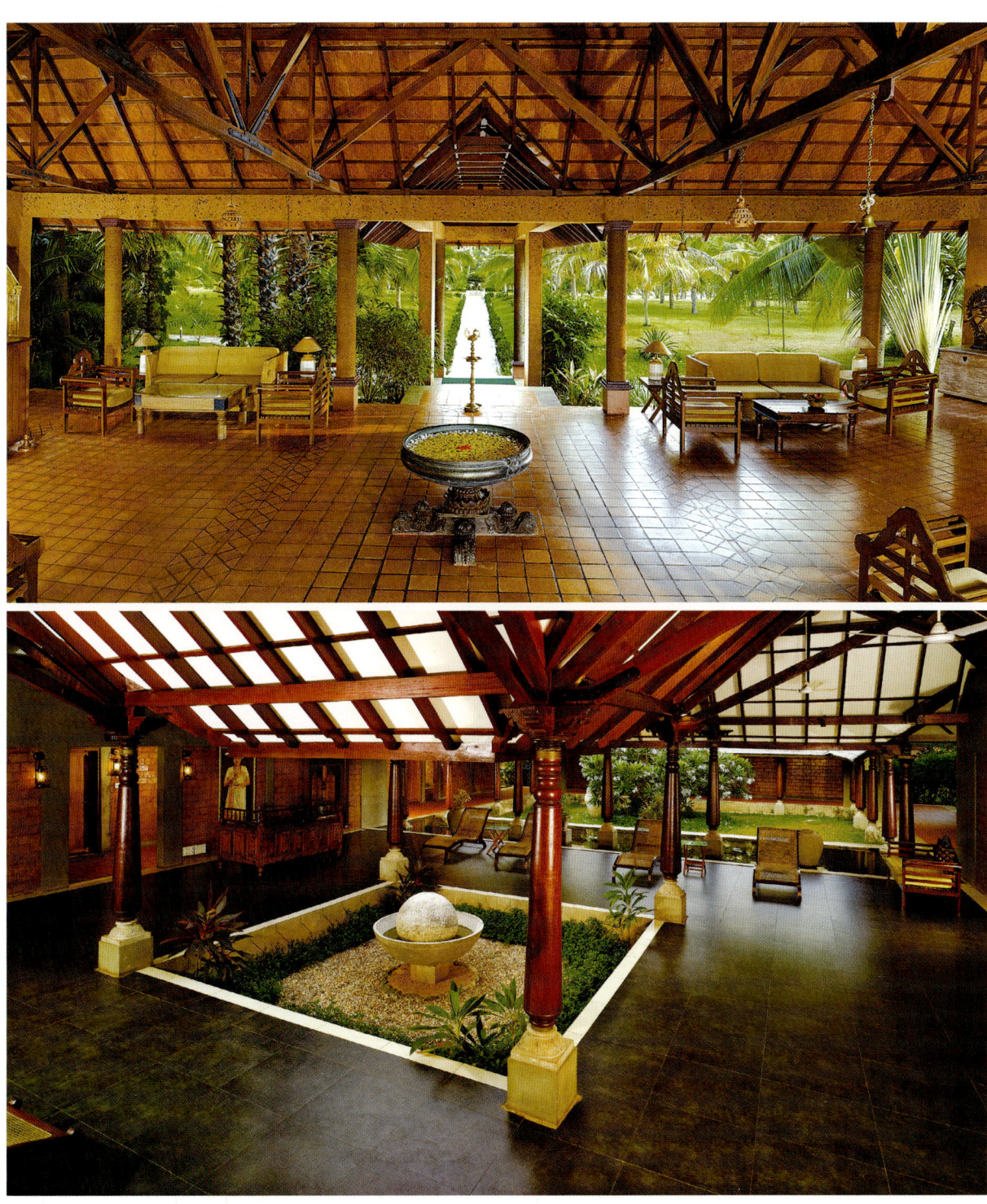

A view (top) of the Resort's lobby and (bottom) the lobby of the Ayurveda treatment centre.

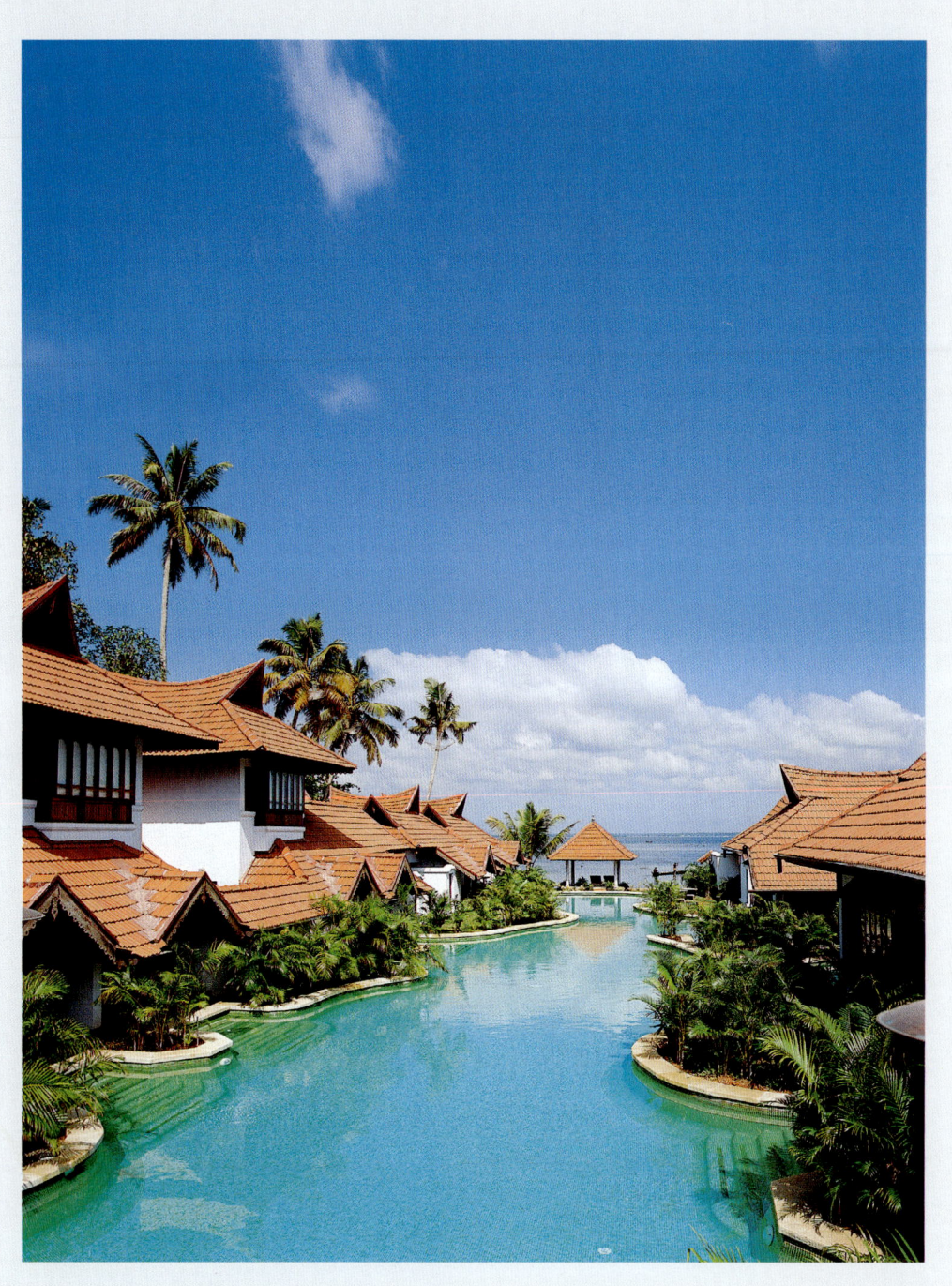

The Kumarakom Lake Resort, Kerala

the place for a holiday pamper

The Kumarakom Lake Resort in Kerala attempts to create a perfect union between heritage, luxury and natural beauty...

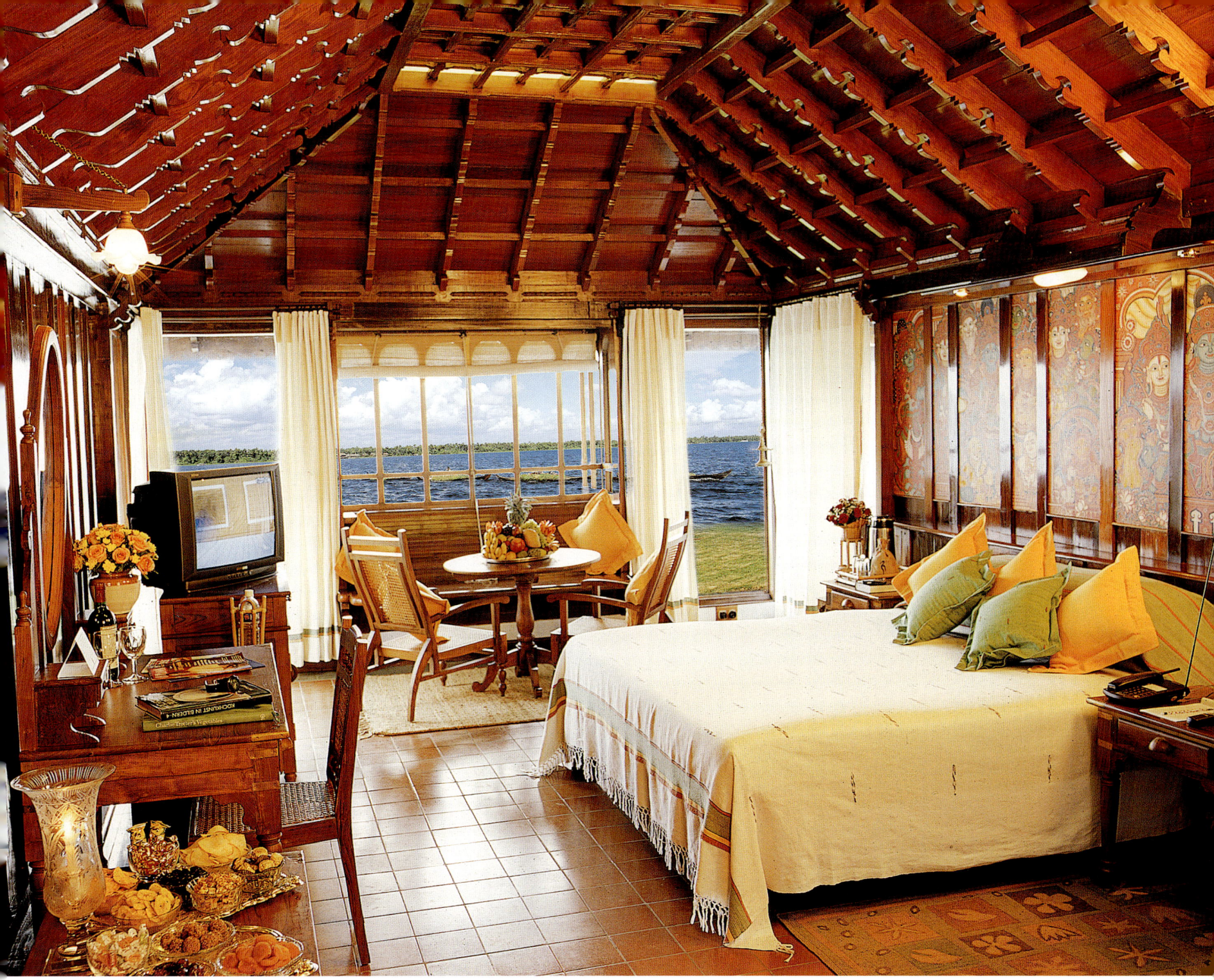

*I*magine spending your vacation in a pool villa with its own private alcove as well as an entry into the pool. And when you go for a swim, you can see the blue waters of the lake beyond, which is surrounded by lush greenery. No, this is not Utopia. This soul-stirring ambience is definitely a reality, called Kumarakom.

This is true Paradise! Your plush and comfortable room overlooks a magnificently landscaped garden and the blue waters of the Kumarakom Lake beyond.
Page 96: Of note at The Kumarakom Lake Resort are 26 enchanting pool villas bordering the immense meandering pool, each with its own private alcove and immediate entry into the pool

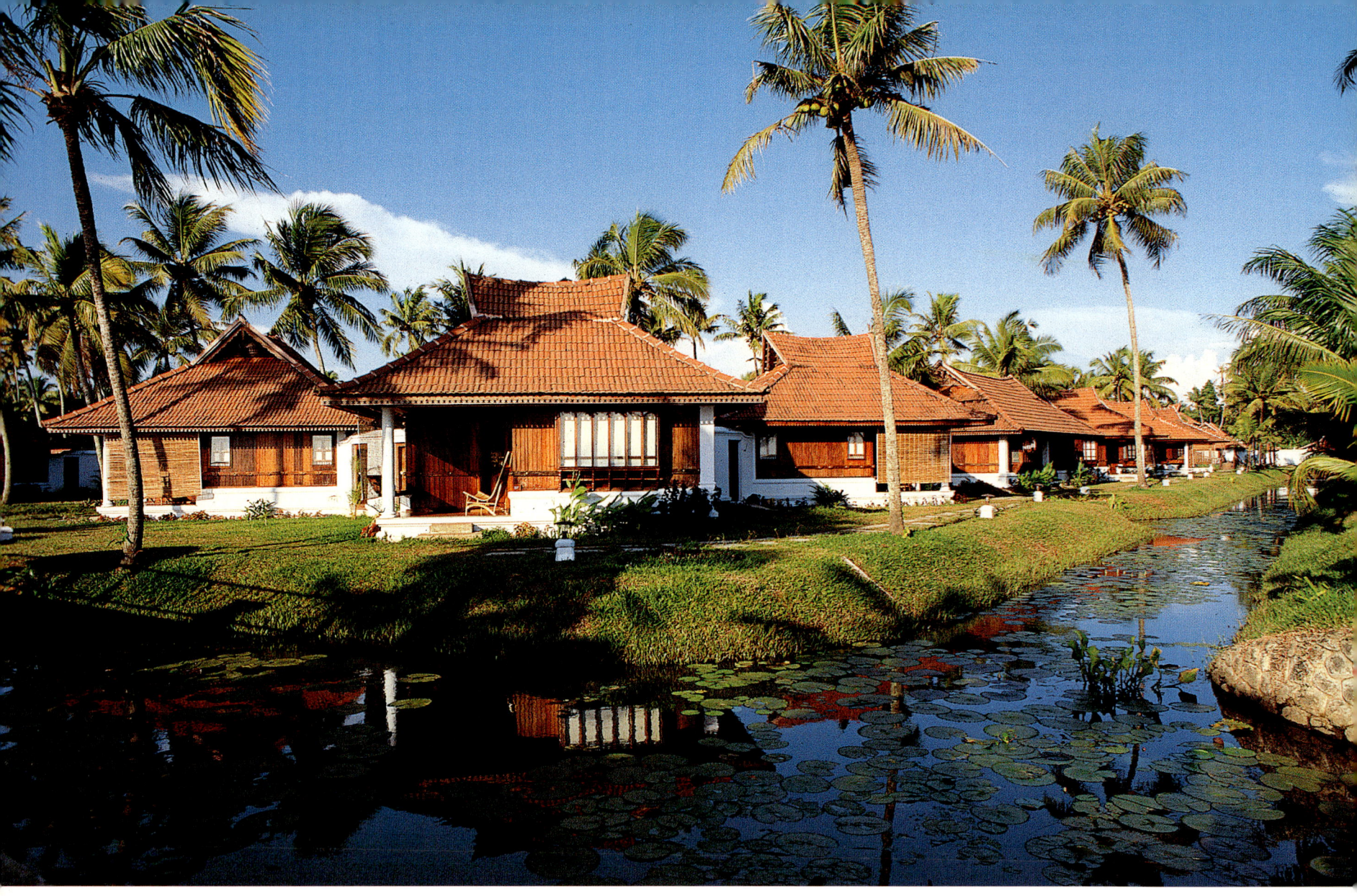

One of the most enchanting villages of God's Own Country (Kerala), Kumarakom is situated on the banks of the Vembanad Lake. The beautiful hamlet is a pleasing world, wrapped in a quaint charm of its own with soothing backwaters, thick mangrove forests, green paddy fields and ripe coconut groves as its accessories.

You can easily access it by flying down to Kochi and taking a drive along the 72 kms long road through the lush green countryside of Kerala. The best and the most ideal place of accommodation in the town is the Kumarakom Lake Resort.

Set amidst a sprawling 25 acres of lush greenery, the lake resort (which is a Paul John enterprise) literally lives up to the name of the state it is situated in. Exuding the charm of Kerala's true heritage, the villas and suites of the resort are a careful reconstruction of manas, the 16th century traditional homesteads of God's Own Country. Most of them have been transplanted from their original locations across the state and reassembled painstakingly by hand – plank by plank, tile by tile.

A premium heritage retreat aesthetically developed on the serene banks of the Vembanad Lake in the tiny hamlet of Kumarakom, the resort caters primarily to the world's most discerning travellers and attempts to create a perfect union between heritage, luxury and natural beauty. A member of the elite Small Luxury Hotels of the World, Kumarakom Lake Resort has been hailed as 'the place for a holiday pamper'. It was also recently given the World Travel Award as India's leading resort for the year 2006-07 and then again in 2007-08. Apart from this laurel,

Exuding the charm of Kerala's true heritage, the villas and suites of the resort are a careful reconstruction of manas, the 16th century traditional homesteads of God's Own Country. Most of them have been transplanted from their original locations across the state and reassembled painstakingly by hand – plank by plank, tile by tile.

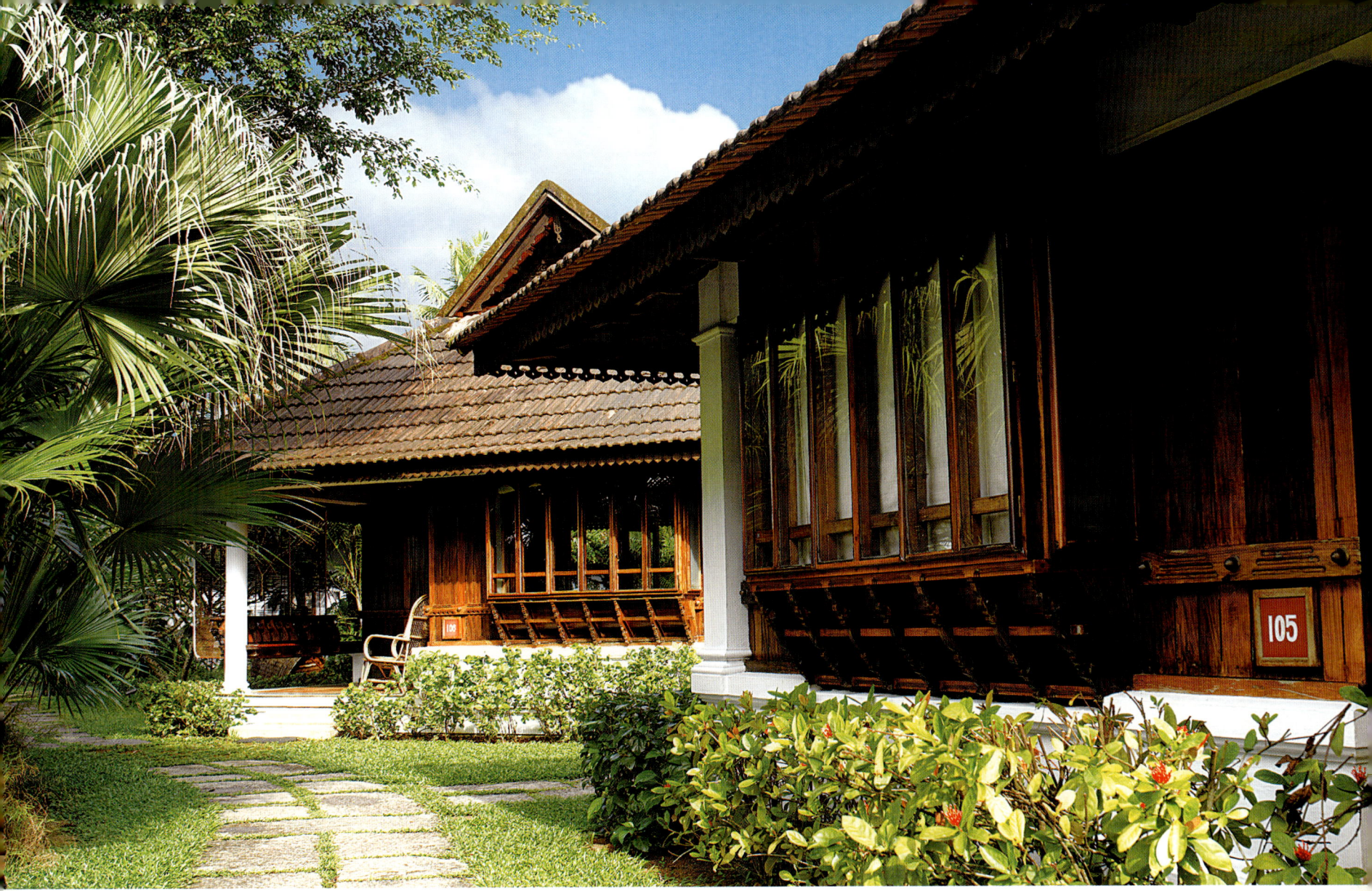

it has also received the Asian Architectural Award.

Bestowed with heritage status, Kumarakom Lake Resort is the "creative culmination of scores of traditional mansions, each over a 100-year-old, purchased from all over Kerala, dismantled from their original locations and reassembled at the resort, to create its 50-odd heritage luxury villas." Almost every wall, every door, every window, every lattice of each structure at Kumarakom has been re-created from these ancestral homes.

Apart from the natural cum man-made wonder that it is, at Kumarakom Lake Resort, you can even unwind at its special Ayurveda spa, the Ayurmana. It even has a self-contained wing that caters to your total rejuvenation and therapy needs, in the ambience of an authentic, age-old Tharavad style.

For the uninitiated, 'Tharavad' is the name given to the original home of a family in 16th century Kerala. 'Nalukettu' means a house with one inner courtyard. 'Ettukettu' would have two such courtyards, and 'Pathinarukettu', four. Important families with a certain social standing were allowed to construct up to 'ettukettu'. Only members of the royal families could have 'pathinarukettu'.

However, what will catch your attention instantly at the resort are 22 plush heritage villas that take in the breathtaking view of the luminous lake. Also of note is the magnificently landscaped garden as well as 26 enchanting pool villas, including duplex villas bordering the immense meandering pool, each with its own private alcove and immediate entry into the pool. The two presidential suites epitomize pure luxury, each in its own royal seclusion, with

A closer look at the villas will tell you how almost every wall, every door, every window, every lattice of each structure at Kumarakom has been re-created from these ancestral homes.

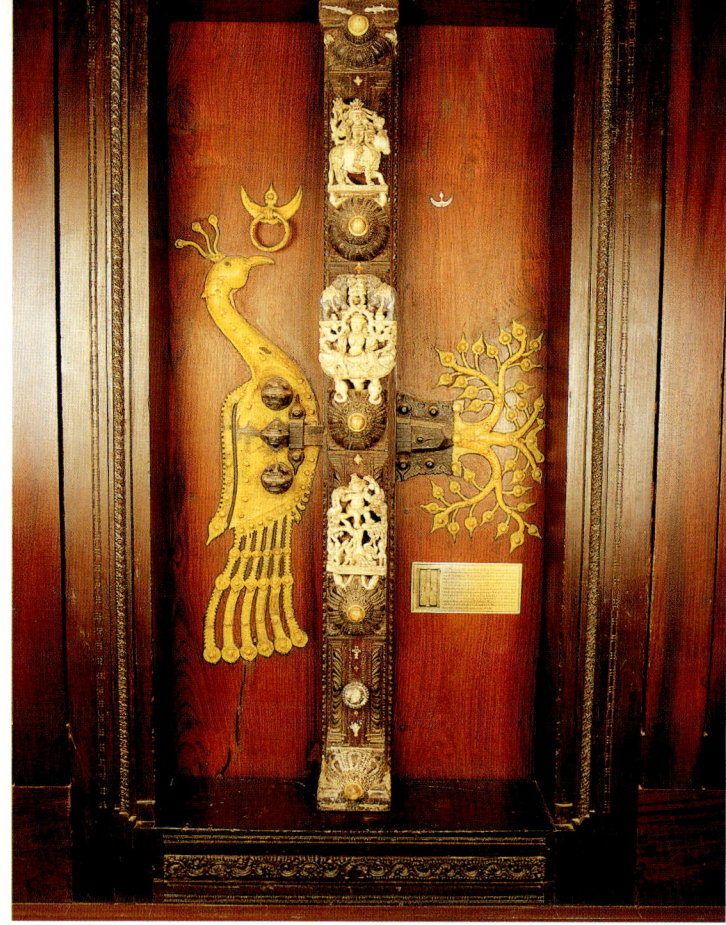

its own pool and very own view of the lake. Each villa owns open-roofed bathrooms and bespeaks of ultimate modern luxury and absolute comfort in the colourful abode of nature.

In its constant efforts to exceed expectations, Kumarakom Lake Resort has recently renovated few of its heritage villas and thus launched its latest category of Heritage Villas with private pools. Offering exotic and exclusive indulgences, each plush villa built in the style of the traditional homestead of Kerala, has its own private courtyard with a private pool and Jacuzzi, ensuring the creation of fabulous memories.

The dining facilities at the resort include the main restaurant of Kumarakom Lake Resort, the Ettukettu. Formerly the home of the King's martial arts guru and built under the commission of the King Marthanda Varma himself, the impressive abode is a fine example of the palatial eight-sided ettukettus unique to Kerala, and had been dismantled from its original location and reassembled in all its glory at the resort.

Today, under the aegis of a fine team of chefs, it serves delicious multi-cuisine fare, while the Vembanad seafood restaurant and bar banks on the wonders of each glorious sunset while catering to gourmet fantasies.

In an environment that clears the mind and lifts the spirit, Kumarakom Lake Resort provides comprehensive personal and business services with a well-facilitated Conference Hall furbished with state-of-the-art communications systems and presentation facilities.

The best part of the resort, however, is the Ayurveda wellness spa, Ayurmana. Housed in a 200-year-old mansion, incidentally, that of the Chathamangalathu Mana, a family of famed practitioners of this ancient healing science, Ayurmana is overseen by two of Kerala's finest Ayurvedic doctors and their team of skilled masseurs.

Some of the signature treatments at the Kumarakom Lake Resort include Andaja Kizhi in which powders of medicinal herbs are prepared, tied in cotton bags and gently heated in medicated oil. This is then applied over the body in rhythmic massage and is effective in muscle wasting paralysis and rheumatic complaints.

In Karpasa Kizhi, boluses is prepared with the seed of karpasam and coconut and then applied to the whole body after

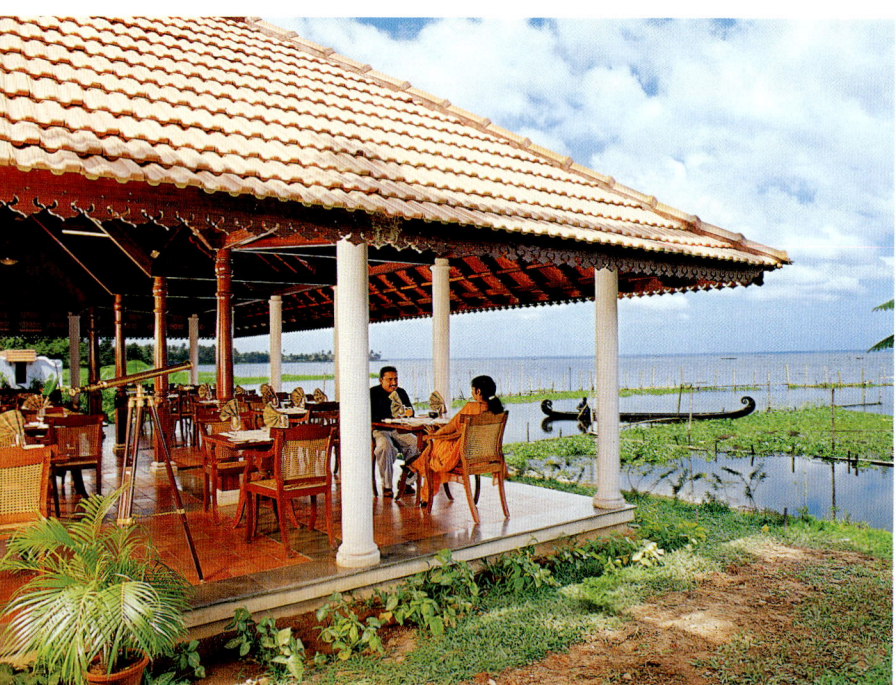

Top: A door at the resort is the creative culmination of scores of traditional mansions, each over a 100-year-old, purchased from all over Kerala, dismantled from their original locations and reassembled at the resort, to create its 50-odd heritage luxury villas. *Bottom:* The dining facilities at the resort include the seafood speciality restaurant and bar called the Vembanad, where you can partake sumptuous food next to the famed backwaters.

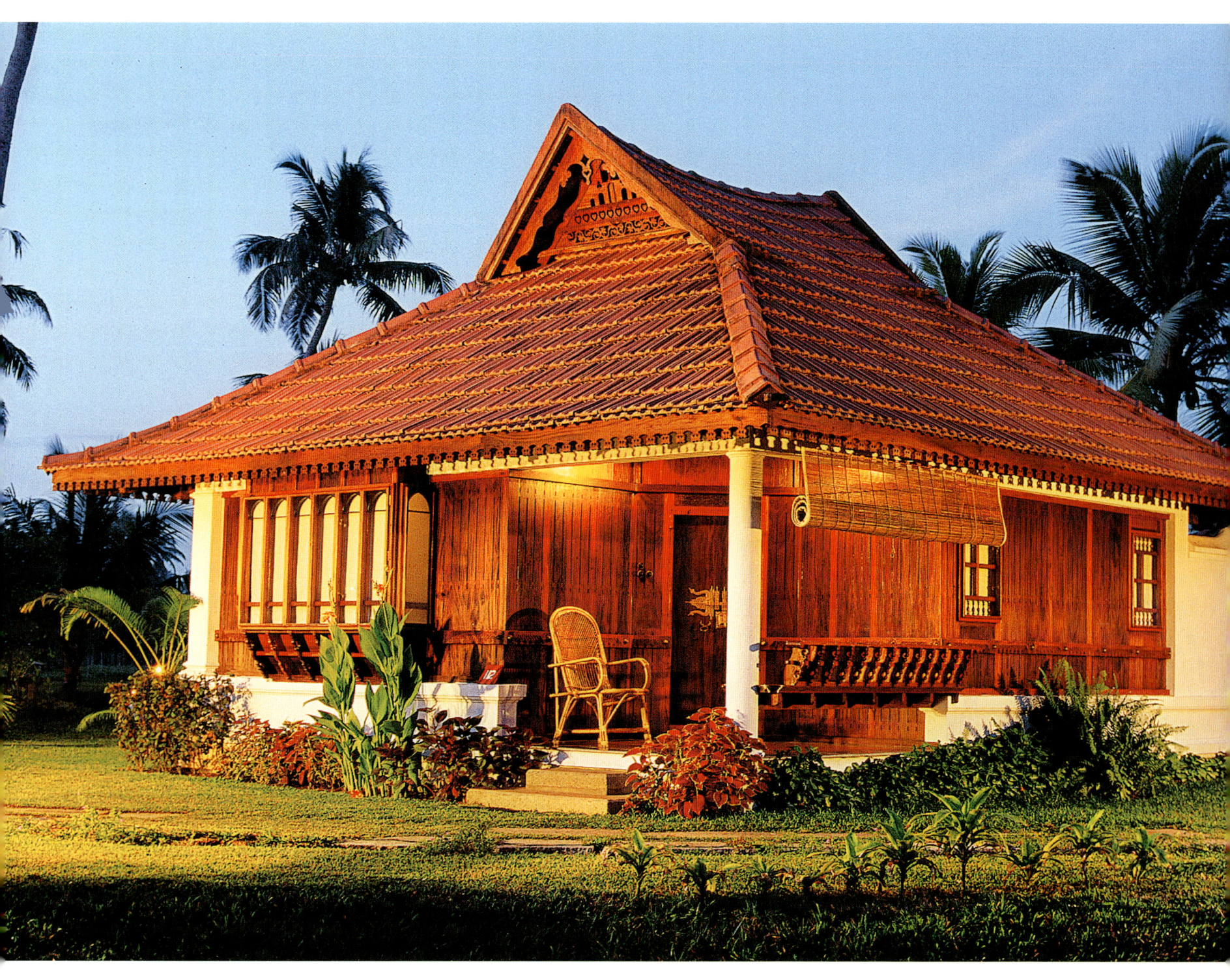

The villas look exotic during sunset, inviting you to be a part of this 'natural' experience in God's Own Country.

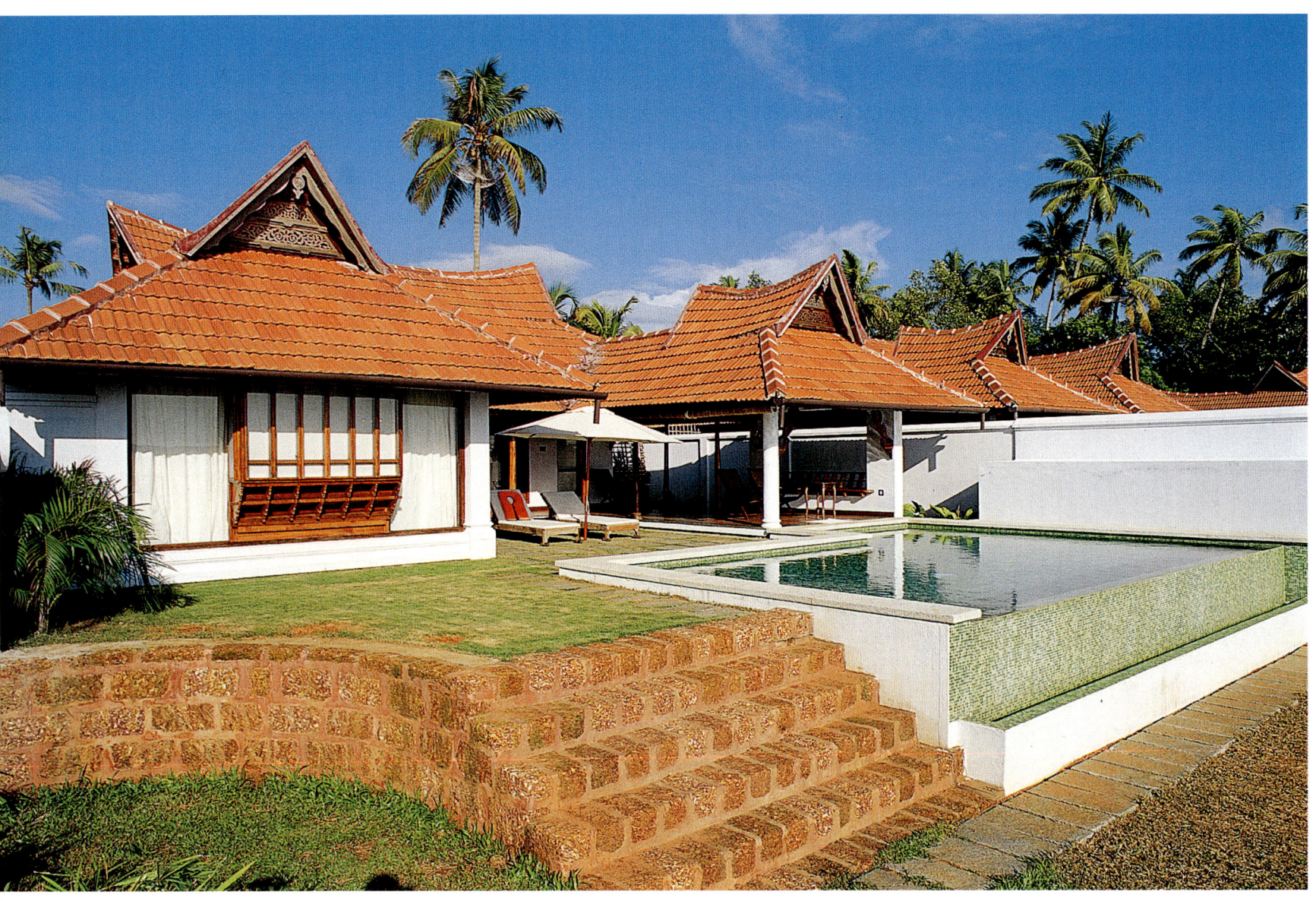

warming in hot medicated oil. This treatment is effective in arthritis, spinal disorders, muscle wasting, etc.

Kana Kizhi is useful for numbness, pain, etc., while in Patra podala swedam leaves and powders of medicinal herbs are fried in medicated oil and applied over the body to cure arthritis, spondylitis, inflammatory conditions, etc.

Pizhichil is a highly rejuvenative treatment useful in nervous break down and as a treatment for paralytic, rheumatic, diabetic patients, etc. Njavara Kizhi involves a massage combined with the application of extracts of a glutinous rice (Njavarai) or broken wheat and milk. It is useful for problems like muscle wasting and weakness of body.

Pichu includes sponging the body with cotton sponges dipped in medicated oils to cure paralysis, rheumatism, and nervous breakdown, etc.

One can achieve inner peace and harmony with nature at Kumarakom through a revitalising Yoga session. You can get to know your inner self at Kumarakom by discovering harmony with

The two presidential suites epitomize pure luxury, each in its own royal seclusion, with its own pool and very own view of the lake.

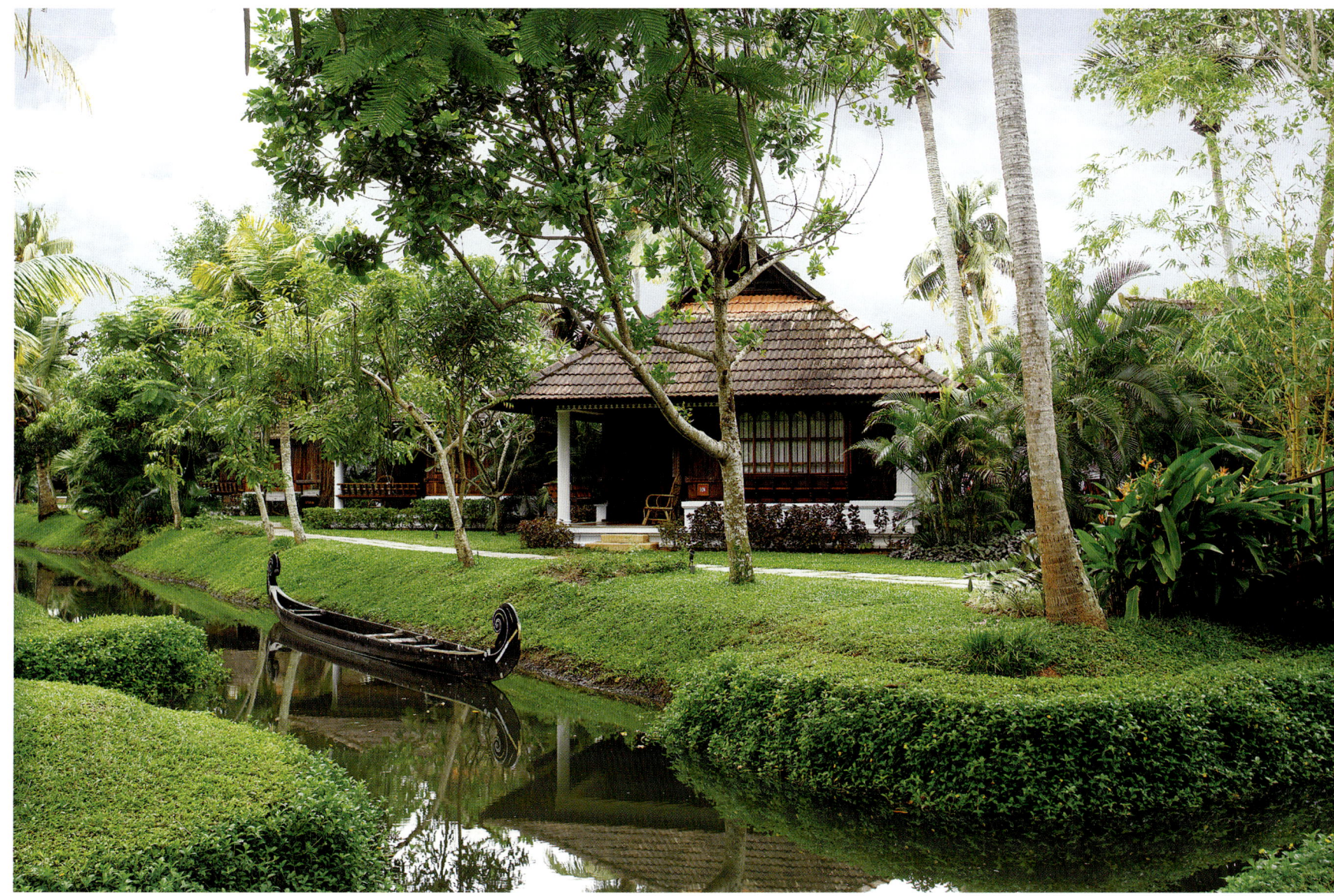

nature by doing Yoga. The *asanas* or postures in Yoga are meant to isolate the ego from the body and mind, and are designed to sharpen your concentration, improve your health and assist you in attaining peace of mind.

After a soothing Ayurvedic treatment, you can spend time at the resort by taking a backwater or a sunset cruise, taking part in indoor games like card playing, etc. or enjoying water sports including water skiing, speedboat and banana boat rides, etc.

Outside the resort you can take a short boat ride to the Kumarakom Bird Sanctuary, home to the Cormorants, Egrets, Darters, Herons, Teals, etc. and migratory birds like the Siberian Storks. You can even go for a sight-seeing trip (either on cycle or foot) to the quaint town of Kumarakom and attend a show of Kerala's traditional dance drama, the Kathakali.

Kumarakom Lake Resort provides a much needed break to pamper oneself.

The back garden of the villas overlooks a small canal and lush greenery that will simply take your breath away.

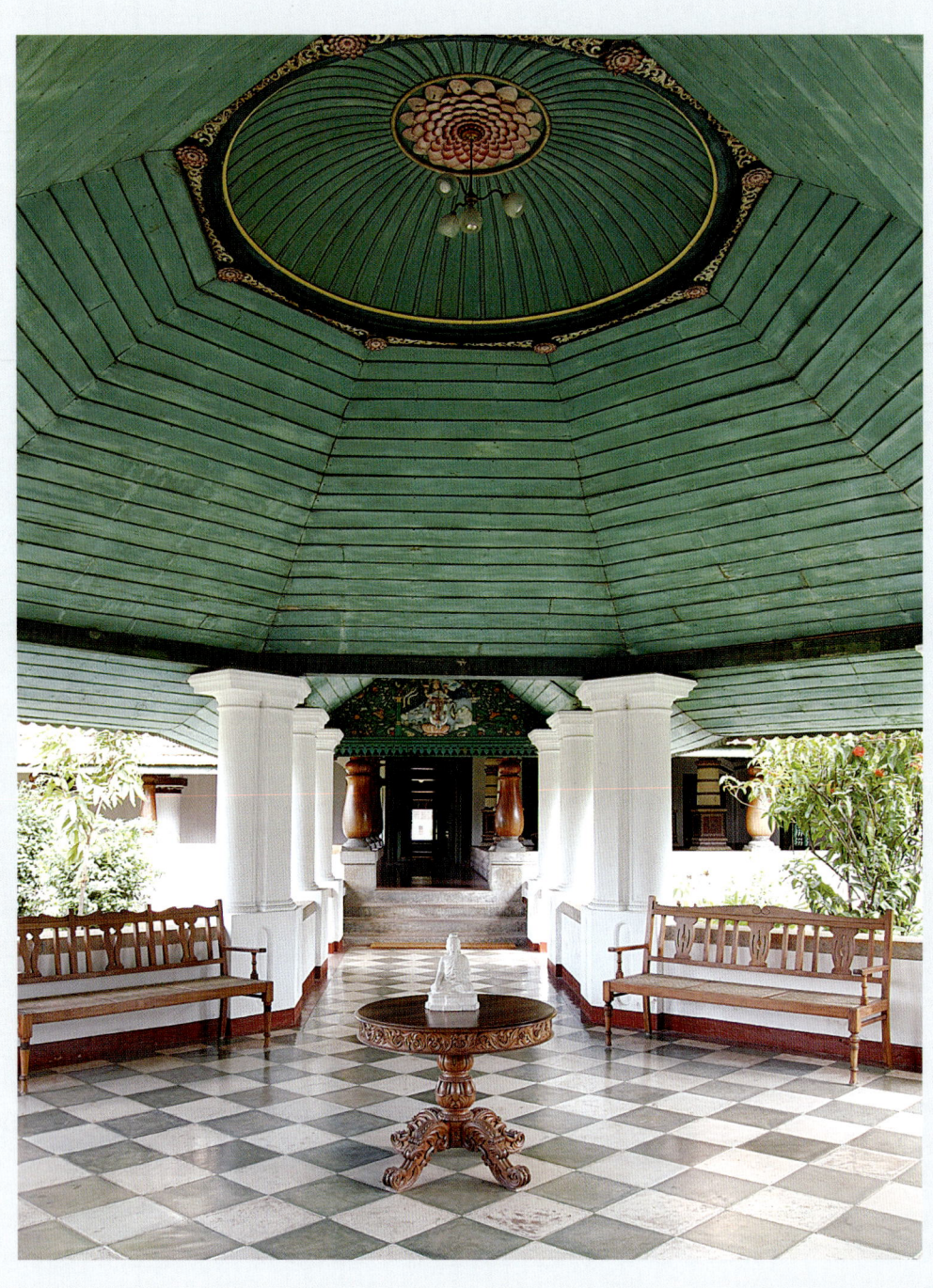

The Kalari Kovilakom, Kerala

balancing life

The Kalari Kovilakom Resort in Kerala is truly the 'Palace of Ayurveda'...

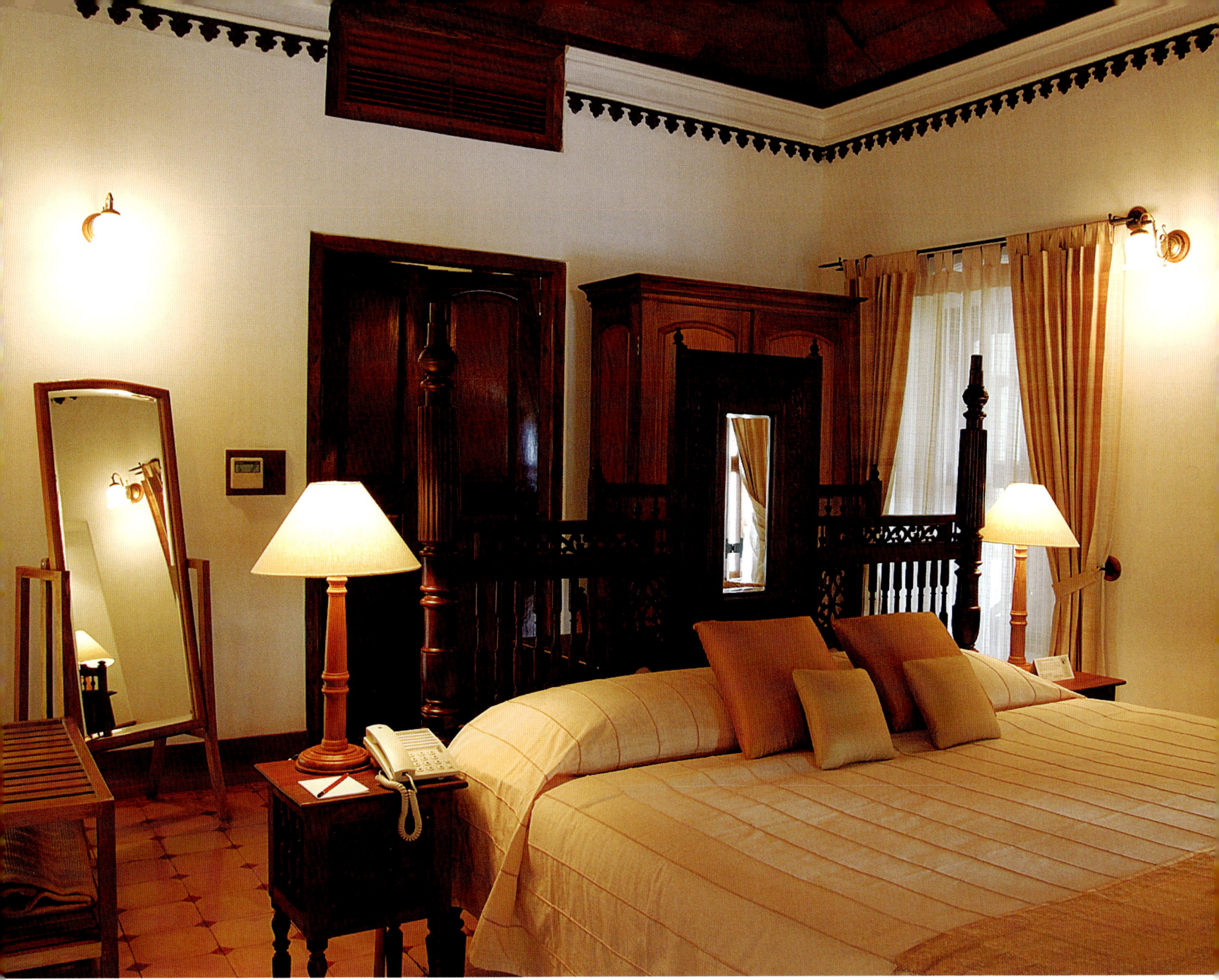

It is like stepping into another time zone, where exquisite corridors take you well over a century back in time to the grandeur and glory of Queen Dhaatri Valiya Rani of Vengunad. The Queen built this sprawling palace (now a resort) in 1890 on a site that once was a Kalari – the training ground for Kerala's renowned martial art form, Kalaripayattu.

At Kalari Kovilakom, palatial rooms envelope you in peace and intimacy alien to the modern world. The breathtakingly beautiful ceiling is the beginning of a truly wonderful journey. The wooden floral runner under the cornice is a quaint throwback to an earlier time just as is the bed. **Page 106:** *Traditional architecture gives you a glimpse of the quintessence of the Kerala ethos at Kalari Kovilakom – that God lies in the details, waiting to be discovered in the most unexpected of places.*

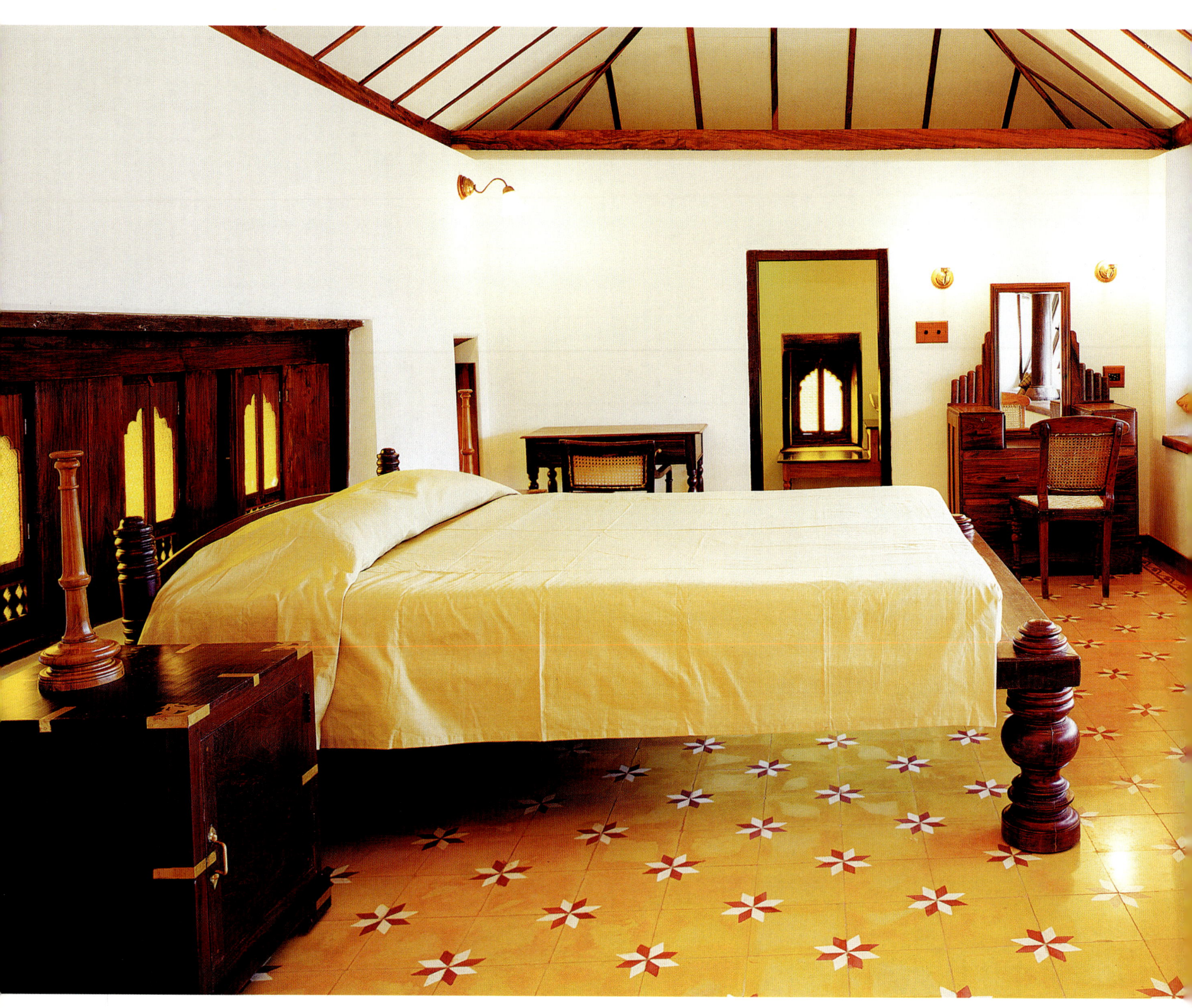

Left: The guest rooms take you into another time zone, where exquisite interiors take you well over a century back in time to the grandeur and glory of Queen Dhaatri Valiya Rani of Vengunad. Right: The bathrooms look resplendent in white.

Kalaripayattu originated in ancient South India centuries ago and draws inspiration from the raw power and sinuous strength of the majestic animal forms – Lion, Tiger, Elephant, Wild Boar, Snake, and the Crocodile. Kalaripayattu laid down the combat code in the era of the Cholas, the Cheras and the Pandyas. Shrouded in deep mystery and mists of secrecy, the ancient martial art was taught by the masters in total isolation, away from prying eyes.

However, following the collapse of the princely states and the advent of free India, Kalaripayattu has lost much of its significance as a mortal combat code.

Set in the lush green foothills of the Annamalai range in Kerala, the place in Kollengode is best reached through the commercial capital of Kochi, which is 105 kms away, and has probably the best private airport in the country. If you want to come via rail, then alight at the picturesque town of Palghat, which is merely an hour's drive away.

If old legends are to be believed, healing is part of Kalari's very soul. Stories are told of a Prince who came to the foothills of Kerala's Annamalai Hills around the 10th century. It seems he was afflicted with a particular troublesome skin ailment. So he came to cure himself in the healing spring waters of this land. Possibly, he also sought the medicinal Venga tree that grew here in profusion.

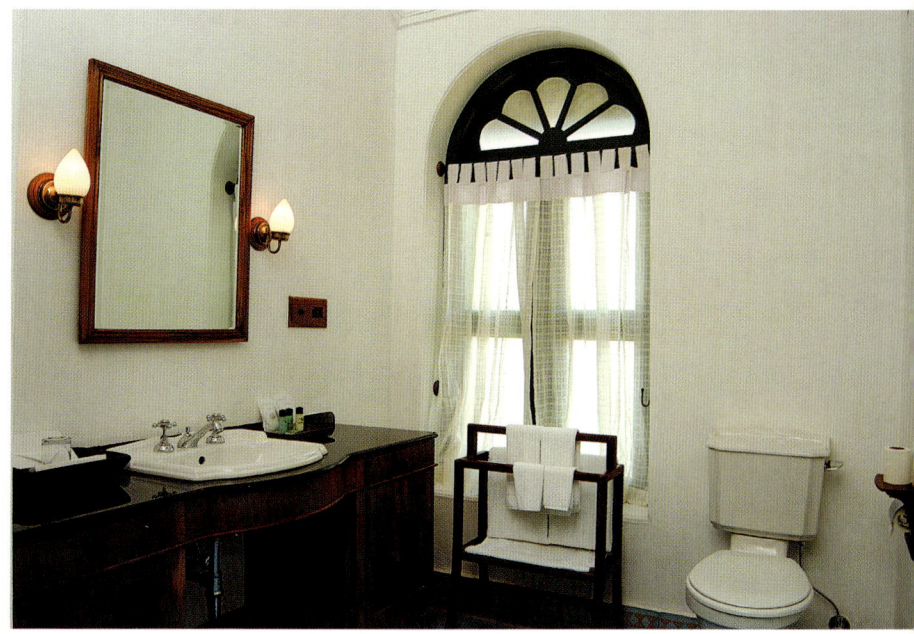

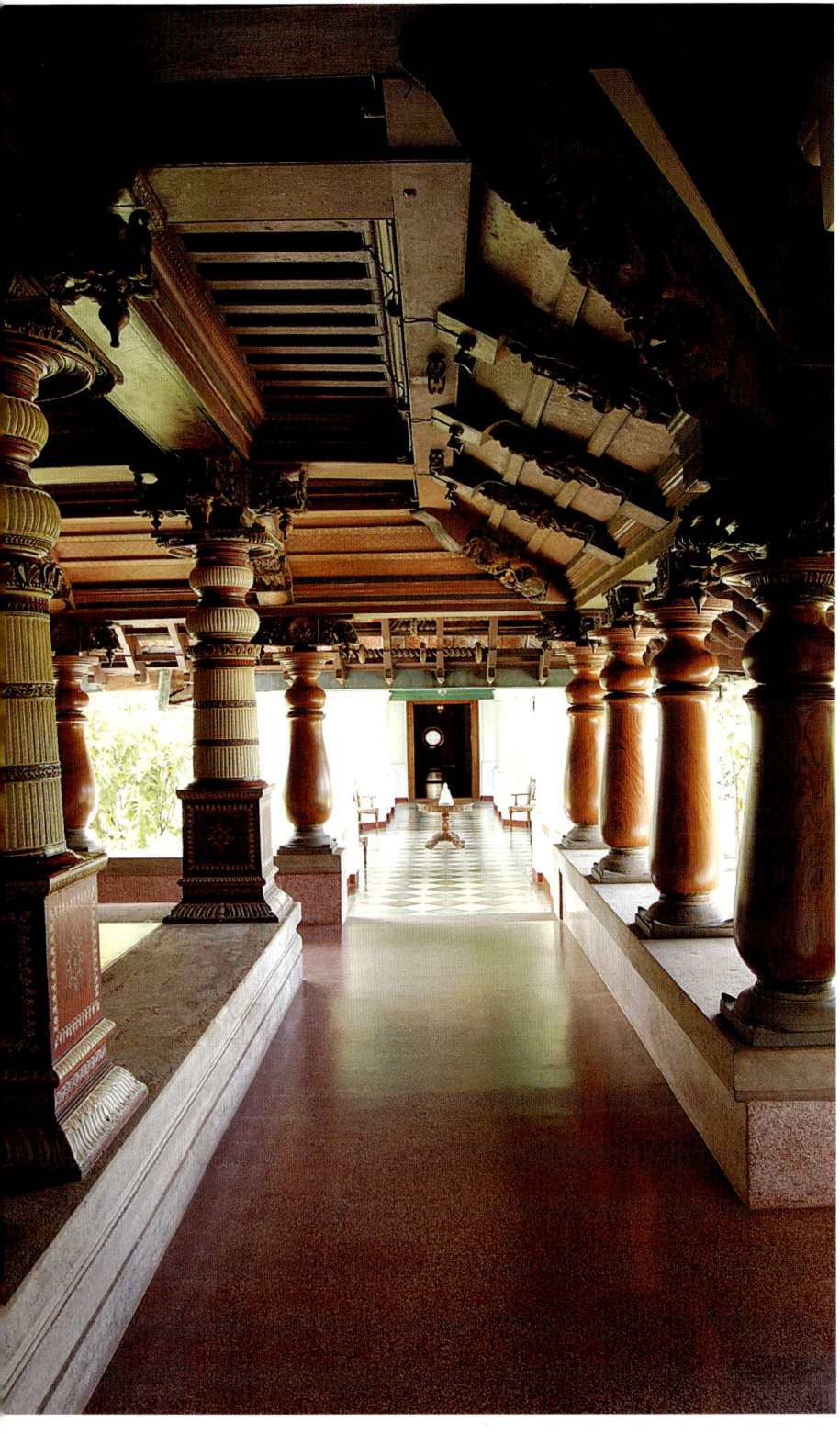

Traditional richly carved and painted wooden pillars are truly fit for a Queen's palace.

Dharmavarman (the Prince) stayed on to find a kingdom, Vengunad, 'The Land of the Venga Tree'. It is his descendent, the Queen Dhaatri Valiya Rani, who strove to retain the cultural ethos and the Ayurvedic traditions, that are so ingrained in a Kalari. Today, this magnificent palace welcomes you to a holistic healing experience based on the time-tested, 5,000 year-old system of medicine, Ayurveda. At Kalari Kovilakom, palatial rooms envelope you in peace and intimacy alien to the modern world. Spread over 30 acres of land, rejuvenation rooms at the resort speak volumes about the wisdom of yesteryears.

Traditional architecture gives you a glimpse of the quintessence of the Kerala ethos – that God lies in the details, waiting to be discovered in the most unexpected of places. In this vibrant ambience, Ayurvedic regimens take you back to your pure self, in sync with the nature that is all around you. Slowly, you will revel in the earthiness that reflects the philosophy that luxury lies in simplicity; that less is more; that the magic you seek lies hidden in what you already have.

Kalari Kovilakom, like Ayurveda, is a way of life. Totally binding, yet absolutely liberating. Wake up call before the sun's up. Warm water to drink. Meditation. Yoga. Ayurvedic regimens based on the physicians recommendations. Time to awaken your senses. Time to read. Time to think. Time to do nothing. All this in an out-of-this world ambience that is not disturbed by the telephone or the television.

It is a total surrender to nature and the healing power of Ayurveda that includes the pleasures of a palatial suite, a vegetarian cuisine and never-ending stories of a rich past. Especially the story of how Kalari Kovilakom was inspired by the matrilineal system of inheritance that existed in Kerala then.

The matrilineal system means that children carried the name of their mother and she was the decision maker in the family. Even property used to be passed on to daughters and the system was particularly prevalent among the Nair community.

At the heart of Ayurvedic philosophy is the belief that the human body is a microcosm of the universe, made up of the five elements of nature. Just as Kerala is the original home of Ayurveda, Kalari Kovilakom is the one place where Ayurveda is practiced to perfection. Here, you will have only holistic, traditional Ayurveda – which means you have to spend 14, 21 or 28 days in this Ayurvedic sanctuary. You cannot go outside and have to give

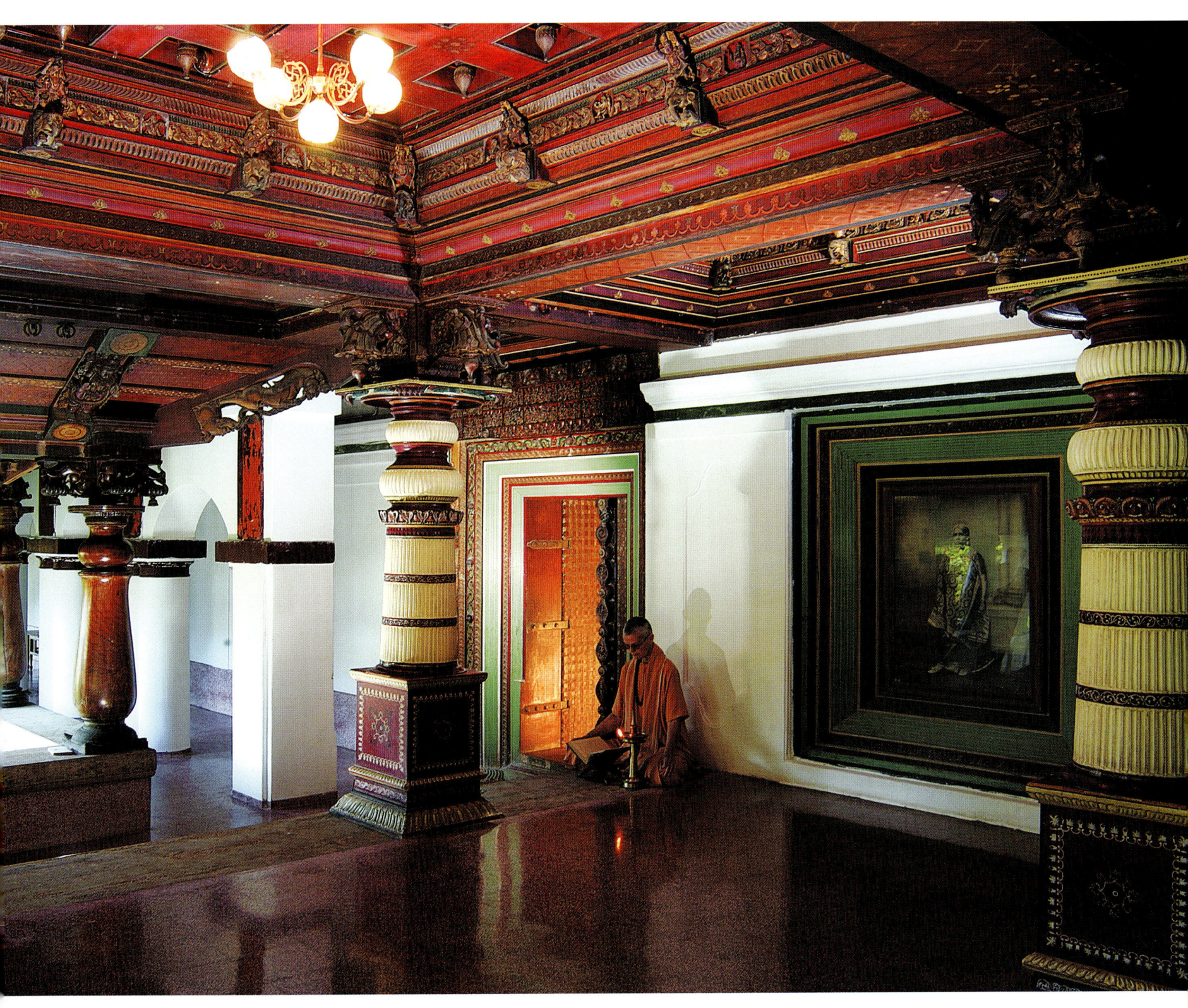

The courtyard style architecture of Kerala is the hallmark of Kalari Kovilakom. The rich colour palette is rejuvenating on its own.

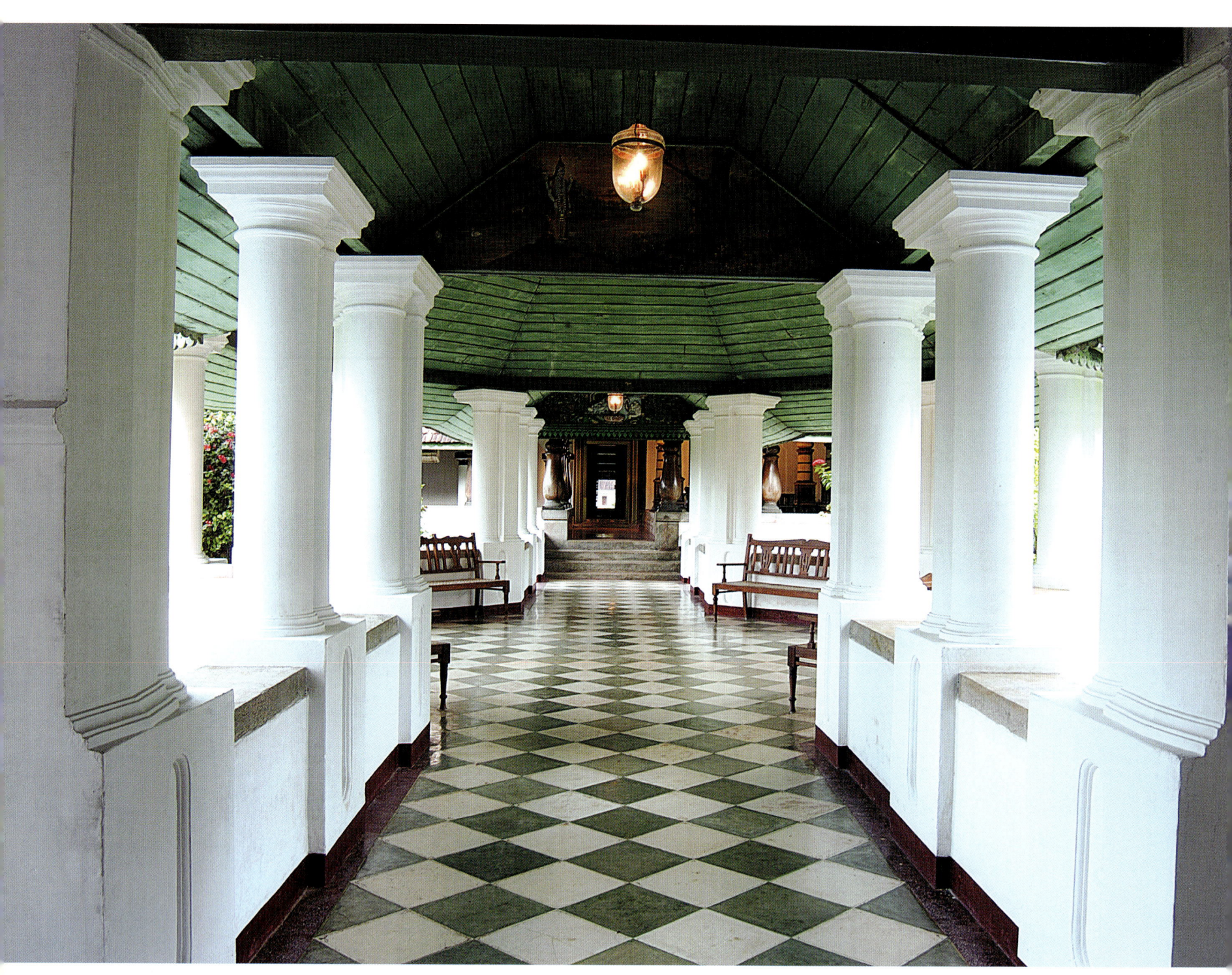

Going through the corridors, you will feel as if you have been transported into an altogether different era – that is princely, artistic and stately.

yourself up totally to Ayurveda. It is an experience that becomes a part of the collective consciousness.

At Kalari, every therapy is personal. The treatments are customized and often combined with Yoga and other methods to provide deep healing from within and outside. The evenings are alive with chanting and hymns, unsullied by the sounds of the city. In fact, apart from these post-dinner gatherings where guests and staff alike participate, there is nothing, absolutely nothing, to disturb your new-found inner silence.

The resort has ten therapy and massage rooms with expert masseuses and therapists working with you from head to toe, bringing new life to tired muscles, bones and tendons.

The herbs used in the treatment are freshly picked, usually from the herb gardens maintained on the resort's own extensive grounds. Through a combination of massages, herbal treatments, medicines, diet and purifying baths, the Kalari experience promises you a chance to see the world afresh.

Kalari uses the Bihar school of Hatha Yoga, a gentle, yet powerful form that combines particularly well with other therapies. Afternoons at the Yoga Centre are reserved for 'Yoga Nidra', a special meditative technique that brings about deep relaxation in the individual.

There are four basic types of Kalari training, viz. body control exercises, training with wooden staffs, the use of weapons such as swords and shields, and unarmed combat. There is also training in the use of a unique Kerala weapon, the lethal flexible sword, called the 'Urumi', that can be concealed as a waist belt.

Another special feature of Kalari is training in 'Marma', the art of knowing and activating the 107 energy points in the body. At Kalari Kovilakom, there are regular training sessions in Kalaripayattu, held in a traditional covered pit arena on the grounds. Simple Kalari movements are great exercises for strengthening and toning the whole body, and can make your treatments much more beneficial.

So at Kalari Kovilakom, not only can you watch the experts at play, you can even take a crack at Kalaripayattu yourself! A perfect place if you want to really rejuvenate yourself away from the hustle and bustle of daily routine.

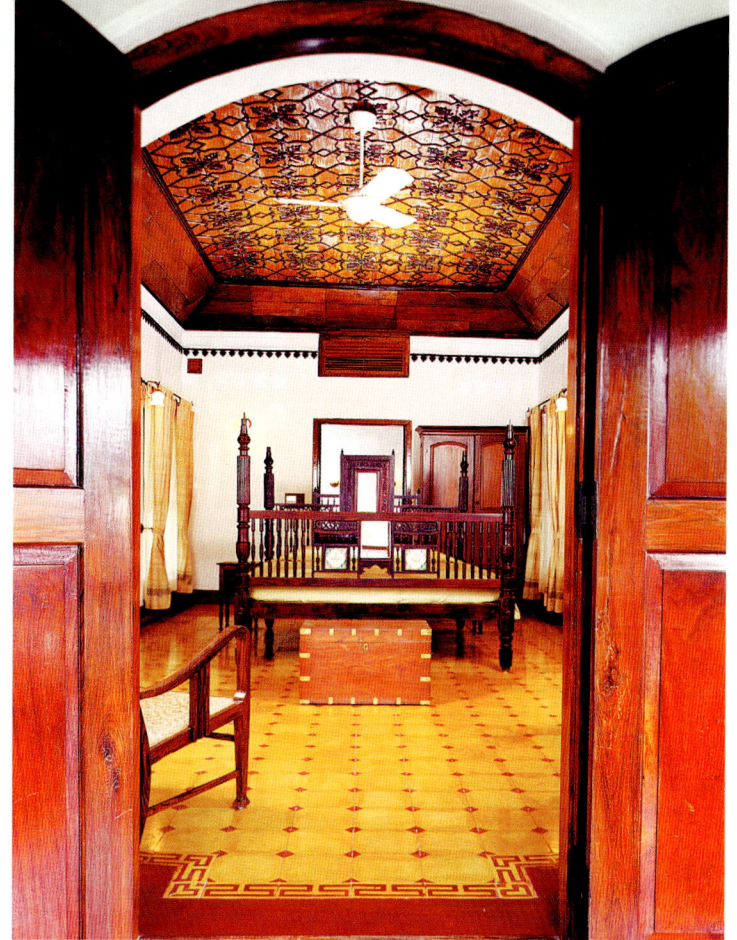

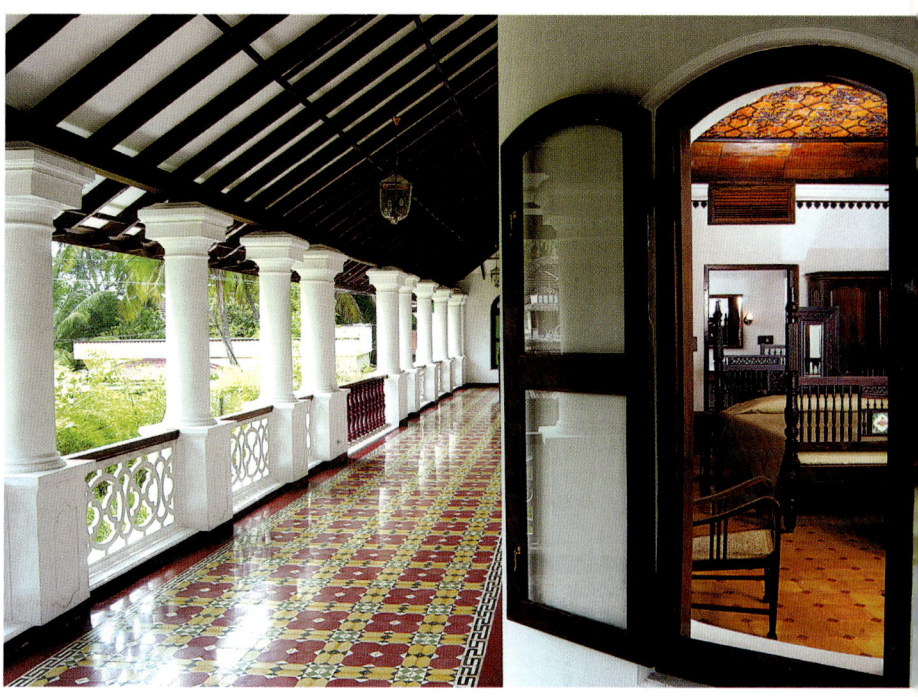

Top: A peep into a yellow-tiled guest room that is colourful and comfortable. Bottom: Another example of the Kerala-styled corridor and antique furniture. The beautiful floor tiles are truly one of a kind.

Shreyas, Bangalore

the Yoga retreat

The essence of Shreyas is wellness of body, mind and soul...

In the Indian tradition, Shreyas is interpreted as "all-round excellence, the manifestation of which is the purpose for which our lives have been given to us".

Shreyas, a Yoga Retreat on the outskirts of Bangalore, India offers guests a private and tranquil haven to pamper, nourish and recharge themselves. At the same time, guests can immerse themselves within the wisdom of the timeless spiritual tradition of

*Contemporary, modern and minimalistic interiors are what characterize this Yoga retreat situated outside Bangalore. **Page 116**: Spread over 25 acres of landscaped gardens, the architecture and interiors of the Shreyas retreat are a seamless confluence of the traditional as well as the modern – tiled roofs, antique doorways and stone pillars give way to contemporary interiors and state-of-the-art facilities.*

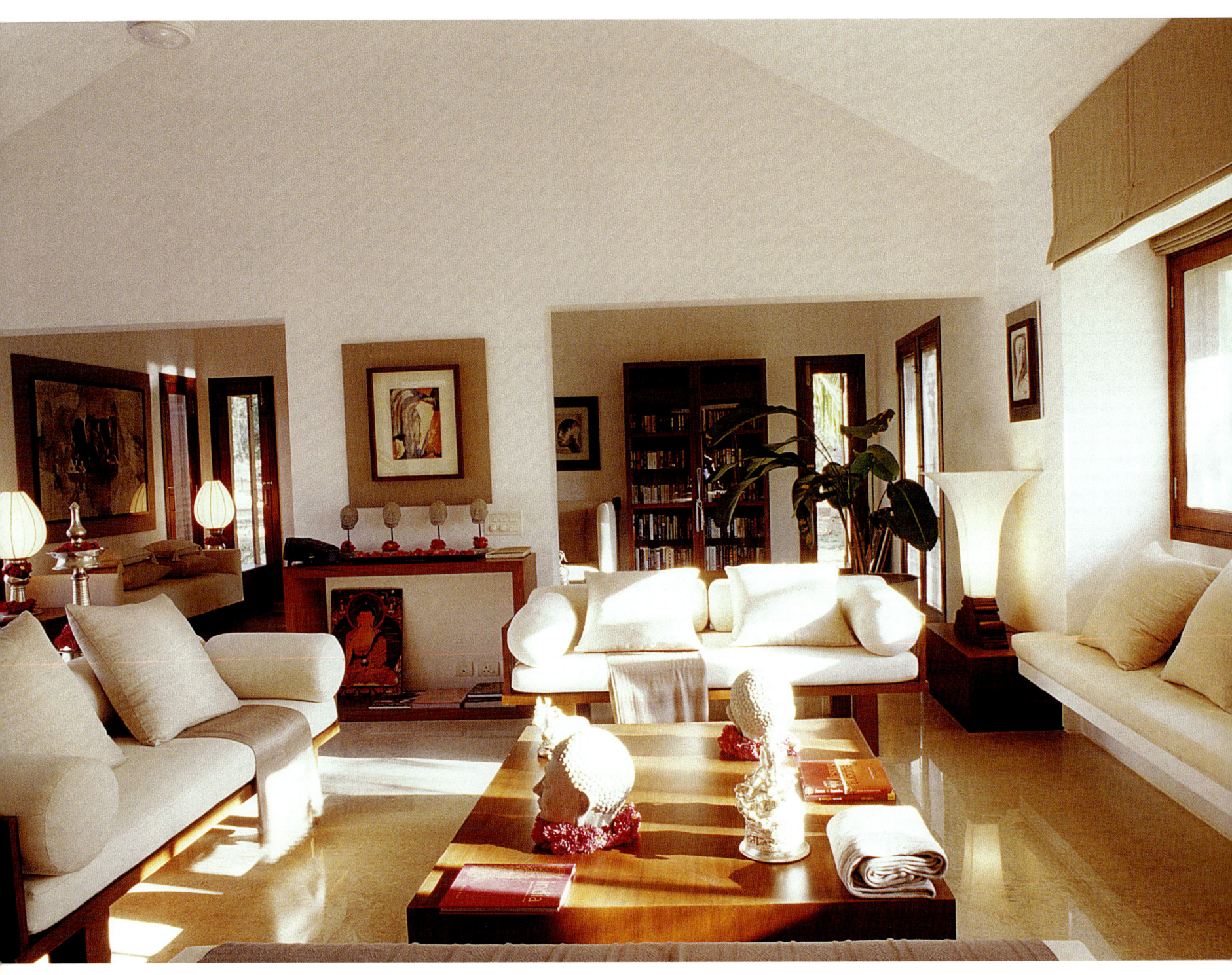

One of the elegantly designed seating arrangements at the retreat.

Yoga and Vedanta. The retreat is dedicated to helping guests achieve a perfect balance in body, mind and spirit through the medium of Yoga, which is non-denominational and open to people of all faiths. Yoga has an amazing effect on our body and mind energies, allowing us to deal with life's bouquets and brickbats with a sense of equanimity.

Spread over 25 acres of landscaped gardens, the architecture and interiors of the retreat are a seamless confluence of the traditional as well as the modern – tiled roofs, antique doorways and stone pillars give way to contemporary interiors and state-of-the-art facilities. Shreyas is an environment-friendly retreat, and care has been taken to retain the original landscape and the natural beauty of the place.

Guests have a choice of accommodation of 3 Poolside cottages, 8 Garden Suite cottages and a 3 bedroom cottage. The 'tented' Garden Cottages, spaciously scattered across the property are surrounded by lush vistas of greenery and have en-suite bathrooms that open onto private walled courtyards. The Poolside cottages overlook the signature Antique-Pillared entrance, Infinity Pool & Jacuzzi and the central courtyard of the retreat.

Meals at Shreyas are a gastronomic selection of various international cuisines and the lone dining hall provides a relaxed ambience for guests from around the world to interact and share experiences with each other. Al fresco dinners in one of the many beautiful outdoor settings are an enchanting affair with paper lanterns, glowing candles, bonfires, petal-strewn table settings, pool-side views... each day is different. The menu is a welcome surprise – truly vegetarian. The gourmet meals at Shreyas vary everyday – from local South-Indian delicacies, mouth-watering "tandoori" (clay-baked) cuisine of Northern India to varied Continental, Mexican and Oriental dishes – made mostly from ingredients organically grown and freshly picked from the retreat's own fields.

However, it is Yoga that defines Shreyas. In the Indian tradition of Yoga, life is a journey of experiences that leads us to discover Shreyas ("all-round excellence") inherent within us. As such, Yoga at Shreyas is much more than the traditional physical postures, and the numerous self-discovery packages/retreats offered such as Wellness for the Soul, Ayurvedic Rejuvenation, Yoga Retreat, etc. aim to catalyse your thinking/living philosophy

*Shreyas has 12 exclusive cottages that come with a plush bed (**bottom**) and a small seating area (**top**).*

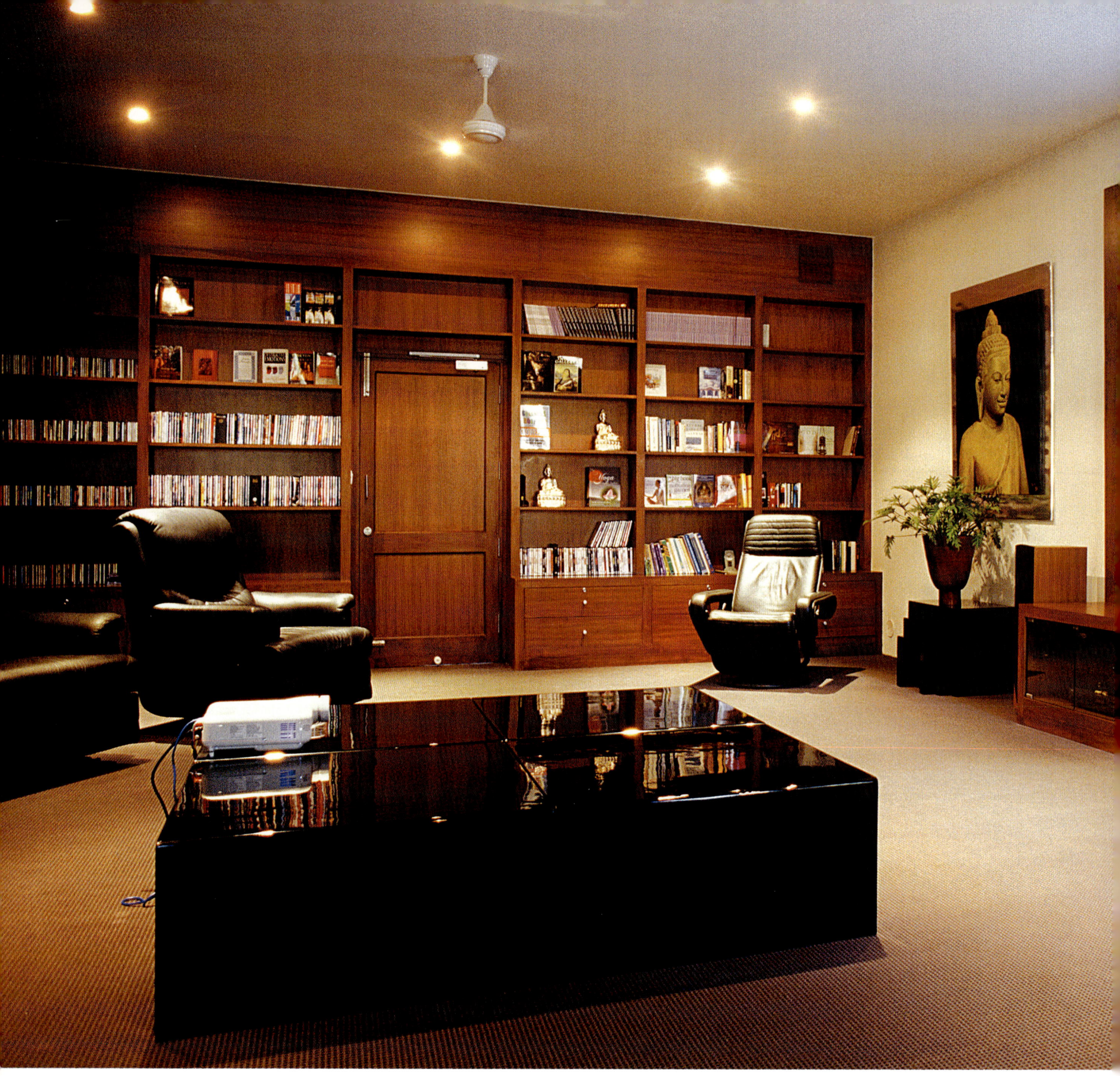

The state-of-the-art study to help the guests relax and spend a cosy evening reading their favourite authors.

and harmonise it with the timeless wisdom enshrined within the Indian philosophical tradition. These retreats are designed to help you achieve a better understanding of your self, and hopefully, the role and purpose of your life.

If you are looking to spend some time reflecting and connecting with your inner core, Shreyas provides a sacred space and structures your stay with dedicated Yoga sessions, Community Service exercises, guided Meditation sessions, mouna (silence) and Karma Yoga (working with a selfless attitude), rejuvenating spa treatments, nature farming and more.

Yoga classes at Shreyas are based on the classical Hatha Yoga, and combined with Pranayama (breathing techniques) and Pratyahara (withdrawal of sensory inputs) processes drawn from the Yoga Sutras – an ancient yogic doctrine that aims to integrate our body, mind, heart and soul for holistic living.

A typical day at the boutique Yoga retreat dawns with guests waking up to the gentle rustle of the coconut trees, the chirping of birds and the crisp cool air. Stepping out of your poolside cottages or luxury garden cottages with tented canopies, the curving pathways lead to the open-air Yoga hall where you gently stretch and tone your body, practice deep relaxation, Meditation and breathing exercises. Guests looking to deepen their practice of Yoga and Meditation can opt for private one-on-one sessions.

After a bout of Meditation and exercise, you can head to the Rejuvenation Spa and Massage Centre at the retreat that offers an ideal solution to the damaging effects of accumulated stress and aids in harmonizing a troubled body and mind. Some of the massage treatments at Shreyas include traditional Ayurvedic massages such as Abhyanga (a combination of soothing and long strokes that help in restoring balance and harmony in the body), Shirodhara (where therapeutic oils are poured in a continuous stream to bathe the head, directed at the mid-forehead), Udwarthanam (reverse body massage using powdered herbs, which reduces kapha, strengthens the muscles and beautifies the skin), Choorna Pinda Swedam etc, Balinese Massage (smooth but deep thumb pushes along each individual muscle, following the course of the body's energy channels); Thai Massage (a blend of Yoga, acupressure and reflexology that uses point pressure, muscle stretching and compression in a rhythmic movement); Swedish Massage (which increases the oxygen flow in the blood and releases toxins) and Aromatherapy Massage (which improves chronic conditions such as stress, insomnia, menstrual problems, stiffness of joints and fatigue).

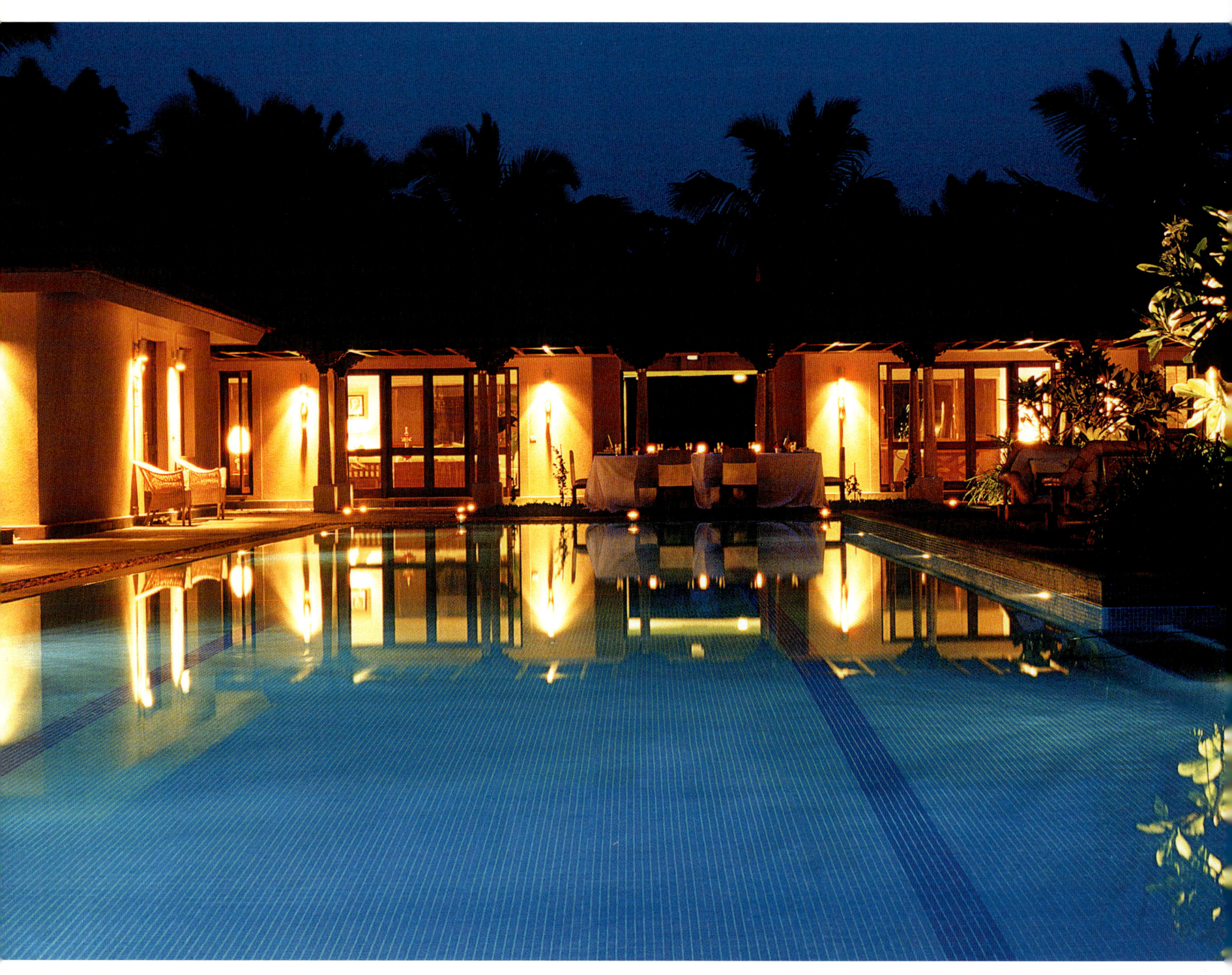

For recreation, you can opt to swim in the temperature-controlled 25 metre lap pool or simply sunbathe around it. **Opposite page, Top and Bottom:** *Views of the pool, well-lit in the night imparting a soothing and cool feeling to the retreat.*

Shreyas offers a wonderful opportunity for guests to get a glimpse into the simple, hardworking lives of the local villagers. And, for those who are interested, exercises in Community Service and 'Voluntourism' are arranged at the local village, schools and orphanages. This may include procuring or collecting vegetables from Shreyas farm, preparing and serving a meal to children at a local school or orphanage, planting saplings in the village, contributing towards the village school's requirements such as uniforms, stationery and infrastructure for villages needs like rainwater harvesting projects, etc.

For recreation, you can opt to swim in the temperature-controlled 25 metre lap pool or simply sunbathe around it. You can even test your batting skills in the retreat's cricket nets against BOLA, the professional bowling machine. Working out in the gymnasium can be followed by steam and a dip in the heated outdoor Jacuzzi. Guests can also spend time in Shreyas' 20 acre organic farm with rice paddy, agricultural and herb gardens, where you get an opportunity to get your hands and feet dirty and truly commune with nature.

Wind up your day in the state-of-the-art home theatre that has over 500 movies for your viewing pleasure.

A perfect ambience to meditate, relax or just BE.

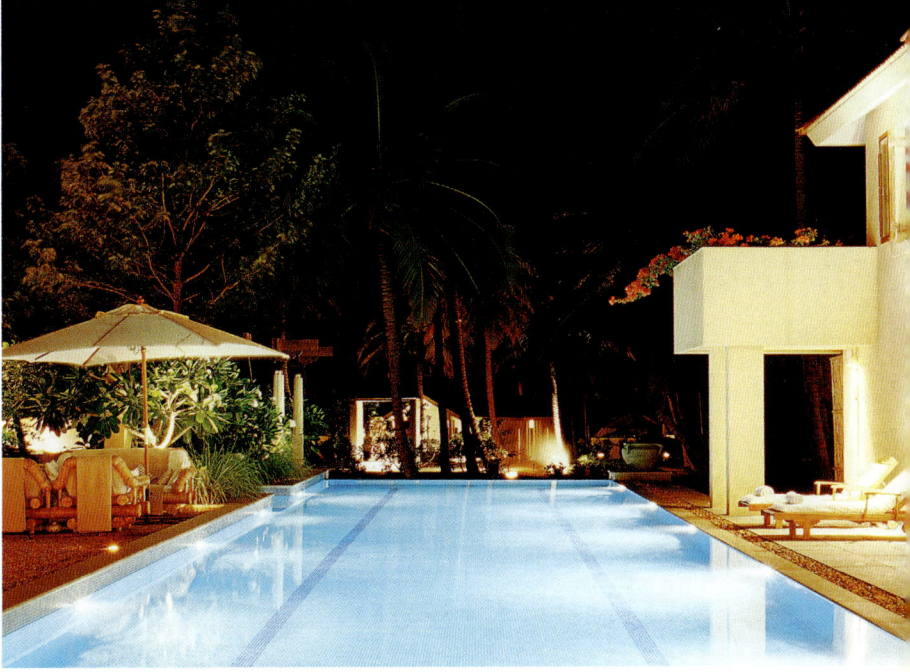

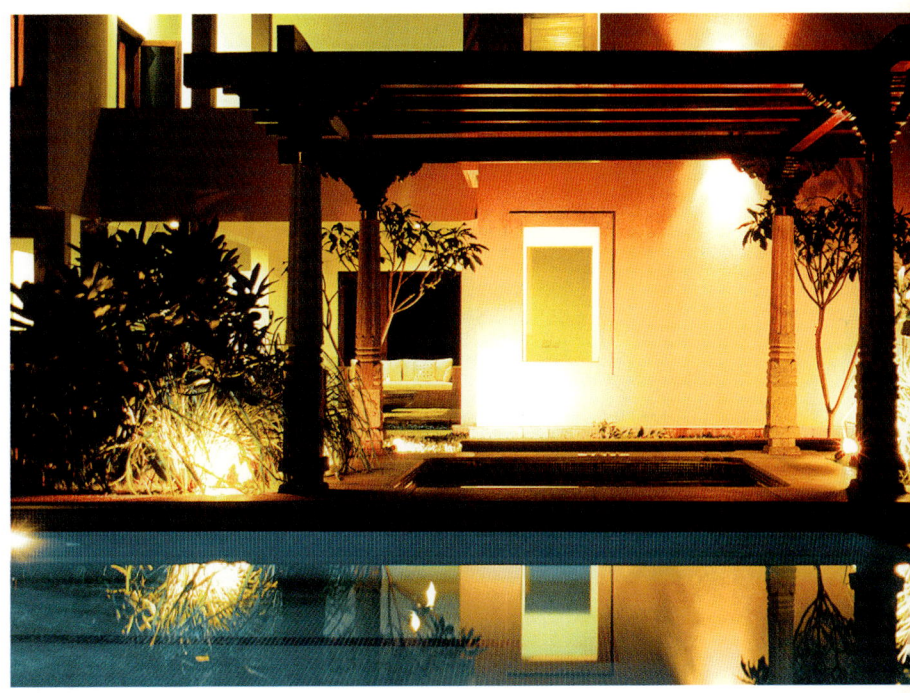

Page 126, Top: Shreyas has three en suite cottages that overlook the signature swimming pool and one three-bedroom cottage with its own living room. *Bottom:* Shreyas is an environment friendly retreat, and care has been taken to retain the original landscape and the natural beauty of the place. *Page 127:* The outside **(top)** and inside **(bottom)** view of an outdoor seating area with a thatched roof and wooden planks covered with white cushions to sit on.

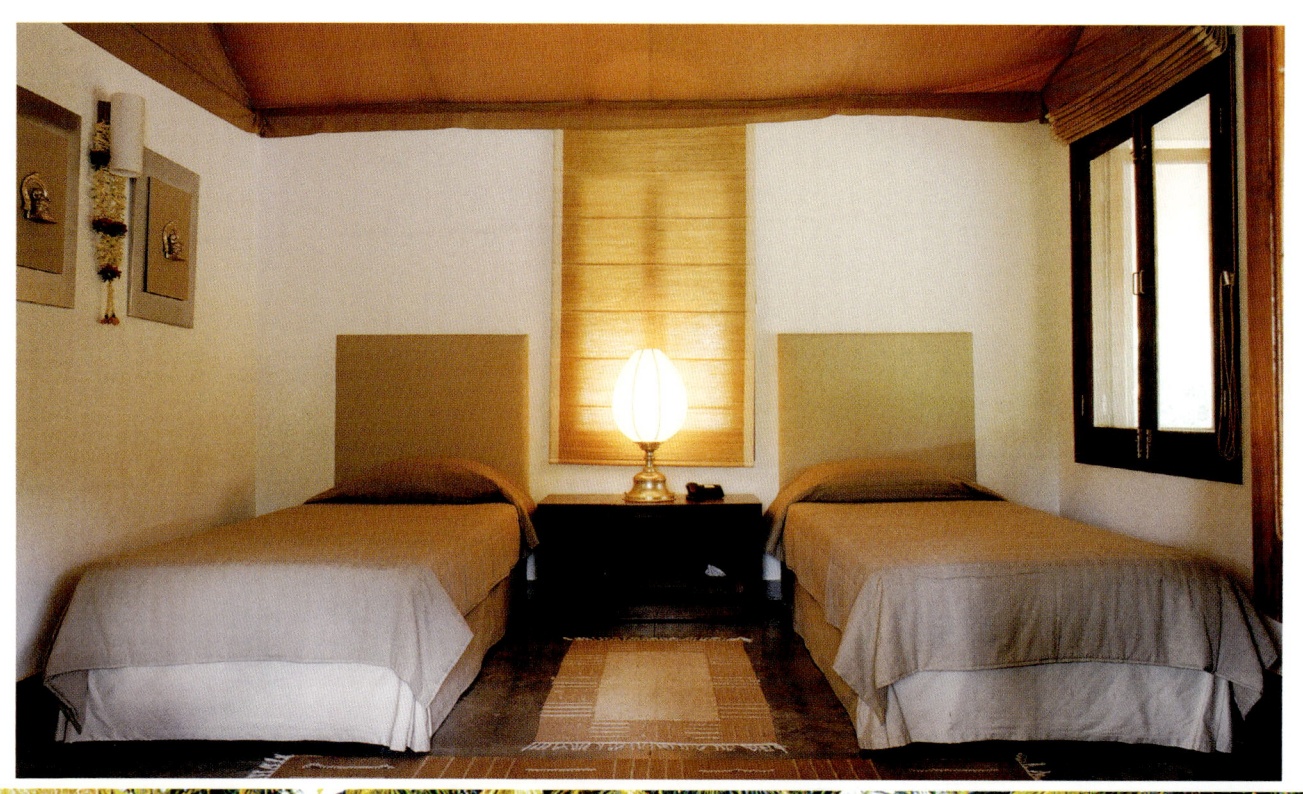

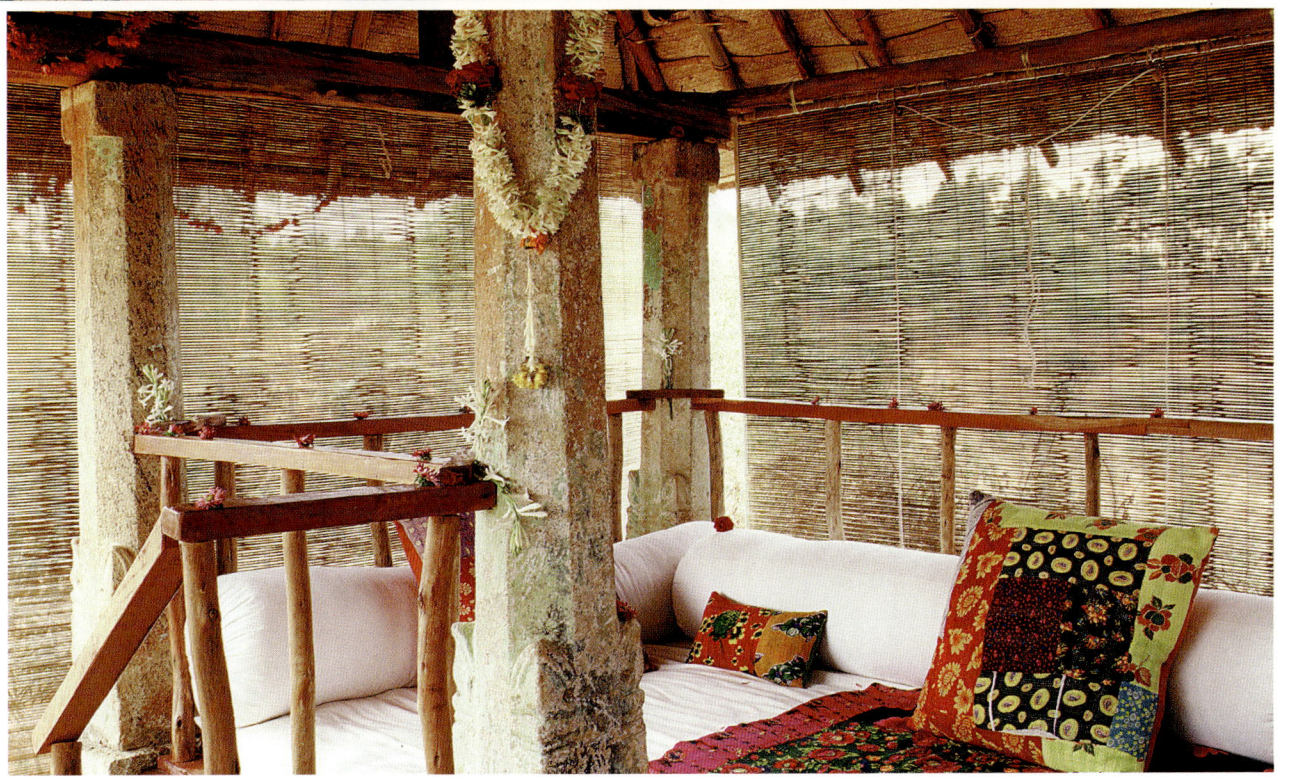

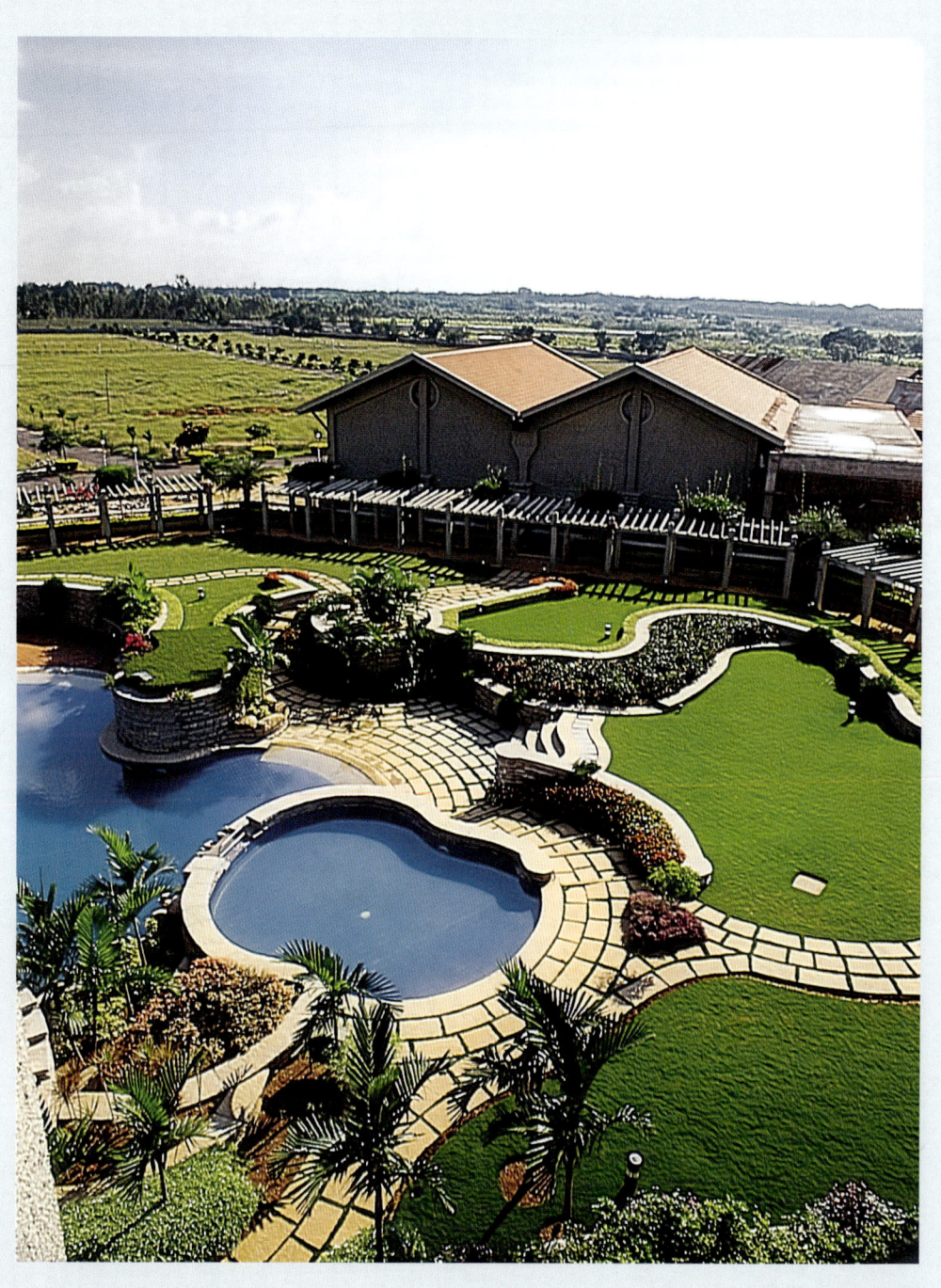

Angsana Oasis Spa & Resort, Bangalore

a dreamy oasis

The Angsana Oasis Spa & Resort offers you a new, generous,
exotic reality on the outskirts of Bangalore...

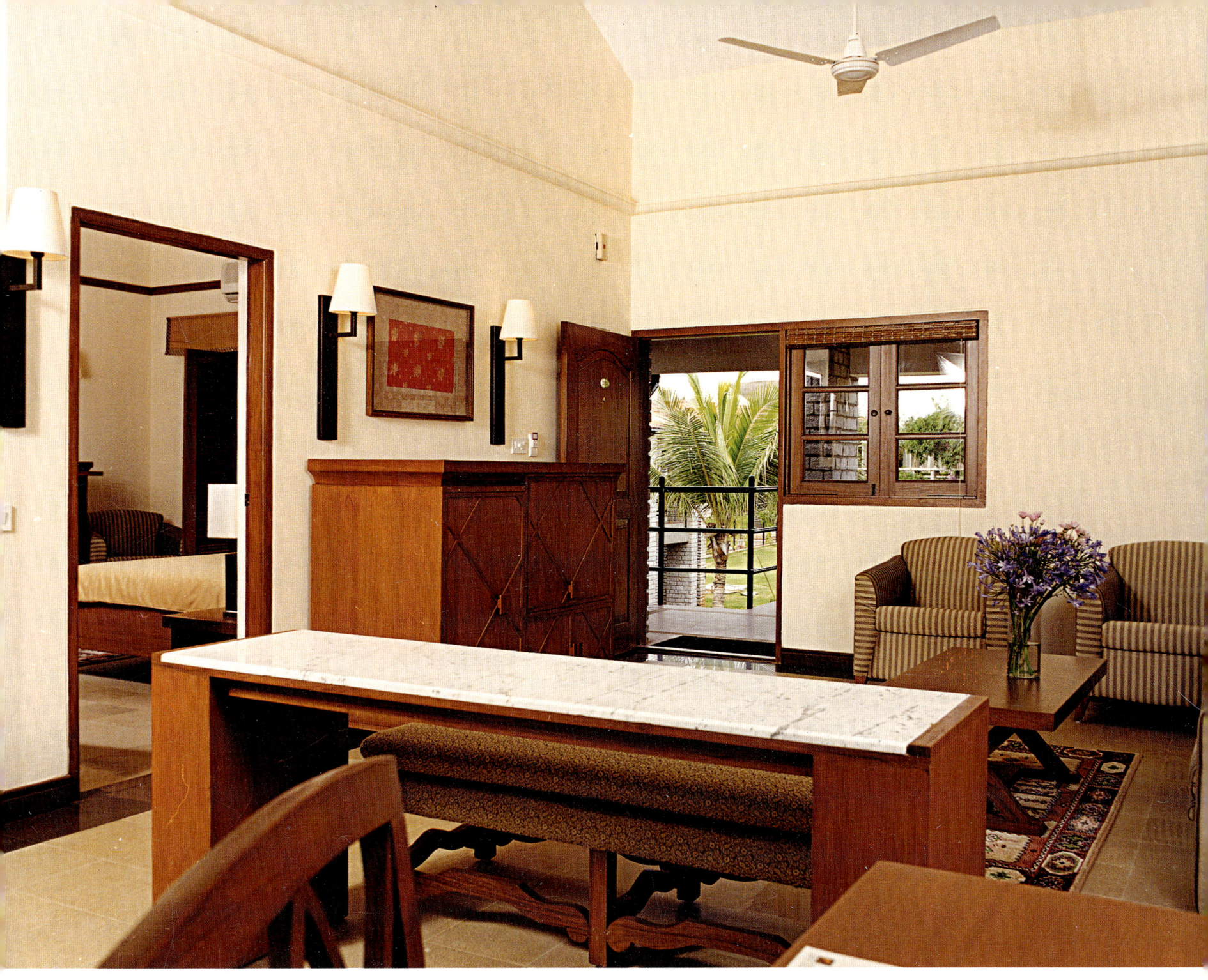

As the gateway to Southern India, Bangalore combines the attraction of a modern metropolis with the delightful charms of one of India's most enchanting regions. World-famous today as the Silicon Valley of India, the Information Technology industry in the metropolis attracts people by the droves.

A 79-room resort, Angsana Oasis Spa & Resort, Bangalore combines elegance, luxury and comfort including rooms and suites that feature private balconies, elegant furnishings, fully-equipped kitchenettes, manicured lawns and a spectacular view of the greens. **Page 128:** *Nestled in the privacy of lush greenery beneath a canopy of palm leaves and seamless architectural interpretations, Angsana Oasis Spa & Resort has been conceived by the Prestige Group and Singapore's Banyan Tree Hotels and Resorts.*

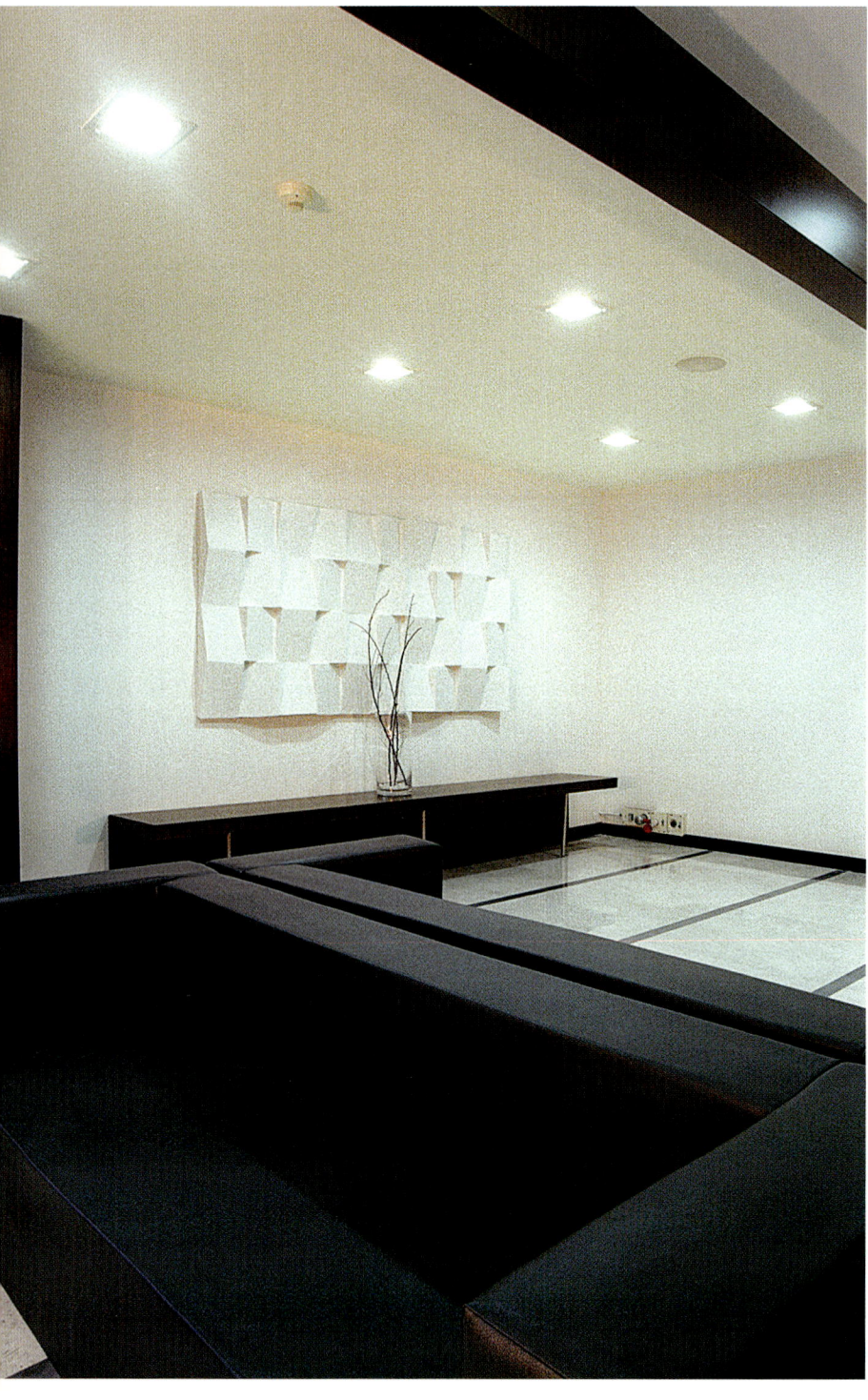

A seating arrangement in the lobby strikes a balance between rustic beauty and Art Deco.

It is to provide a relaxing environment to thousands of professionals, who have today made Bangalore their home, that Angsana Oasis Spa & Resort was conceived. Part of an international chain of spa resorts, the resort is situated just 24 kilometres from the Bangalore International Airport and enjoys the convenience of being both close to the city and the lush open countryside. Bangalore is well-connected with all the major national as well as international destinations by air.

Nestled in the privacy of lush greenery beneath a canopy of palm leaves and seamless architectural interpretations, Angsana Oasis Spa & Resort has been conceived by the Prestige Group and Singapore's Banyan Tree Hotels and Resorts. The resort is located on the Doddaballapur Main Road with convenient access to Bangalore city & close to Bangalore International Airport, thus striking a balance between rustic beauty and modern conveniences.

A 79-room resort, Angsana Oasis Spa & Resort combines elegance, luxury and comfort including rooms and suites that feature private balconies, elegant furnishings, fully-equipped kitchenettes, manicured lawns and a spectacular view of the greens. With so much more to offer, every moment at The Angsana Oasis Spa & Resort, Bangalore is one to savour.

The resort has thoughtfully catered to guests of all ages and interests with its comprehensive facilities. From the well-stocked library, aerobics center and Meditation/Yoga room to the squash and tennis courts, it helps you unwind and recharge. There is a huge expanse of space for plenty of activities, including a gym to work your excess energy.

You may find a soak in the Roman pools or a visit to the spa pavilions enticing after a day's workout. The sprawling landscaped gardens and inviting pools also add to the charm of this enchanting resort.

From spicy to just sublime, the diversity of cuisines served here will surely delight your taste buds, regardless of how delicate, or robust, they might be. First and foremost is The Sun Dance Bistro, a sunny and spacious multi-cuisine all day dining restaurant that offers a range of dishes including special dishes for the health conscious, and is the ideal setting for a lazy luncheon. You can

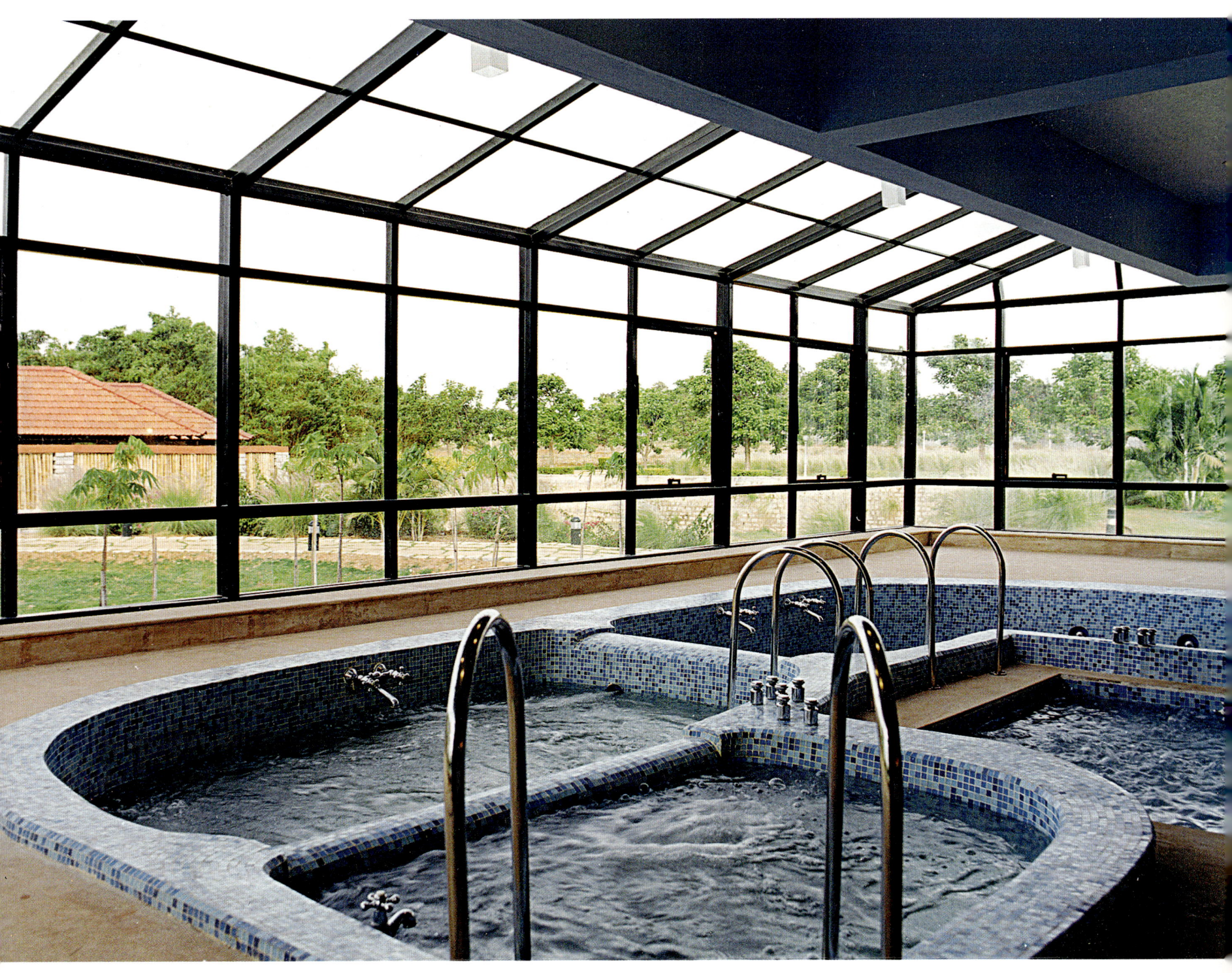

Get wet for pure luxury – Angsana Oasis Spa & Resort is one of the few resorts in the country that have Roman baths for its guests.

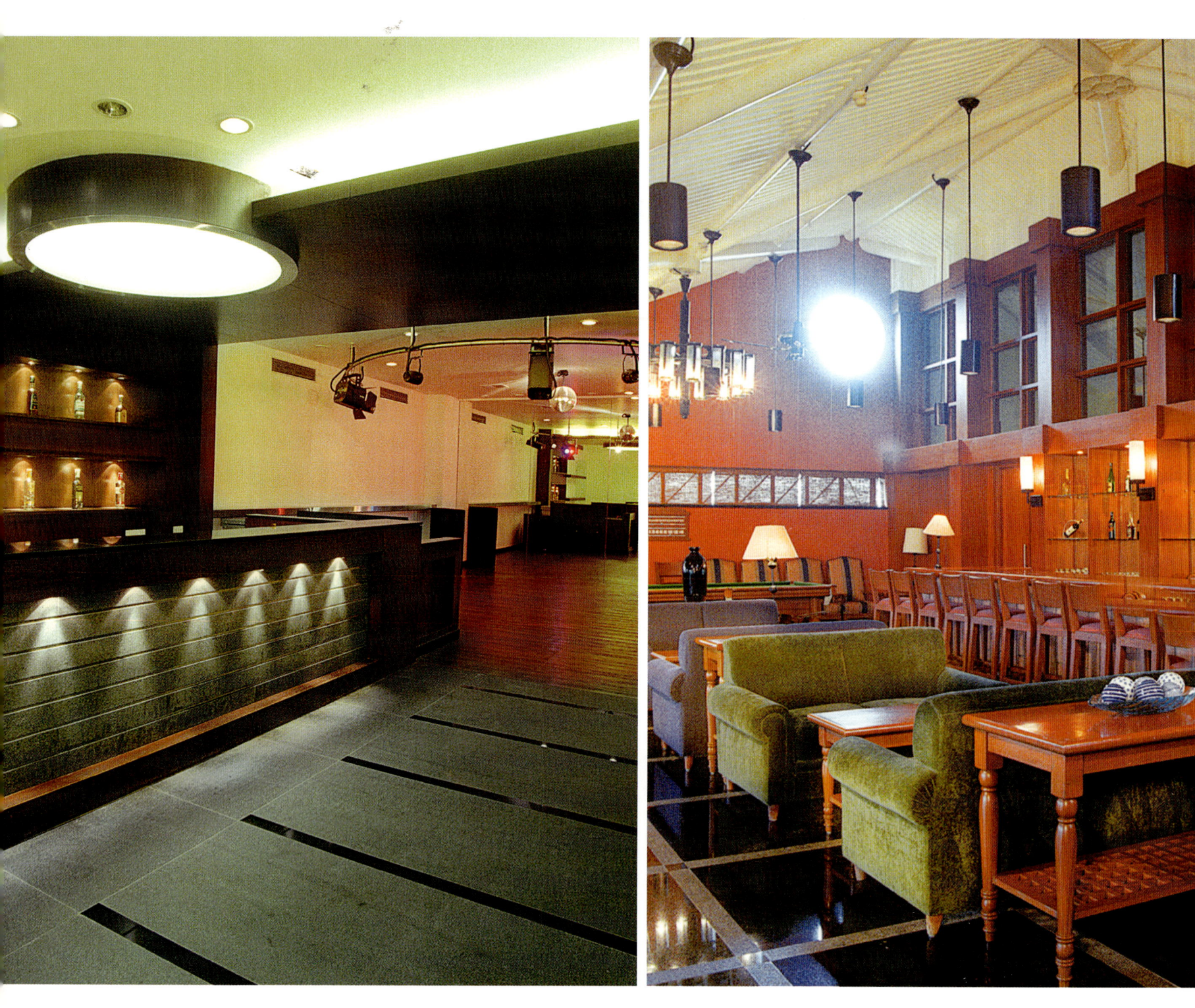

Left: Mirage is the bar and lounge with luxurious yet cosy inside and outside spaces to spend a quiet evening with the right company. Right: The completely equipped Burgundy Room is the ideal setting for an elegant conference with the breathing space around it.

also grab a juice and a snack on the Aquamarine deck and enjoy the perfect view. Mirage is the bar and lounge with a luxurious yet cosy inside and outside spaces to spend a quiet evening with the right company. The completely equipped Burgundy Room is the ideal setting for an elegant conference with the breathing space around it – opening out on to the Oasis Cabana and the tennis gardens.

Home to a range of award-winning treatments, Angsana Oasis Spa & Resort places emphasis on the therapeutic sense of touch, and uniquely adopts fresh ingredients and flowers with essential aromatic oils to revive your senses. The exquisitely designed spa pavilions allow you a chance to pamper yourself. Nestled in a bamboo grove, you can almost forget reality here.

Offering services that are imaginative, individual and infinite sensory, Angsana Resort takes care of your needs, through personalized therapists and customized packages for the ideal mix of traditional Asian massage and beauty therapies.

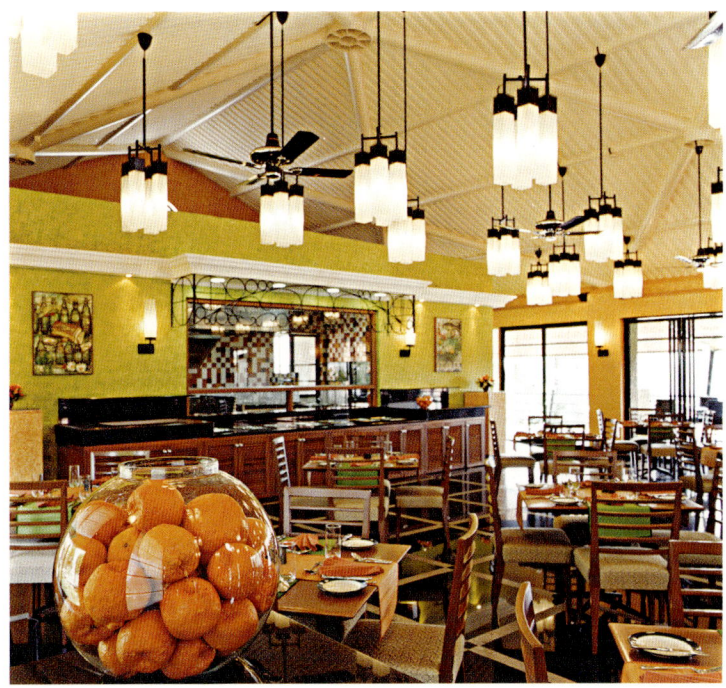

This is one resort where you can have both an Ayurvedic massage as well as a spa treatment straight from Thailand. Apart from this, you can also go in for an herbal steam healer that includes a Russian bath as well as lunch. There is even a hydro-massage with a jet shower or a Swedish massage with Russian bath. Something that will take you on a dreamy, exotic oasis where you are pampered with a scented three hour long spa massage!

The massages range from a 60 minute one to a 90 and a 120 minute treatment. The Angsana Massage uses palm strokes and thumb pressure on your body's key pressure points to free you from stress and strengthen your inner self. This 90-minute signature massage has been created exclusively for the Angsana Spa and uses the specially formulated Euphoria Oil to enhance the experience.

Adapted from traditional Thai methods, the Ayuthaya dry massage (no oil is used) works on the body's meridian lines to stretch every limb and ease aching muscles. It improves blood circulation and mobility, as well as relieves tension, leaving you limber and supple.

The Fusion massage as its name suggests is a blend of Thai and Swedish massage techniques. The therapist uses strong

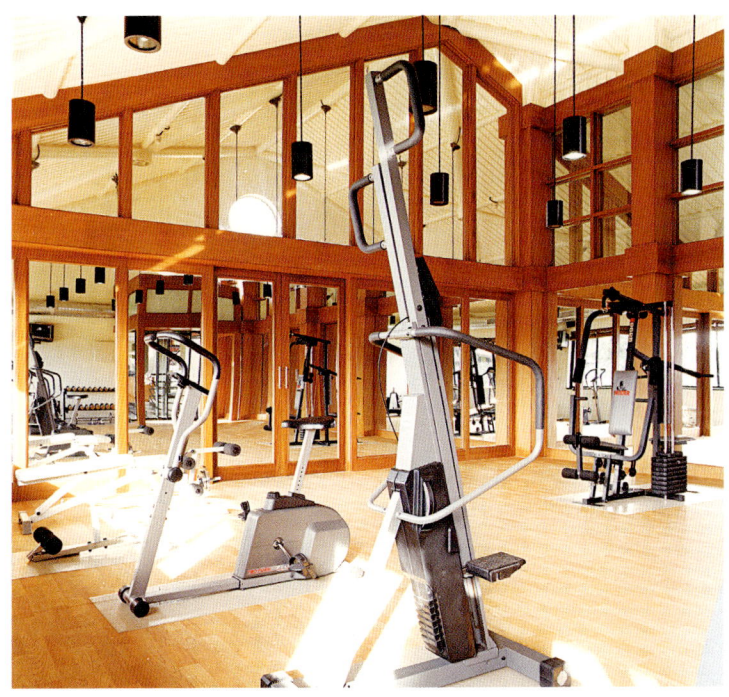

Top: The Sun Dance Bistro is a sunny and spacious multi-cuisine all day dining restaurant that offers a range of dishes including special dishes for the health conscious, and is the ideal setting for a lazy luncheon. Bottom: A fully-equipped gym enables you to keep in shape.

palm strokes while stretching you at various points of the session for maximum impact and complete relaxation that leaves your body satiated.

Inspired by traditional Hawaiian techniques, Waves is a strong yet sensual massage that relaxes your body. On the other hand, adapted from traditional Balinese techniques, Ibu is a deep tissue massage that uses thumb and palm pressure to soothe aching muscles and relieve tension.

Last, but not the least, Dreams has been created specially for your tired body. This 60-minute warm oil massage uses long and firm palm strokes with sesame oil to soothe tensed muscles and helps to lull the body, mind and soul to a state of complete relaxation. A calming experience that's a perfect remedy for jet lag!

While inside the resort, you can use facilities like the gym and laze around in the greenery; if you want you can always have a dekho at Bangalore. Once a summer resort of the British, it is now one of the most attractive modern cities in India with beautiful parks, avenues, impressive buildings and shopping malls some 3,000 ft above the sea level. Known as the Garden City, it has the best weather in India.

And the Angsana Oasis Spa & Resort all in all, with its spa and Roman pools, exclusive spa pavilions and a host of great leisure activities, is a perfect compliment to the city and is a place for people who – whether at work or on holiday – value good health and a luxurious lifestyle.

While inside the resort, you can laze around in the greenery, giving you a glimpse of what the Garden City has in store for you. **Opposite page:** *Make a splash in the beautiful swimming pool at the resort with a cascading waterfall.*

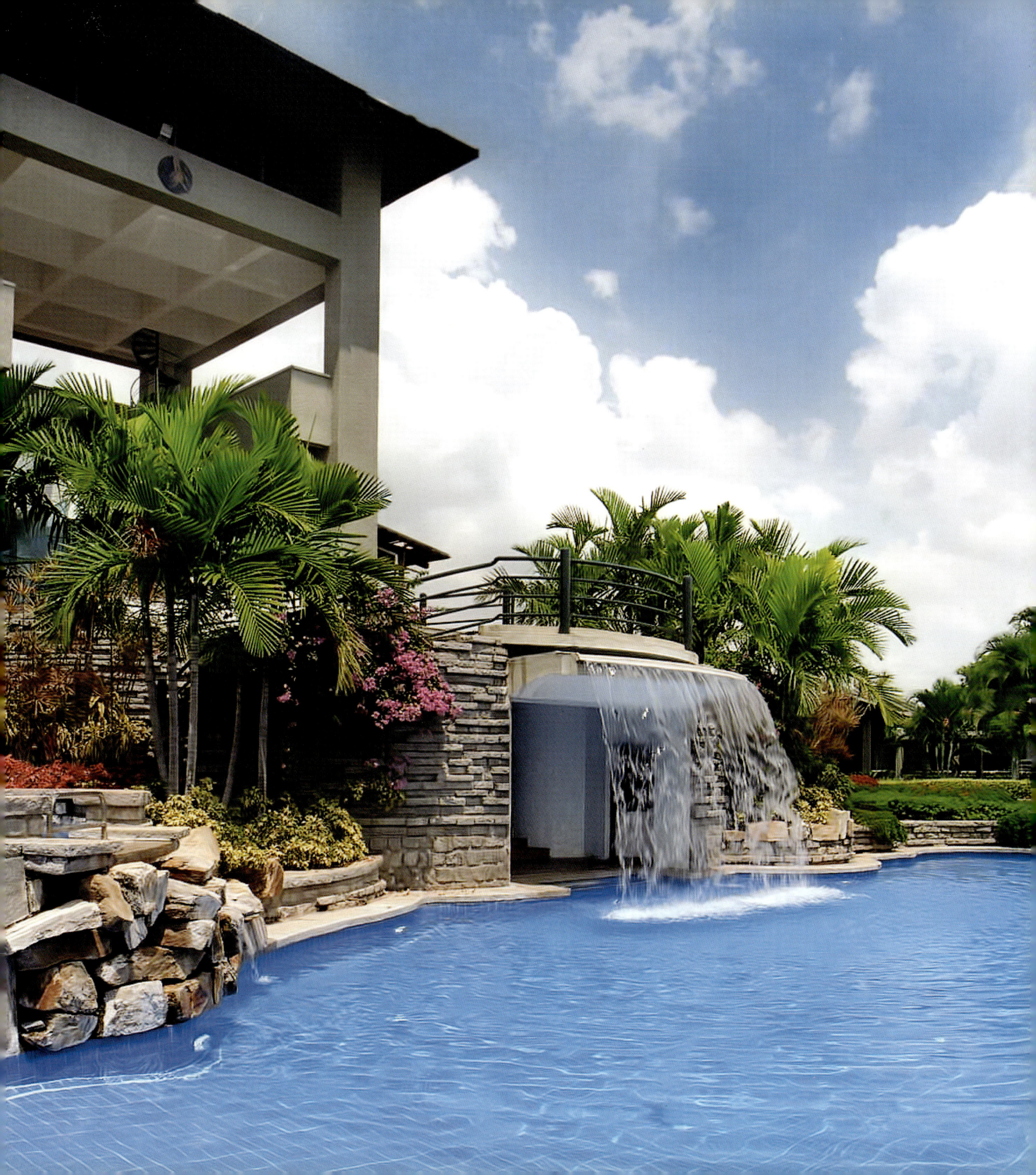

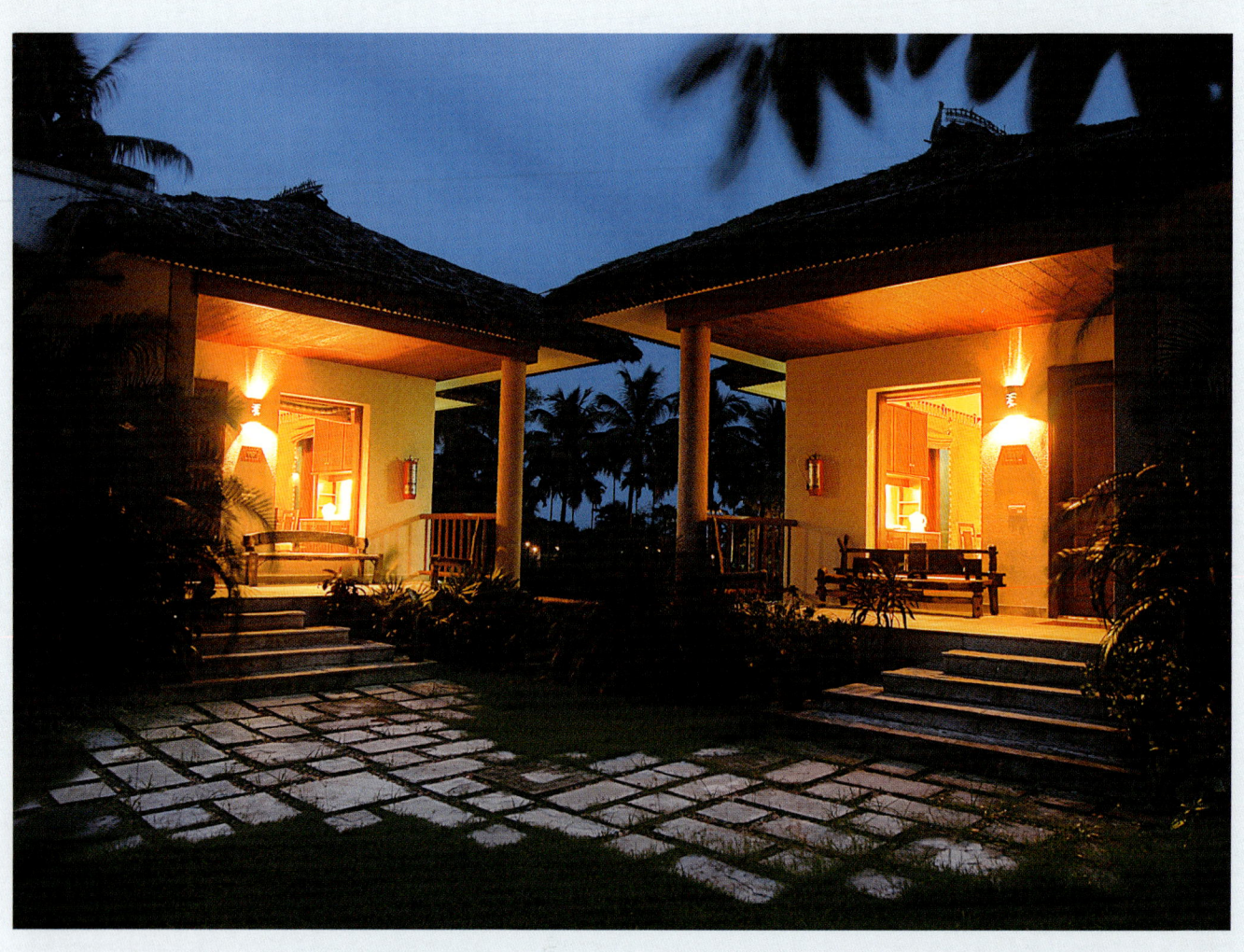

The Vedic Village, Kolkata

attaining nirvana in the lap of luxury

Acres of organic farmland surrounded by tranquil water bodies make The Vedic Village outside Kolkata, an ideal option for healing, unwinding and de-stressing...

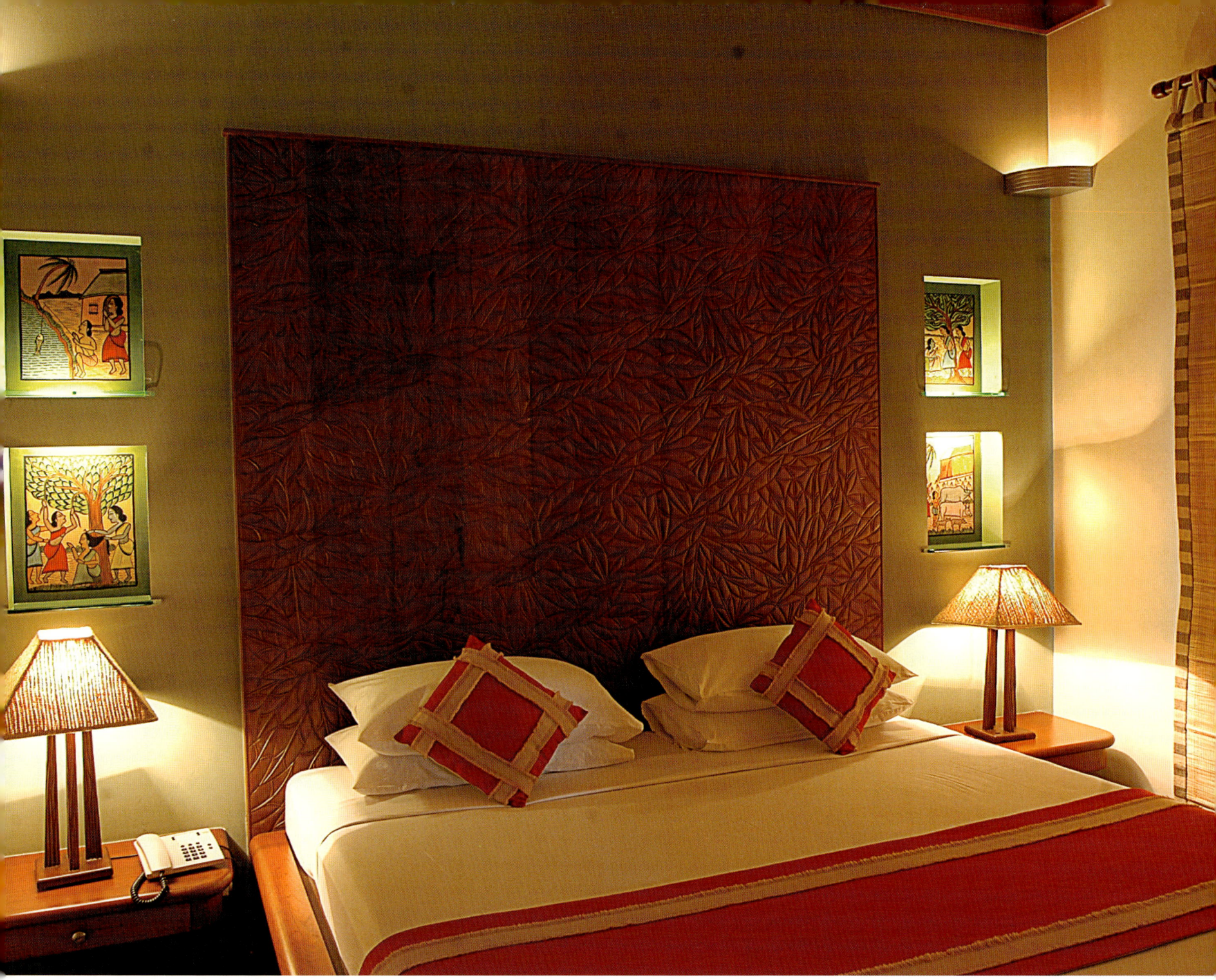

In a world that is seeking the ecological side of luxury, this spa resort offers a host of health, wellness and fitness facilities through a range of Ayurveda, Naturopathy and feel-good therapies, and rituals. The objective: to attain nirvana in the lap of luxury.

Rich earth tones juxtaposed with soothing greens, natural fibres and colourful Madhubani paintings come together in this guest suite, continuing the nature theme of the resort. **Page 138:** *The Vedic Village has earned its reputation as one of the best resorts, offering a seamless fusion between five-star amenities and ethnic ambience.*

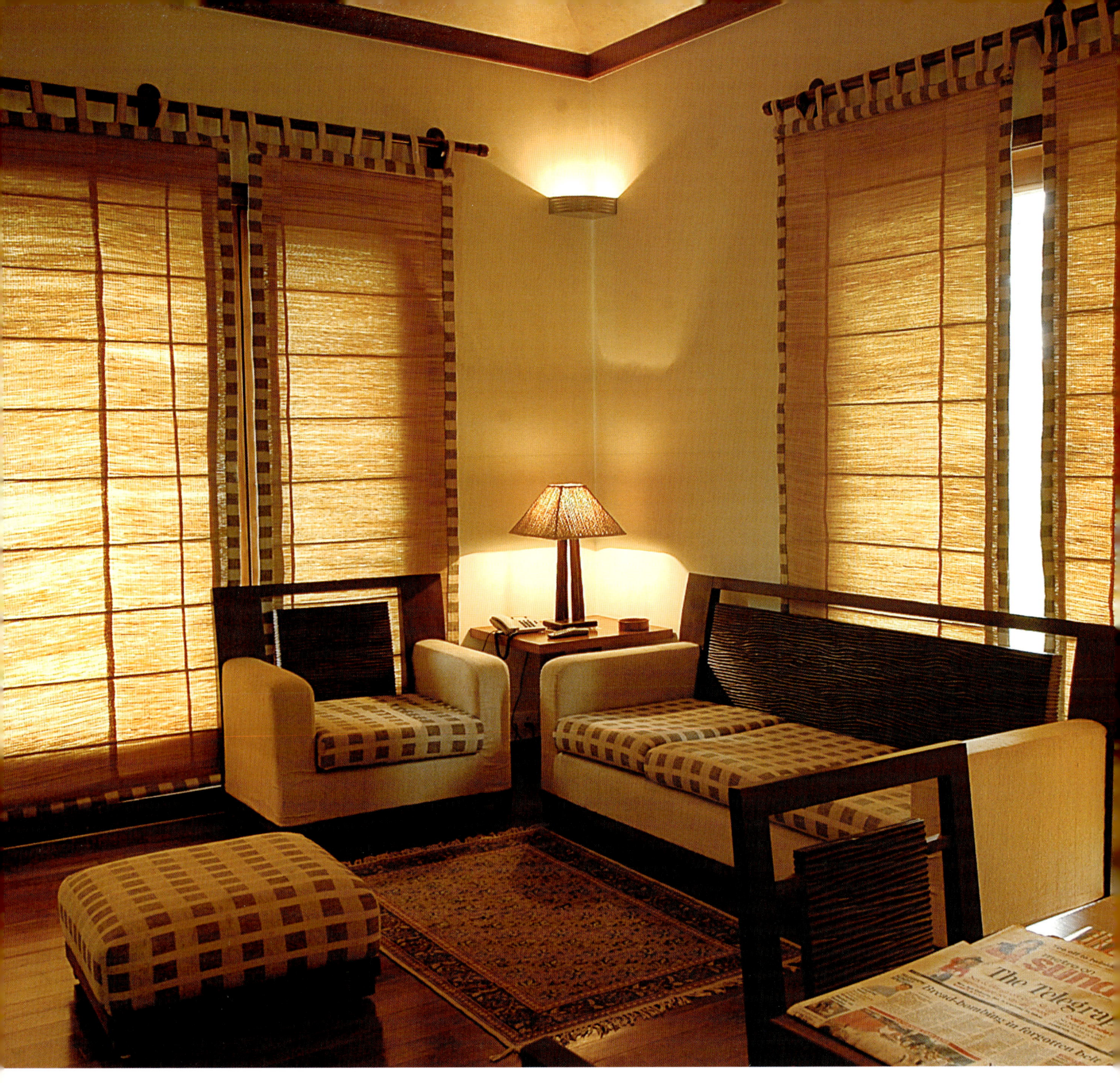

Natural fibres are used to highlight contemporary design sensibilities. Calming brown tones are brightened with a red bloom in the vase.

This is The Vedic Village – a unique spa resort experience with the flavour of the Indian countryside. Set in the exclusive Rajarhat Megacity – a 20 minute drive from the Kolkata city airport and 40 minutes away from the city centre – the resort and spa is the nucleus of the complex surrounded by farmlands, which forms a part of the bungalow estate. A perfect place to relax, renew and rejuvenate.

The Vedic Village offers the world's finest luxury and holistic wellness. It has earned its reputation as one of the best, offering seamless fusion between five-star amenities and ethnic ambience. Within this ethnic environment nestles a multi-residential resort.

The Vedic Village offers its guests a vast choice of dramatic villas, suites, studios and farmhouse rooms including the super luxury Lakeside Villas and Earth Villas. Each is a testament to architectural achievement, where the concrete form and the rural fuse in magnificent harmony. With a spectacular view, the residences transport the guests to another world while ensuring every comfort and luxury of contemporary times.

Guests can stay in an exclusive choice of villas built on a natural lake with a spacious lounge and luxurious bathroom to relax and unwind; Earth Villas constructed in authentic rural style but with all the star comforts to pamper the weary traveller; Guest

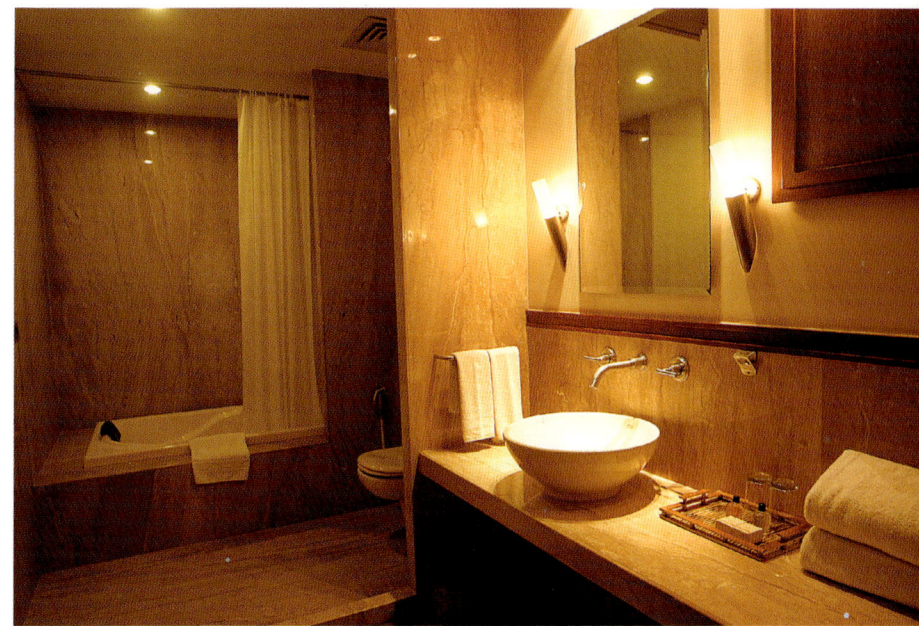

The plush and trendy bathrooms incorporate all state-of-the-art amenities.

Suites (single & double bedrooms with separate sitting room and bathrooms) attached to the resort complex, providing a new experience in hospitality; and Studio and Farm House Guest Suites which are a cost-effective choice for the budget traveller.

An array of outdoor facilities including horse riding, archery, cricket, football, croquet, biking, etc. are available to add to the fun experience. A gym, library and a host of indoor games including pool, table tennis, carrom, air hockey and board games are also an add-on feature. A state-of-the-art Medical Spa is at hand to check you out, should you need it or just pamper yourself to a 'feel good' experience in the spa.

Of note at the resort is the lotus-shaped swimming pool that has been designed with a waterfall which tempts day-long soaking and is part of the restorative experience.

Guests also have the opportunity to enjoy a multi-cuisine fare from specialised chefs or may try the resort's Wellness Food range on offer. The Vedic Village provides a healthy environment for

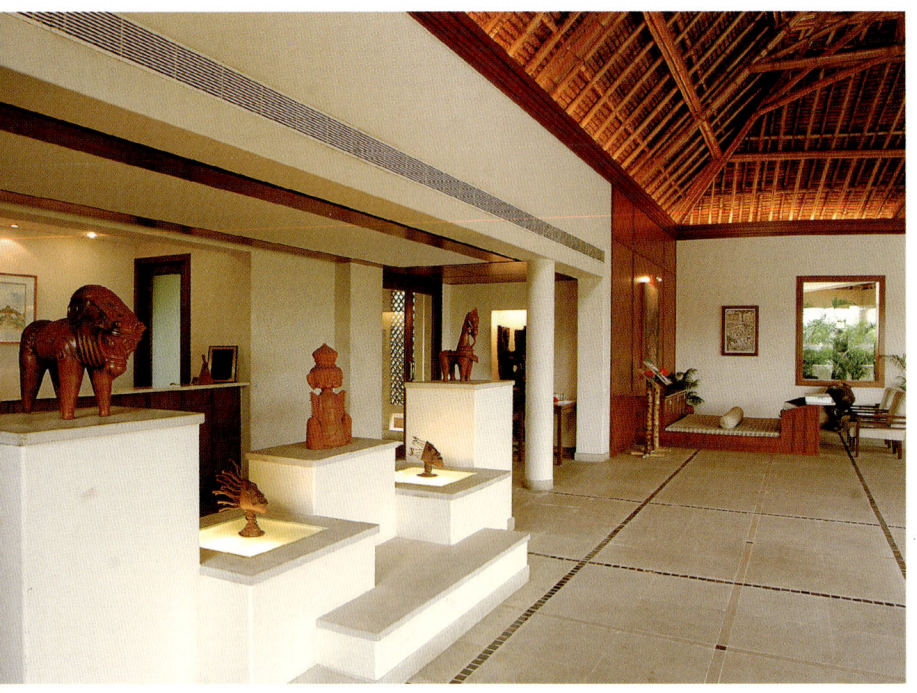

Traditional Terracotta figurines grace many a seating area in the resort.

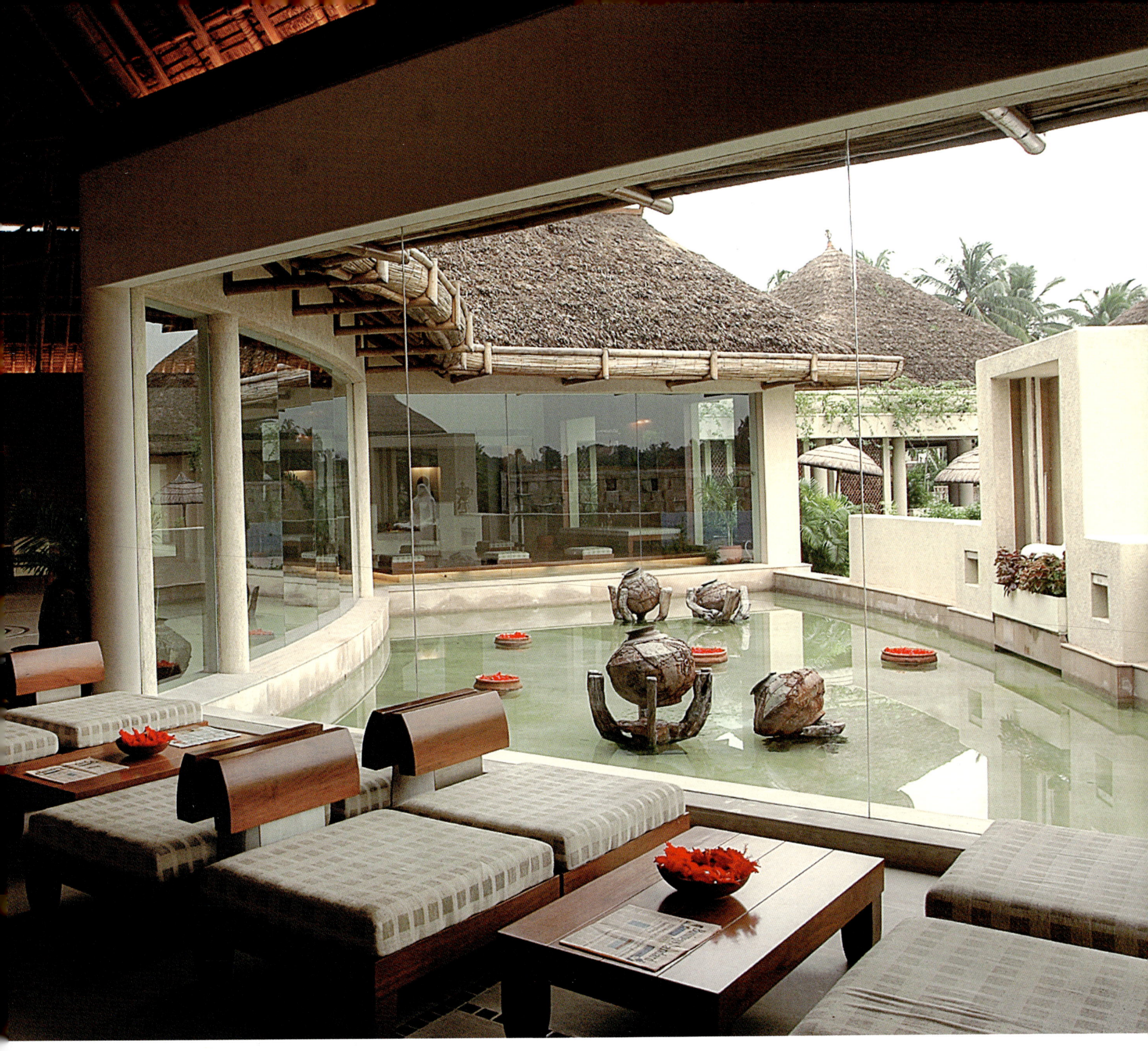

The Vedic Village is a testament to architectural achievement, where the concrete form and the rural fuse in magnificent harmony, seen here in the exquisite thatched roofs and a small water body full of artistic sculptures.

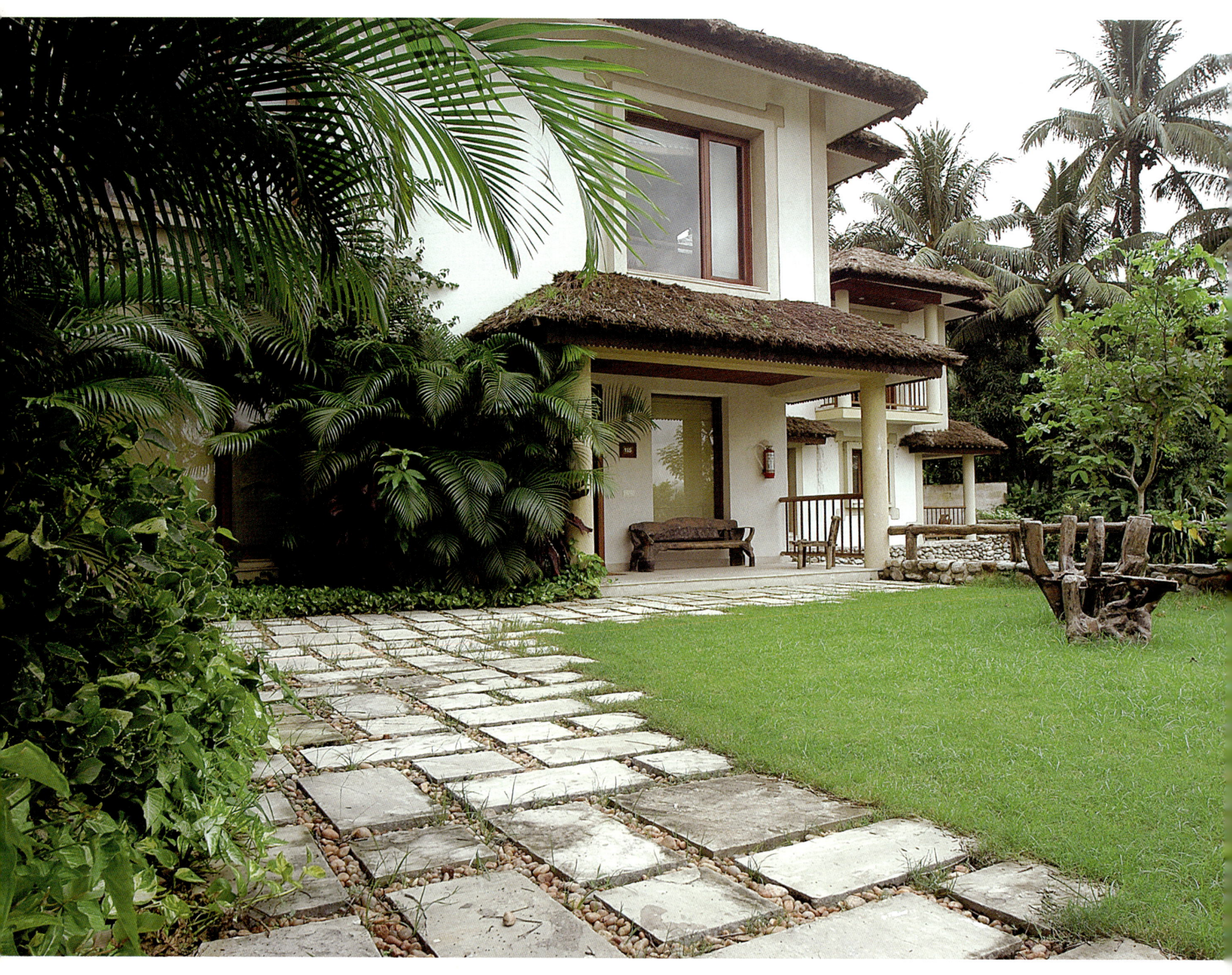

Thatched roof cottages set amidst lush green gardens.

intensive training sessions. Combine this with morning Yoga and a fitness regime, health consultations, wellness advice, adventure sports and even farming exercises.

You can relax at Agni (fire), the lounge bar at Vedic Village, where you can savour some of the finest wines and spirits whilst enjoying the beautiful vista that surrounds it. Enjoy the spread at Yagna (the source), the multi-cuisine restaurant which caters to all tastes. The menu provides a choice of Indian, Oriental or Continental fare. Should you be undergoing a Wellness Programme at the Medical Spa, you can have a choice of Wellness Meals, specially designed and prepared to keep you healthy.

Bhoomi (earth) is a unique and much talked-about 'specialty' restaurant. The ambience is a village and the cuisine – mouth-watering, traditionally Bengal.

At Vedic Village, you have a choice of rejuvenation and therapeutics to choose from – Spa, Naturopathy, Wellness, Yoga or the traditional Kerala Ayurveda.

In Ayurveda, the emphasis is on Shodhana Panchakarma – the zenith of detoxification and rejuvenation protocols. The resort is equipped with an exclusive pharmacy for authentic Ayurvedic formulae from The Arya Vaidya Sala, Kottakkal, Kerala.

Some of the exclusive treatments at the resort include the Aloe and Fruit Body Wrap. This exotic wrap consists of full body aromatherapy massage, using a sea salt body scrub mixture, massage with pure aloe and a seasonal fruit followed by a banana leaf wrap.

The Honey and Yogurt Body Polish with Aromatherapy Massage consists of a full body aromatherapy massage, sea salt body scrub, pure forest honey application and nourishing massage with cool natural yogurt.

There is also the Dead Sea Mineral Mud Wrap, which consists of a relaxing full body massage, stimulating sea salt body scrub and therapeutic Dead Sea Mineral Mud body wrap followed by a covering with banana leaves.

The Revitalising Coffee Ritual is a relaxing, specially formulated foot soak with bath salts, followed by a relaxing almond oil Swedish massage. A Cappuccino Scrub topped with a mochaccino paste. An invigorating warm shower followed by coffee moisturising lotion application, ending with a hot cup of coffee.

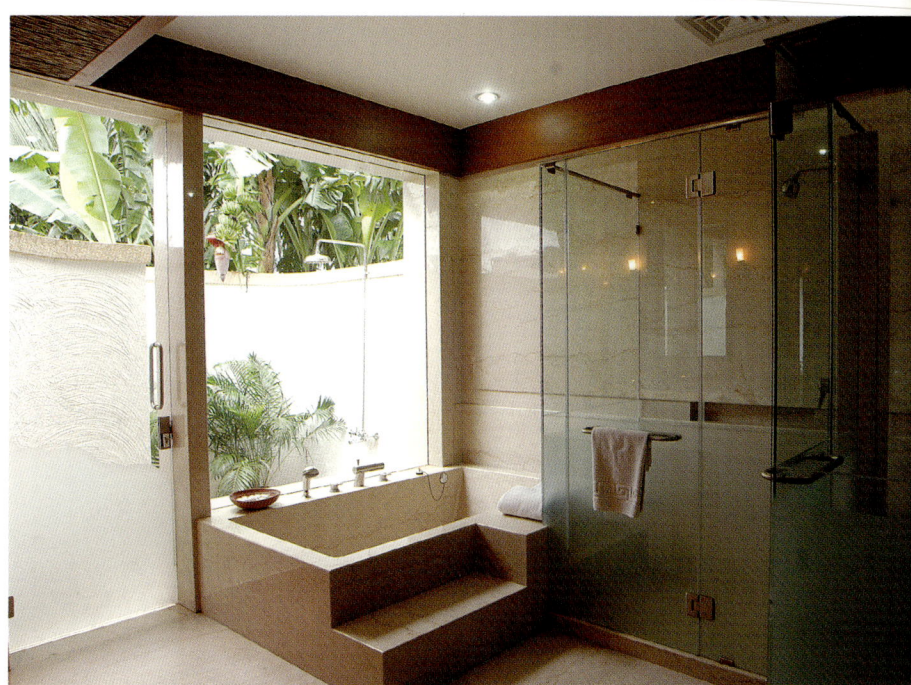

Top: A relaxing way to spend the evening sitting in front of a small water body. *Bottom:* Shower areas open to nature is a fascinating design element.

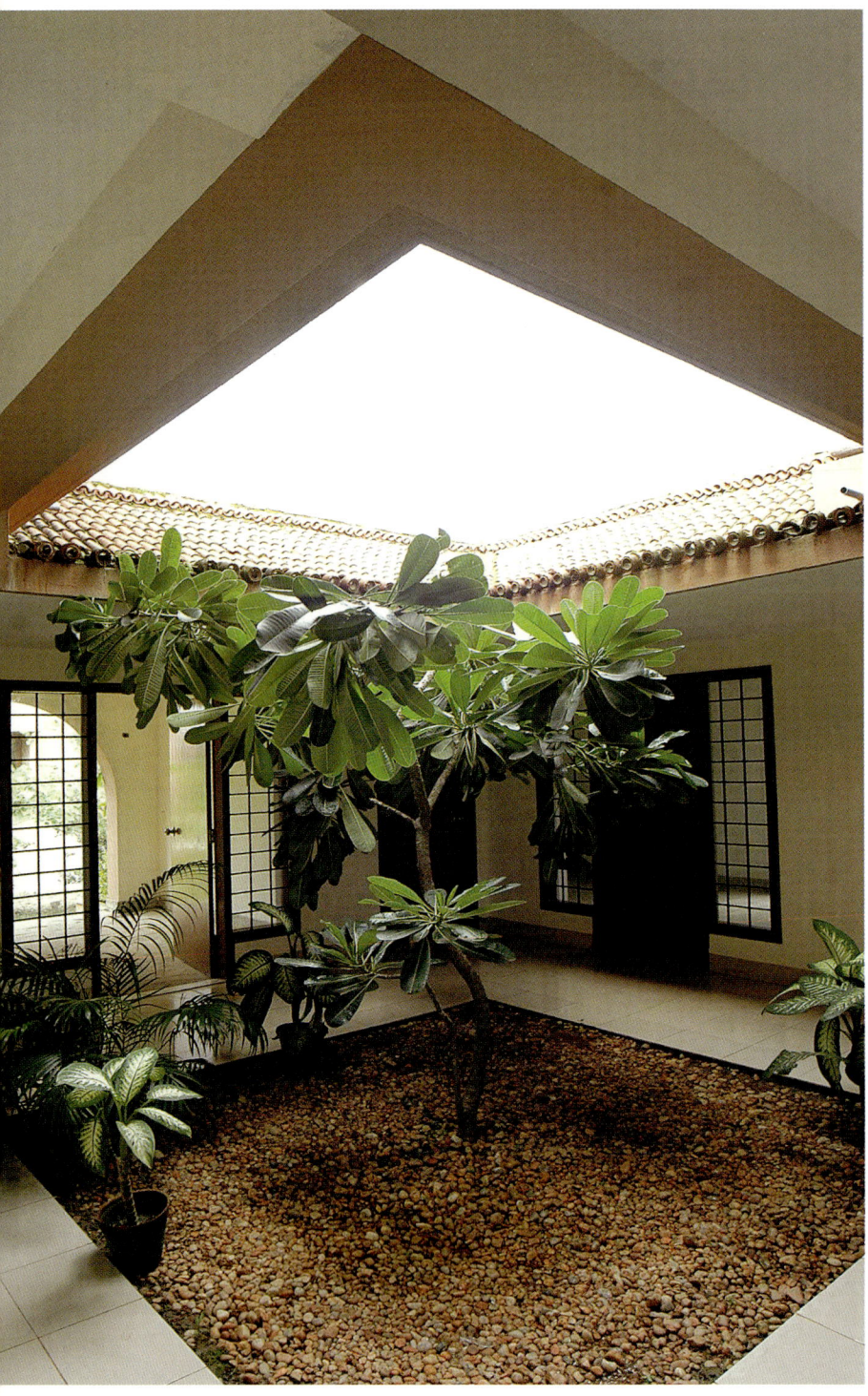

A peep into a small courtyard full of pebbles and potted plants, with natural light bathing the place.

Last, but not the least, there is the Cellulite Breakdown. This is a special massage technique which incorporates special fat reduction natural medicines, that aid in the breakdown of fat cells and removes fluid accumulation from the tissues, resulting in effective weight control.

Yoga at The Vedic Village Spa is intended to improve and develop the physical health and induce tranquility of mind with a final goal of self-realization. It offers courses, classes, workshops, meditation sessions and stress management programmes.

The resort's Wellness Doctors are highly experienced and are extensively trained by a specialist from Australia. Unique diagnostic methods are adopted for a comprehensive health evaluation. Health supplements are specially blended to suit the individuals.

At The Vedic Village, there is extensive counseling on diet and lifestyle, designed to take care of your specific condition and is based on effective natural principles. Other areas where you can seek advice is acupuncture and homeopathy.

Though the resort keeps you occupied throughout your stay, but if you still have some time, then a drive to the City of Joy – Kolkata – is a must. There you can see monuments like the Victoria Terminal, or the rituals performed by the pundits at the banks of the holy Ganges River or just saunter along its many bazaars taking in the smell of fish and experiencing the Bengali way of life.

Definitely, a divine experience for your mind and soul.

The entrance to one of the cottages looks inviting.

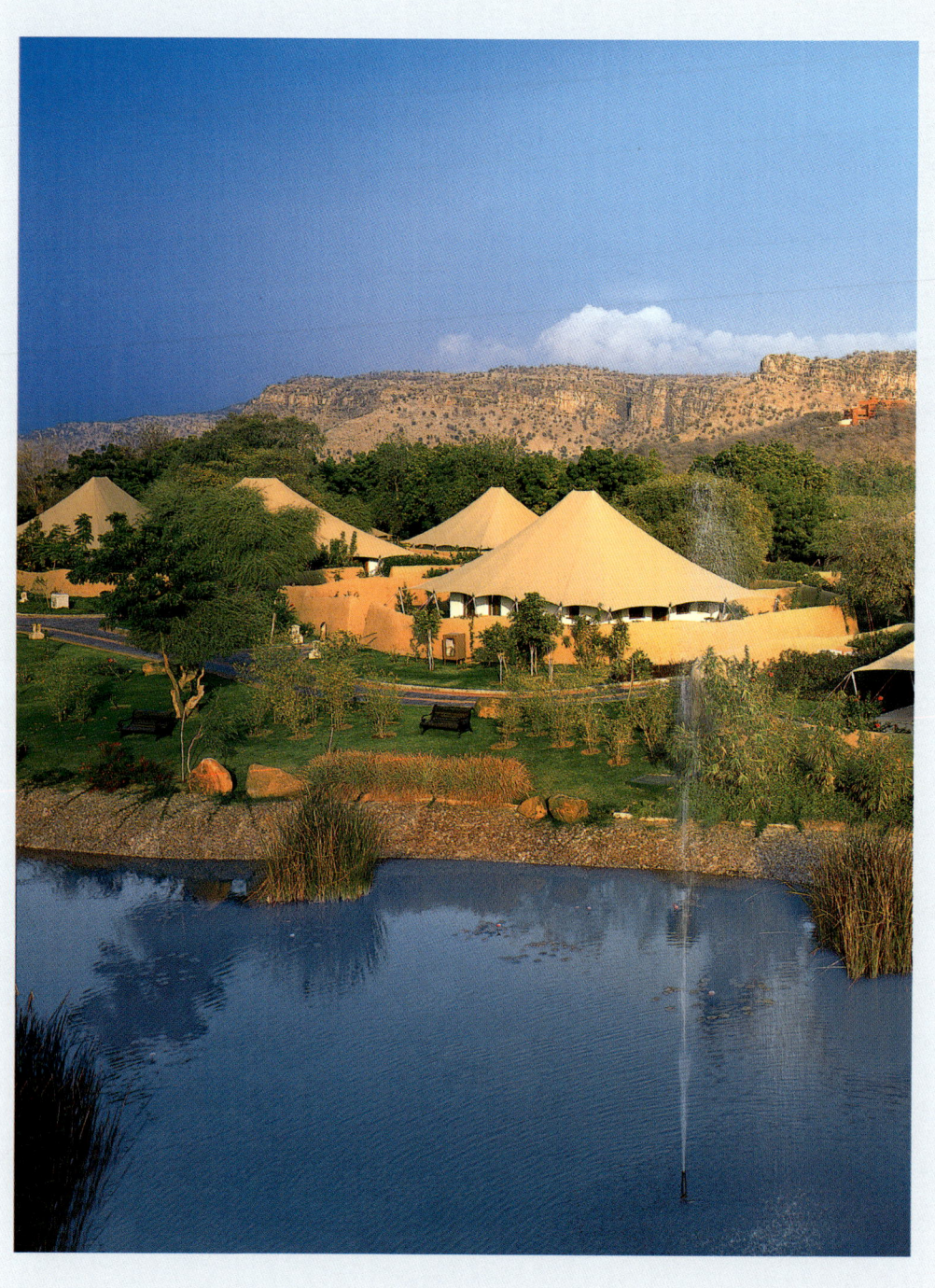

The Oberoi Vanyavilās, Ranthambhore

secrets of the forest

The Oberoi Vanyavilās at Ranthambhore pampers you with relaxing massages after an adventurous day in the jungle – enabling you to become one with nature...

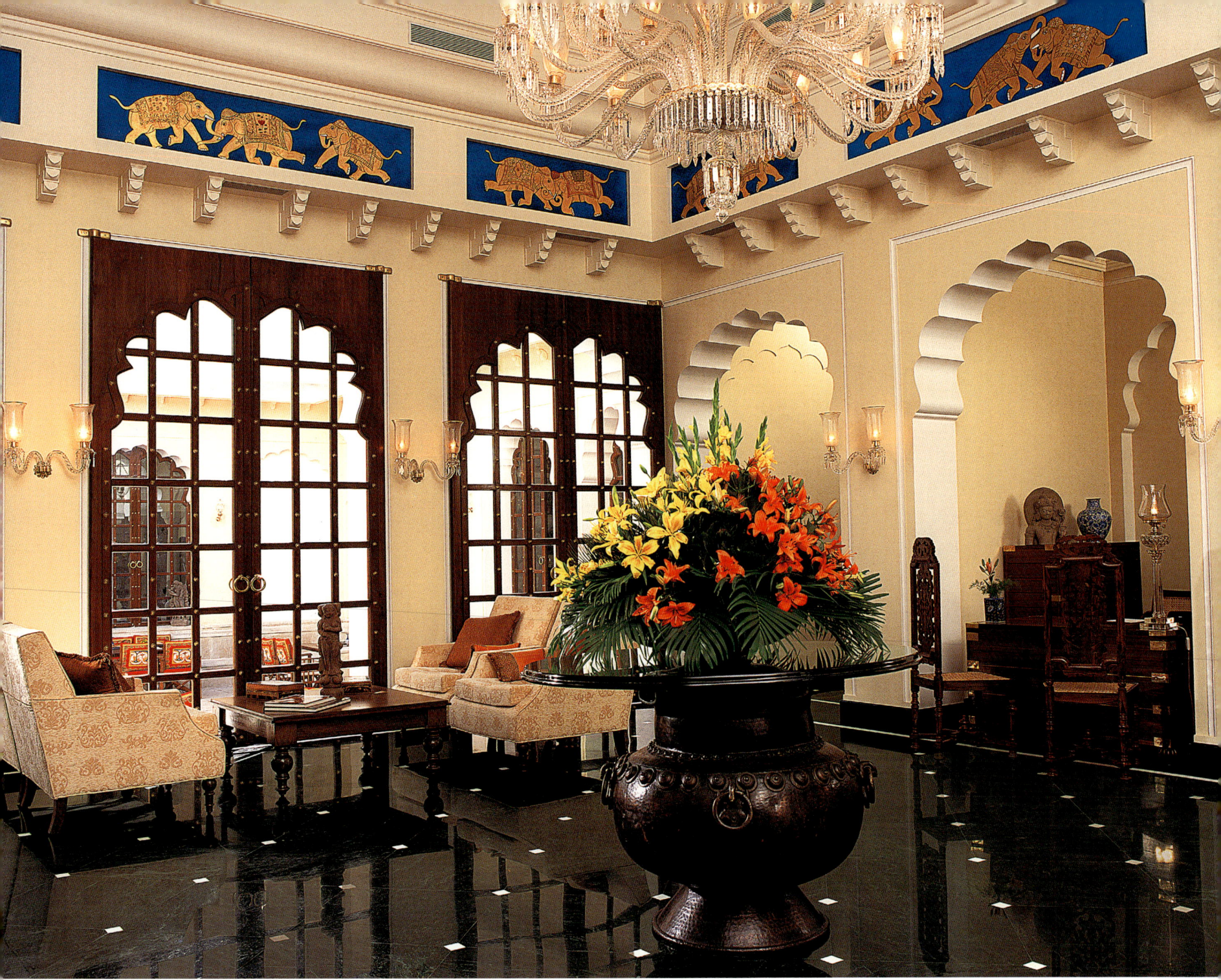

The drive down the national highway from Jaipur, winding its way through thick forests, heightens your expectations, kindling your adventurous spirit in the bargain. As you drive into the resort, you come across beautiful gardens where the riot of colour provides you with the charm of enjoying nature's bounty. Its uniqueness lies in the fact that it is

The main building of this Oberoi resort has been fashioned in the style of a traditional Rajasthani haveli or mansion. Classic furniture, traditional brass and stone artifacts, and elephant murals adorn this sitting area. **Page 150:** *Aptly named The Oberoi Vanyavilās, this resort is set in 22 acres of landscaped gardens with a meandering water body and more than a thousand fruit trees against a backdrop of the spectacular Aravalli hills.*

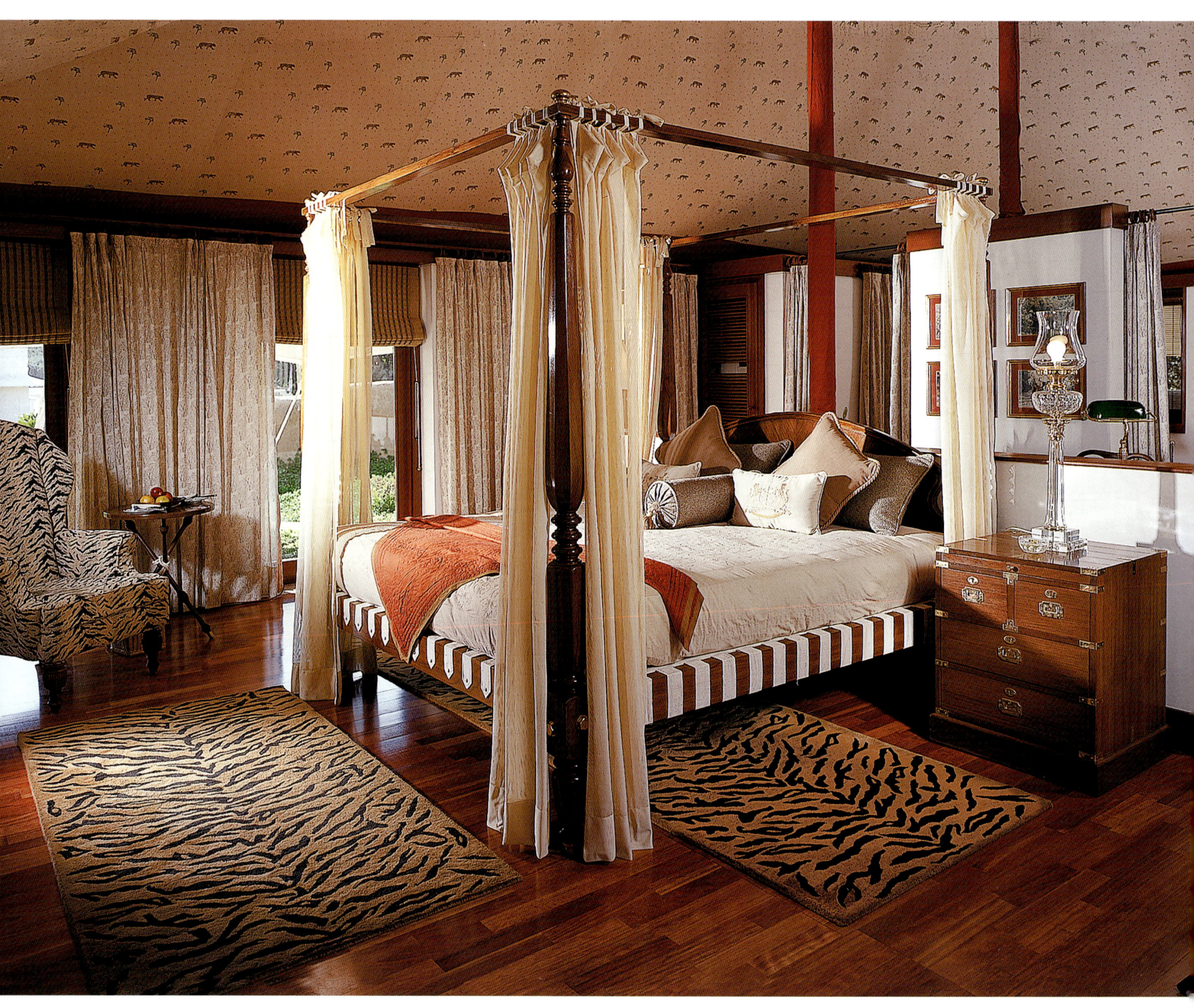

Twenty-five elegantly appointed air-conditioned tents are located discreetly across the resort. With teakwood floors, luxurious bathrooms, private decks and walled gardens, the tents ensure that neither privacy nor luxury is sacrificed while seeking adventure. The jungle theme is emphasized with tiger-print rugs, colonial lamps and the four poster bed.

adjacent to the famous Ranthambhore National Park and Tiger Reserve in Rajasthan, making it probably the first luxury jungle resort of India.

The Oberoi Vanyavilās is located on the Ranthambhore road in Sawai Madhopur district of Rajasthan. From Jaipur city, it takes approximately three-and-a-half hours to reach the jungle resort. The distance from the nearest railway station (Sawai Madhopur) is only five kilometers. Most trains going from Delhi to Mumbai stop at the Sawai Madhopur railway station.

Aptly named The Oberoi Vanyavilās, this resort is set in 22 acres of landscaped gardens with a meandering water body and more than a thousand fruit trees against a backdrop of the spectacular Aravalli hills. A ceremonial gatehouse provides a dramatic entry to the main building, fashioned in the style of a traditional haveli or mansion.

Reflection pools, brilliantly painted frescoes and richly detailed interiors recreate the splendor of a royal era. Twenty-five elegantly appointed air-conditioned tents are located discreetly across the resort. With teakwood floors, luxurious bathrooms, private decks and walled gardens, the tents ensure that neither privacy nor luxury is sacrificed while seeking adventure.

The restaurant serves fine Indian and Continental cuisine and offers al fresco dining in the adjoining courtyard. Overlooking a mango grove, the Library Bar presents a selection of wines, spirits and cigars, and is well-stocked with a variety of books. The setting is perfect for exchanging jungle stories and listening to lectures by eminent wildlife expert and conservationist, Fateh Singh Rathore.

Exclusive therapy suites, overlooking the lush landscape, are a special feature of the resort. After an adventurous day, guests can pamper themselves with relaxing massages by trained masseurs at the Oberoi Spa that provides a sanctuary of peace in an environment totally conducive to relaxation.

After an encounter with the rugged beauty of nature, discover the sheer pleasure of relaxation. Feel the transformation as trained therapists restore the natural balance of your body with personalised holistic therapies based on Ayurveda and western techniques.

The spa has three private therapy suites overlooking the lake and mango orchards. These are designed to provide complete privacy when receiving a series of therapies and are ideally suited for couples. Each includes a steam room and a freestanding Victorian bathtub. You can enjoy the luxurious ambience of these

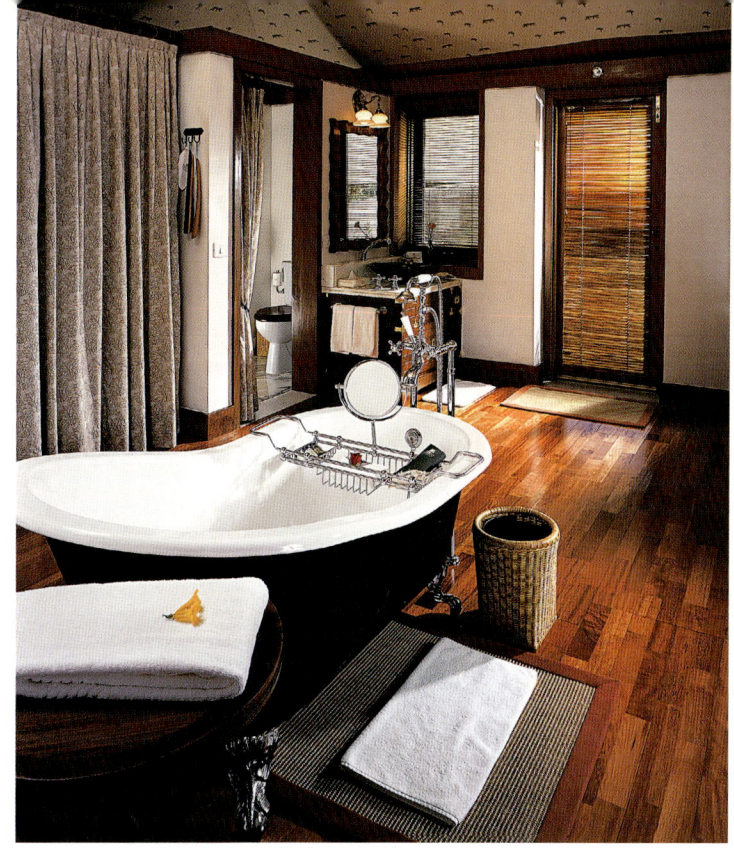

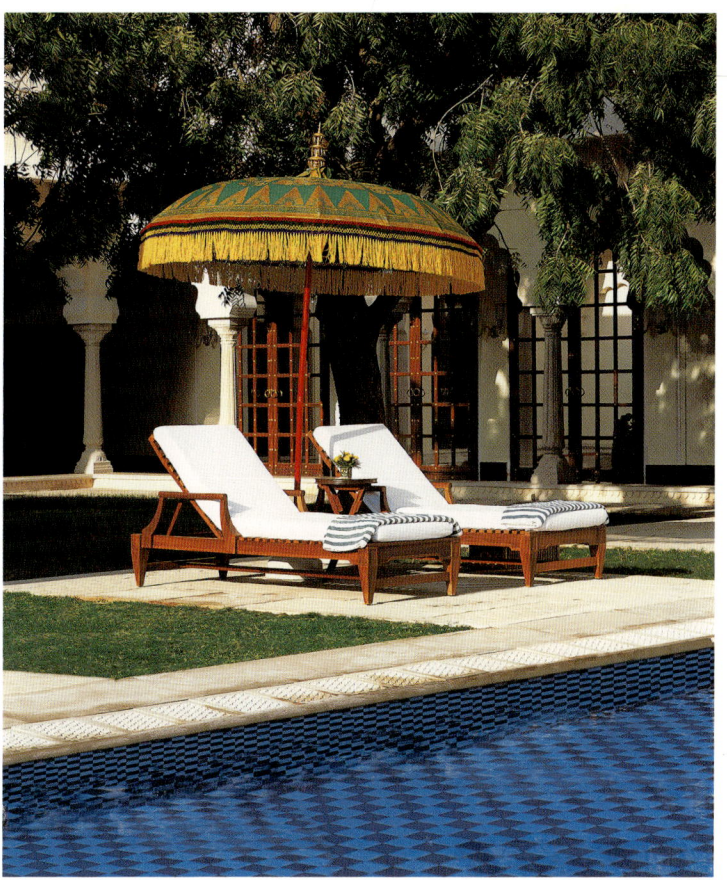

Top: A glimpse of the luxurious bathroom in one of the Luxury Tents. Bottom: The swimming pool in front of the main building of the resort. The colourful Rajasthan finds reflection in the umbrella.

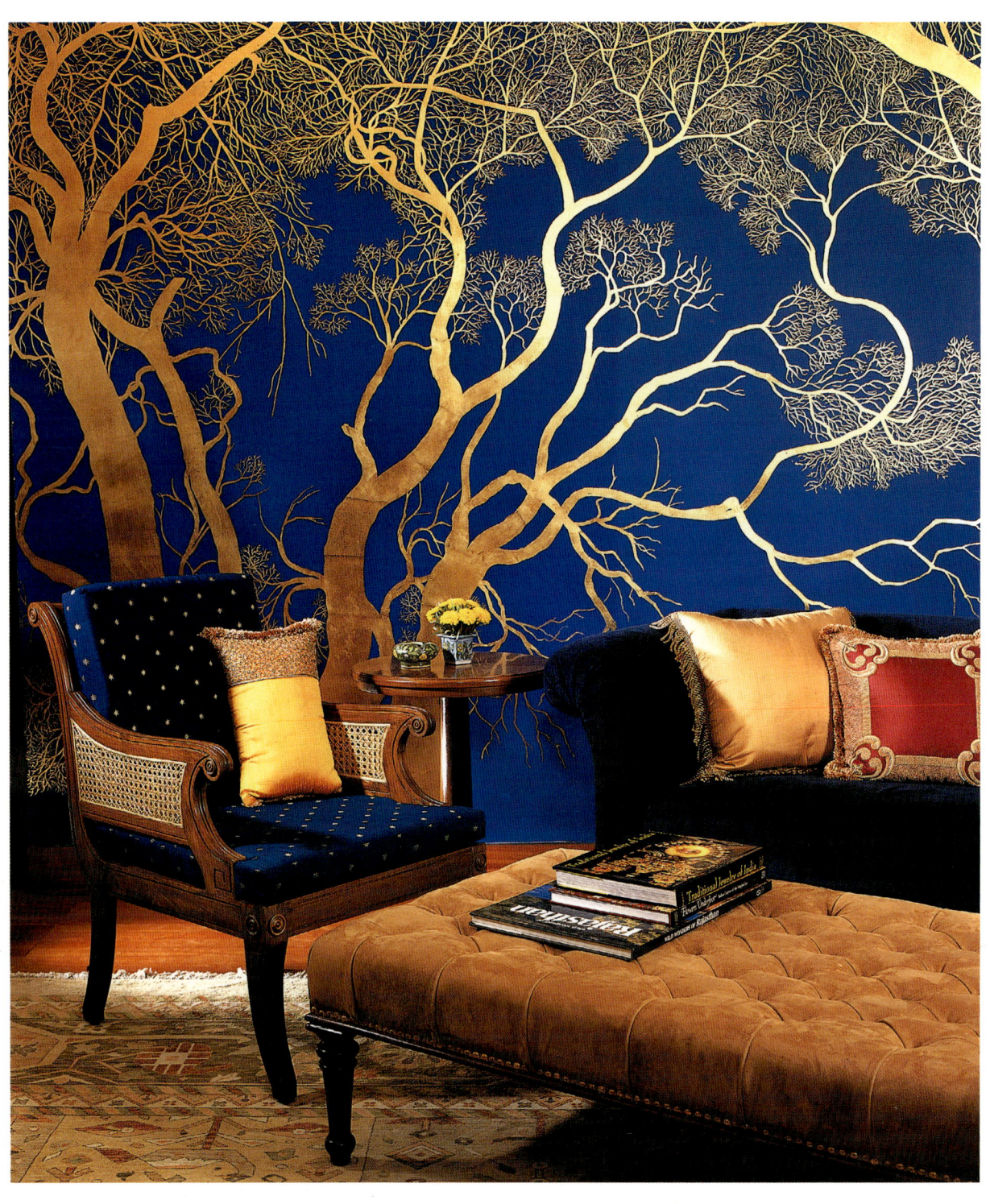

Brilliantly painted frescoes and richly detailed interiors recreate the splendor of a royal era at The Oberoi Vanyavilās. Period furniture adds to the charm.
Opposite page: *The Library Bar with an elegant fireplace makes for an aristocratic evening at the resort. Wing-backed chairs share space with cushy couches for an eclectic feel.*

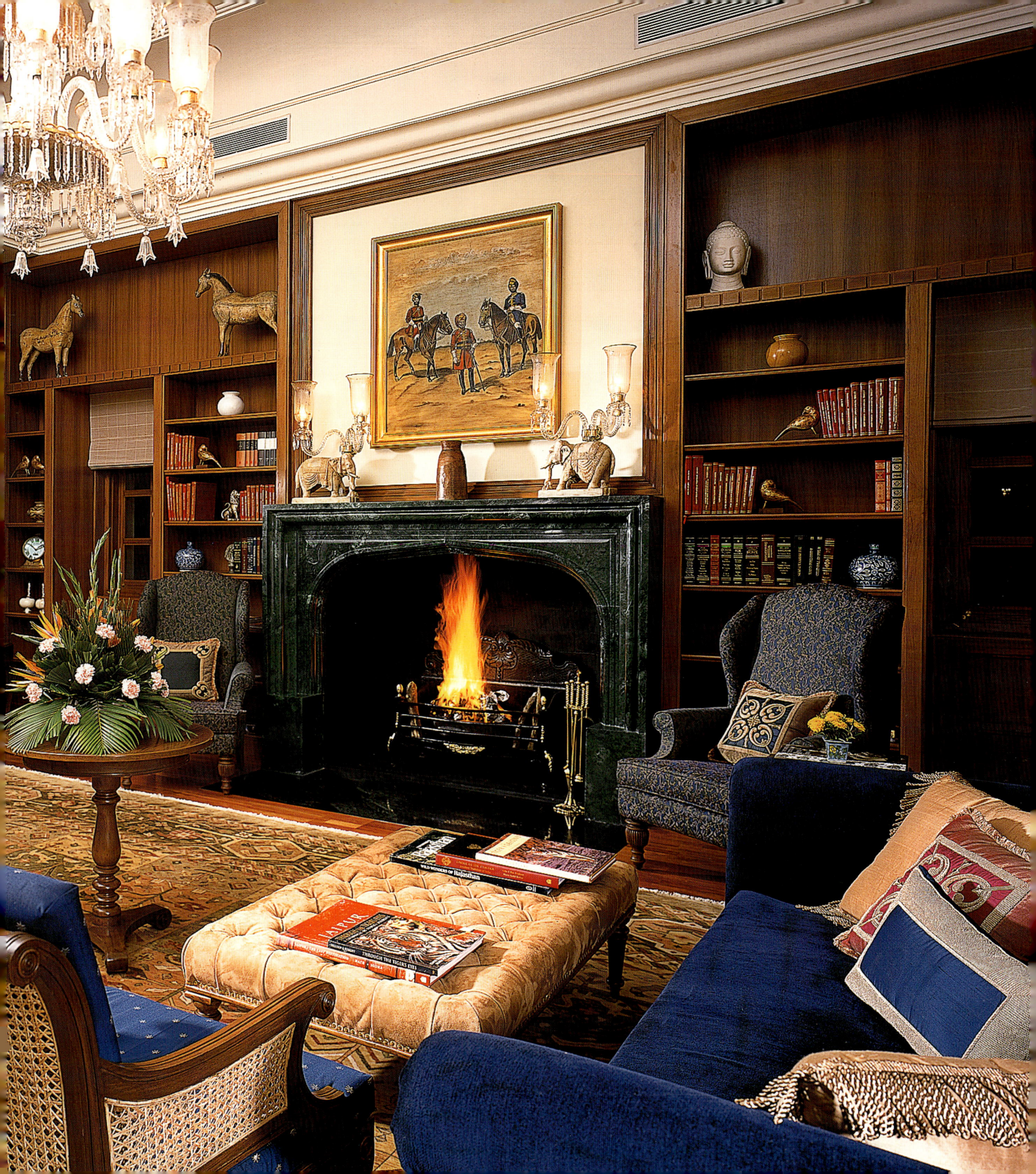

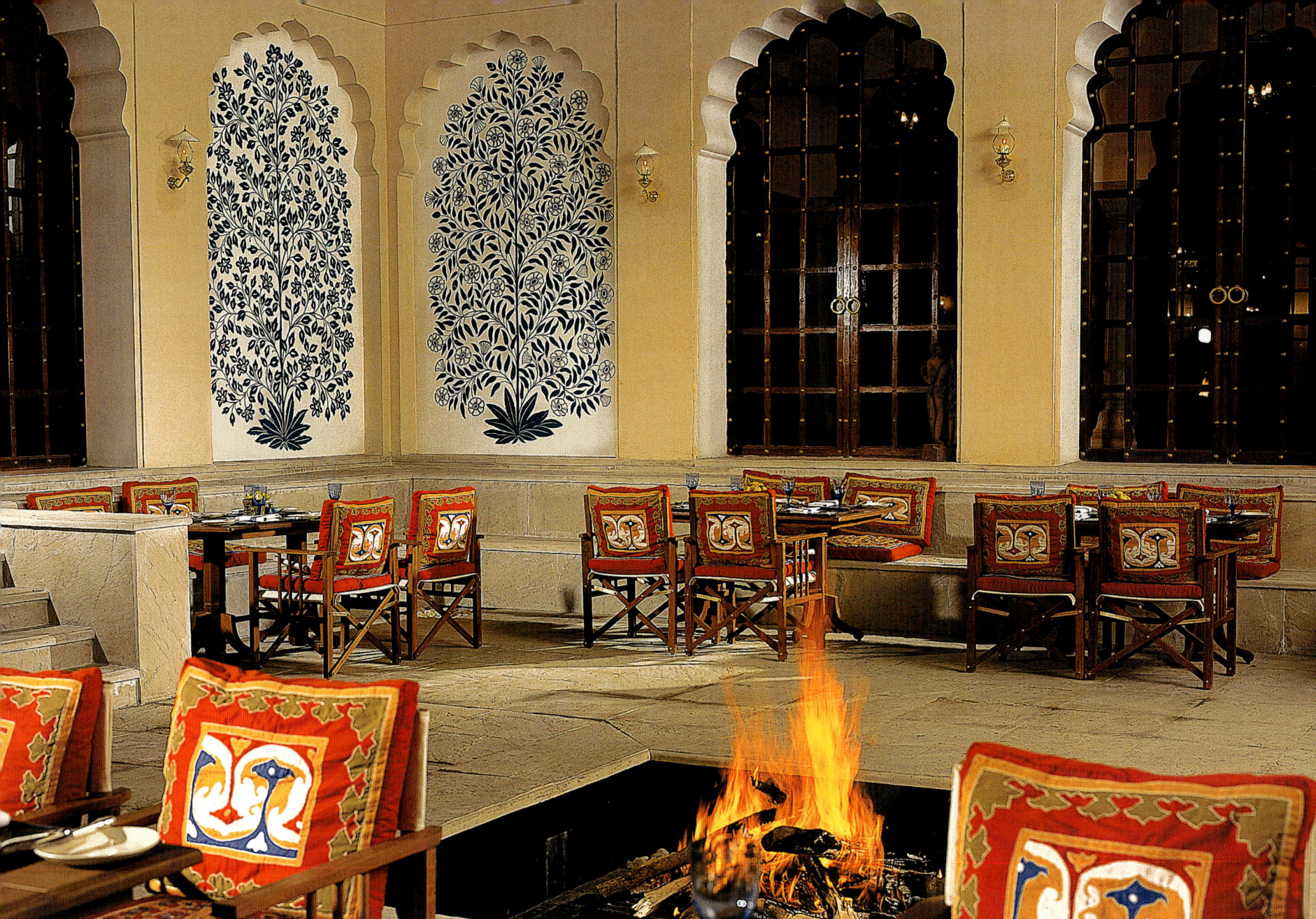

private suites with the soothing sound of birdsong, the beauty of hand-painted floral frescoes and the fragrance of the fruit groves, while you reflect on your inner self.

The therapies and programs range from the best in ancient Ayurveda to Aromatherapy. Holistic, non-clinical therapies are designed for rejuvenating, relaxing and pampering – enabling you to become one with nature.

The Oberoi Spa offers fascinating therapies for the mind and body that leave you feeling pampered and utterly relaxed. On offer are experiences like the Safari Sanctuary that rejuvenates, restores and pampers your body. Listen to the sounds of nature as your body is gently exfoliated followed by a nourishing application of mineral-rich Hungarian mud whilst a unique facial massage revives your complexion. Your therapist will pamper you with a relaxing Earth massage. Your treatment concludes with a rejuvenating bathing ritual. Relax and enjoy the signature tea blend as you reflect on your journey in the jungle.

Traditional Ayurveda therapies like Abhayanga, Shiroabhyanga and Marma Point Therapy are also available along with uplifting Yoga experiences.

Additional recreational activities within the resort include a heated outdoor swimming pool, Yoga and meditation session with the resident Yoga instructor and cooking classes. A 52 ft high watchtower affords spectacular views of the entire resort and

Rajasthani patchwork cushions on low chairs around a fireplace in the courtyard; just perfect for sharing hunting tales of yore.

adjoining countryside and offers an ideal setting for an intimate evening of cocktails and canapés.

Further recreational options include visiting the Ranthambhore National Park, which is a part of the much larger Ranthambhore Tiger Reserve, a Project Tiger Reserve. It is the only forest reserve in Rajasthan and in the entire Aravalli hill range, where wild Bengal tigers still exist. The dry deciduous habitat of the reserve makes it much easier to find and observe tigers in their natural habitat. Inside the park, you will come across the Ranthambhore Fort, which dates as far back as the 8th century A.D.

The park is contiguous to Sawai Madhopur town, and Misradhara gate, from where tourists enter the park, and it is about 12 kms from the heart of the town. The twin towns of Old City and Man town together constitute Sawai Madhopur. The railway station and the main market – Bajariya – are located in Man town. The older Old City lies 4 kms away in a valley surrounded by cliffs and steep slopes.

Almost all hotels in Ranthambhore are located along the Ranthambhore road from Man town. By Indian standards, Sawai Madhopur is a small rural town with a population of around 100,000. The town serves as a market for the rural hinterland and Sawai Madhopur is known for its winter guavas, red chillies and mustard.

A perfect ambience for adventure and relaxation! A resort highly recommended if you are looking forward to a relaxed weekend coupled with the thrill of sighting the great Indian tiger.

A wide-angle view of the resort, with its meandering water body and luxury tents in the background.

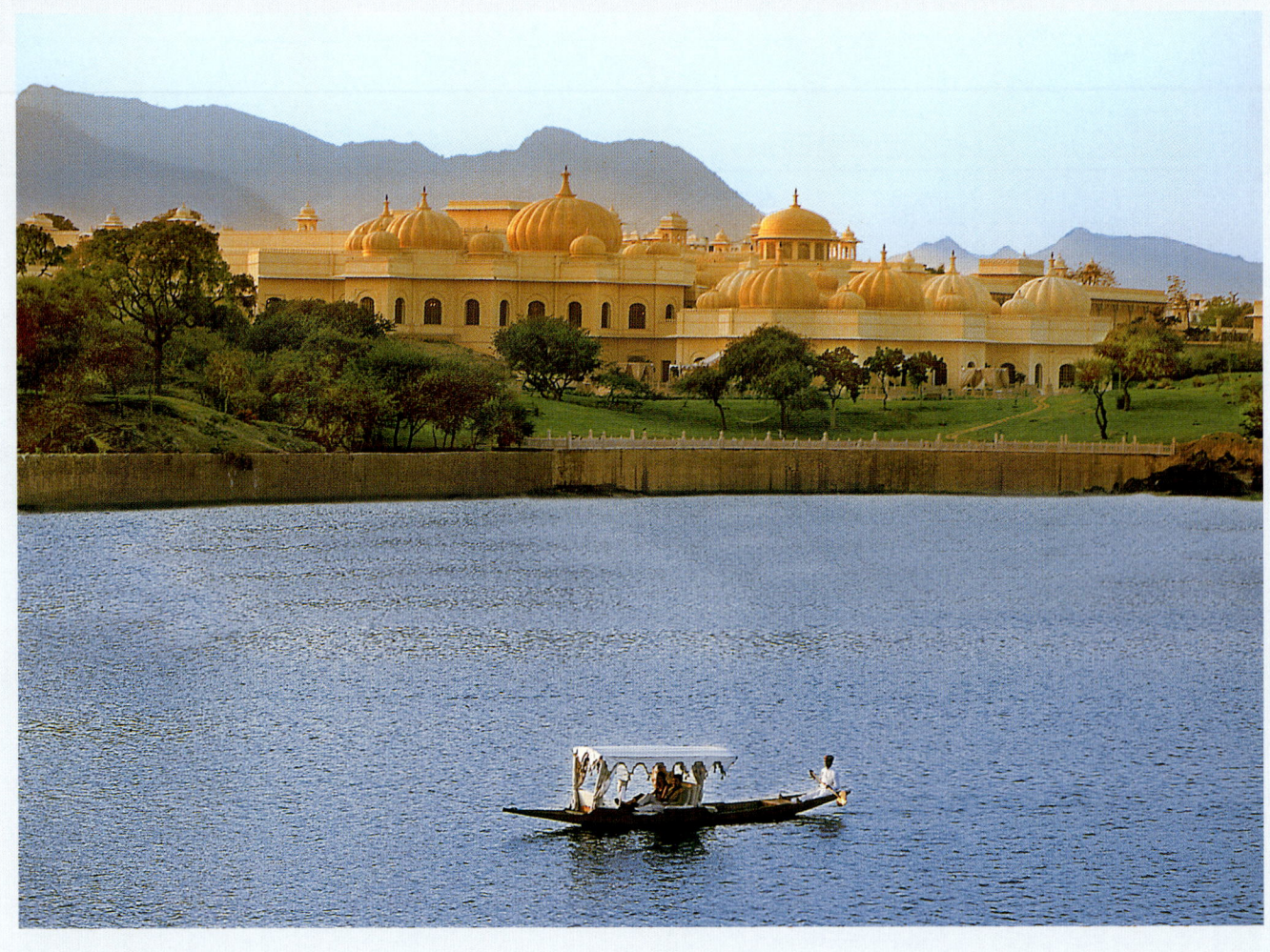

The Oberoi Udaivilās, Udaipur

recreating royal grandeur to perfection

Conceived as a splendid palace, The Oberoi Udaivilās creates the romance of the past and yet is completely in keeping with the 21st century...

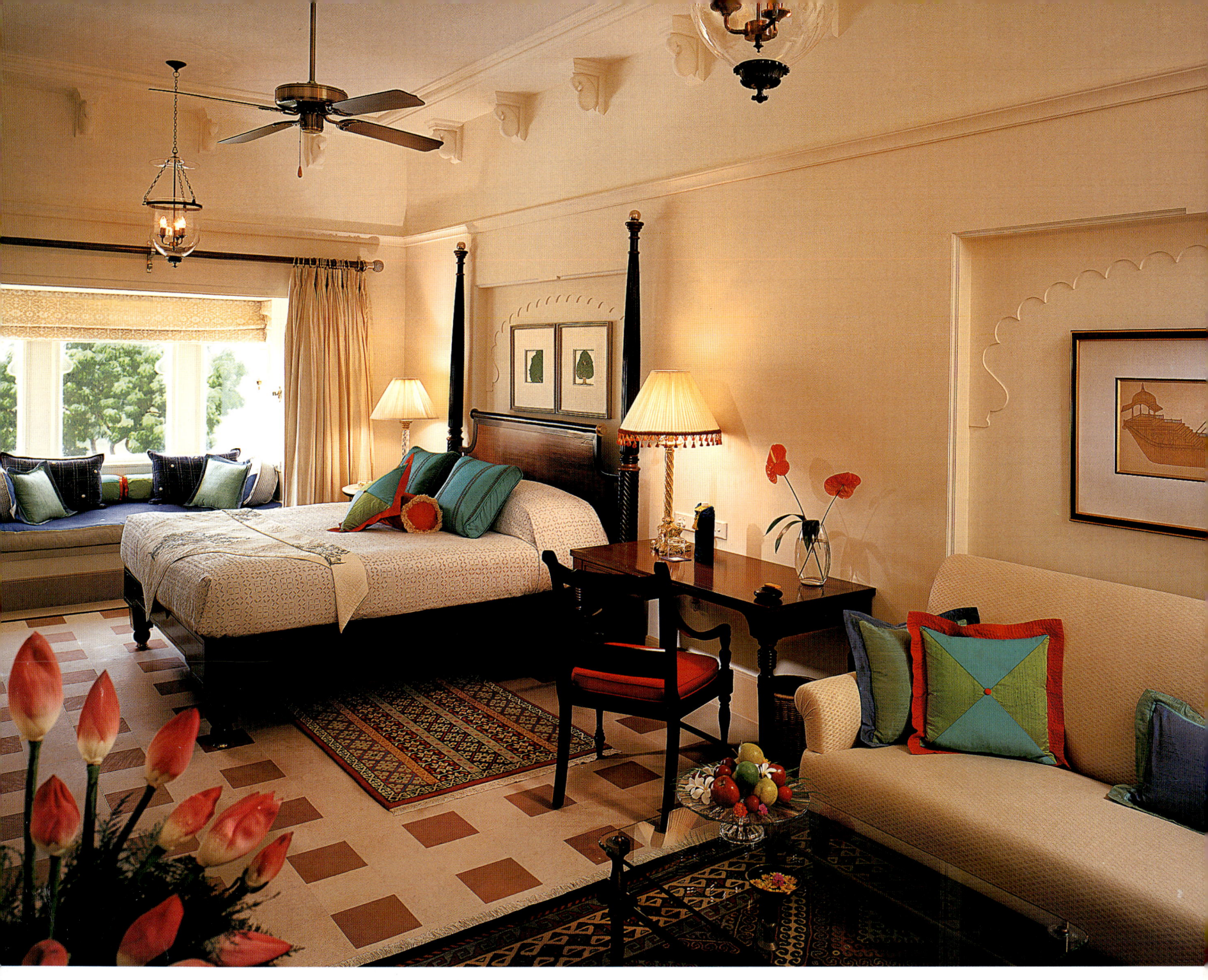

daipur (the City of Sunrise) is the capital of the erstwhile kingdom of Mewar, one of the oldest surviving dynasties in the world and was established around 1567 A.D. Legend has it that the royal Rajput rulers had descended from the Sun God. Set against this dramatic backdrop of the Aravalli range and steeped in the romance of the historic region of Mewar, The Oberoi Udaivilās, The Oberoi Group's luxury

Fit for Royalty – The guest rooms at The Oberoi Udaivilās are furnished in a princely style. **Page 160:** *Situated on the banks of the Lake Pichola in Udaipur, The Oberoi Udaivilās is set against the dramatic backdrop of the Aravalli range.*

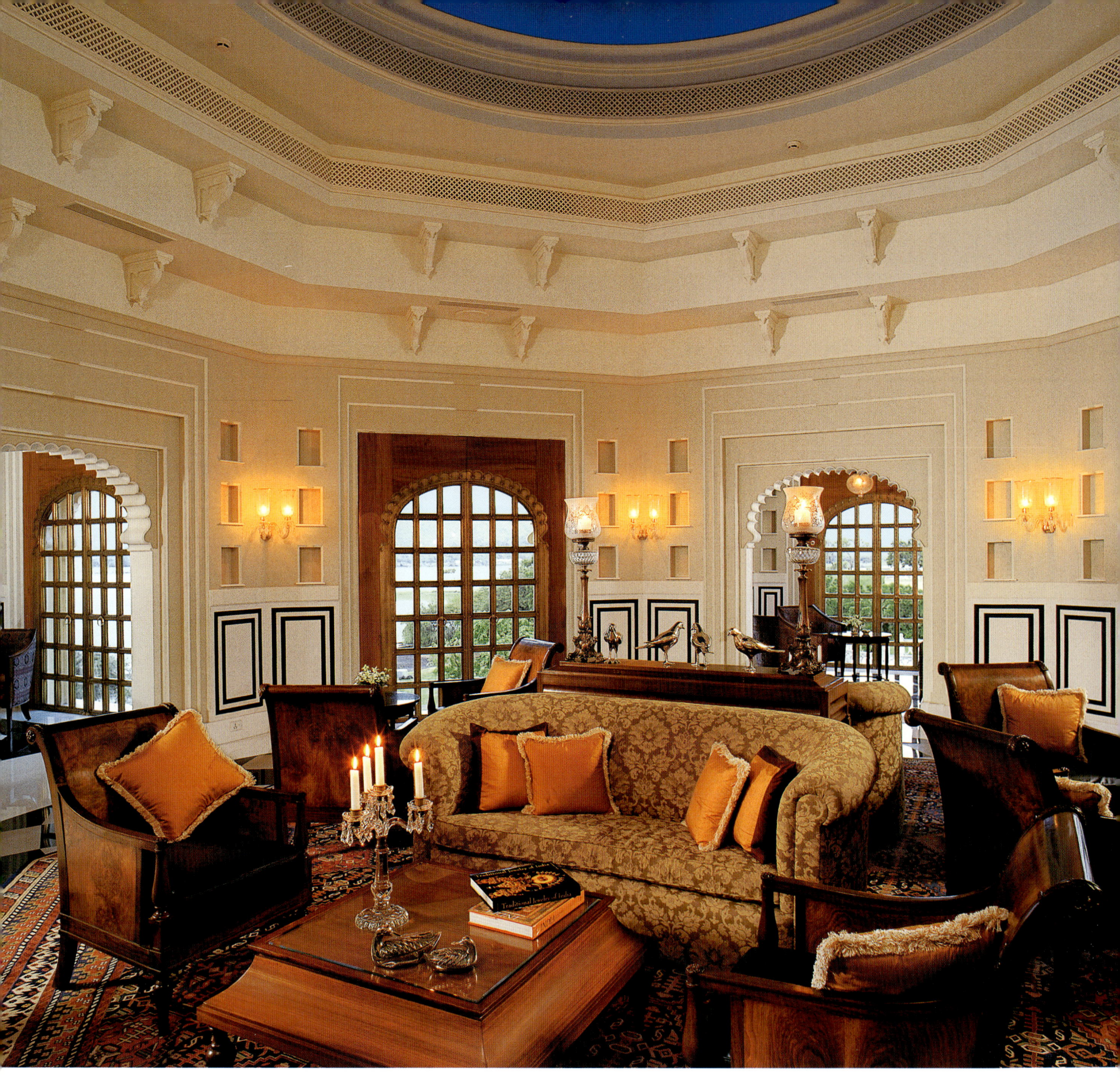

The lobby lounge, warm and inviting, with hand-crafted carpets and furniture, offers stunning views of Lake Pichola and the City Palace. The lounge is richly decorated with Thekri work, and a central dome painted in deep cobalt blue with rays of the sun in gold leaf.

resort, is situated on the banks of the Lake Pichola in Udaipur. In fact, the golden sun, representing the Sun God, is still the royal insignia of the Maharana of Mewar and a recurring motif in the design of The Oberoi Udaivilās.

In this tranquil, salubrious setting, The Oberoi Udaivilās has been conceived as a splendid palace, wonderfully creating the romance of the past and yet completely in keeping with the 21st century. Udaipur's Dabok airport is 27 kilometers from the hotel and the drive takes 45 minutes. The city is well-connected to New Delhi and Mumbai with daily flights operated by all major domestic airlines.

The hotel is spread over an expanse of 30 acres, and its carefully planned design has evolved as a seamless assimilation of spaces resembling the old palaces. Courtyards and walkways, gently rippling fountains and reflecting pools, exquisitely landscaped gardens, sculptures and frescoes, arches and domes, niches and alcoves – the hotel lends itself to discovery and continual surprise. Embellished by beautiful works of art and craft from in and around the region, The Oberoi Udaivilās is a vast canvas with an almost lambent quality, changing with the light and seasons and possessed of a sense of timelessness.

The architects of the hotel had been working in the region for more than a decade and a half, in order to re-establish traditional building methods, materials and technologies in the contemporary context. The design has therefore evolved as an assimilation of spaces of a traditional palace and the complex surrounding it. With domes and arches, pavilions and balconies, turrets, niches and *jalis* (screens), it is a reflection of the history of the area.

Located on the banks of Lake Pichola, The Oberoi Udaivilās commands a beautiful view of the City Palace and two 17th century island palaces on the lake. Situated on an undulating hill, The Oberoi Udaivilās, though primarily a single-storeyed structure, has been built on three varying elevations, adding to the sense of scale.

In the main courtyard of The Oberoi Udaivilās, soft green landscaping offsets black granite and white marble. A luminous white marble lotus seemingly floats on a reflection pool. As night falls, the ambience takes on an almost surreal quality with the pale gold façade of The Oberoi Udaivilās shimmering on the dark waters of the lake.

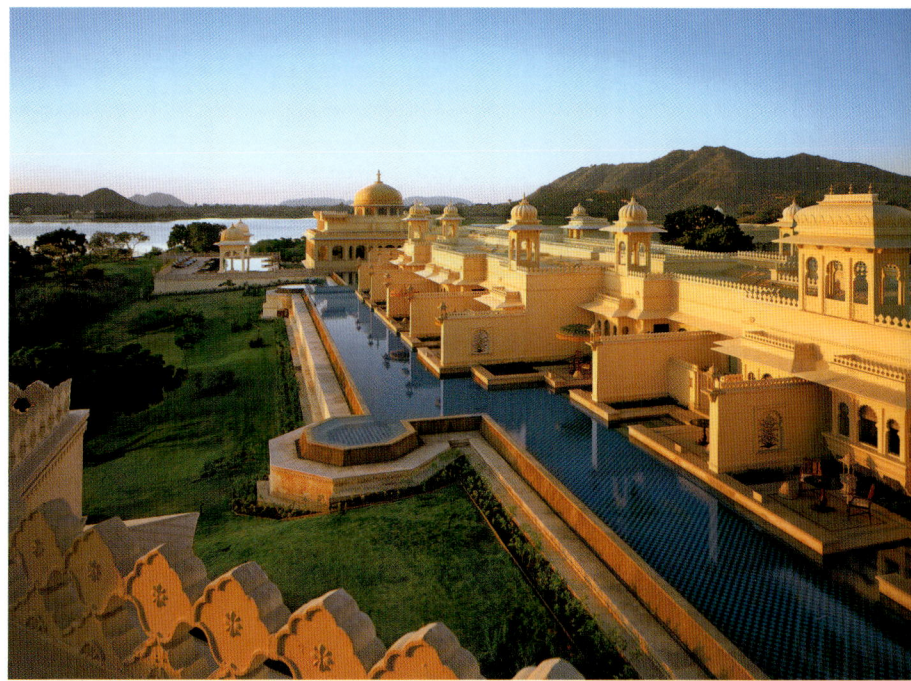

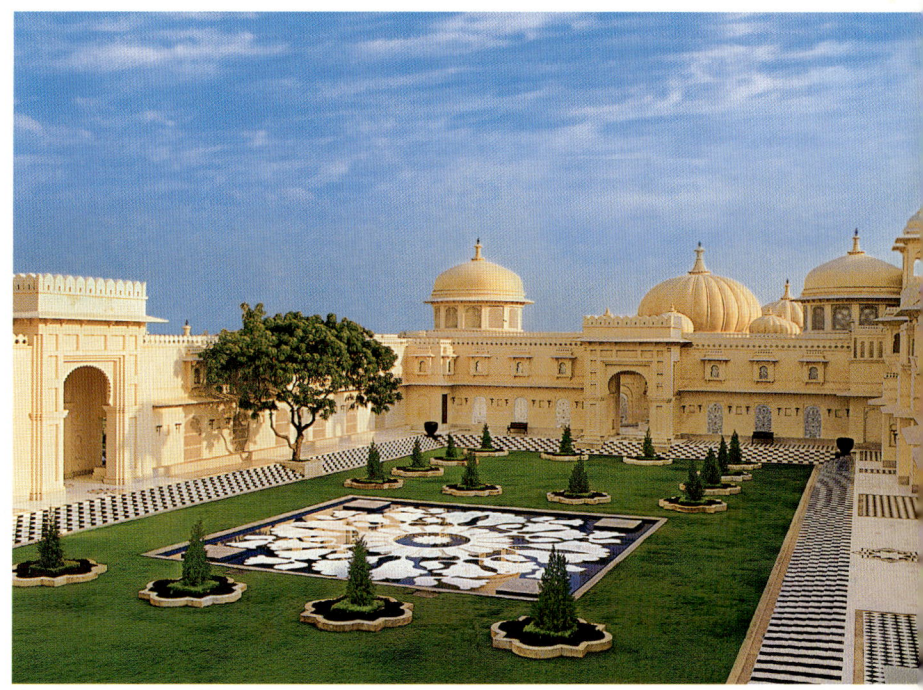

Top and Bottom: The hotel is spread over an expanse of 30 acres, and its carefully planned design has evolved as a seamless assimilation of spaces resembling the old palaces. Courtyards and walkways, gently rippling fountains and reflecting pools, exquisitely landscaped gardens, sculptures and frescoes, arches and domes, niches and alcoves – the hotel lends itself to discovery and continual surprise. **Page 166:** *Early morning Yoga when the sun rises amidst the beautiful reflecting pools is an experience you will never forget.* **Page 167:** *The lobby of the hotel has a central dome resplendent in gold leaf, complemented by a magnificent hand-crafted chandelier and a white Thassos marble fountain.*

The lobby, an arterial space with views of the lake and the surrounding mountains, has a central dome resplendent in gold leaf, complemented by a magnificent hand-crafted chandelier and a white Thassos marble fountain. The flooring is in a combination of beige Karoli sandstone, Udaipur green marble and white Thassos marble. Thekri work, an art form unique to the region wherein molten mercury is used with lead, adorns the space. The reflecting pools and fountains play an important part in the overall design. These impart different ambiences at various times of the day and night, augmented by the soothing sound of trickling or cascading water.

Adjacent to the lobby is the Candle Room, a miniature 'sheesh mahal' (glass palace). In palaces, Maharajas used at least one of these rooms as a bedroom for the special ambience it created. The ceiling, 25 ft high and 18 ft in diameter, is a stunning reflecting canvas, with intricate Thekri work in the dome. Surrounding wall niches also have Thekri work in a floral pattern. In the centre of the room is a recessed table in which candles are set. When lit, a spectacular effect is created by the flickering shadows.

The lobby lounge, warm and inviting, with hand-crafted carpets and furniture, offers stunning views of Lake Pichola and the City Palace. The lounge is richly decorated with Thekri work, and a central dome painted in deep cobalt blue, with rays of the sun in gold leaf.

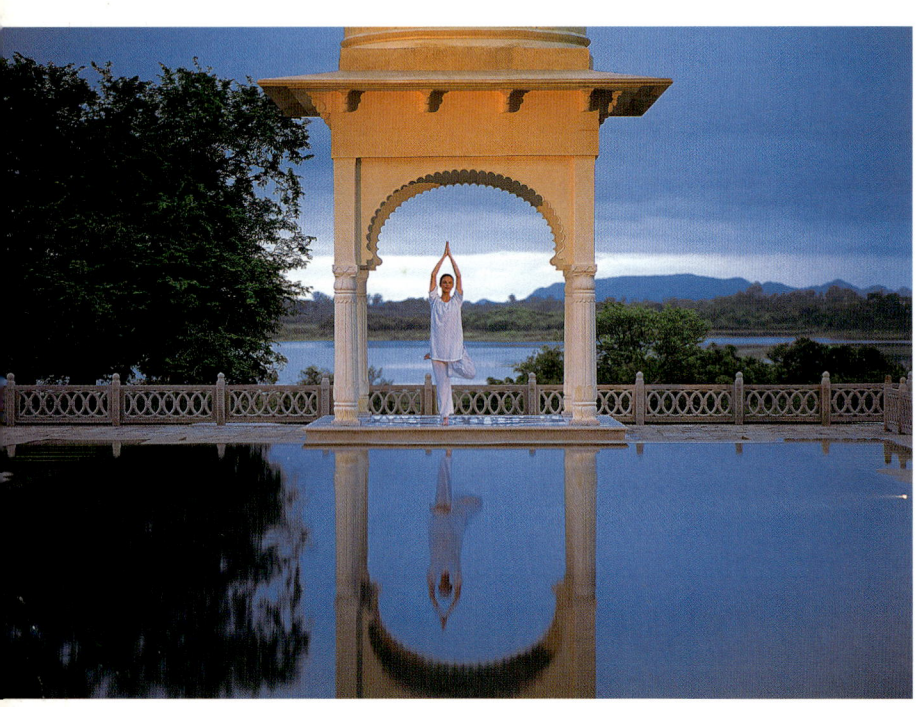

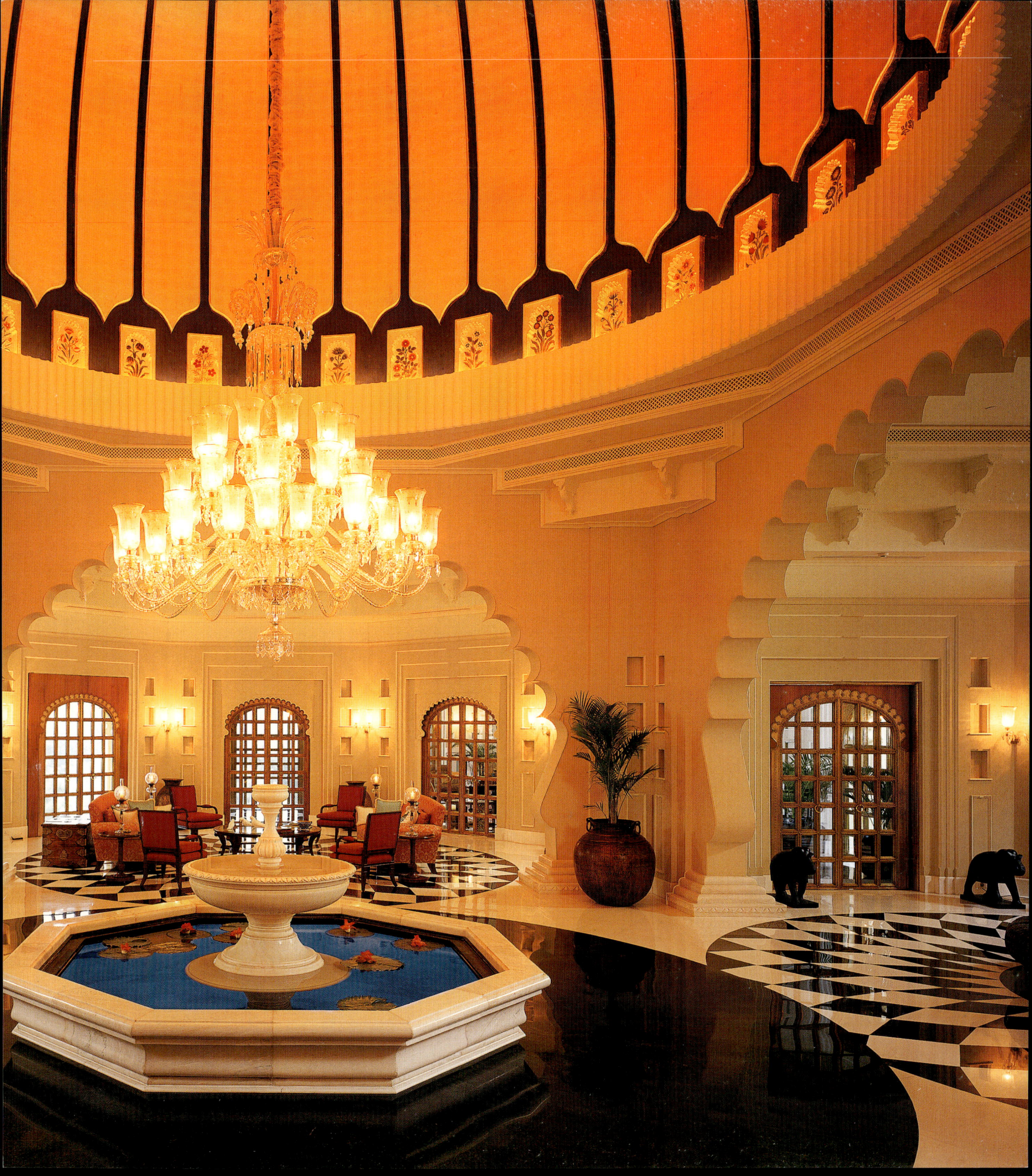

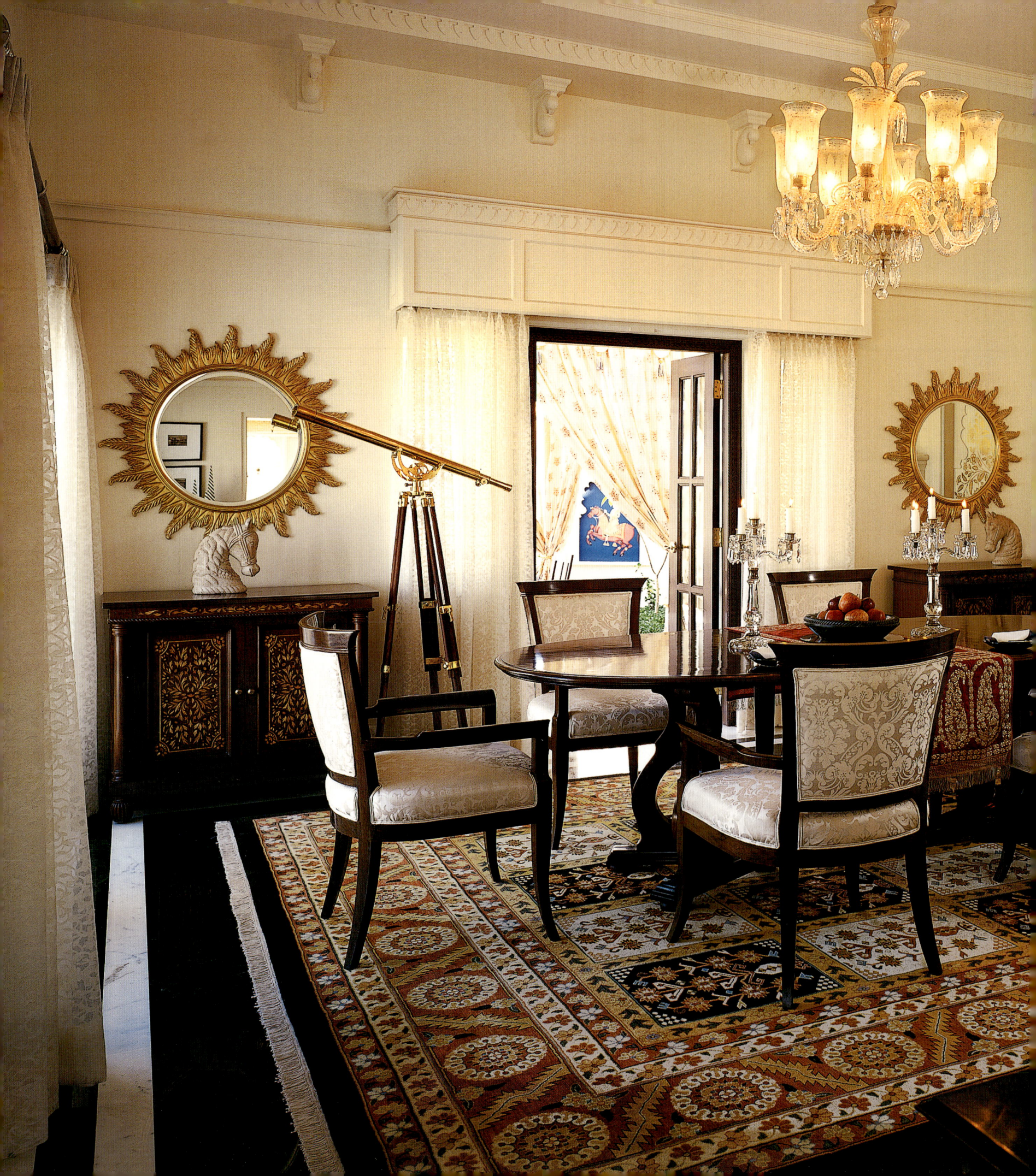

The Candle Room offers views of a cascading terraced garden, flanked by stone column torches, which at night create dancing flames on the water. The cascade culminates in a hand-crafted bronze sun, which is the royal insignia of Mewar.

From the palatial Kohinoor Suite to the Premier Rooms, interiors are beautifully appointed, with exclusively designed furniture, hand-knotted carpets and fine Indian works of art. The Premier Rooms are over 600 sq ft each, featuring a seating area and private courtyard. Luxurious white marble bathrooms, with Victorian style bathtubs, overlook the private courtyard. The Premier Lake View Rooms have access to a semi-private infinity edge swimming pool off a patio. The Kohinoor Suite features two bedrooms, a living room with working fireplaces, and a private swimming pool overlooking the City Palace, Lake Pichola and the Aravalli range.

The corridors leading to the guest rooms have 450 stone columns, each individually hand-crafted. Many are finished with ghutai, a technique, which like Thekri, is unique to the region. Craftsmen are reluctant to share details of the process, but it is generally known that various kinds of stone are ground and mixed with egg white and tamarind. The final finish is naturally creamy, ivory-like and glows with a special luminosity. It takes a craftsman a month to make a single column and the smooth stucco, made by mixing lime mortar with lime plaster and crushed marble, takes a year to 'cure'.

The Oberoi Udaivilās has two restaurants – Suryamahal, the main dining room, and Udaimahal, the specialty Indian restaurant. The domes over Suryamahal recreate the day sky, while those over Udaimahal represent the night sky. The vibrancy and richness of Indian and Rajasthani culture are reflected in the blue, green and gold colour scheme.

However, amongst the most popular facilities on offer at the hotel is the Oberoi Spa, which is a sanctuary of peace in an environment totally conducive to relaxation. The spa and fitness centre encompasses two floors with a circular balcony looking onto an atrium with a central dome from which hangs a crystal chandelier. The lower level includes separate changing rooms for ladies and gentlemen, each with a sauna, steam room and chilled water shower cubicle. The gymnasium and hair salon, are located around a central pristine white marble fountain. The garden courtyard is ideal for outdoor dining and there is a spa menu on offer.

The second floor of the Oberoi Spa has 8 therapy suites ideally suited for couples. Each therapy suite has two massage beds, steam room, sauna and a freestanding Victorian bathtub. Some suites offer magnificent views of Lake Pichola, the City Palace and beyond. The Oberoi Spa also includes individual treatment rooms for manicures and pedicures, and a private swimming pool overlooking the lake and the dramatic Aravalli range.

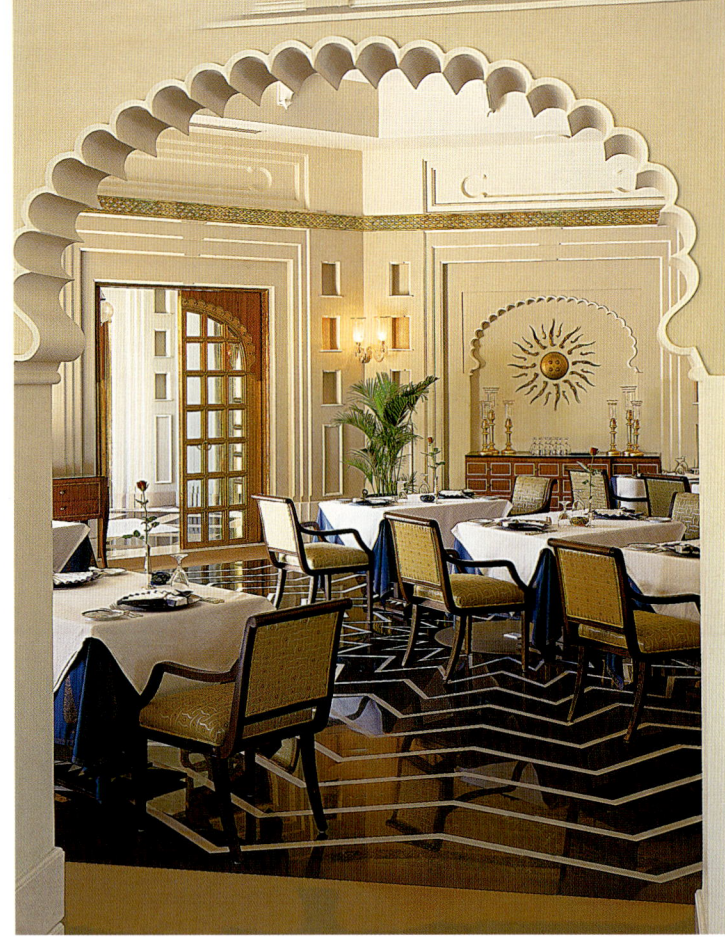

Expert therapists provide a variety of professionally administered therapies and programs ranging from the best in ancient Ayurvedic to Aromatherapy. Holistic, non-clinical treatments are designed for rejuvenating, relaxing and pampering. Extended and personalised programs are also available.

The Oberoi Spa at The Oberoi Udaivilās offers a vast range of exotic body massages and scrubs. The Oberoi Hot Stone Massage is wonderfully relaxing with its unique combination of heated basalt stones and the ancient Ayurvedic palm-based massage. The Thai Massage that uses no oil, the Balinese and Hawaiian Messages are worth a try. The Body Scrubs use only natural ingredients like honey, sesame seeds, mint, sandalwood, turmeric and almond. They are a delight to the senses.

Traditional Ayurvedic treatments such as the Navara Kizhi and Pizhichil offer a holistic healing experience. The Navara Kizhi is a rejuvenating treatment. In this, medicated Navara rice filled in linen pouches is applied in rhythmic movements on the body to induce total relaxation. This massage therapy nourishes, revitalises and strengthens the body to endure the stresses and strains of a busy life.

A spa massage can be followed by a sunset Shikara cruise on the beautiful and serene Lake Pichola with champagne and canapés. A custom built entertainment pontoon anchored just off The Oberoi Udaivilās, Udaipur on Lake Pichola, offers a wonderful setting with a breathtaking view of the palaces, the old city and the hotel.

Children can visit the Royal Car Museum where the vintage car collection is kept for display. There are around 35 classic and interestingly rare transportation vehicles; some stately and vintage like Cadillac, Chevrolet and Morais; while the others are sleek and fast.

Outside the hotel, apart from going around the ancient city taking in its various architectural nuances, you can also visit Shilpgram – the rural arts and crafts complex. Spread over 70 acres of land and surrounded by the Aravalli range, the complex is conceived as a living ethnographic museum to depict the lifestyles of the folk and tribal people of the west zone of India.

All in all, the grand setting of The Oberoi Udaivilās, combined with its palatial architecture and a beautiful spa, offers an experience created exclusively for those who know there is nothing like too much luxury.

Top: The Oberoi Udaivilās has two restaurants – Suryamahal, the main dining room, and Udaimahal, the specialty Indian restaurant. The domes over Suryamahal recreate the day sky and reflect the vibrancy and richness of Indian and Rajasthani culture. Bottom: A close-up view of one of the many marble fountains in the hotel.

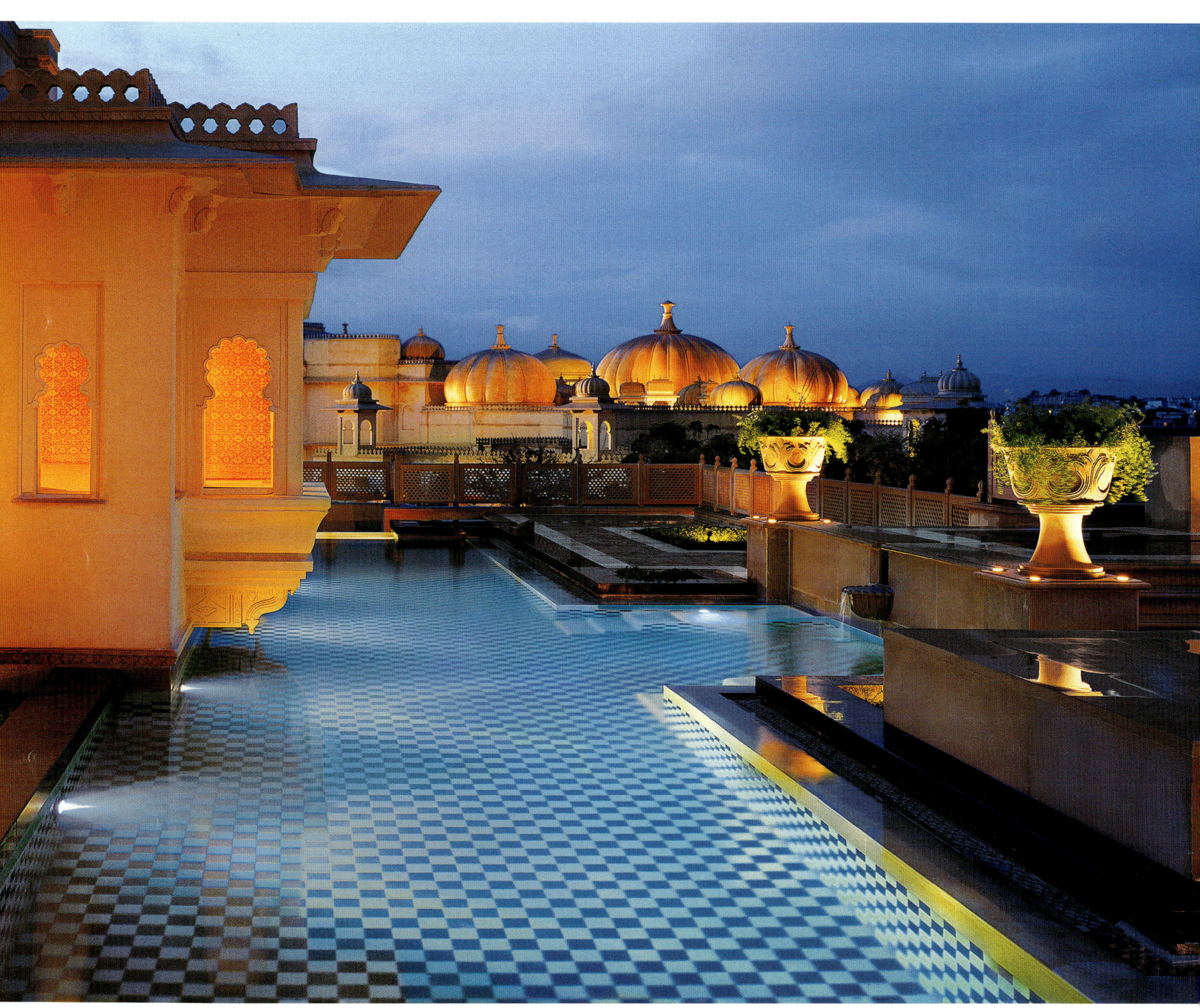

With domes and arches, pavilions and balconies, turrets, niches and jalis (screens), The Oberoi Udaivilās is a reflection of the history of the area. It looks ethereal in the evening light. **Page 168:** *The Kohinoor Suite features two bedrooms and a living room with working fireplaces. The telescope is a nice touch and the elegant horse heads and sun-framed mirrors add the Rajput element.*

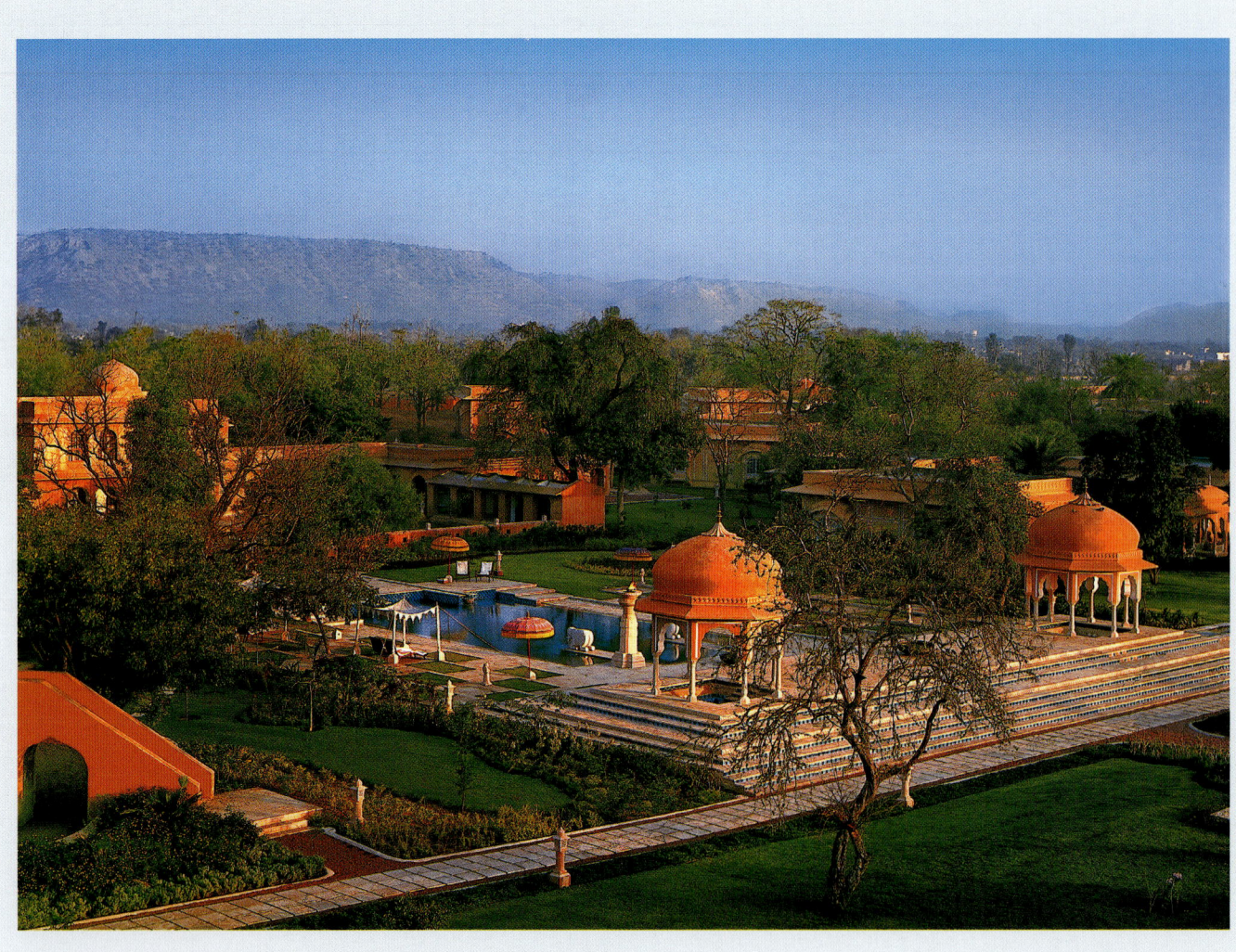

The Oberoi Rajvilās, Jaipur

evoking a princely era

Located just 8 kms from the historic city of Jaipur, The Oberoi Rajvilās is the perfect base from where to explore one of India's most exotic and vibrant cities...

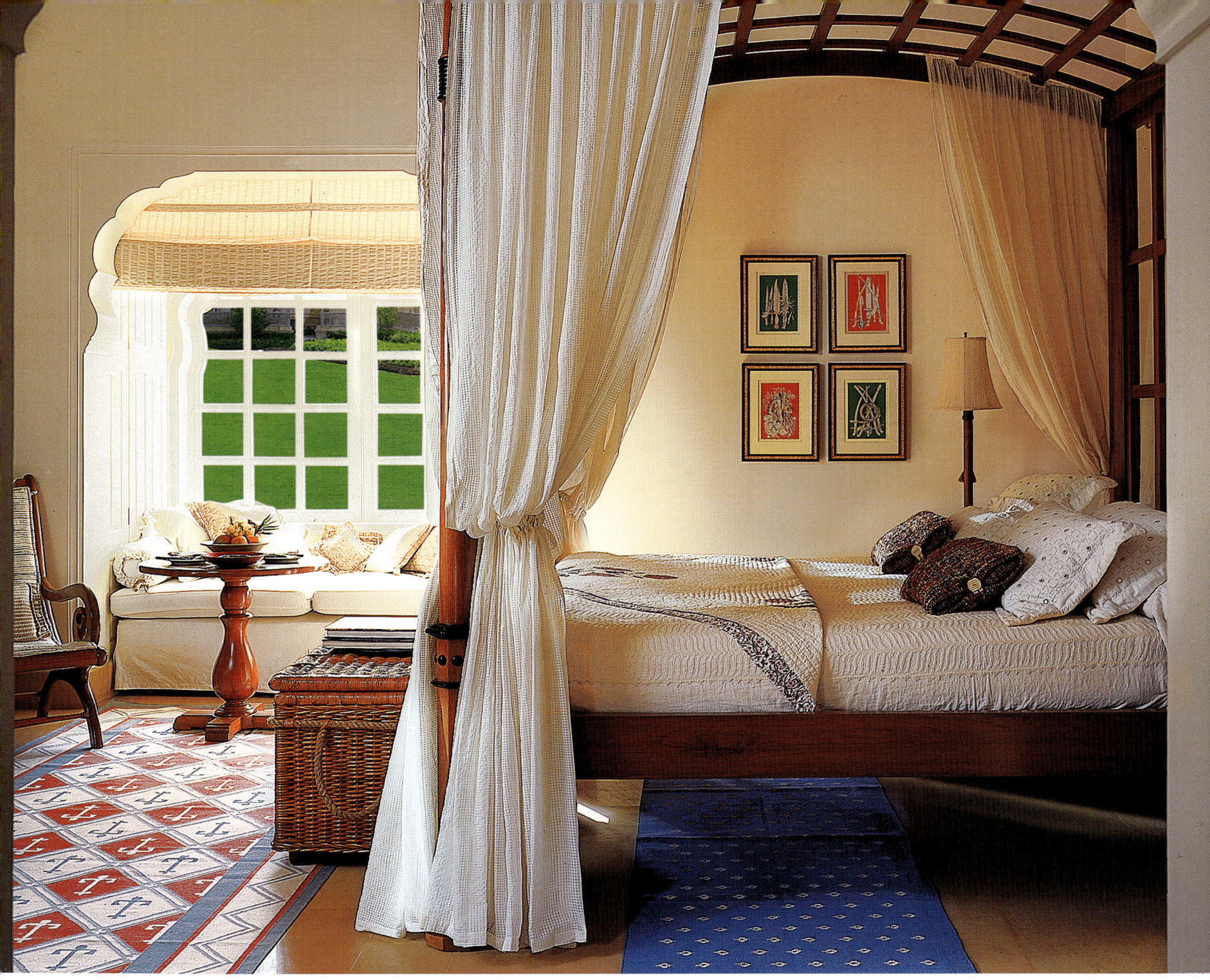

A trendsetter in the field of luxury hospitality in India, The Oberoi Rajvilās introduced a new concept of luxury leisure hotels to India when it opened in 1997. Five years before the hotel project commenced in 1995, Mr. P.R.S. Oberoi, Chairman of The Oberoi Group, had embarked on a painstaking restoration of an old Rajasthani fort at Naila, near Jaipur. The results were stunning.

The guest rooms at The Oberoi Rajvilās include a four poster king-size bed, a dressing room with walk-in closet and a plush seating arrangement overlooking the gardens.
Page 172: The idyllic retreat Oberoi Rajvilās evokes princely Rajasthan with luxury villas and royal tents in a fort-like setting, situated on 32 acres of lush gardens, flowering trees and cascading fountains.

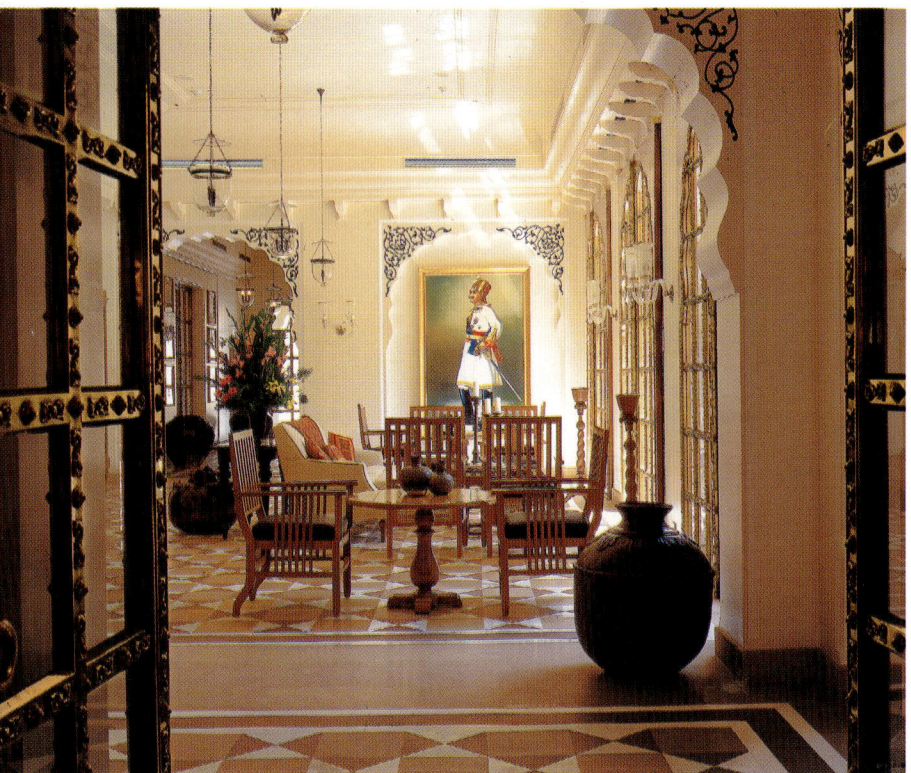

The combination of authentic restoration, fascinating new architecture, beautiful interiors and gardens and the Oberoi tradition of fine hospitality received accolades from guests and visitors from around the world. So much so that today the hotel has received many awards and accolades from the readers of various international magazines including Travel + Leisure and Conde Nast Traveler.

Located just 8 kms from the historic city of Jaipur, The Oberoi Rajvilās is the perfect base from where to explore one of India's most exotic and vibrant cities. This idyllic retreat evokes princely Rajasthan with luxury villas and royal tents in a fort-like setting, situated on 32 acres of lush gardens, flowering trees and cascading fountains. The hotel has 54 Premier Rooms, 13 air-conditioned Luxury Tents, 1 Royal Tent and 3 Villas with private swimming pools.

A 250-year-old Shiva temple and a Rajasthani haveli or mansion on the premises has been carefully restored. The haveli has been converted into a Spa, which offers holistic, Ayurvedic and western therapies for relaxation and rejuvenation.

The Oberoi Rajvilās is built in a traditional Rajasthani fort style. The main fort is embellished with decorative brass-clad doors. Each handmade door is eleven feet wide and weighs approximately 500 pounds. Every door is a unique piece of art and took over six months to craft.

Antique, mounted wooden statues lend a contemporary feel to the lobby, along with beautiful brass hand-worked urlis or large bowls filled with floating flower petals. Old armory that is majestically mounted on the walls is a constant fascination for guests. Beautiful gold leaf hand-painted wall murals, and colourful Indian miniature paintings are a presence throughout the fort. Original paintings by renowned Indian artist, Paresh Maity are also part of the modern art collection.

Adding to the hotel's elegance and rich detail are the beautiful carved stone pillars and marble statues used extensively throughout the hotel. More than 50 highly skilled stone carvers were retained to produce over two hundred stone pillars and statues.

The gardens of The Oberoi Rajvilās are testimony to its magnificent tradition: peaceful courtyard gardens, the gentle trickle of fountains, the turquoise sparkle of a reflection pool, moats with flowering water lilies and lotus, pergolas entwined with

*Top: The bathtub filled with rose petals inviting you to take a relaxing warm bath. **Bottom**: Antique mounted wooden statues and paintings lend a contemporary feel to the lobby, along with beautiful brass hand-worked urlis or large bowls filled with floating flower petals. **Opposite page**: The Oberoi Rajvilās is built in a traditional Rajasthani fort style. The main fort is embellished with decorative brass-clad doors and antique glass chandeliers.*

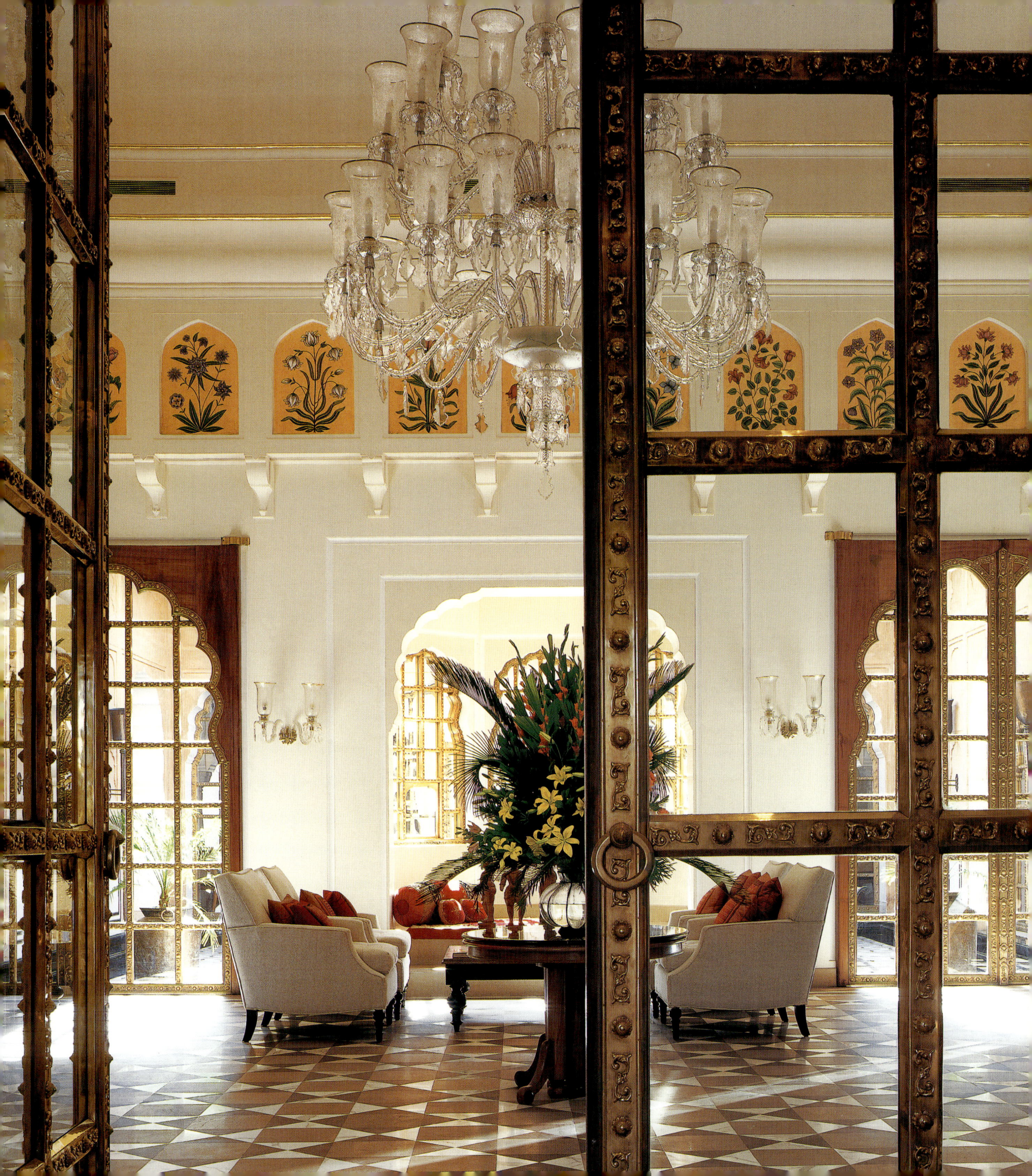

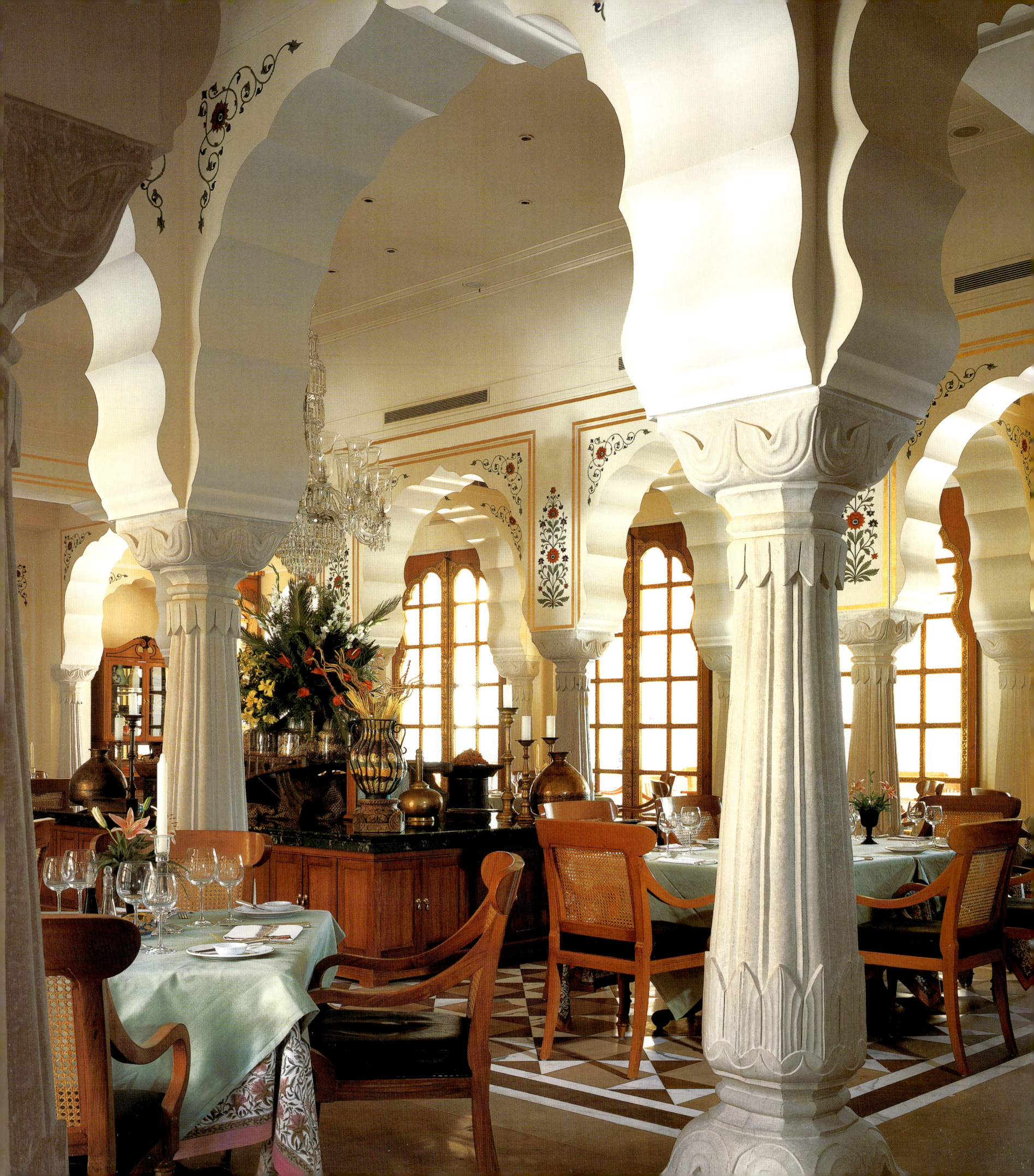

climbing bougainvillea, emerald swathes of lawn, desert palms, neem trees, beds of jasmine and fragrant herb gardens.

The Oberoi Rajvilās has 54 Premier Rooms separated in clusters of 4 and 6 rooms. Each cluster has a central courtyard with a garden and fountain. The Premier Rooms cover an area of approximately 42 square meters, and include an elegantly appointed bedroom with a four poster king-size bed, a dressing room with walk-in closet and all basic facilities.

The Oberoi Rajvilās has 13 air-conditioned Luxury Tents that have an area of approximately 45 square meters, surrounded by a private garden. The tents have spacious, beautifully appointed interiors with block-printed, hand-embroidered fabrics and teak wood flooring. The Luxury Tents have a private terrace and garden around the perimeter and are surrounded by traditional Rajasthani mud walls.

The Royal Tent has an area of 650 square meters with a private patio for sunbathing surrounded by a private garden for outdoor dining. The beautifully appointed, air-conditioned living room is separate and has a dining table for 6 people, a small lounge, washroom and a writing desk.

The Oberoi Rajvilās has two single bedroom Luxury Villas, each with a total area of approximately 355 square meters. Each villa has a private swimming pool which is heated in winter, a separate living room, a pantry and an outdoor dining pavilion overlooking the pool.

The Royal Villa with a private swimming pool is reached by crossing a small moat bridge. Guests enter through magnificent hand-crafted doors, into a private oasis of over 1,057 square meters, including gardens, a large private swimming pool, an outdoor dining pavilion, and sumptuously appointed individual accommodations. The master suite has its own sauna.

When it comes to dining, the options at The Oberoi Rajvilās include Surya Mahal, Rajmahal, Rajwada Library Bar and the Poolside. For dinner, the setting is magnificent in the Outer Courtyard. Evoking an almost mystical ambiance of an era bygone, the folklore-like sounds of traditional Rajasthani music and dance reverberate amongst the columns and around the fort walls. The private patio adjoining the Luxury Tents and the private courtyard enclosing the Villas are a romantic venue for intimate dining.

The most popular recreation facility at the hotel is The Oberoi Spa. Housed in a restored 250 years old Rajasthani haveli or mansion, the spa offers the ideal setting to experience holistic therapies. The facilities at The Oberoi Spa include steam rooms, saunas, plunge pools and an outdoor Jacuzzi. The Spa includes four private therapy suites, two double therapy rooms, two single therapy rooms, a facial room and separate changing areas for ladies and gentlemen.

The extensive spa menu offers non-clinical therapies, massages and beauty treatments incorporating ancient Ayurvedic principles, Aromatherapy and western techniques that are designed to rejuvenate, relax and pamper. The therapies at The Oberoi Spa include only the finest natural ingredients remaining true to the Asian tradition of respect for the environment. The menu features massages, exotic body scrubs, floral baths and rejuvenating beauty treatments.

Once rejuvenated, you can immerse yourself in a historical discourse about the royal kingdom of Jaipur presented by an eminent historian. With the historian, guests embark on a journey through the adventurous exploits of the family who established the dynastic rule in 977 AD to the splendors and culture of the Mughal Court and then the period of friendship with the British Raj until the Independence of India.

Outdoor recreational activities include horse riding or an amateur horse Polo session at the Anokhi Farms located 8 kms from The Oberoi Rajvilās. The Anokhi Village offers rides along numerous trails, which lead through interesting countryside.

Drive in an old US army jeep accompanied with a local expert through the countryside and tribal villages on an off-the-beaten track to the fort on a hill, camel ride in the village below the fort, visit the village homes and schools followed by picnic on top of the fort overlooking the plains. You can also proceed for an elephant safari through the beautiful countryside of Jaipur. However, your stay at the The Oberoi Rajvilās is incomplete if you do not explore Jaipur's many famed forts and palaces.

A true royal experience that transports you into a different era!

Opposite page: *Adding to the hotel's elegance and rich detail are the beautifully carved stone pillars and marble statues used extensively throughout the hotel. More than 50 highly skilled stone carvers were retained to produce over two hundred stone pillars and statues.*

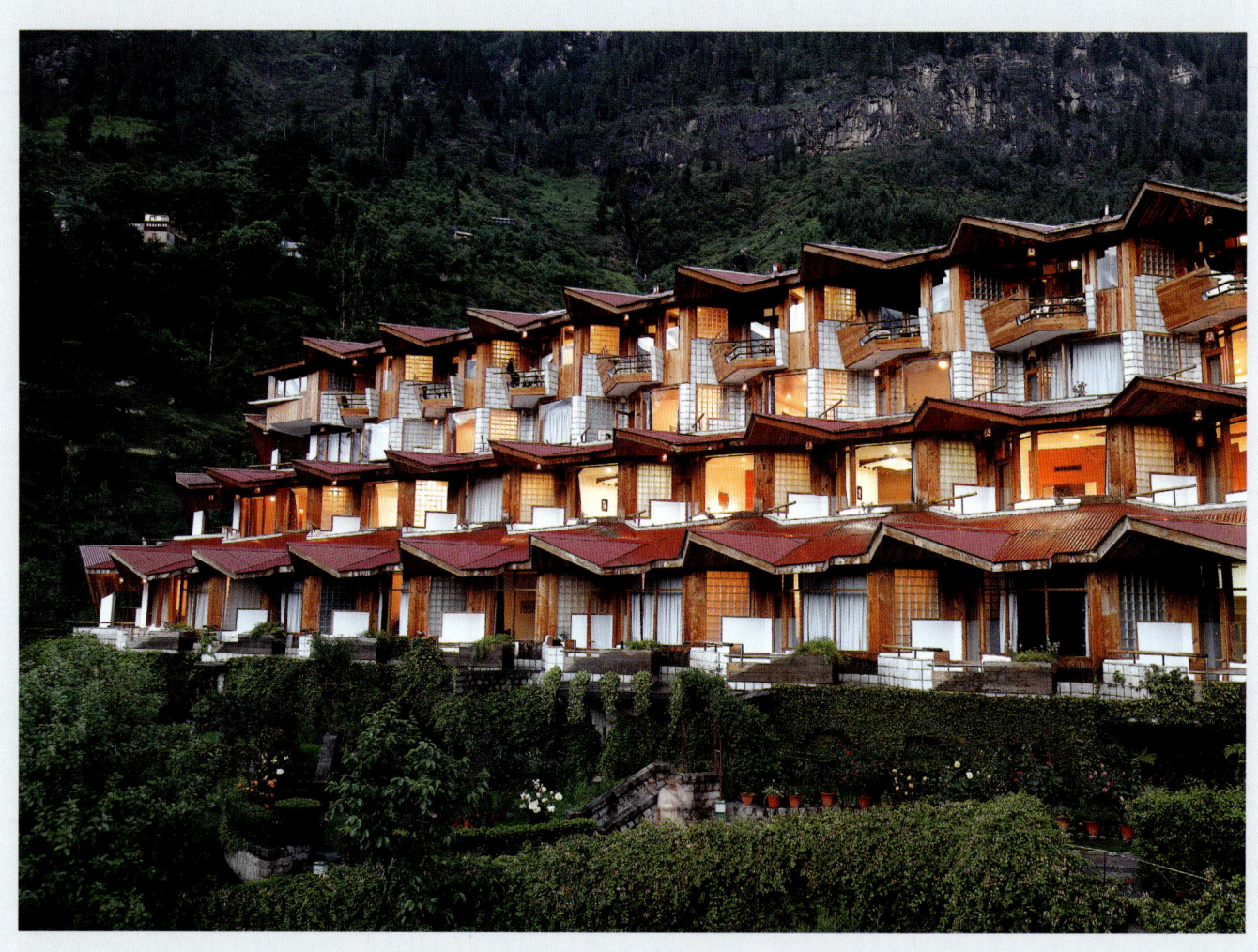

Manuallaya, Manali

a Himalayan odyssey

The spa resort of Manuallaya at Manali enables you to rejuvenate in a blessed geography that eats, sleeps and drinks spirituality...

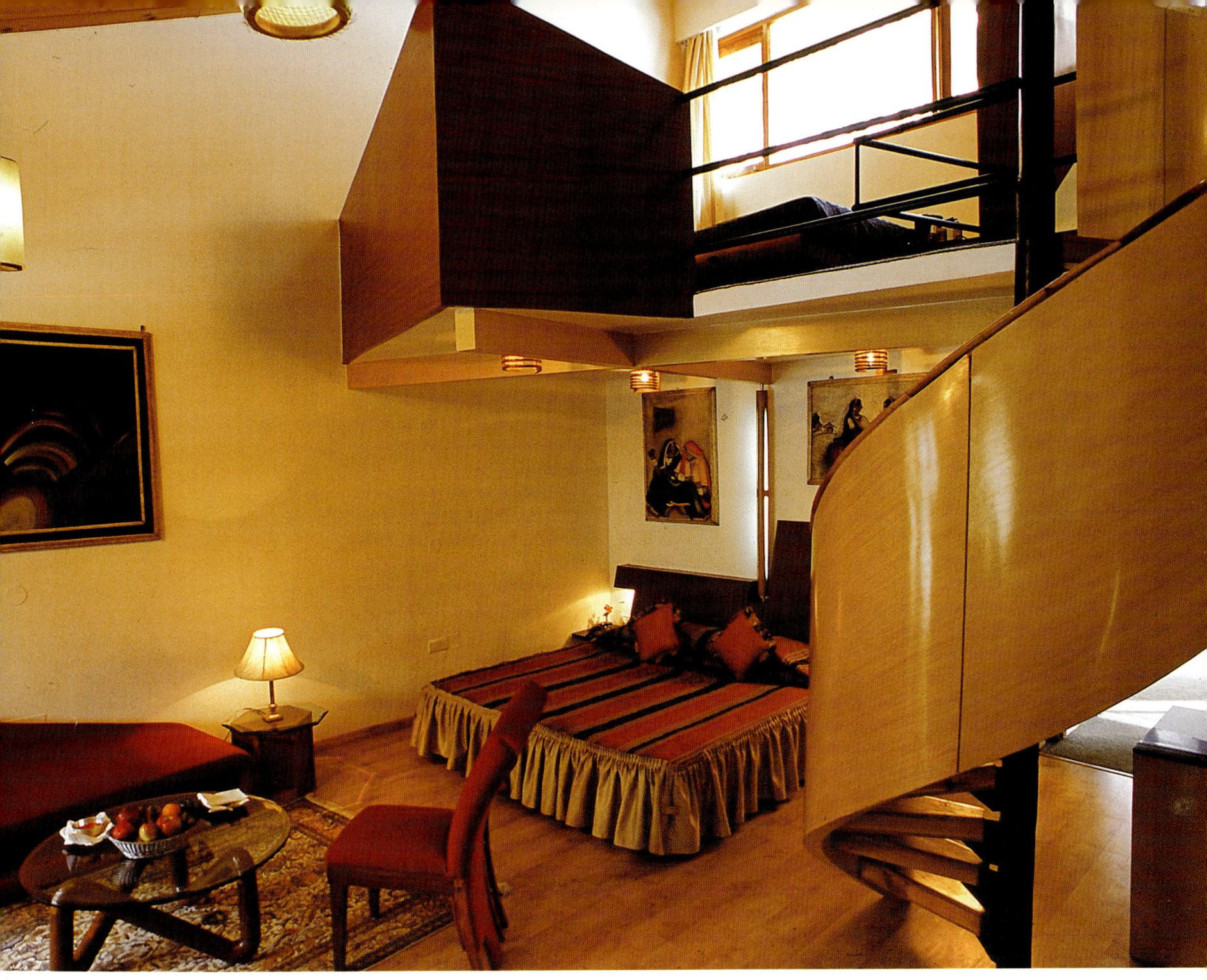

As legend has it, on the Almighty's directives, centuries ago a great upheaval took place to rid Mother Earth from evil forces. Torrential rains flooded land, changing the very shape of the planet of life. Everything was submerged. However, Noah (or Manu as he is called in Hindu scriptures) and his ark full of fauna managed to escape God's wrath and found sanctuary in a green, picturesque valley

The seven duplex rooms in the resort have their own small hideout approachable via a winding wooden staircase. Interiors are a balanced mix of traditional hill style and modern architecture. **Page 180:** *Built 2050 meters above sea level to the left of the Beas, the spa resort of Manuallaya is a true picture of tranquility, peace and beauty.*

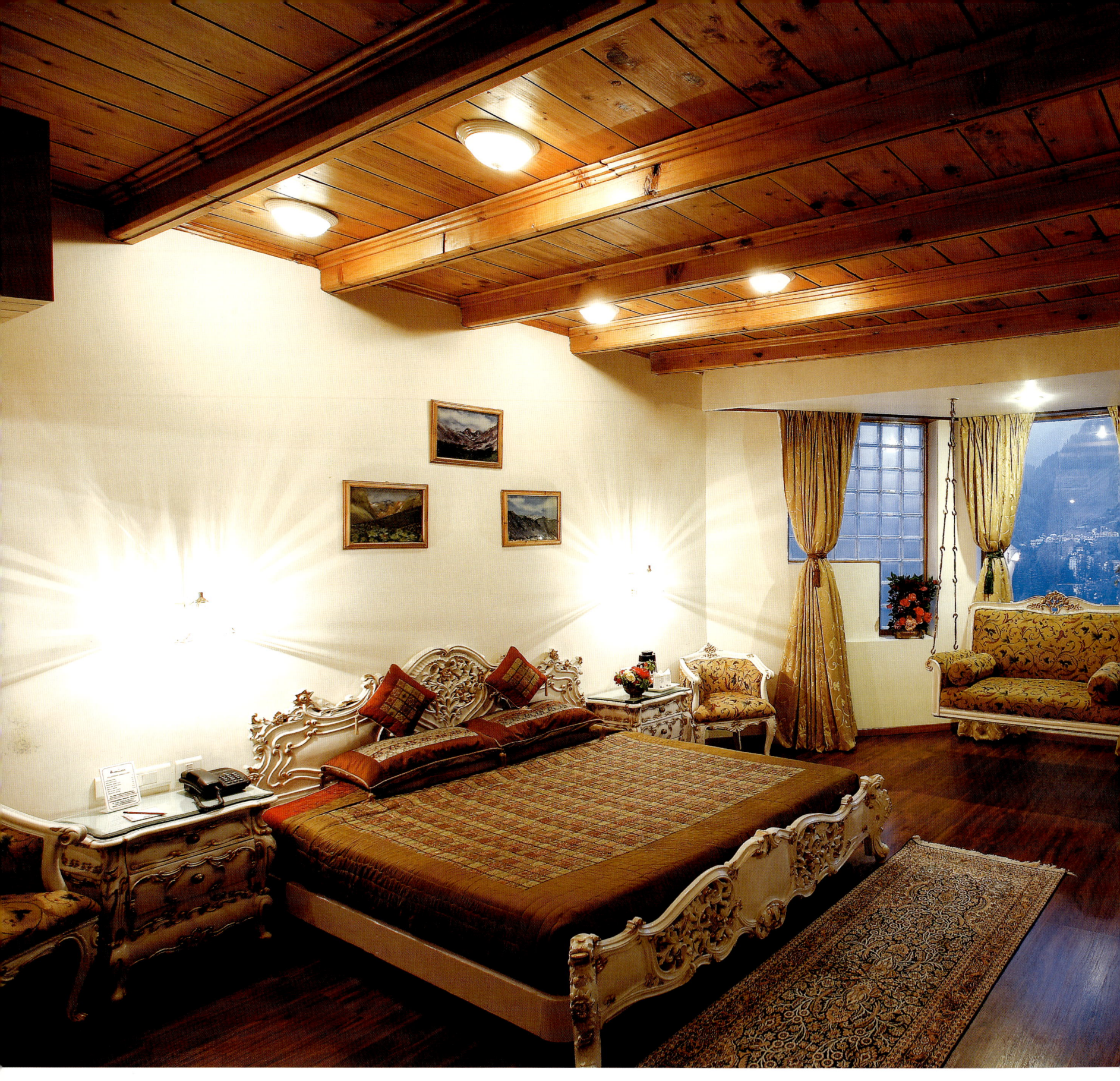

The plush guest rooms overlook the breathtaking panorama of snow-capped Himalayan mountains on one side and slopes filled with pine trees on the other. Wooden floors and ceilings keep the cold out.

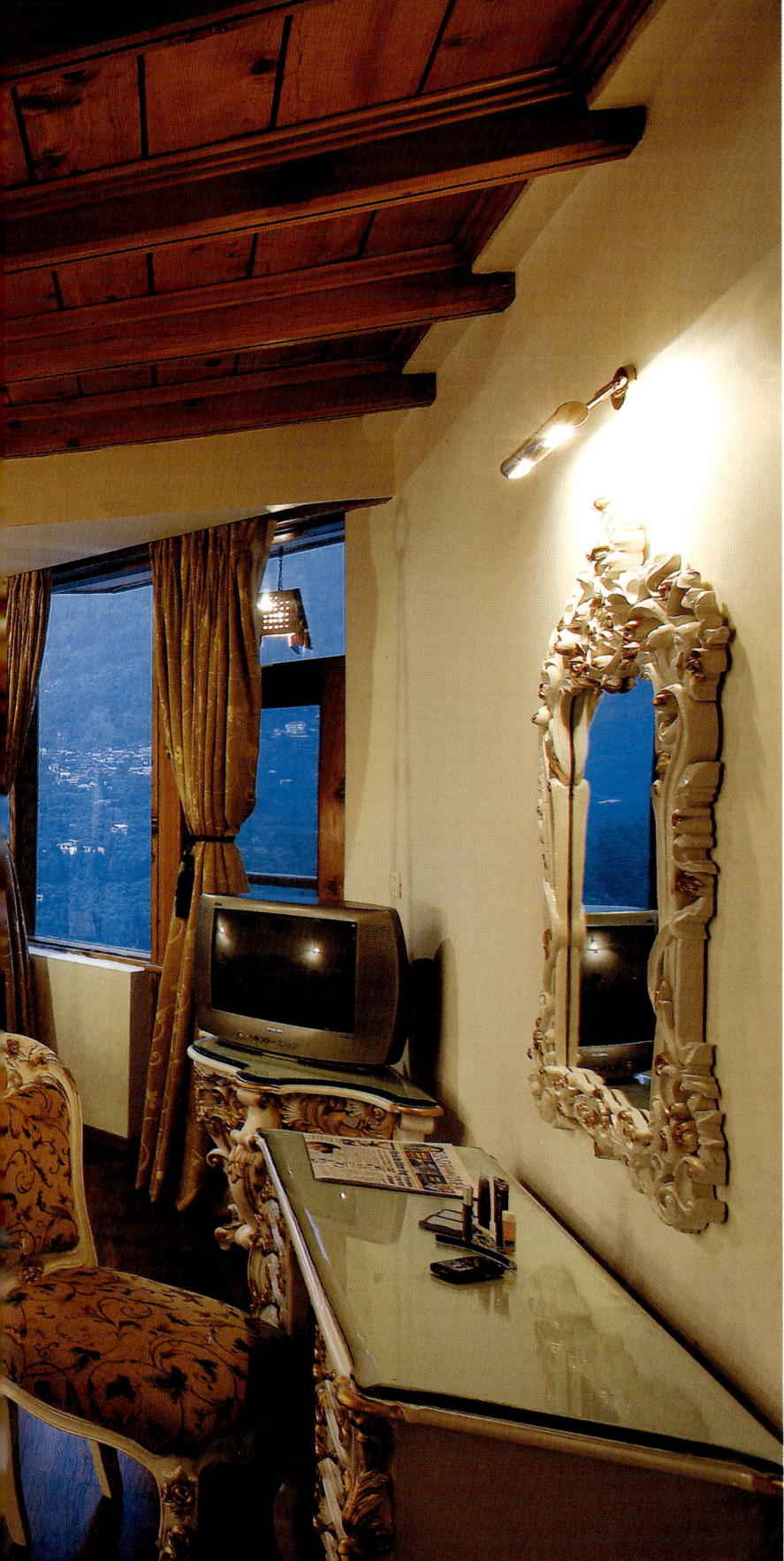

nestled amidst the Himalayas. The valley came to be known as Manuallaya, the mountain of Manu, over time.

Giving life to this legend is a spa resort by the same name, Manuallaya perched atop a mountain in the land of Manu, known to everybody as the picturesque hill station of Manali in the state of Himachal Pradesh. Manali is both approachable by air with direct flights from Delhi as well as by road through the scenic valleys of the state alongside the course of the Beas river.

Manuallaya has it all – a divine land as location, spiritual air and a blessed geography. Add to it beautiful landscaping, plush interiors, Ayurvedic massages and world cuisine, and the spa resort becomes the perfect place to rejuvenate. Managed by the Ambassador Resorts, Manuallaya is built 2050 meters above sea level to the left of the Beas. Its 55 rooms across eight categories are a true picture of tranquility, peace and beauty.

Built over 6 acres, the design concept of the resort is an amalgamation of modern amenities and luxuries with traditional hill architecture. A lot of changes have been made to the existing old structure with architectural interventions carried out at various points in the complex. Horizontal timber members have been incorporated to act as a buffer in times of an earthquake.

The plush guest rooms have been supplemented with new balconies with tiled roofs, overlooking the breathtaking panorama of snow-capped Himalayan mountains on one side and slopes filled with pine trees on the other. While wooden flooring provides a rich and cozy feel, the bathrooms have been fabricated in black granite. The form of the bathrooms echoes the design of the sunken ponds in the nearby Vashisht temple.

Out of the 55 rooms, 14 sport a private balcony, 7 come with their own garden, 7 are deluxe and an equal number are duplex (with their own small hideout approachable via a winding wooden staircase), 7 of them are deluxe suites, one presidential and one sunny side cottage. The balcony rooms are located on a unique boutique floor that has its own distinctive interior and design. The rooms have large glass windows and balconies providing a clear view of the entire valley.

As far as dining is concerned, Manuallaya has five eating areas. Café Jardin is the English coffee shop. The largest cafe in the valley, it offers breakfast, mini-lunches and is a great place for get-togethers. The Library Bar matches the mood and is set amidst two small waterfalls and a small water body. The minimalist space

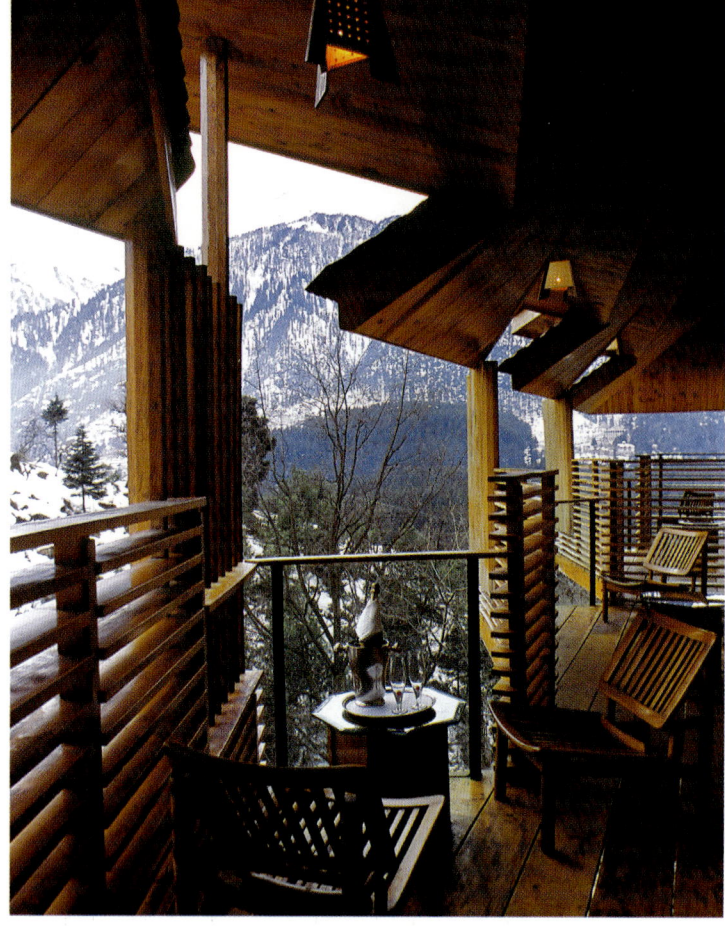

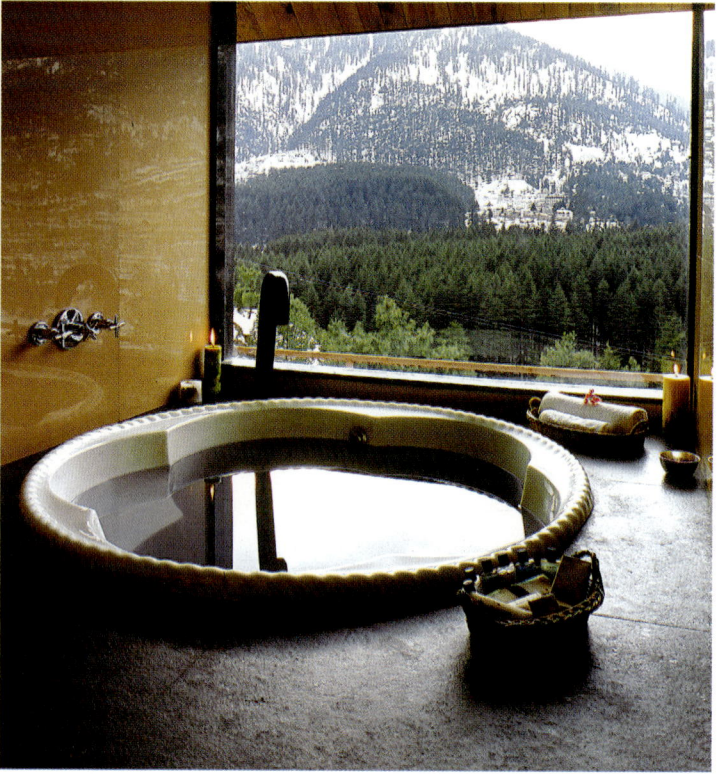

boasts of subdued lighting and a modern bar counter along with a variety of reading material to choose from. The gentle sound of water makes it a favorite place to spend hours lazing around.

The only Tibetan-Chinese specialty restaurant in the valley, D'Jong has beautifully carved and hand-painted walls, roof, windows and doors. With a Tibetan Monastery in the neighbourhood, the restaurant has a typical Tibetan quintessence.

However, your stay at Manuallaya is incomplete if you do not savour the delicacies at Bar-be-cue. Hosted in the lawns in the summer, the bonfire is like an icing on the cake. However, if kebabs and kebabs is what you want, then Kibber is the place for you. Serving North-West Frontier cuisine, Kibber will actually leave you craving for more!

To further relax your senses, Manuallaya welcomes you into its spa, called the Tva. Tva is an effort to restore the harmony and bring back the wellness of mind, body and soul. On offer is a huge array of treatments: a full body massage, Padabhayam (foot massage), a couple massage that redefines sensuality (Tantra), the famous Shirodhara Ayurvedic oil treatment and the powder massage that helps in reducing cellulite and excess fats.

Tva also offers a whole lot of modern day treatments like Mud Therapy, Swedish Massage, Hydro Therapy, Reflexology and Bach Flower remedy. Yoga and meditation sessions further help you attain the harmony of mind, body and soul. A complete Ayurvedic diet – *Aahar* – depending upon the type of body leads you onto the path of a healthy lifestyle.

Apart from the massage treatments, you can even put your body into shape by using the gym or playing squash, badminton, skating and tennis. For the leisurely, Billiards is an ideal pastime.

However, relaxation at Manuallaya is not just restricted to activities available inside the hotel. Adventure trips to explore the beauty of Manali can also prove to be therapeutic. The most thrilling is going for river rafting at Pirdi (after Kullu) on the unruly and tumultuous Beas river. You can even go fishing in the river at Manali itself.

Trekking around the slopes and rock climbing at Jagatsukh village are favourite pastimes in summer. Horse safari at Gadhani village is another great option to explore the divine beauty of Manali.

During winters, the virgin slopes of the Himalayas provide a "white thrill" that is unparalleled. The snow points are the Solang Valley as well as the Rohtang Pass.

Manuallaya truly lives upto its motto of "Rejuvenating life as only life can".

*Top: The wooden balconies give you breathtaking views of the snow-peaked mountains of the mighty Himalayas. The design concept is themed on wood, in keeping with the locales. **Bottom:** To relax your senses, a Jacuzzi while soaking the natural wonders through the glass windows is ideal.*

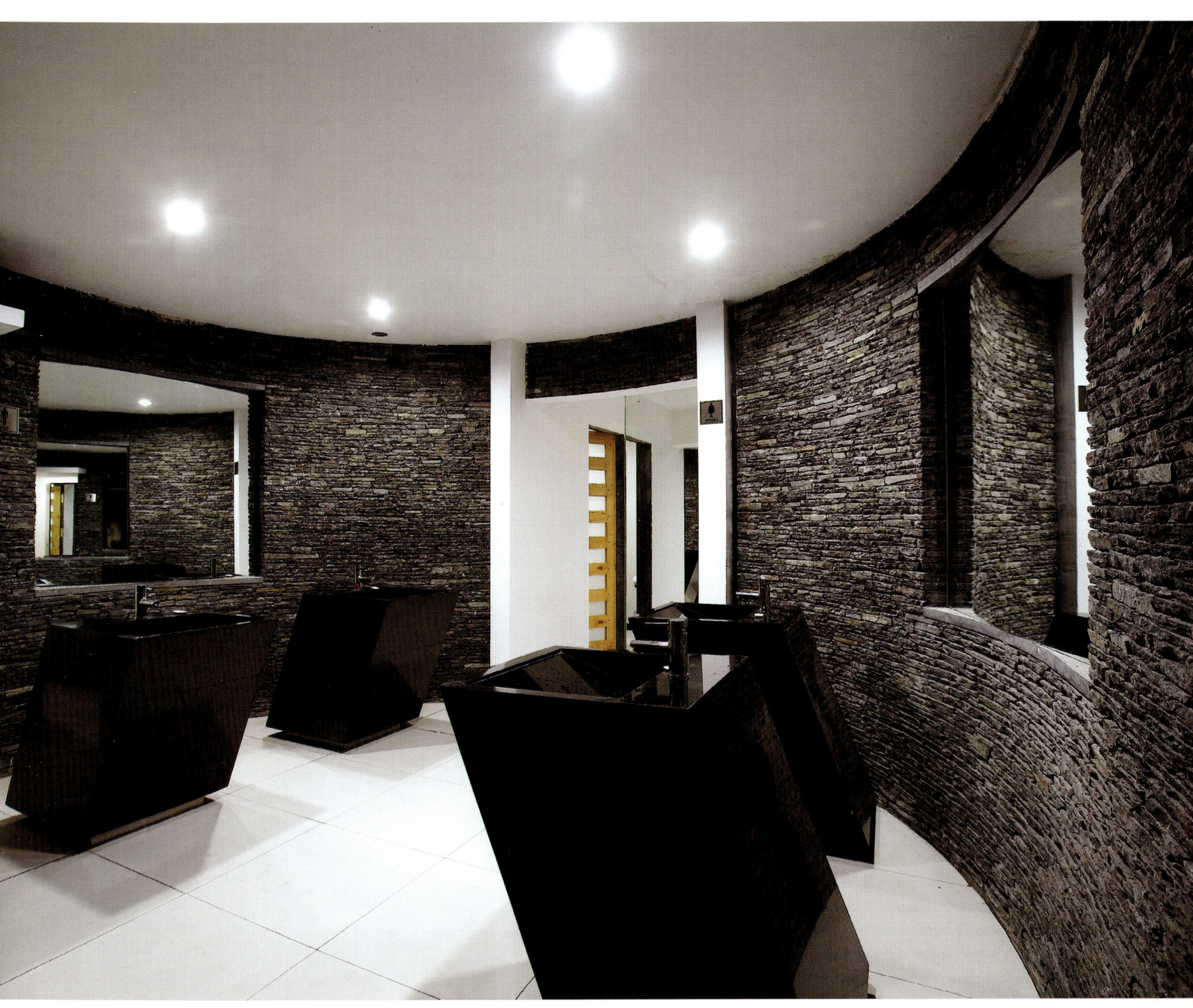

Fabricated in black granite, the bathrooms at the resort are eclectic and modern.

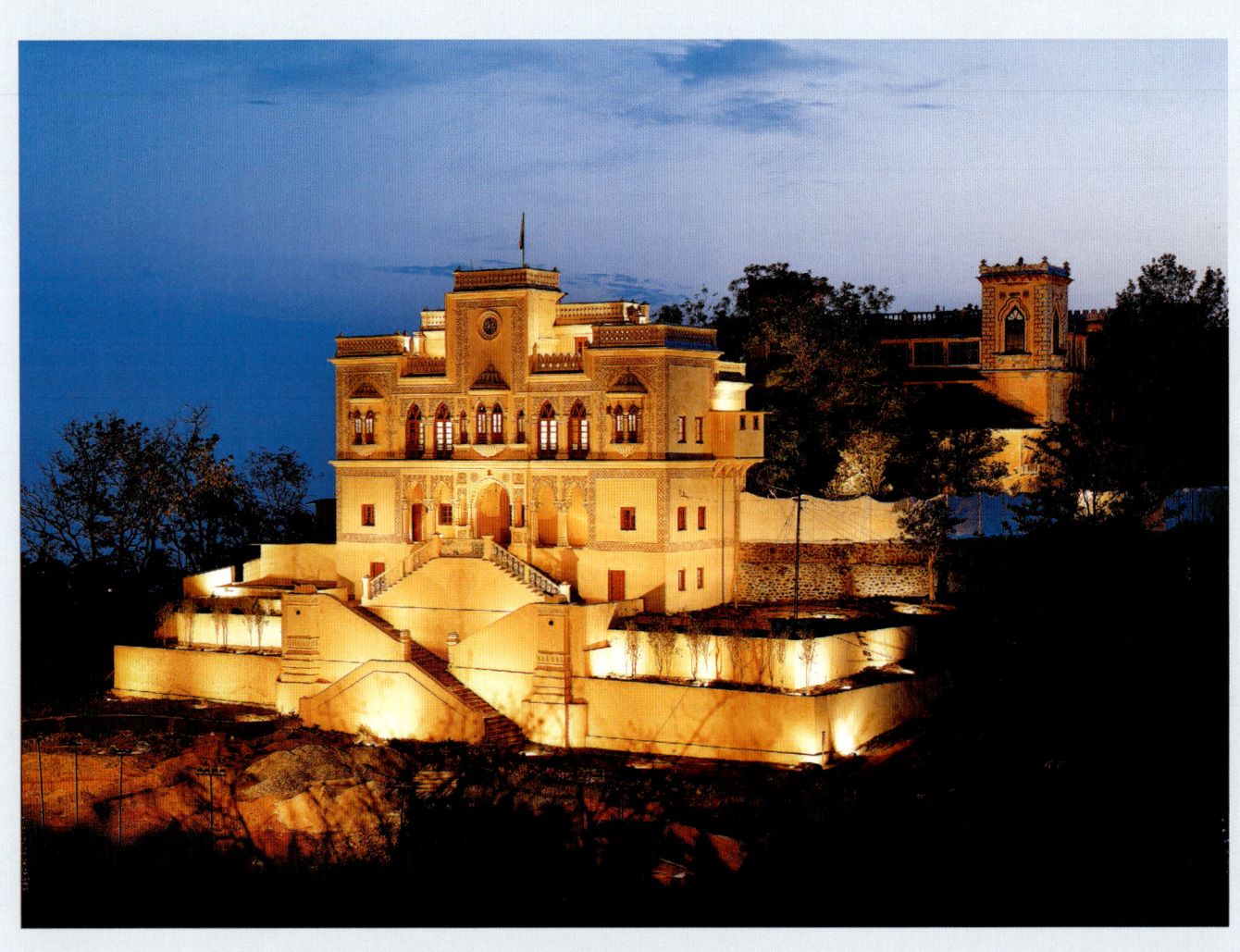

Ananda in the Himalayas, Tehri Garhwal

focussing on wellness

At the heart of Ananda's wellness focus, is the integration of Yoga and Ayurveda philosophies, incorporating the five elements of Nature...

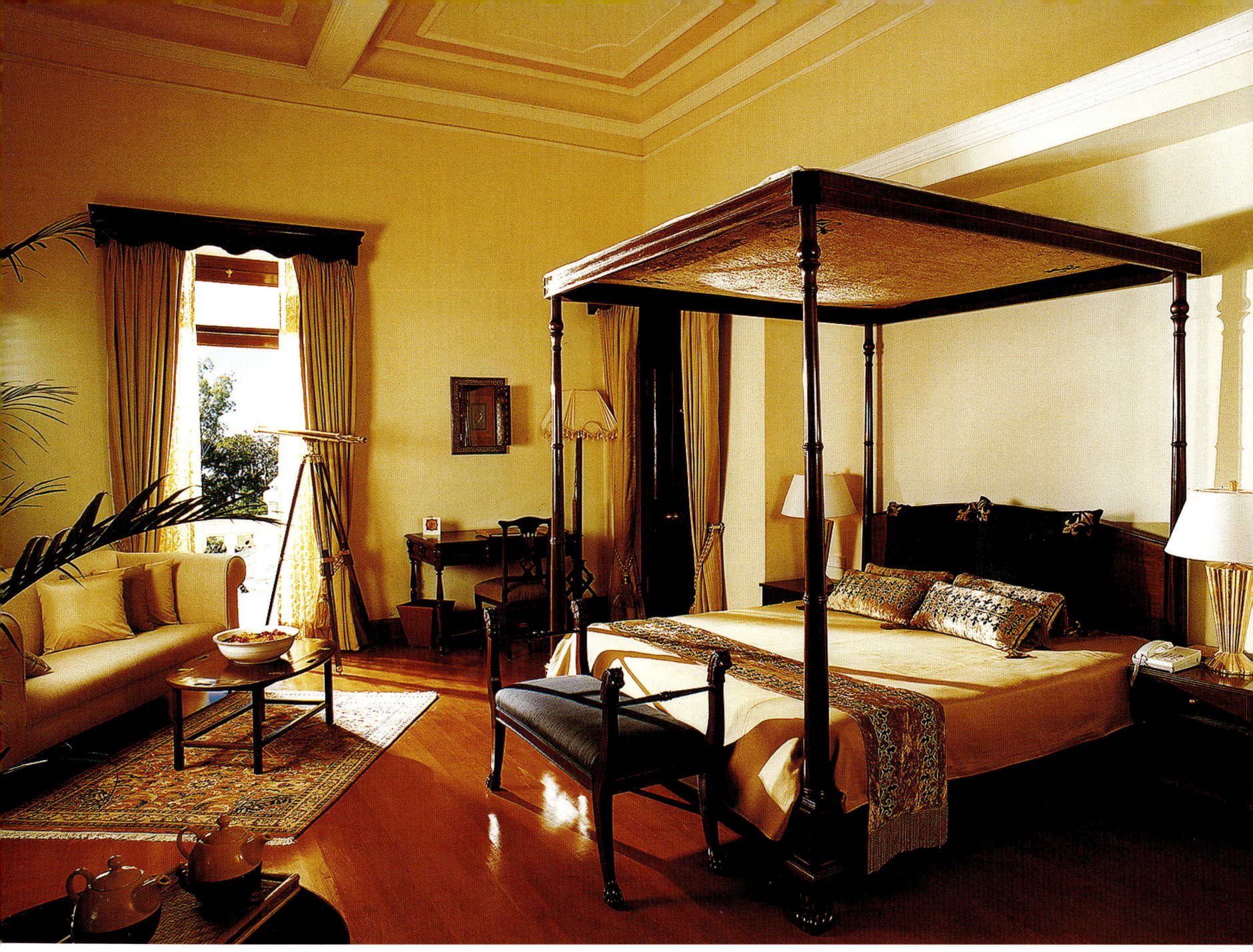

The drive along the winding road up the Himalayas from Haridwar is lined with tall trees and lush greenery. But, as soon as you reach Narendra Nagar and enter the palace of the erstwhile Maharaja of Tehri Garhwal, you feel as if you have been transported into a different era.

Within the precincts of this palace is Ananda in the Himalayas, adjudged the Best Overseas Spa Retreat as well as rated among the top three spas in the world by the Conde Nast Traveller for five consecutive years. Located in the picturesque foothills of the mighty

*The living quarters in the Viceregal Palace is a throwback to colonial times with the furniture and colour scheme to match the period. **Page 188**: Set amongst 100 acres of virgin forest and opened in September 2000, Ananda in the Himalayas is built around a Maharaja's palace estate, and located 260 kilometers north of New Delhi.*

Himalayas, the birthplace of India's ancient arts of Yoga, Meditation and Ayurveda, it can best be described as a luxury destination spa resort. Set amongst 100 acres of virgin forest and opened in September 2000, Ananda in the Himalayas is built around a Maharaja's palace estate, and located 260 kilometres north of New Delhi. The resort comprises the restored Viceroy's Palace, a world-class Spa and has 75 deluxe rooms and suites in its guest wing, with breathtaking views of the Ganges River and the mountainside.

The hotel design is divided into four sections – the Palace of the Maharaja consists of the reception area, the library and the Viceregal Suite. The guest wing is separate from the Palace where there are luxurious rooms for a comfortable stay. Within the precincts of the Palace grounds is the spa and sports complex coupled with an amphitheater for entertainment and concerts, and chanting of mantras. Then there is the lounge and restaurant area offering special Ayurvedic balanced diet apart from regular luxury fare.

The quaint Palace of the Maharaja of Tehri Garhwal sports a very individualistic style. It draws heavily from Moorish architecture, with accents of Italian Renaissance columns coupled with Gujarati/Rajasthani *jharokhas*, which extend into the Viceregal Palace. The Viceregal Palace is again a composite structure, but much less stylized, with Indian Bijapuri arches on the outside, and an Art Deco interior. The reception of the spa is an airy atrium hall, where natural breeze flows through ancient pines and wild flowers. The spa consists of three levels including a state-of-the-art gymnasium and aerobics hall overlooking the gardens of the Palace and the valley of Rishikesh. The gymnasium has its own training master and a hall for aerobics.

The six-floor guest residence – approachable through its fifth floor by a wooden platform – consists of three Deluxe Suites, 70 Deluxe Rooms and one Ananda Suite. It has been built along the hill, so that "it does not bulge out and look ugly". The restaurant with its magnificent wooden deck, that overlooks the vistas beyond is the heart of the resort. It has a 100-year-old Sal tree growing through it, adding to the feeling of being one with nature. While an island fireplace forms the focal point of the restaurant, with its Art Deco design, it complements the architecture of the Palace annexe.

The Ananda menu places emphasis on the importance of a balanced diet. Ayurvedic food can be divided into six fundamental categories according to taste: sweet, sour, salty, pungent, bitter and astringent, with each taste containing nutritional factors that the body needs for proper functioning.

Top: The guest rooms at the resort overlook the mighty Himalayas with the sacred river Ganges meandering its way in the valley below. Wooden floors are complemented by light-coloured interiors. *Bottom:* The seating arrangement in the deluxe suites is Art Deco in style, and exudes luxury from the word go.

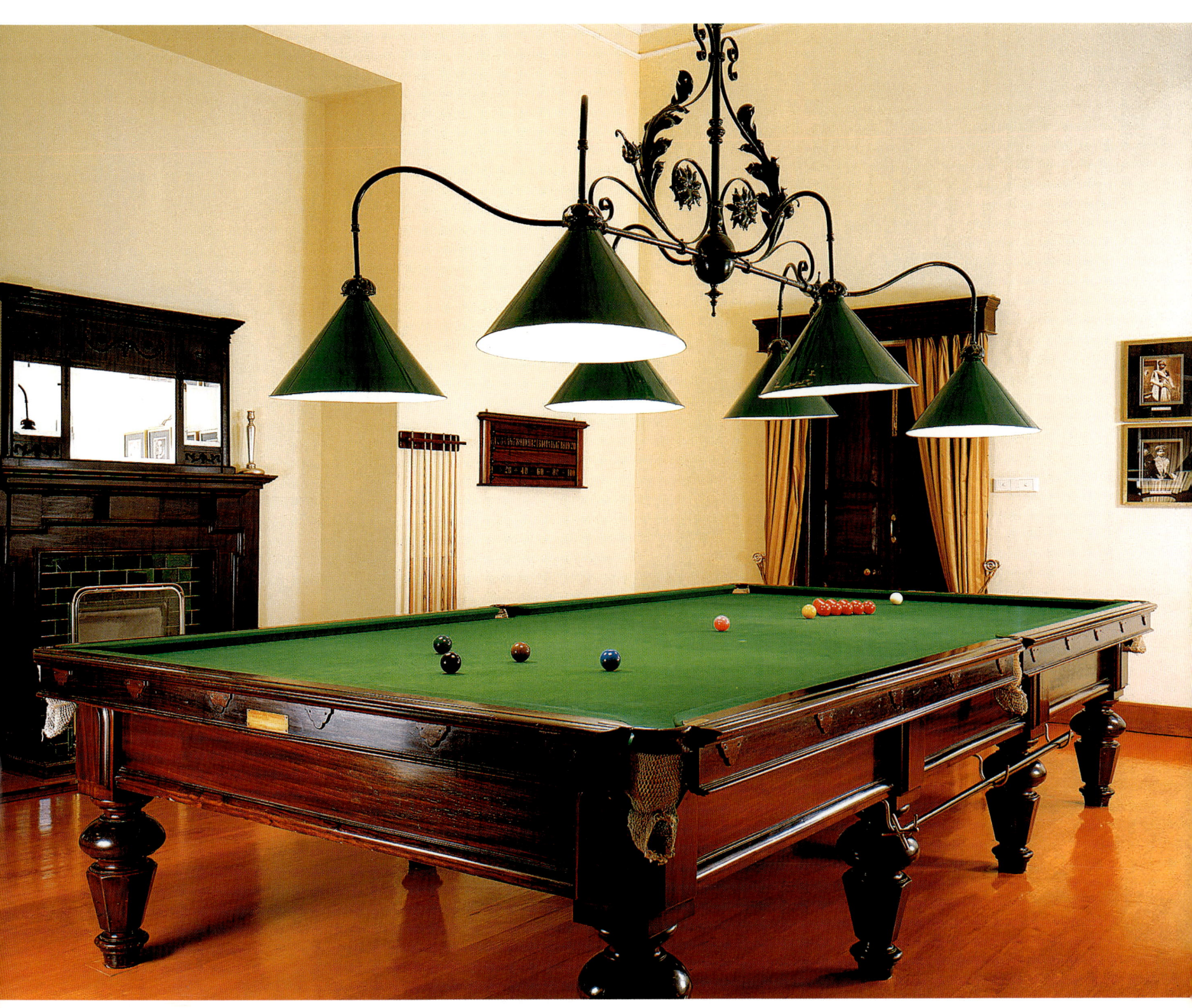

The billiards room at the Viceregal Palace is one of the indoor play areas at the resort. A rich masculine place on sleek, elegant lines. **Page 194:** *The reception of the spa is an airy atrium hall, where natural breeze flows through ancient pines and wild flowers.* **Page 195:** *The egg-shaped chandelier is the highlight of the conference room at the Viceregal Palace.*

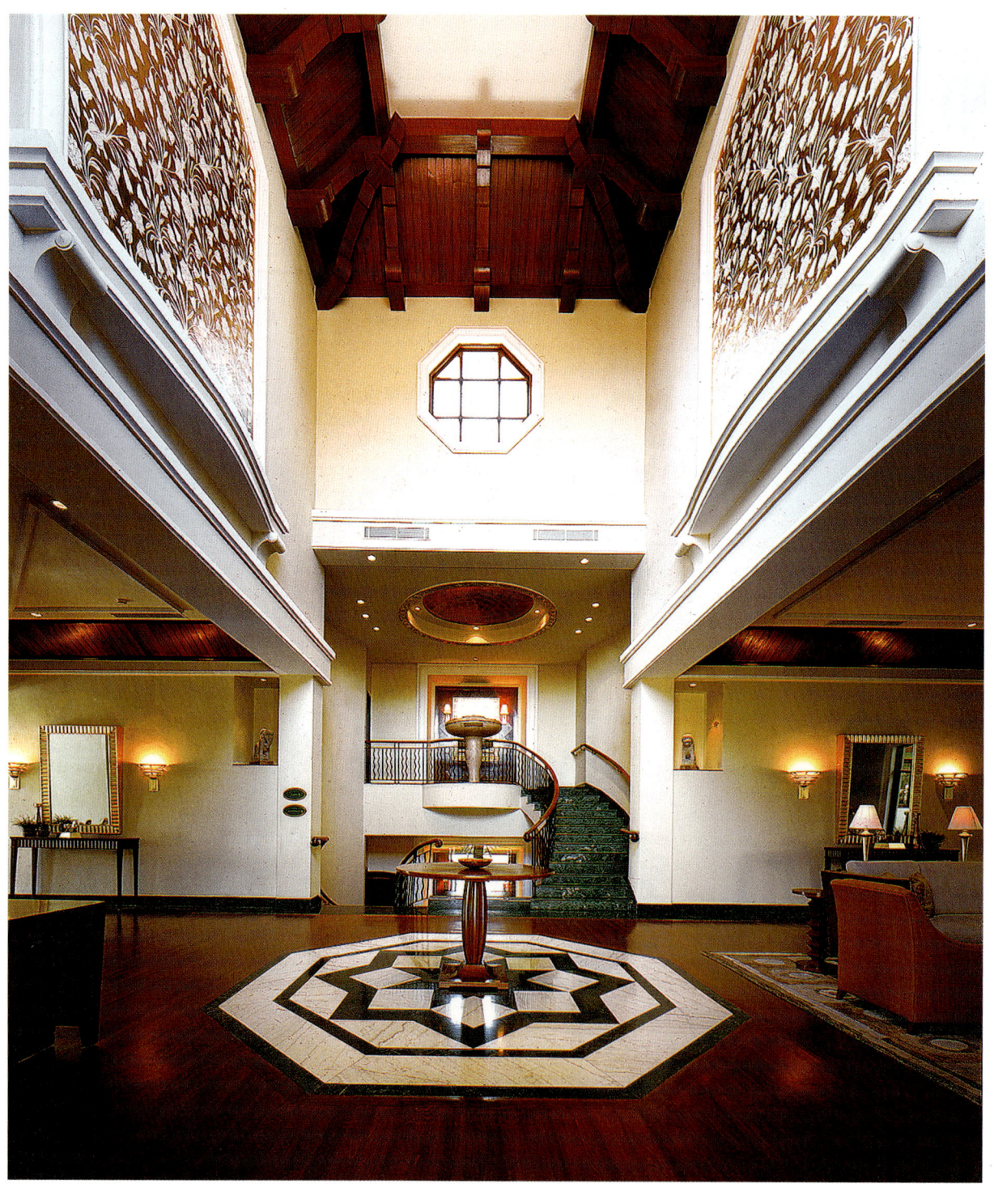

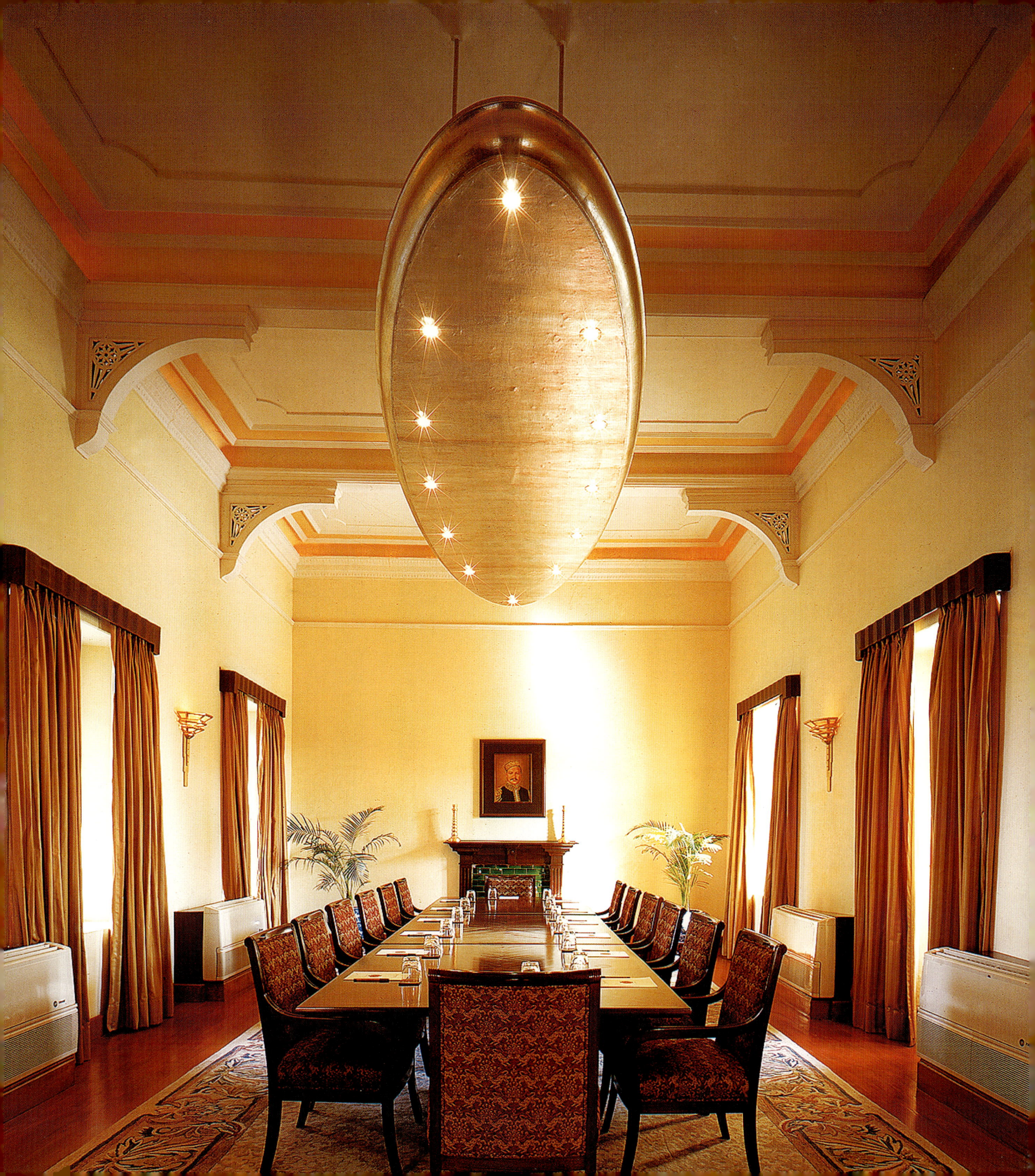

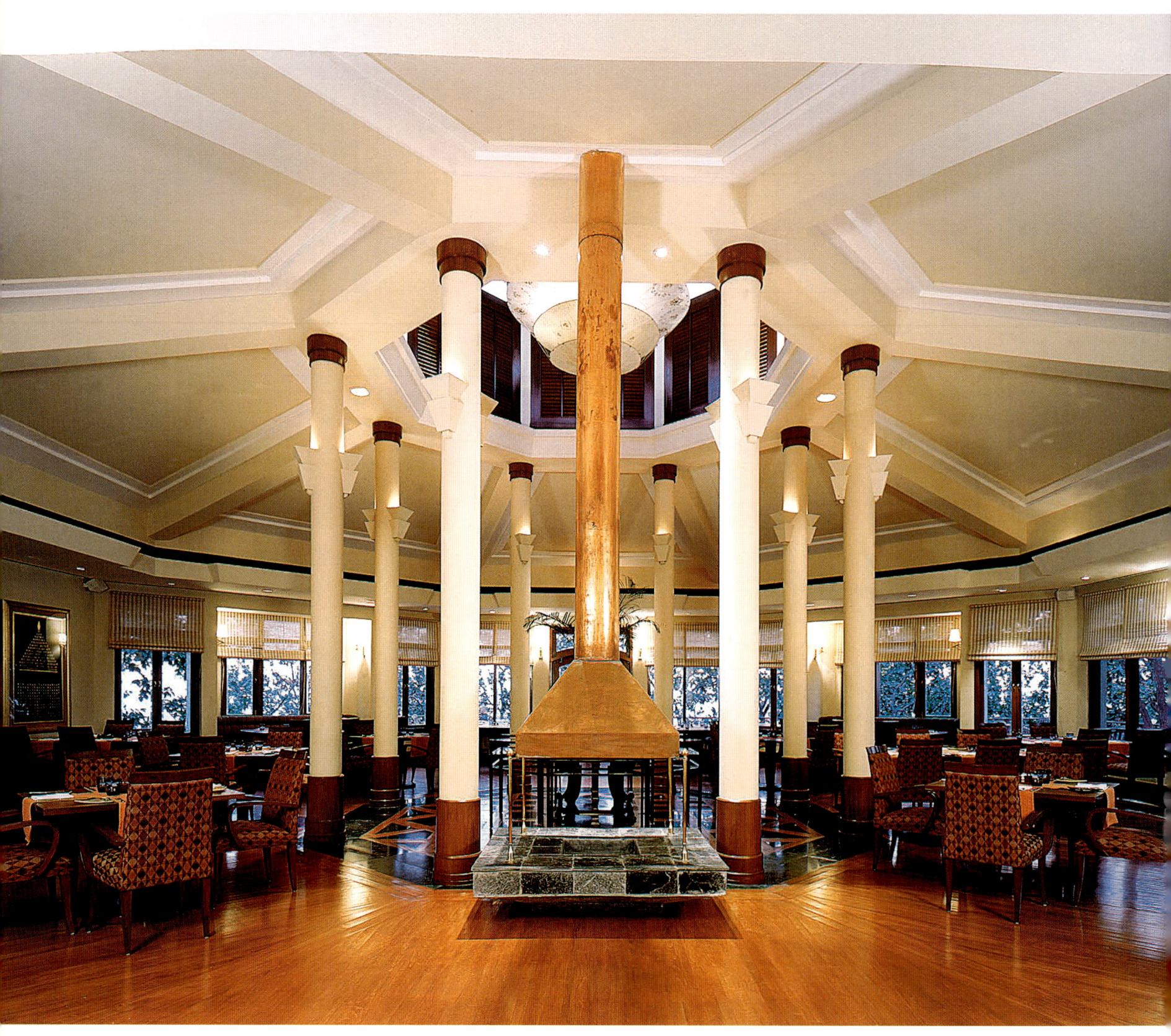

An island fireplace forms the focal point of the restaurant at Ananda, with its Art Deco design complementing the architecture of the Palace annexe.

To follow Ayurvedic dietary principles, one has to consider individual body type, personality; response to factors like stress, weather and factor in the time of year and life, while suggesting specific food and activity options. Each individual is categorized into body types – Vatta, Pitta and Kapha depending on activity level, medical condition and lifestyle. Ananda Yoga enhances the physical, mental, emotional and spiritual qualities of guests, utilizing three branches of Yoga – Hatha, Kriya and Raja. Beginners and experienced participants are encouraged to experience a higher level of personal contentment through individualised practice incorporating devotion, dedication and discipline to one's lifestyle.

Ananda Sadhana focuses on Pranayama (breathing), Asana and Dhayana (meditation). The flow of Prana (air) is channelled, stimulating the reflexes and helps to stabilise the mind and overcome hypertension, anxiety, stress and high blood pressure. With experience and guidance, the Prana can be used for healing as well as achieving a primal state of being. The most exhilarating experience at the resort is the spa, facilities like a Finnish sauna overlooking the valley and the forest, a Turkish steam bath, a chilled plunge pool, a Jacuzzi with a spectacular view, a footbath area with natural rounded Ganga pebbles, in which, the water temperatures change from one segment to the other segment of the footbath, and a built-in hydro-massage system. There is also the 'Kneipp' pool, where the different temperatures have therapeutic value.

The massage rooms are equipped with private aromatic baths and rest rooms. Each of these rooms has individual showers. A unique feature of the spa is the large Couples' Suite, steam rooms, resting areas and treatments, where guests can have a private facial or body wrap. The resort has customised the Ayurvedic treatments by the use of Herbal Ayurvedic Dosha specific oil and slow synchronised massages to make the body soft and disintegrate the morbid doshas, which are eliminated more easily from the subtle channels of circulation.

The Ananda Spa advocates three precise steps for the detoxification and cleansing process – Snehana, Swedana and Snana. Snehana extracts toxins from the body with the use of scrubs, wraps and packs. Swedana goes a step further, and here detoxification takes place through saunas and steam baths. Snana or the bath is the last step in this holistic cleansing process.

The resort offers the Classic Swedish Massage, the Aromatherapy Massage, the Ananda Touch (stress-relieving scalp, neck and shoulder massage), the Thai Massage, Reflexology and the Couples Connect Massage (a luxurious experience for two in the Kama Suite).

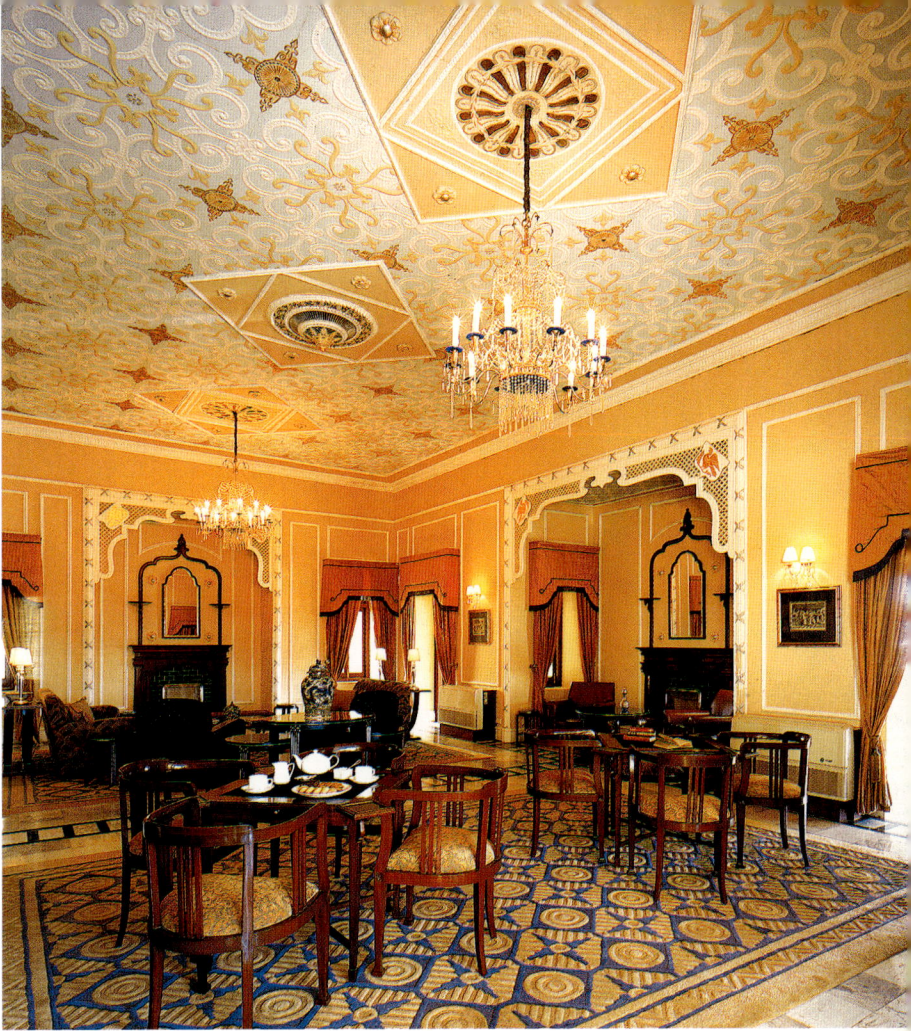

*Top: The reception and welcome lounge at the Palace draws from Moorish architecture and Italian Renaissance interiors. **Bottom**: The footbath at the spa has natural rounded Ganga pebbles of different grades, in which, the water temperatures change from one segment to the other segment of the footbath and also has a built-in hydro-massage system. This is known as the Kneipp pool where the different temperatures have therapeutic value.*

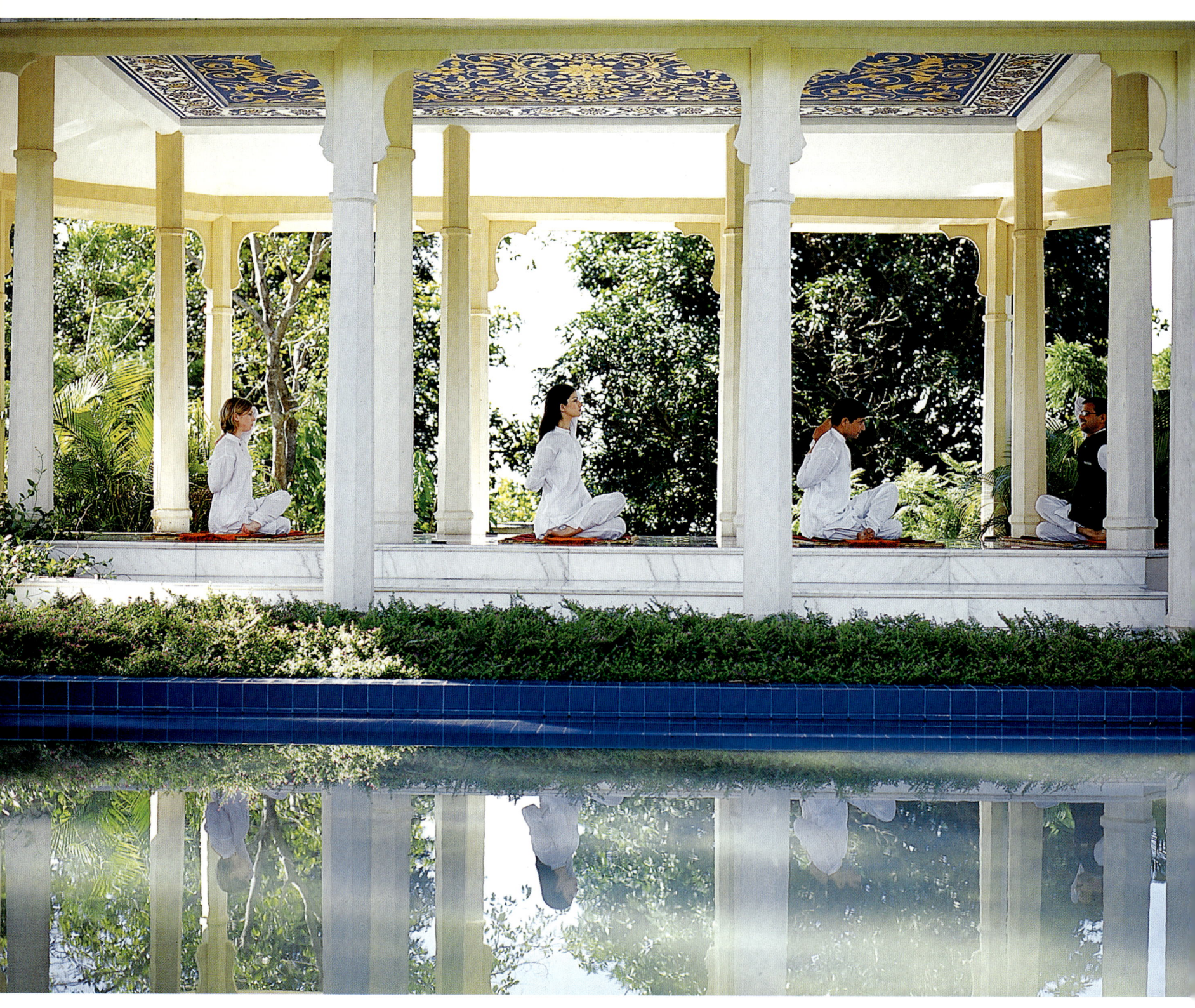

Both pages: Ananda Yoga (seen here being practiced to perfection at the Yoga pavilion in the garden area of the resort) enhances the physical, mental, emotional and spiritual qualities of guests, utilizing three branches of Yoga – Hatha, Kriya and Raja. Beginners and experienced participants are encouraged to experience a higher level of personal contentment through individualised practice incorporating devotion, dedication and discipline to one's lifestyle.

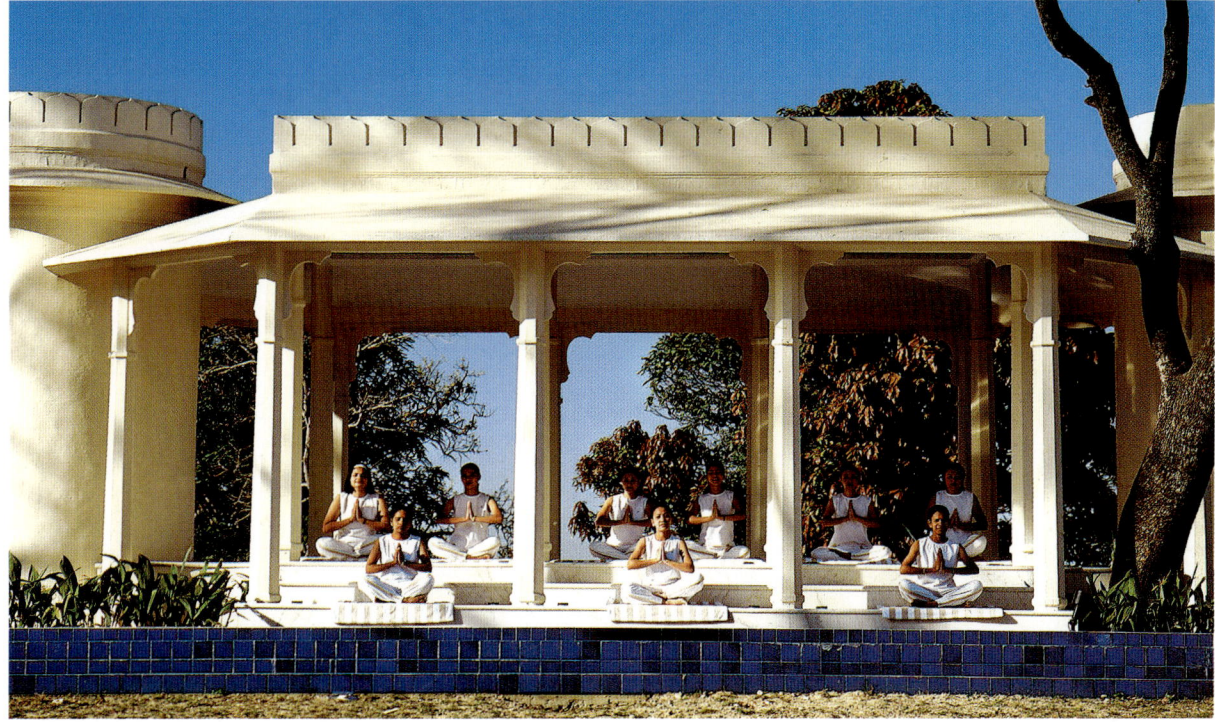

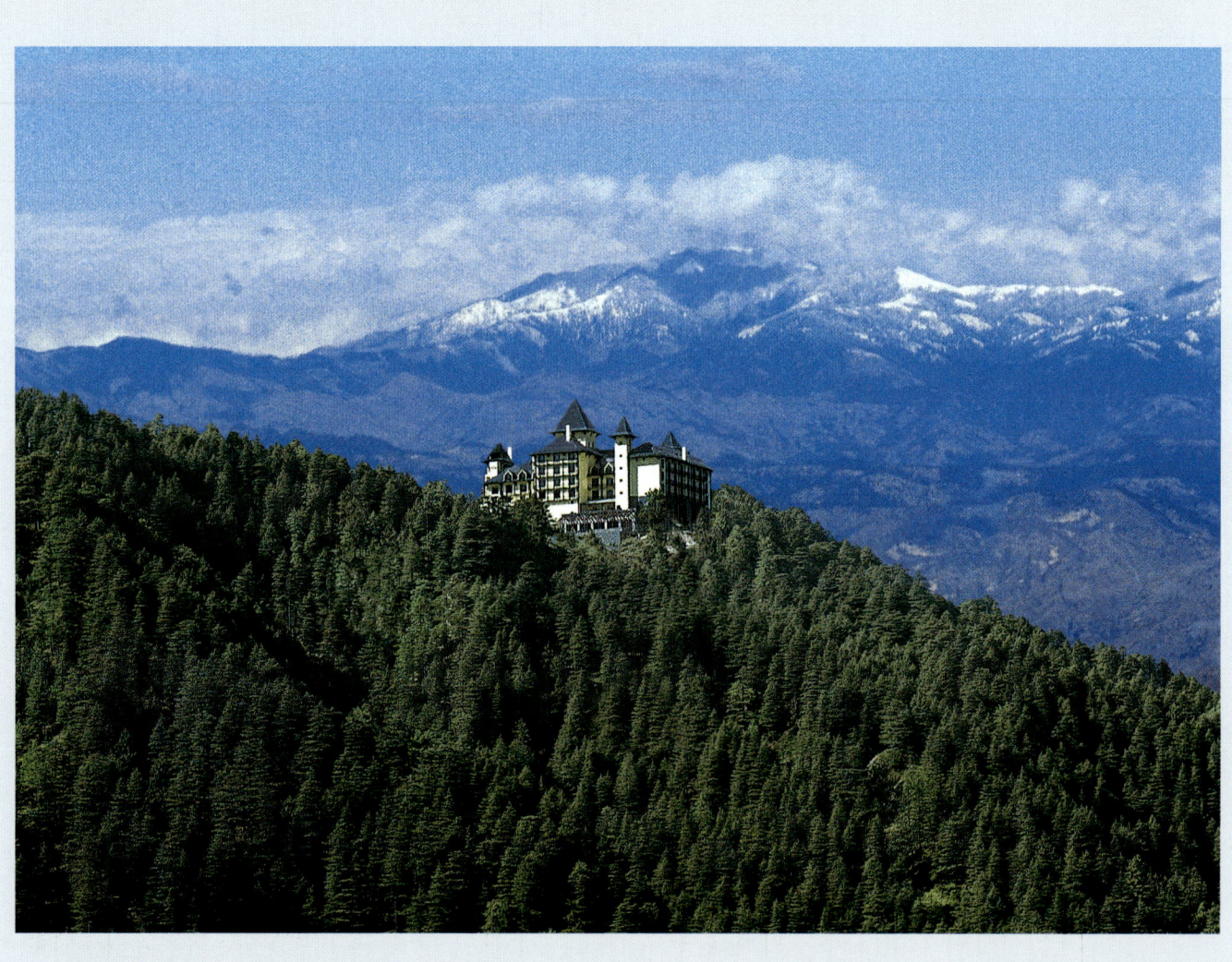

Wildflower Hall, Shimla in the Himalayas – An Oberoi Resort

blending the past with the present

The erstwhile residence of the British Commander-in-Chief Lord Kitchener,
Wildflower Hall, Shimla in the Himalayas – An Oberoi Resort
reflects its gracious past albeit in a modern way...

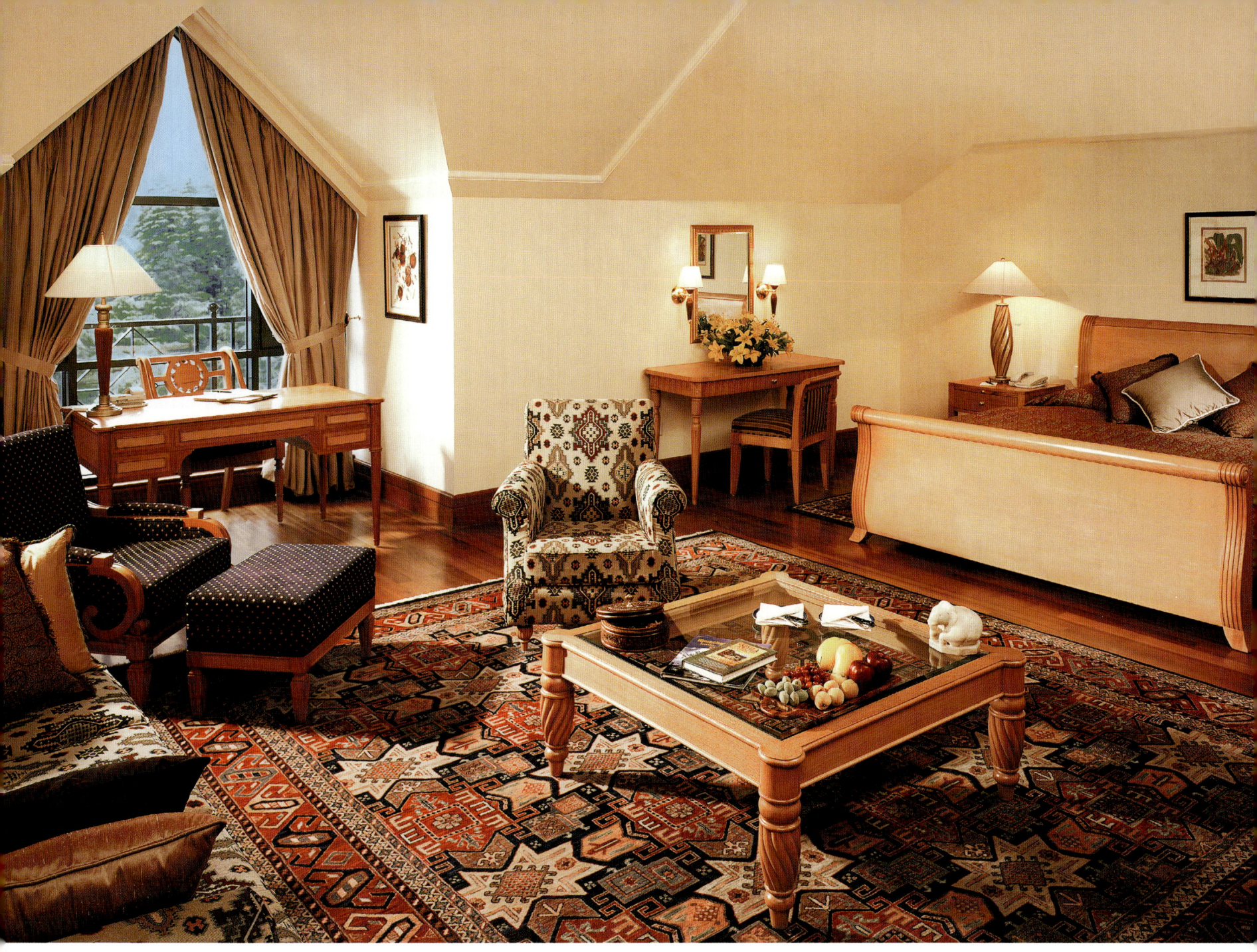

It is a picturesque 45-minute drive over a 13 km distance through forested hills from Shimla, the capital of Himachal Pradesh that brings you face-to-face with Wildflower Hall, Shimla in the Himalayas – An Oberoi Resort. Located at an altitude of 2,500 metres (8,250 ft), the resort is a serene and relaxed getaway offering an experience of nature in all its grandeur. From its vantage point on top of a knoll, the resort looks out onto a magnificent vista of rugged mountains, snow-clad peaks, verdant meadows and cedar forests.

The guest rooms with timber flooring, hand-knotted rugs and rich furnishings complemented by spectacular views, offer a sanctum of comfort and serenity.
Page 200: Set amidst thick evergreen forests, Wildflower Hall, Shimla in the Himalayas presents a picture of breathtaking natural beauty.

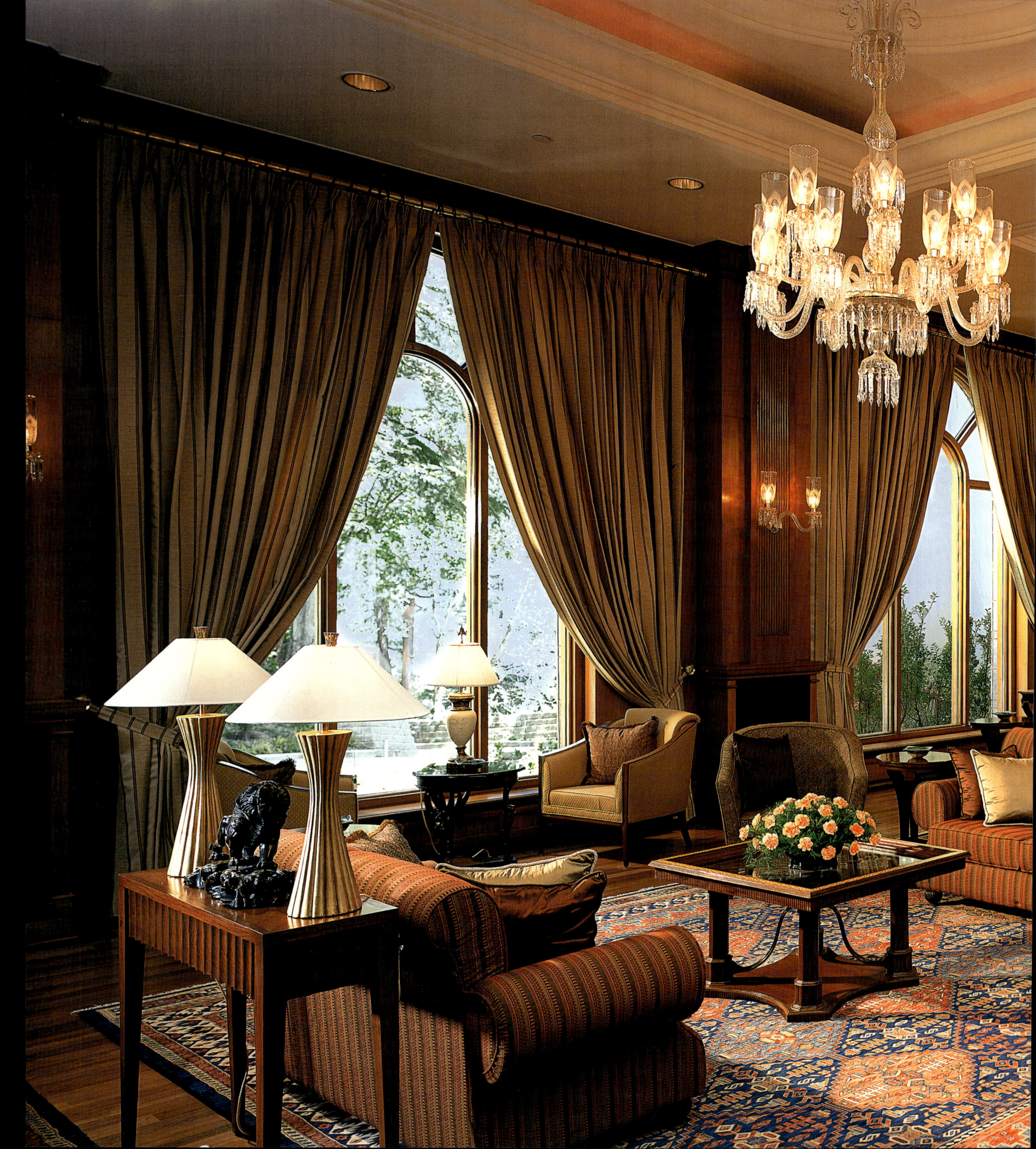

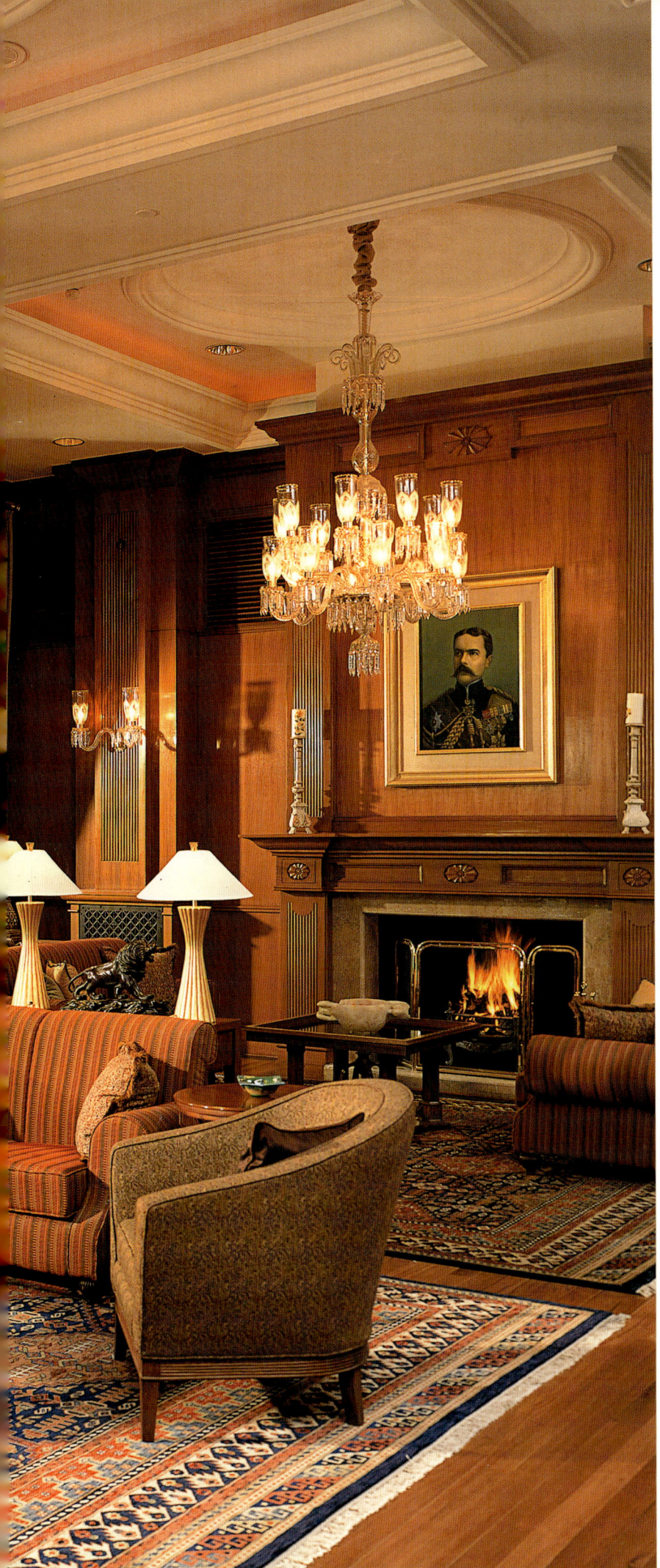

Shimla is easily connected by road from Chandigarh (124 kms), Kalka (110 kms) and Delhi (385 kms). You can also fly down now as there is a daily direct flight to Shimla from Delhi. However, if you want to enjoy the scenic beauty of the Himalayas, then it is best to take the train from Kalka that runs on a quaint narrow gauge railway, built in 1903.

Set amidst thick evergreen forests, Wildflower Hall, Shimla in the Himalayas presents a picture of breathtaking natural beauty. The resort stands handsomely amidst 22 acres of cedar and pine trees, bearing testimony to its rich heritage. Reflecting its gracious past, the interiors of the resort are luxurious and inviting. Wood panelling and original artwork create an aura of old-world charm. The rooms with timber flooring, hand-knotted rugs and rich furnishings, complemented by spectacular views offer a sanctum of comfort and serenity.

The erstwhile residence of the British Commander-in-Chief Lord Kitchener, the Oberoi resort reflects its gracious past. Located in Mashobra, Wildflower Hall, Shimla in the Himalayas overlooks breathtaking natural beauty. The British chose the splendour of Mashobra to build their country homes as a sanctuary. With a large expanse of dense cedar and pine forests, Mashobra offers awe-inspiring views of the majestic snow peaks.

Built to the most exacting international standards, the resort combines the beauty indigenous to the area with modern comforts. Burmese teak panelling and polished parquet floors covered with oriental rugs imbue the interiors with an element of luxury. Arched picture windows of the spacious lobby lounge offer splendid views, bringing in the beauty of the outdoors and flooding the public areas and restaurants with natural light.

The resort has 85 well-appointed guest rooms and suites with a breathtaking view of magnificent snow-capped mountains, beautiful valleys and dense pine forests. Period memorabilia and bric-a-brac lend an added elegance to the atmosphere.

The dining experience at the resort includes Lutyens – The Indian restaurant, which reflects an old-world charm reminiscent of the Raj with elegant woodwork, arched windows and an inviting fireplace; The Restaurant opens onto a large terrace with an enchanting conservatory that overlooks the magnificent mountain ranges and valleys; and The Cavalry Bar, with its welcoming log fire, classic upholstery and artifacts relating to the British Cavalry regiments, offers magnificent vistas.

A Billiards Room at the lobby level with upholstered high benches, exquisite lighting fixtures and a warm fireplace recreates the days of Lord Kitchener. The Oberoi Spa at Wildflower Hall, Shimla in the Himalayas offers non-clinical therapies, massages and beauty treatments incorporating ancient Ayurvedic principles, Aromatherapy and western techniques that are designed to rejuvenate, relax and pamper.

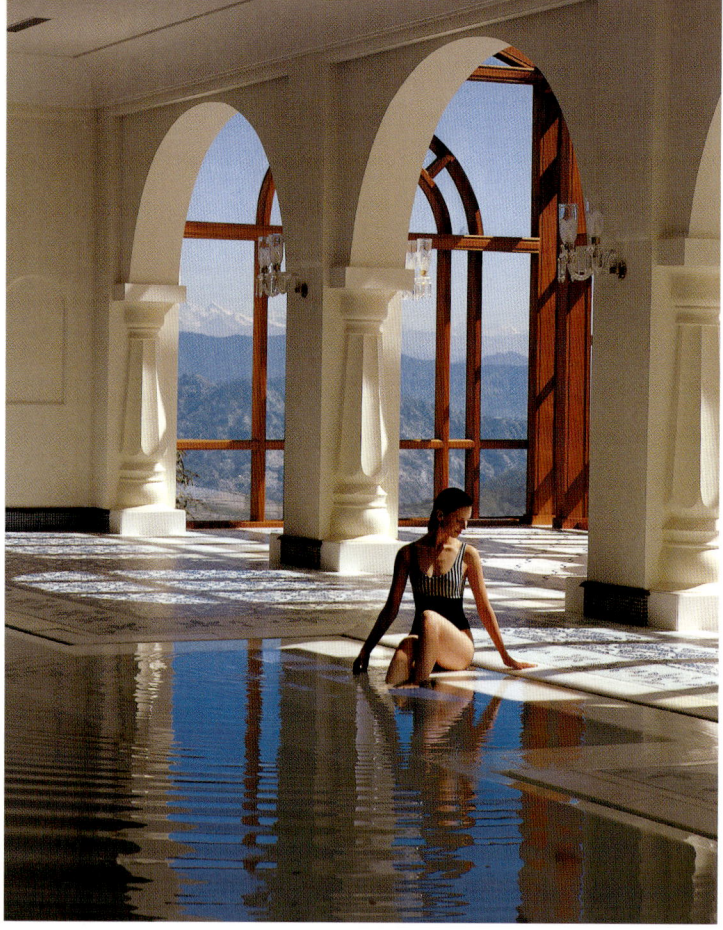

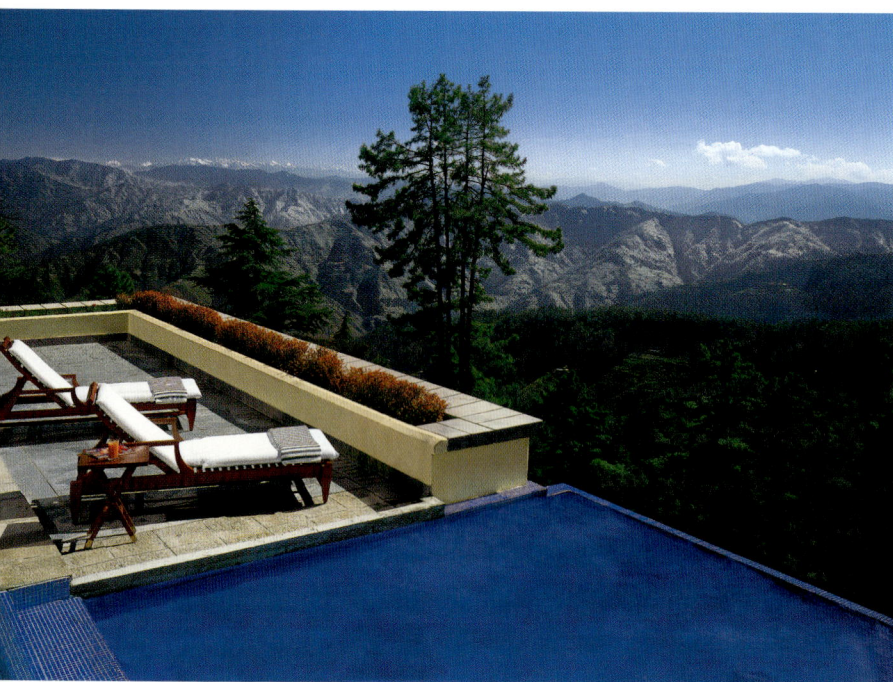

The Oberoi Spa at Wildflower Hall, Shimla in the Himalayas offers two Spa Suites, located on the third floor of the resort, which offer panoramic views of the valley, cedar forests and the majestic Himalayas, and two Spa Pavilions, located within the dense cedar forest.

Each Spa Suite and Pavilion is furnished with two massage beds, a freestanding bathtub and steam shower, making it ideal for a couple to enjoy a treatment together, or for a luxurious spa experience which includes a combination of a cleansing scrub, body wrap, head and body massage followed by a bath.

Out of the spa therapies, some are indigenous to region and have been specially created for Wildflower Hall, Shimla in the Himalayas. The therapy, Himalayan Mysteries, begins with a lavender-scented scrub that cleanses and refreshes, leaving the skin delicately scented. Then it lulls you into a state of total relaxation under the soothing hands of the therapist who eases away the tension with a Hawaiian massage, known for its flowing and rhythmic strokes. A basic cleansing facial precedes a fragrant jasmine bath that adds the finishing touches to the elaborate therapy.

Himalayan Retreat, on the other hand, starts with a body scrub that cleanses the skin. This is followed by the hypnotic touches of an Indian head massage, performed traditionally by ladies to maintain long, healthy and shining hair. Next, a full body massage enhances the overall well-being as blood circulation improves and stress is soothed by skillful hands. The session ends with a Himalayan cedar bath.

While at Wildflower Hall, Shimla in the Himalayas, you can take leisurely walks through the fragrant cedar forest gourmet picnic hampers adding a special element to these explorations. The adventurous can choose from a range of exhilarating activities like white water rafting, horse riding, trekking, (in winter) ice skating and mountain biking. The resort also has an indoor heated swimming pool and an outdoor whirlpool.

For those looking for excursions from the resort, the best option is to visit to the bustling city of Shimla, see the historical sites and shop at the Mall or enjoy a horse ride to the hilltop at Kufri or drive to Chail that has the highest cricket ground in the world or tee off at the Naldehra golf course or better still just enjoy the scenery at Narkanda.

Wildflower Hall, Shimla in the Himalayas is truly a gem in the mountains.

Top: Wildflower Hall, Shimla in the Himalayas is one of the few resorts in the country that feature an indoor heated swimming pool. Here too, the expansive picture windows let in the bright natural light and the arched pillars add to the element of colonial grandeur. Bottom: You can soak in the mountain sun while sun-bathing on the terrace next to the outdoor heated whirlpool. Page 204: Burmese teak panelling and polished parquet floors covered with oriental rugs imbue the interiors of the resort with an element of luxury. Arched picture windows of the spacious lobby lounge offer splendid views, bringing in the beauty of the outdoors and flooding the public areas and restaurants with natural light.

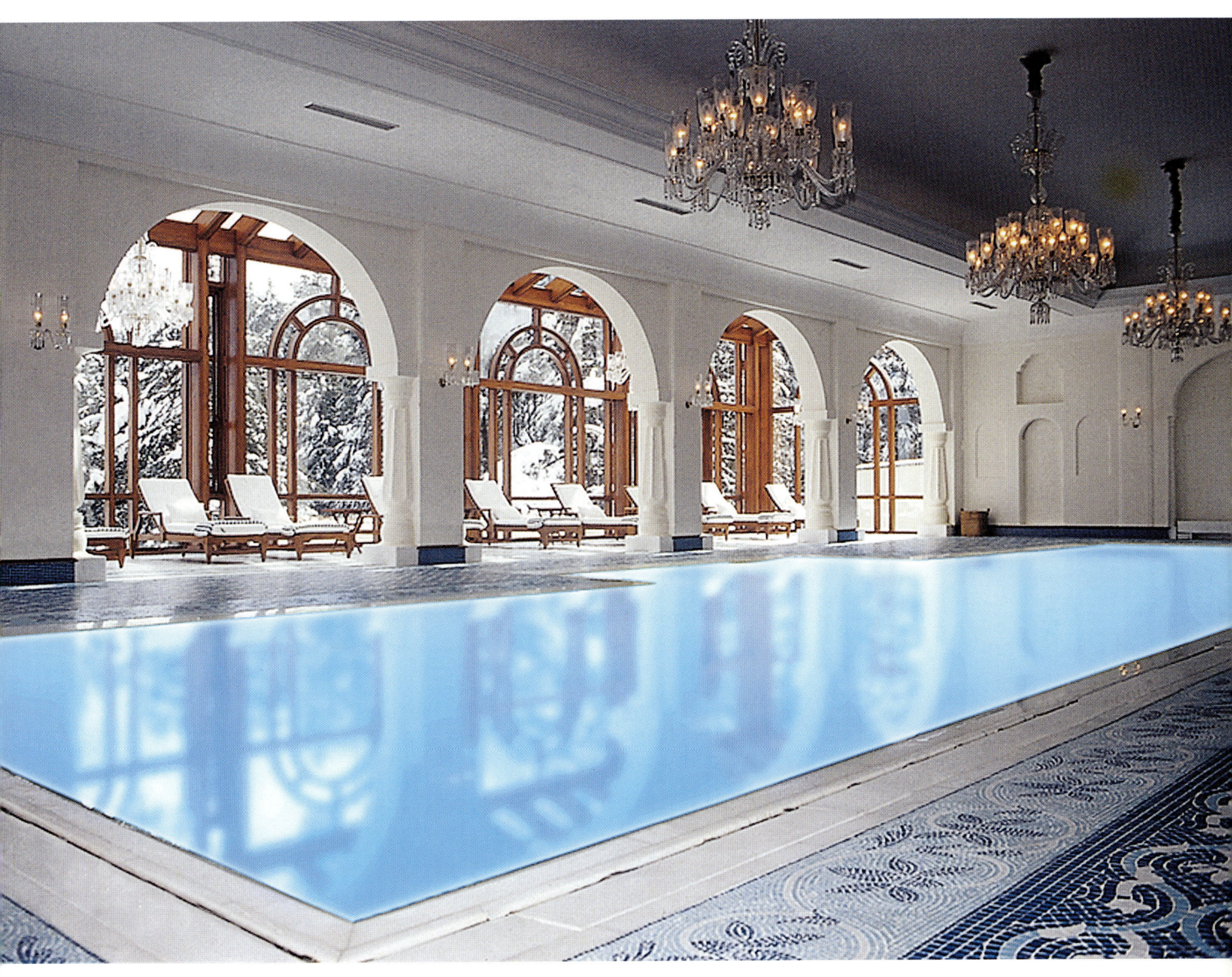

You can see the snow-covered peaks through the glass windows of the indoor heated swimming pool. Classic chandeliers impart a soft romantic glow to the evenings. **Page 208-209:** *The resort is simply breathtaking located amidst snow-clad peaks and pine and cedar forests in the foothills of the Himalayas – just like a castle in a fairy tale.*

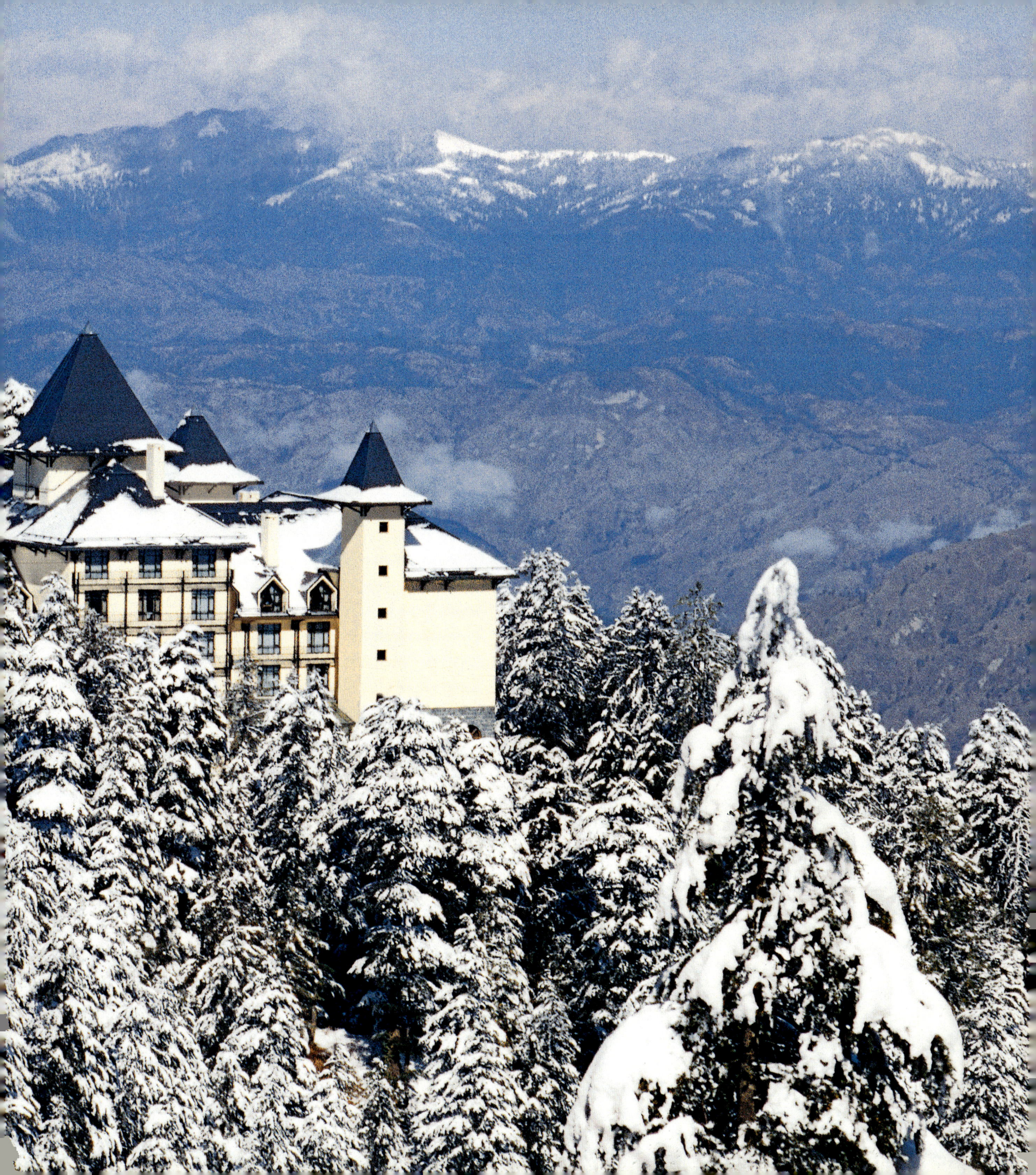

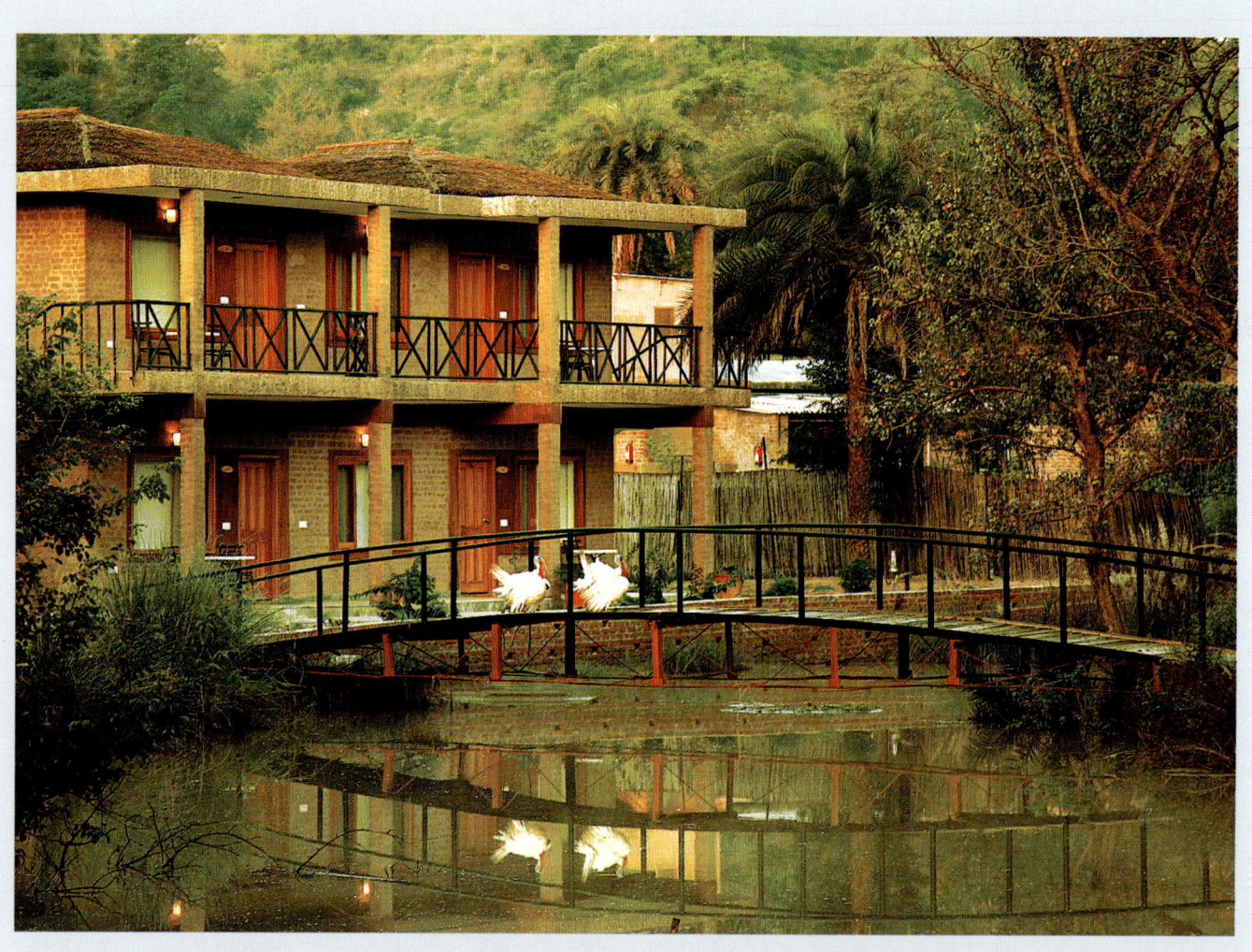

The Kikar Lodge
Nature Retreat and Spa, Ropar

true to nature

A kikar tree is a symbol of the spiritual seeker who must face the barbs and arrows of the worldly people – a theme that The Kikar Lodge Nature Retreat and Spa at Ropar revolves around...

\mathcal{S}troll among endless acres of lush greenery, experience the allure of the wilderness or better still refresh your soul with cultural and natural heritage. This is The Kikar Lodge Nature Retreat and Spa for you – the perfect getaway to serenity.

Nestled in the foothills of the Shivaliks, The Kikar Lodge is located in Ropar district of Punjab and is arguably the country's first

The architecture style of the Resort is a surprising mix of the contemporary and the rustic, and blends in seamlessly with nature's fauna and flora.
Page 210: *Situated close to the shimmering blue band of the Ropar Wetlands, the resort is spread over 1,800 acres of land.*

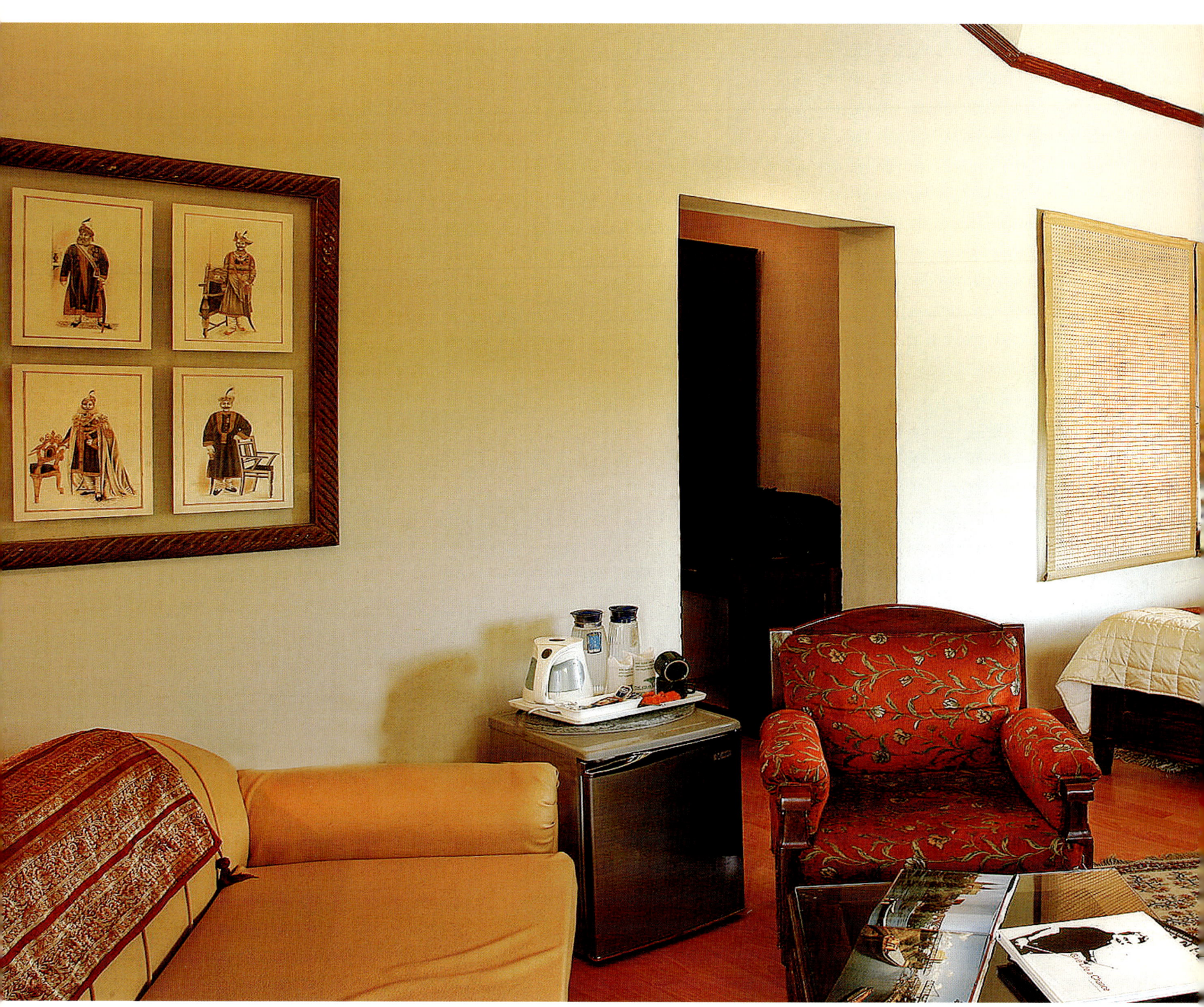

The guest rooms are done up in bright hues and ethnic fabrics, suffused with warm comfort.

A peek inside one of the tents where guests can stay to experience a true nature retreat.

private forest reserve. Situated close to the shimmering blue band of the Ropar Wetlands, the resort is spread over 1,800 acres of land.

The Ropar Wetlands were formed with the construction of a barrage over the Sutlej River in 1952 and are the breeding ground for a variety of wildlife including the Indian Otter, Hog Deer, Sambhar Deer and Pangolin, about 35 species of fish, and local and migratory birds including Coots, Common Pochard, Red-Crested Pochard, Tufted Pochard and Shovellers.

Ropar is an hour's drive from the city of Chandigarh, which is well-connected with the rest of the country by air and rail.

However, at The Kikar Lodge, there is much more to do and see than witness nature's progress. It is also home to an in-house automated dairy for all milk products, an organic farm for fruits, vegetables and herbs, and a natural cascading spring for pure fresh water.

The resort includes four suites and fourteen deluxe cottages and twelve luxury safari tents that are well-appointed to cater to all comforts and tastefully done to reflect the tranquility of the surroundings. The location of the lodge gives it full advantage for a number of exploratory and adventure activities, while permitting it to tap into the tranquility of the locale to set up a spa.

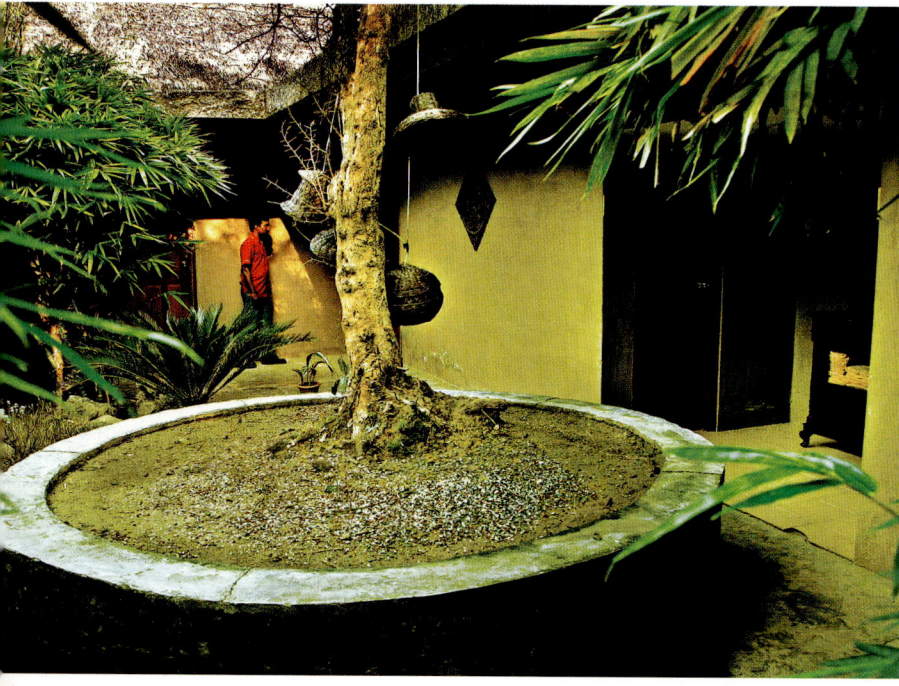

The spa helps you rejuvenate your senses, experience the calm of nature and immerse yourself in tranquility; re-energize your mind and body with adventure activities that test your endurance and revitalise and detoxify your soul.

Serenity, the spa has various massages for relaxation and toning. It also offers various packages catering to specific situations or complaints like weight reduction, arthritis, post-pregnancy, migraines, eye-care, etc.

The purification and alleviating therapies of Ayurveda help in achievement of individual health goals, stress management, deep relaxation, detoxification, nutrition or exercise. The spa offers different types of programmes including a unique health programme with herbal oil massages.

There is also an ancient treatment to treat sinusitis and migraine effectively. A special programme helps restore and repair the worn-out tissues, improve blood circulation, stop premature ageing, get rid of toxins from your system and give you a glowing wrinkle-free skin.

A special beauty therapy takes care of pimples, wrinkles, acne, sagging of the skin and falling of hair. The oil nourishes and cleanses the tissues to make the complexion glowing and youthful, smoothes wrinkles and enhances beauty. The eye-care treatment helps in relieving tension in the eye which causes poor eye sight, pain, fatigue; it brings lustre to the eyes and smoothes away wrinkles.

At the resort, you will wake up to the call of the jungle fowl, experience a plethora of bird life, numerous species of deer and the elusive bara singha in their natural habitat as well as be able to pay a visit to Anandpur Sahib, one of the holiest Sikh shrines in the country. Apart from Anandpur Sahib, you can even go up till Kiratpur Sahib or visit the picturesque, yet man-made Bhakra Nangal Dam at Nangal. Myriad voices of nature beckon… from jungle trails, horse and camel safaris, motorized Quad biking to all terrain cycling to the more serene aspects of meditation and Yoga.

The eating options at The Kikar Lodge include the Pheasants Nest, a multi-cuisine restaurant and a bar called the Watering Hole.

The outdoors also provide an opportunity to experience off road Quad biking, paint ball and an eighty feet rappelling wall which are an extremely powerful medium for training managers in new skills or helping them improve old ones.

A nature retreat that enables you to become one with the surroundings!

*Serenity, the Ayurvedic spa that is run in collaboration with the experienced Kairali Institute has various massages for relaxation and toning. Seen in the pictures are the entrance (**top**) and inner courtyard (**bottom**) of the spa.*

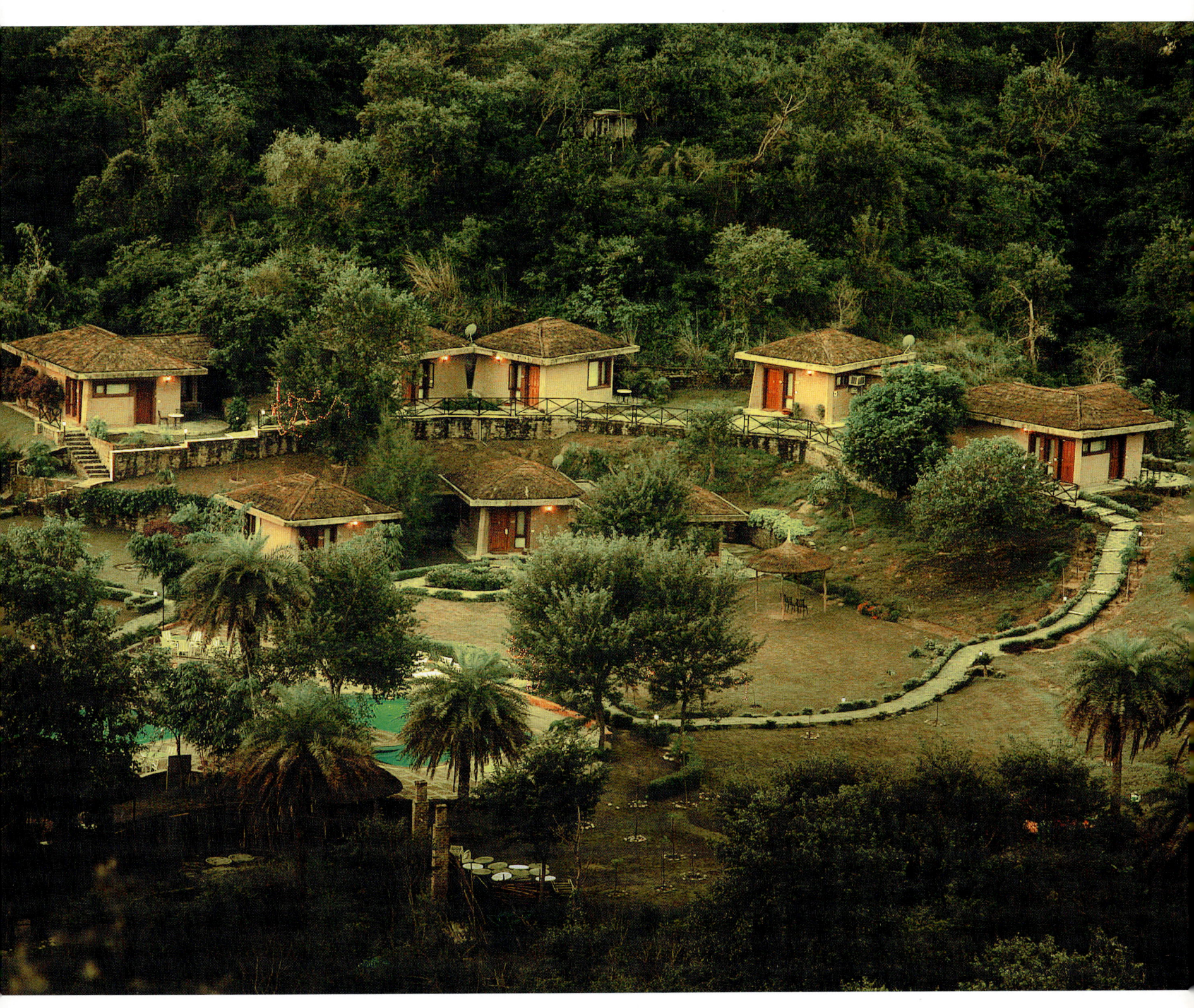

Rustic cottages set amidst tranquil greens exude a quiet charm.

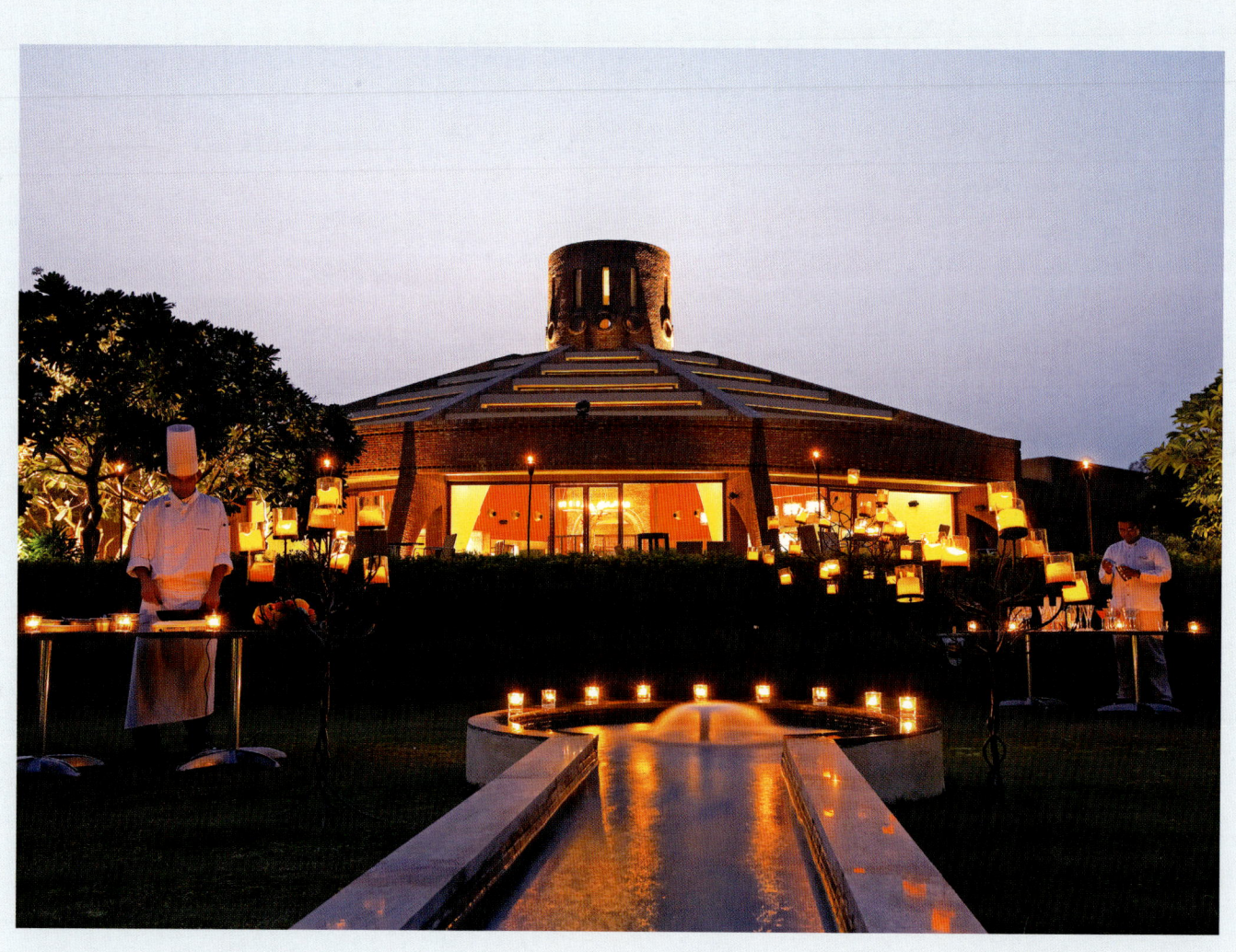

The Westin Sohna-Gurgaon Resort and Spa

as natural as it can get

The Westin Sohna-Gurgaon Resort and Spa is a place where you can achieve your best, as you immerse your body and soul into the sights, sounds and scents of the natural surroundings...

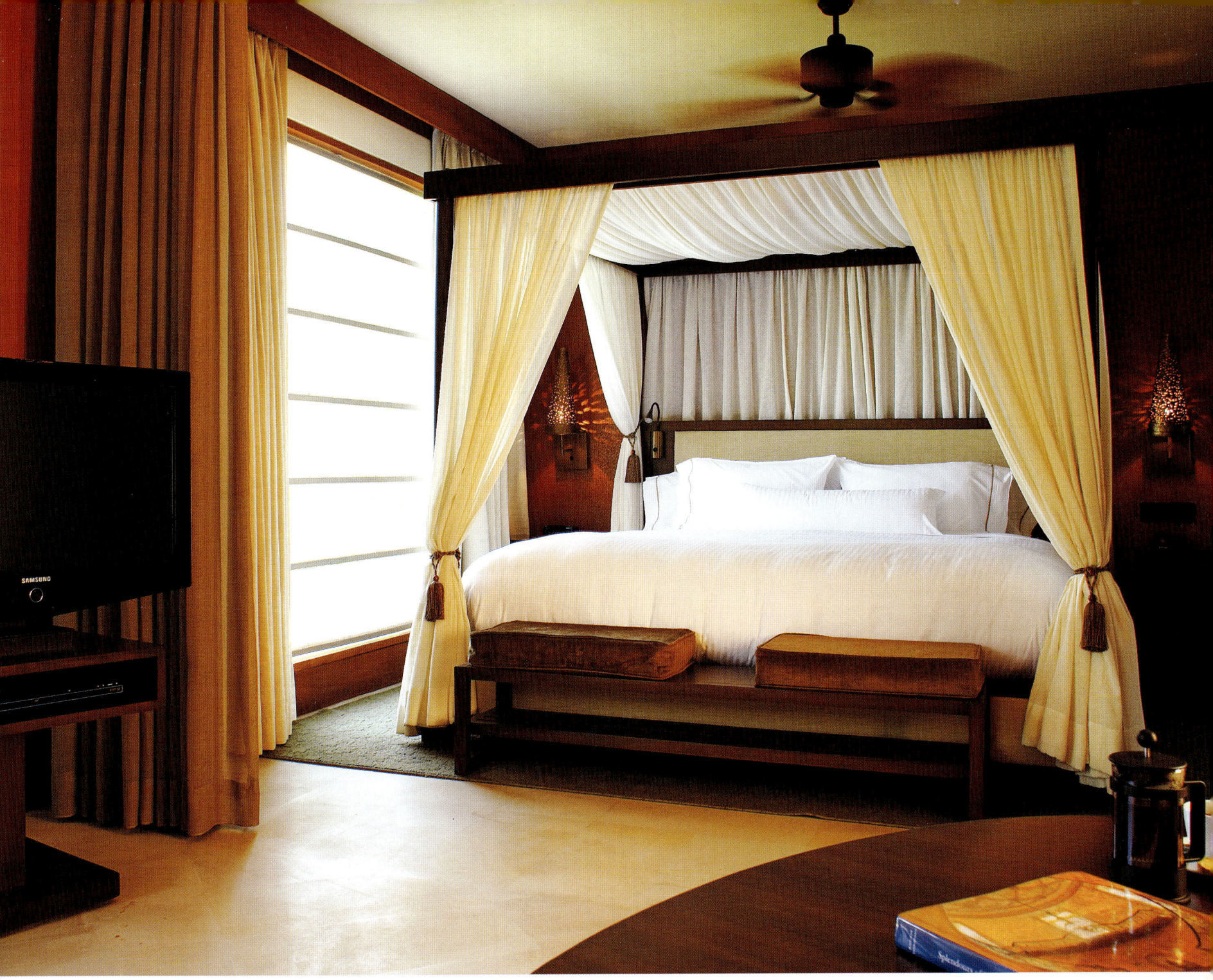

The Westin Sohna-Gurgaon Resort and Spa is probably the only spa resort in the country that allows children also to be a part of the experience – partially, if not fully. Not only does it allow them entry into the resort, but also has a separate, dedicated day-care centre for kids, catering to all their needs and requirements, becoming a family destination in every sense.

Taking pride in providing its guests what it calls "a truly out-of-this-world sleep experience". The fluffy white duvet gives the elegant four-poster bed its 'meringue' effect, inviting you to dive into a sea of five pillows. The colour palette is a soothing mix of white, beige and browns.
Page 218: The open-air pavilion – Xiao-Chi serving authentic Chinese cuisine – illuminated in the night sky, all set for a romantic dinner.

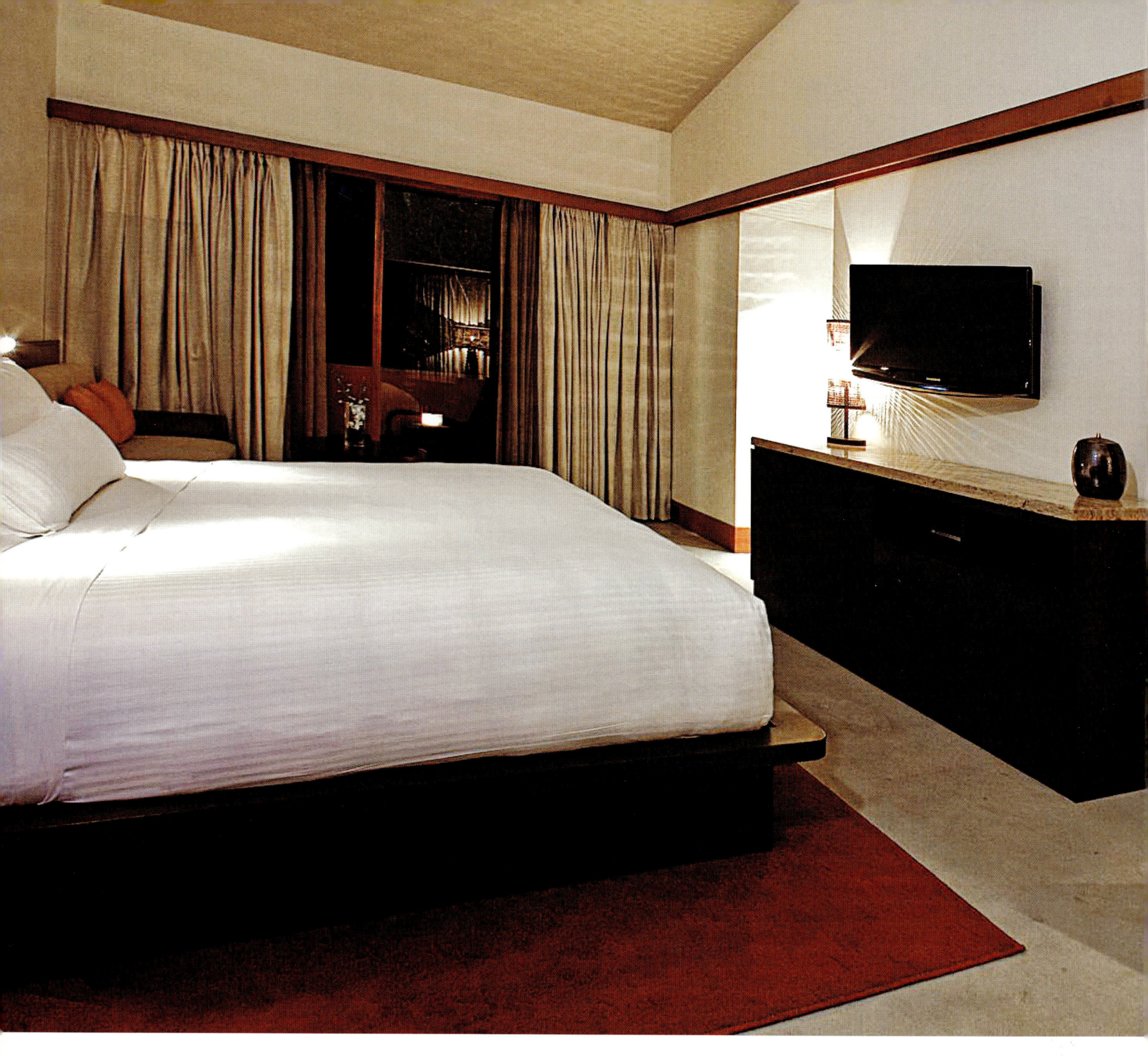

Left: The suites at the resort are designed in a contemporary fashion, imparting a plush and luxurious feel. *Right:* The oval bathtub is placed against the glass wall (covered by a blind) overlooking the well-manicured lawns.

Spread over 37 acres of lush green surroundings, the resort compels you to leave the outside world behind and allow your senses to be elevated. As you turn off the National Highway-8 from Gurgaon, the road leading to the resort prepares you for the best. As you wind your way through farms and quaint little villages, your expectations are heightened as to what the resort will be like. All the way to the resort, the only thing that you see is nature at its best – unspoilt and totally virgin. The resort is ideally located at Sohna, a well-known picnic spot famous for its lake and hot springs.

Golf carts usher you into the resort and the reception area lets the story unfold. Encased in glass on all sides, overlooking small water bodies, the reception is chic, modern and state-of-the-art. The resort has 97 rooms comprising 52 Deluxe Rooms, 29 Studio Suites, 15 Deluxe Suites and one Presidential Suite.

Designed by Australia-based architects cum interior designers, Chadha Siemjeda, the entire resort has been built in red brick. The basic design objective was to make a contemporary luxury resort albeit in an Indian way. The resort used to be called the Vatika Garden Retreat and is owned by Delhi-based realty developer, the Vatika Group. Seeing the potential as well as its

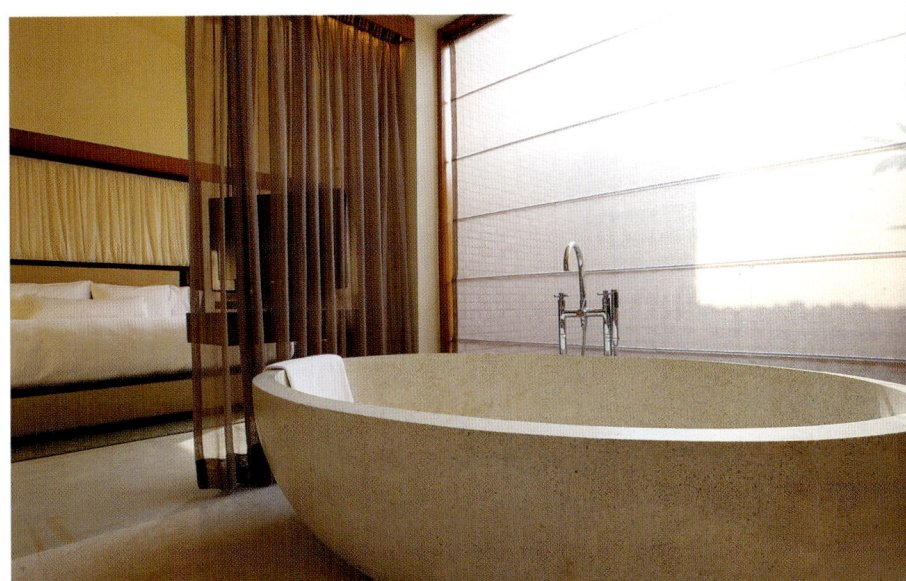

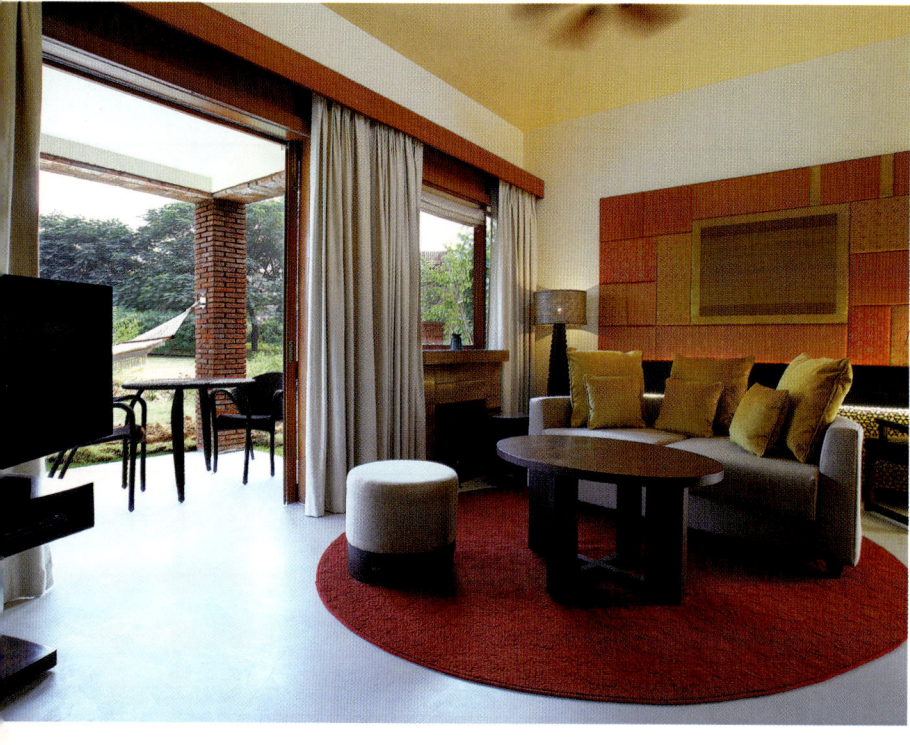

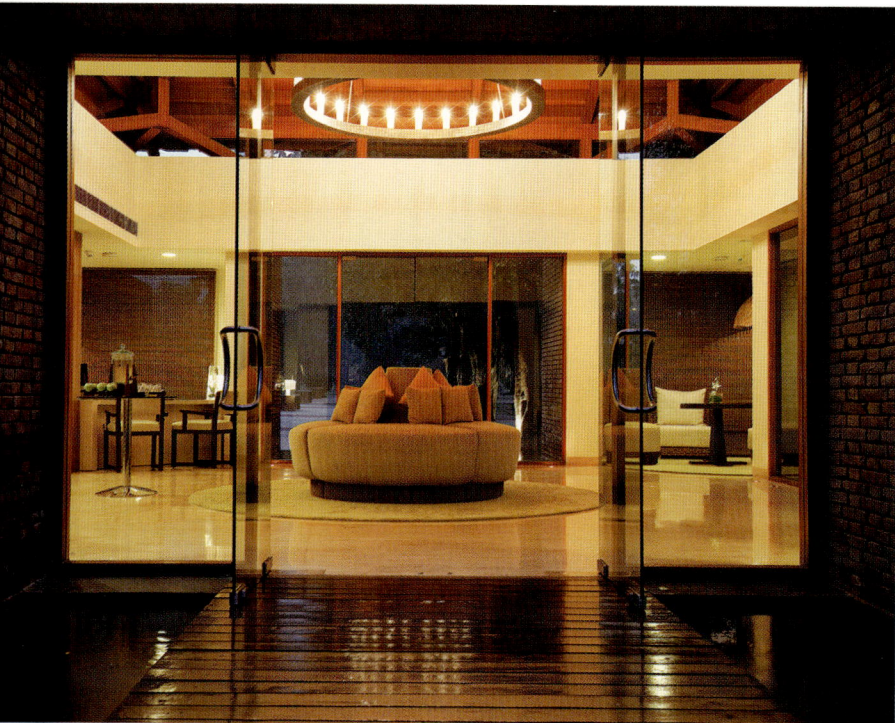

popularity, the Vatika Group decided to enter into an agreement with Westin – a brand owned by US-based Starwood Hotels, so as to enhance the resort's service and image.

The resort has small ponds for ducks, a palatial coffee shop, an authentic Chinese restaurant, a spa, a gym area with a lap pool, an adult and a kids pool as well as a play area for children.

Stone pathways lead you into the suites shaped like cottages. Each cottage has a sitting room, a four-poster bed and an open plan bathroom that will literally take your breath away. The most eye-catching aspect of the bathroom is the tub that has a glass ceiling above – enabling you to soak in the morning rays while taking your bath. The cottage has glass walls that overlook well-manicured lawns and a patio that has a seating area as well as a hammock.

The resort prides itself in providing its guests what it calls "a truly out-of-this-world sleep experience". The fluffy white duvet gives the bed its 'meringue' effect, inviting you to dive into a sea of five pillows. The Heavenly Bed, as it is termed includes a pillow sham, duvet covers, a boudoir pillow, a down blanket, a comforel pillow, down and feather pillows, and a mattress and box spring.

The dining facilities at the resort include the Xiao-Chi and The Living Room. The former is an open-air pavilion serving authentic Chinese cuisine. The Living Room, on the other hand, is an all-day dining restaurant with both indoor and outdoor dining environment. It extends into a small bar that further leads into a lounge cum library.

Another notable aspect of the resort is the over 6,500 sq ft of meeting and function space that it has. However, the talk point of The Westin Sohna-Gurgaon Resort and Spa is its Heavenly Spa and the treatments on offer. Built in a semi-circle with massage rooms coming along with attached bathrooms, the most unique aspect of the spa is a pyramid (inspired by the Auroville township near the Union Territory of Puducherry) that has been built right in the middle of the spa area. Serving as a meditation area, it is perfect for that hour of solace, that you have always been looking for.

Every spa encounter at The Westin Sohna-Gurgaon Resort and Spa begins with a ritual that combines aromatic oils with a massage of the neck and shoulders. The most unique signature treatment available at the resort is the Rollerssage. This massage combines the deep relaxing feeling of a Swedish massage with

Top: The living rooms in the suites are a perfect corollary to the bedrooms – modern, trendy, sleek and state-of-the-art. Bottom: Encased in glass on all sides, overlooking small water bodies, the reception is chic, modern and luxurious.

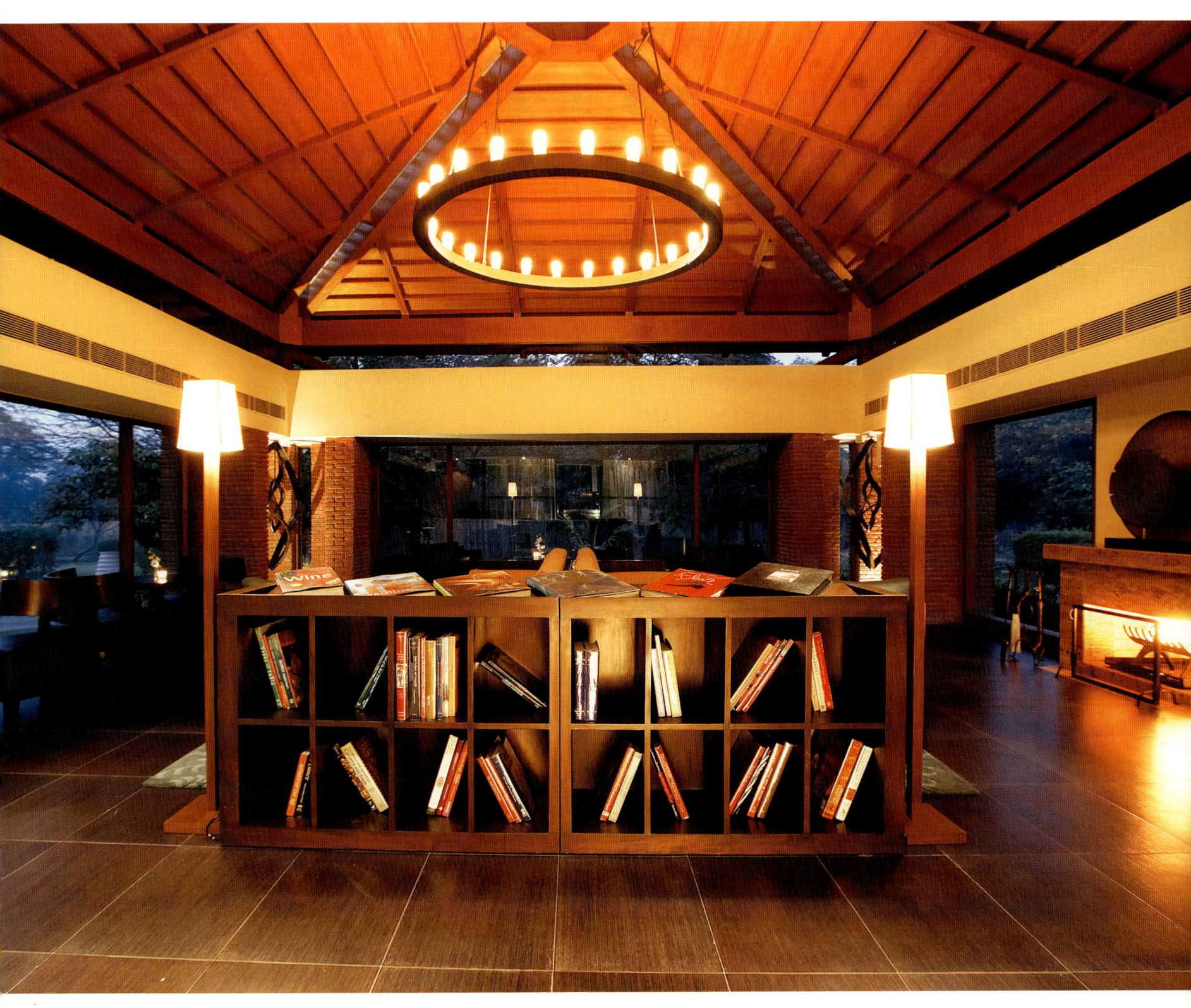

The all-day dining area, Living Room, extends into a lounge cum library that has glass walls on both sides overlooking the lawns. The sloping wooden ceiling and intriguing light fixtures along with the fireplace create a perfect reading niche.

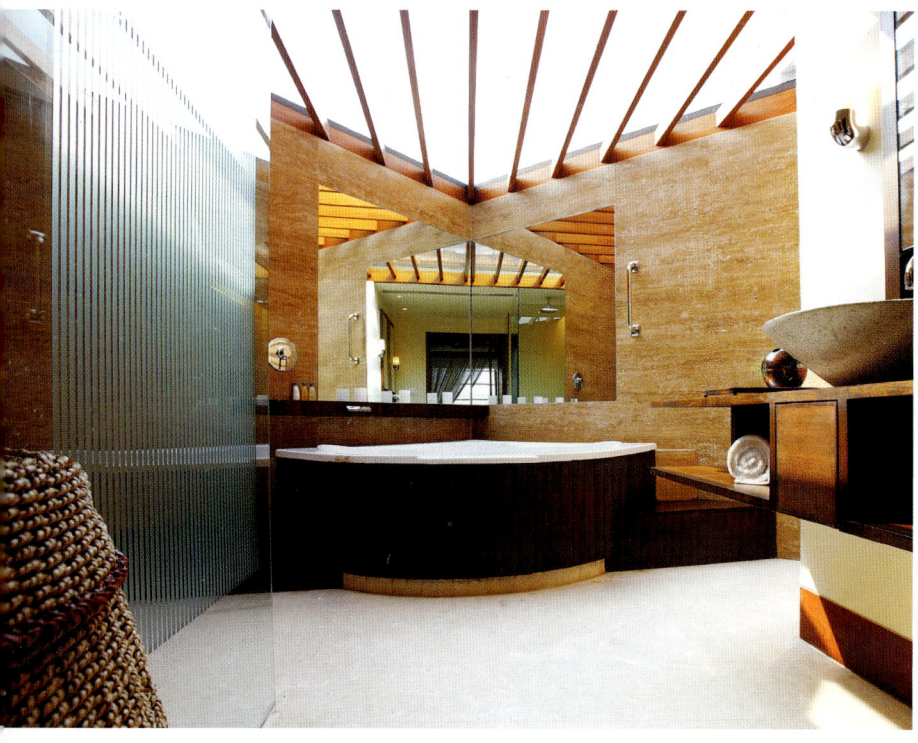

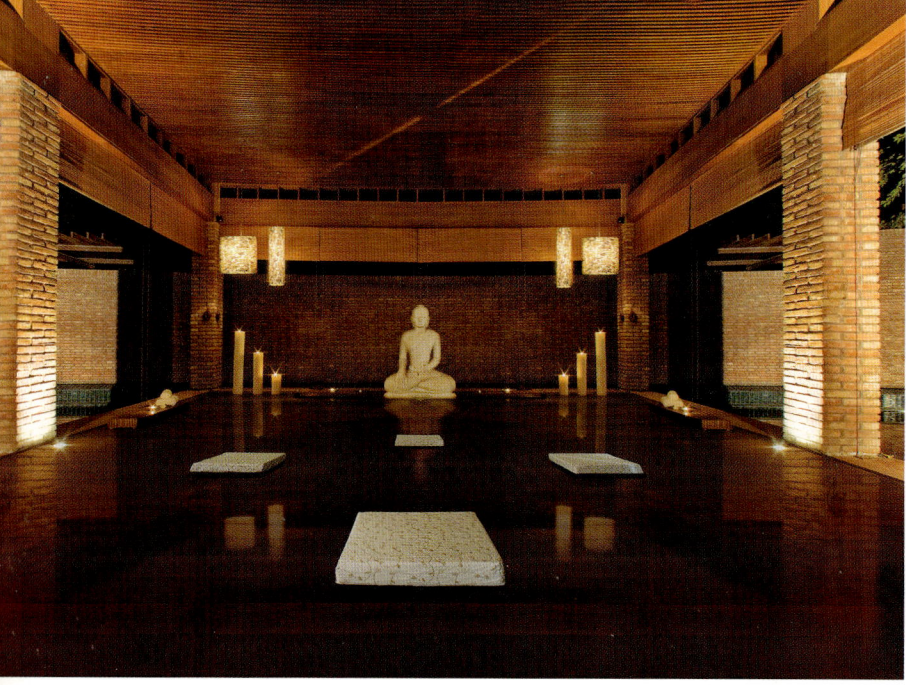

radiating heat to relieve tight muscles. The smoothness and heat from the stones gives a euphoric sensation, unique only to the Rollerssage treatment. It uses stones that hold metaphysical and healing properties and give you a choice of healing desired.

Other special massage treatments at the resort include the Lomi Lomi, the Workout, the Harmony and the Heavenly Massage.

Inspired by the grace and warmth of the Hawaiian culture, the Lomi Lomi Massage uses palms and elbows to soothe tensed muscles, allowing healing energy to flow freely, leaving you relaxed and renewed.

The Workout Massage, on the other hand, is a personalized massage that focuses on specific areas of need to help reduce muscle tension, increase the range of motion and provide a warm-up to activity. This is ideal for recreational lifestyles to help relieve discomfort or pain from overactivity. But, before you go in for this treatment, it is advisable to tell the therapist which areas of the body you want him/her to concentrate on during the treatment.

The Harmony Massage is a blend of six different massage styles – Shiatsu, Thai, Hawaiian, Lomi Lomi, Swedish and Balinese. It is performed by two therapists together in perfect harmony to rejuvenate every part of your body.

Last but not the least, The Heavenly Massage is a heated compress that invites back muscles to relax and ease before your choice of distinct essential oil blends are massaged into the body. Relaxation comes from the harmonious balance of scent and touch.

Apart from swimming and spending time in the lap pool, the best pastime within The Westin Sohna-Gurgaon Resort and Spa is to revel in the beauty of nature. You can spend time reading or playing cards in the library or go shopping in the gift shop.

If you want to take an excursion outside, the best thing is to visit the picnic spot at Sohna and take a bath in the hot spring, which is supposed to have medicinal value. You can even go boating in the Sohna Lake. If you have more time, you can always go shopping in the malls in Gurgaon and a drive alongside its glass buildings might remind you of New York.

All in all, The Westin Sohna-Gurgaon Resort and Spa is an ideal place where you can leave the outside world behind and allow your senses to be elevated.

*Top: The open plan bathrooms in the suites will literally take your breath away. The most eye-catching aspect of the bathroom is the tub that has a glass ceiling above – enabling you to soak in the morning rays while taking your bath. **Bottom**: Lord Buddha presides over the meditation room, inviting you into the world of peace and solace with Zen-like interiors.*

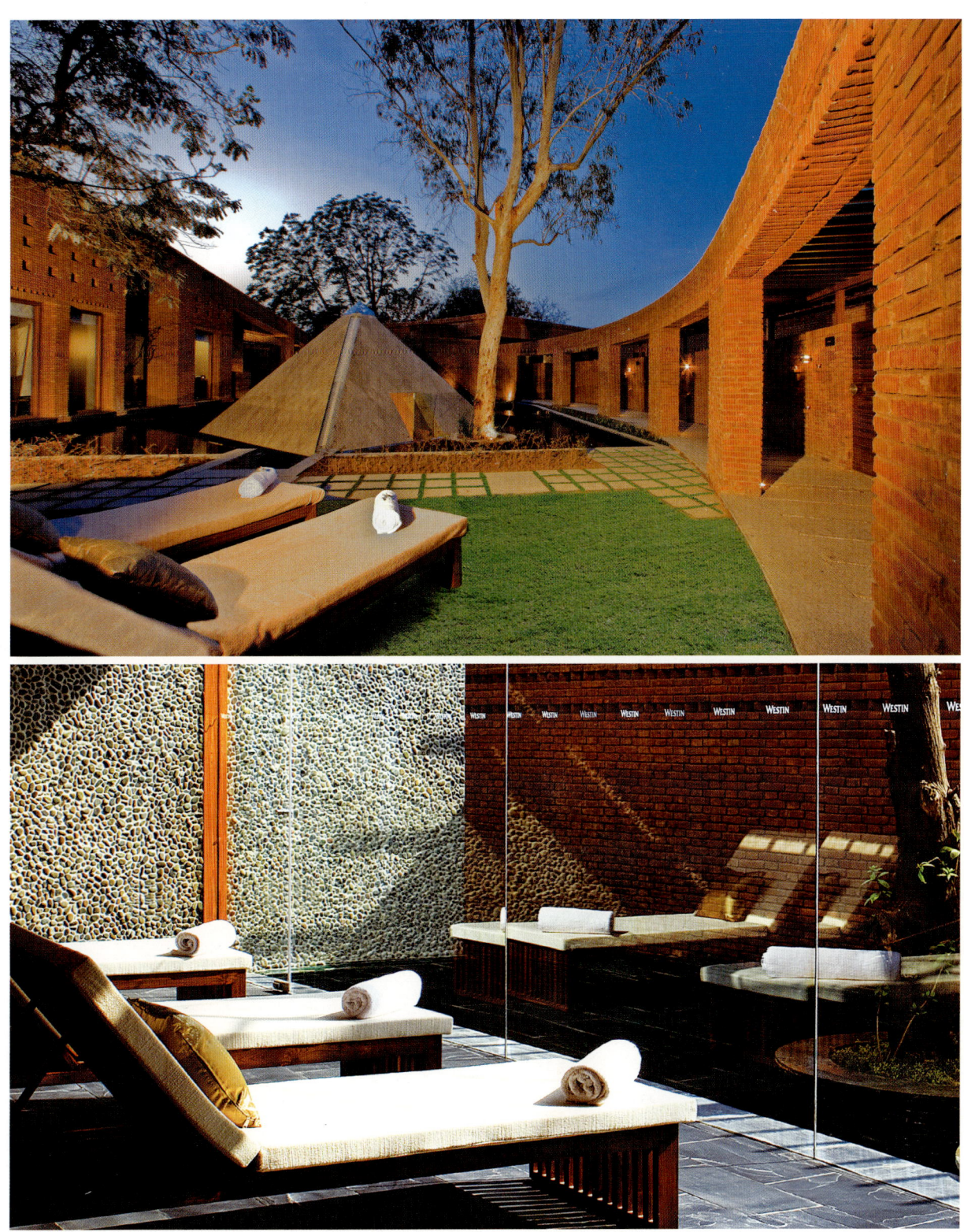

*Top: A view of the sunken pyramid from the outside. **Bottom**: A perfect way to relax after a comfortable massage. **Page 228**: The most unique aspect of the spa is a pyramid (inspired by the Auroville township near the Union Territory of Puducherry) that has been built right in the middle of the Heavenly Spa area of the resort.*

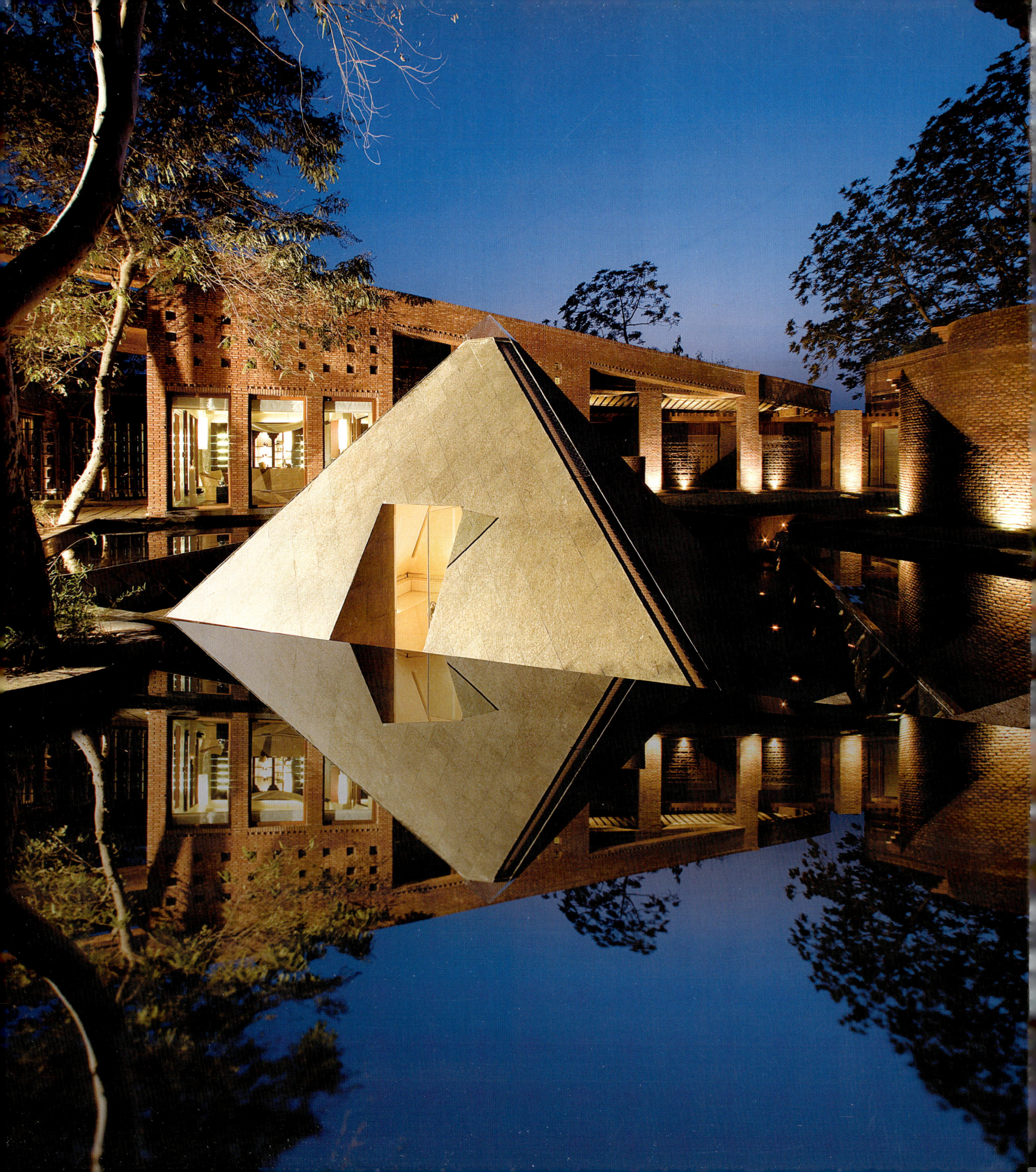